ART IN **AMERICA**

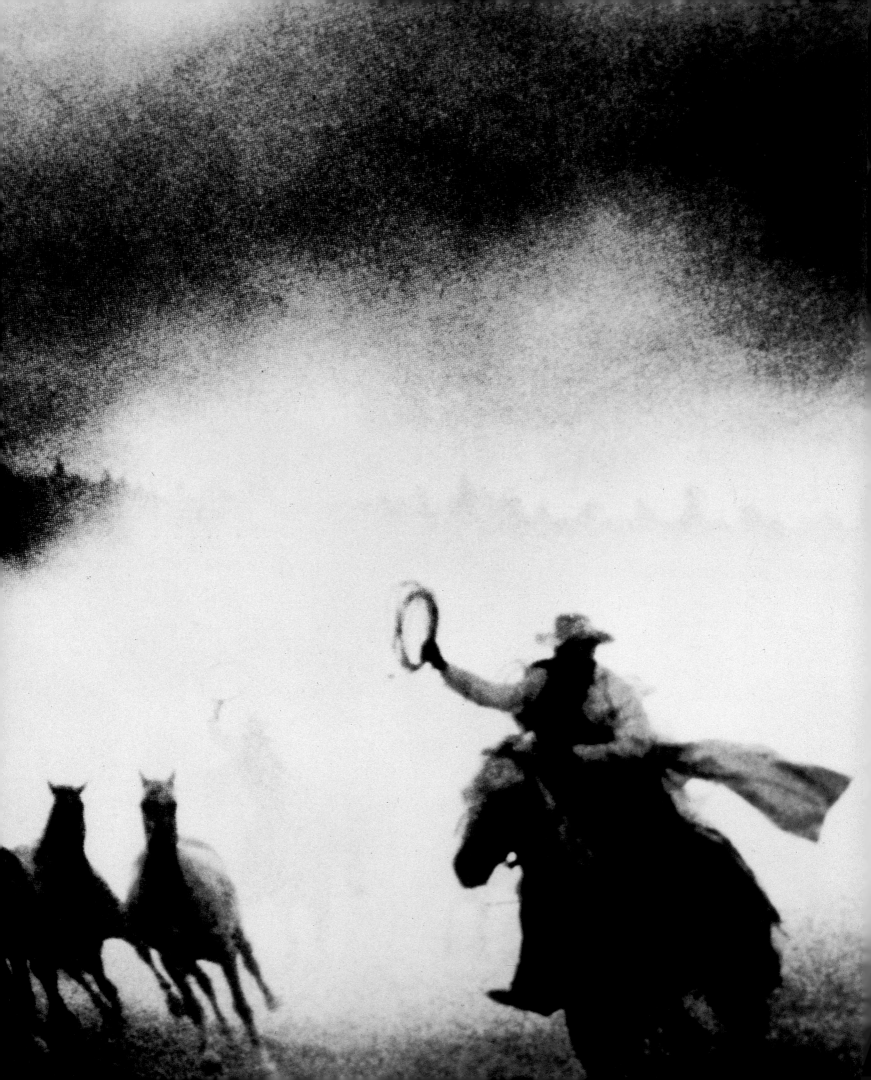

ART IN AMERICA

300 YEARS OF INNOVATION

Edited by Susan Davidson

MERRELL
LONDON · NEW YORK

Guggenheim MUSEUM

TERRA
FOUNDATION FOR AMERICAN ART

Art in America: Three Hundred Years of Innovation

This exhibition has been organized by The Solomon R. Guggenheim Foundation in partnership with the Terra Foundation for American Art.

This exhibition is made possible by ALCOA FOUNDATION

Major original funding provided by THE HENRY LUCE FOUNDATION

Generous support provided by HUGO BOSS

Additional support is provided by Ford Motor Company Fund and Akin Gump Strauss Hauer & Feld LLP.

National Art Museum of China, Beijing
February 10 – April 5, 2007

Shanghai Museum
Museum of Contemporary Art Shanghai
May 1 – June 30, 2007

First published 2007 by

Merrell Publishers Limited Guggenheim Museum Publications Terra Foundation for American Art

Head office 1071 Fifth Avenue 664 North Michigan Avenue
81 Southwark Street New York, NY 10128 Chicago, IL 60611
London SE1 0HX

New York office
49 West 24th Street, 8th Floor
New York, NY 10010

merrellpublishers.com

British Library Cataloging-in-Publication Data:
Art in America : Three hundred years of innovation
1. Art, American – 20th century 2. Art, American – 19th century 3. Art, American – 18th century
I. Davidson, Susan, 1958– II. Solomon R. Guggenheim Museum
III. Terra Foundation for American Art
709.7'3

A catalogue record for this publication is available from the Library of Congress.

English-language hardcover edition: ISBN-13: 978-1-8589-4394-7; ISBN-10: 1-8589-4394-9
English-language softcover edition: ISBN-13: 978-7-5326-2179-8; ISBN-10: 7-5326-2179-0
Chinese-language softcover edition: ISBN 13: 978-7-5326-2168-2; ISBN-10: 7-5326-2168-5

Produced by Merrell Publishers
Designed by Gary Tooth, Empire Design Studio, New York
Copy-edited by Elisabeth Ingles
Indexed by Hilary Bird

Printed in China and bound in Singapore

Front cover (hardcover): Robert Rauschenberg, *Buffalo II*, 1964 (detail; see p. 264)
Front cover (softcover): Charles Demuth, *Welcome to Our City*, 1921 (detail; see p. 215)
Back cover: Marsden Hartley, *Painting No. 50*, 1914–15 (see p. 211)
Page 2: Richard Prince, *Untitled (Cowboy)*, 1995 (detail; see p. 311)

CONTENTS

Sponsors' Statements

The Alcoa Foundation is honored to sponsor the Solomon R. Guggenheim Foundation's project, which brings three hundred years of American art to China.

Inspired by our successful sponsorship of the Guggenheim's exhibition *RUSSIA!,* which brought together national treasures that engaged the imagination of a record number of Americans, Alcoa Foundation is pleased to support another important Guggenheim cultural exchange, *Art in America: Three Hundred Years of Innovation.*

We congratulate the Guggenheim team for assembling this comprehensive, thought-provoking, and impressive array of work representing such an important artistic heritage. We look forward to sharing these rich representations of the American experience with the Chinese people through the presentation of *Art in America*, as well as its educational components, which will provide the opportunity to bring this history to younger audiences and schools in exciting new ways.

Art in America, comprised of artworks selected from collections throughout the United States and Europe, will be the most significant display of American art presented to communities in China. Full of visual richness, this exhibition tells the story of the natural and cultural experience of America and its people.

The American artistic journey featured in this exhibition begins with early impressions, including important portraits of nation-builders and inspired landscape paintings of the unspoiled wilderness of the American West. Additionally, the exhibition presents scenes of the American Civil War and works from turn-of-the-century America depicting industrialization, prosperity, and technological advances. Finally, with works from the twentieth century, it demonstrates how abstract styles, images of American affluence—such as manufacturing, industry, offices, cities, and suburbs—Pop art, and video and multimedia installations have created new cultural references around the world.

Alcoa and the Alcoa Foundation are proud to have been part of this American journey and to support the Guggenheim in bringing this experience and vision of our shared history and culture to China.

Meg McDonald
President
Alcoa Foundation, Pittsburgh

In 1998, the Solomon R. Guggenheim Foundation first approached the Henry Luce Foundation with the exciting idea for the exhibition and catalogue *Art in America: Three Hundred Years of Innovation*. As the late Henry Luce III said at that time, "Given our longstanding commitment to promoting better understanding between America and China and to bringing the work of American artists to more widespread attention, this was a natural fit." And it remains so.

To date, the Luce Foundation's American Art Program has distributed more than $110 million to enhance the study and presentation of American art. It has supported exhibitions, publications, and other research in forty-seven of the American states and the District of Columbia, the UK, France, Germany, and, now, China.

For the past seventy years, the Foundation's East Asia Program has worked to increase understanding between Americans and the people of the Asian Pacific. Reflecting the Luce family's history, the Foundation continues to support cultural and scholarly exchange with China, including Chinese art exhibitions in the United States.

The Henry Luce Foundation is honored to assist the Solomon R. Guggenheim Foundation in its undertaking to bring three hundred years of American art to China. We applaud the team for organizing such a comprehensive, stimulating, and impressive array of work, and we look forward to sharing this artistic heritage with the Chinese people, who have long shared theirs with us.

Michael Gilligan
President
The Henry Luce Foundation, New York

 THE HENRY LUCE FOUNDATION

Directors' Statements

The National Art Museum of China is extremely happy to work with the Solomon R. Guggenheim Foundation and the Terra Foundation to bring such an important exhibition as *Art in America: Three Hundred Years of Innovation* to Chinese viewers. As an exchange program, this event is a response to the exhibition *China: 5000 Years*, which was so highly acclaimed in the United States several years ago. It is borne of friendship between the Chinese and American people, as well as a symbol of the broadening of artistic exchange between China and the US that will be a feature of the twenty-first century.

Through the foundation's curatorial skill, the entire spread of American art has been condensed into the six chronological sections of this single exhibition, no doubt an extremely challenging task. The foundation has used its rich collection, augmented by works from many distinguished public and private American collections. The successful mounting of this exhibition is undoubtedly the result of daring and innovative collaboration among many Chinese and American organizations and individuals.

Art is always the most reliable visual evidence of social change and historical development, and provides a record of the development of the human spirit. This exhibition reflects the evolution of American society from the pre-industrial era through today's age of information, and tracks changes in the formal language of American art. We see both American cultural ideals and the exploratory spirit of generation after generation of American artists.

After the reforms of the 1980s, China's artistic circle cast its eye outward, paying special attention to the US as being representative of Western modern art, and drawing on and absorbing that nation's rich experiences. Some Chinese artists were indeed influenced conceptually and stylistically by Modernism. Today, while China continues to absorb all the achievements of human civilization and creativity, the relationship between Chinese art and that of other countries has evolved from one of unidirectional influence into one of active exchange. Understanding and dialogue between different cultures is beneficial to the formation of multiplicity in global culture. This exhibition has provided us with a glimpse of the cultural logic of American art as well as an opportunity to understand further how the art of the US relates to art worldwide, and will thus lay the foundations for exchange and dialogue between Chinese and American art in the emerging global cultural landscape.

I would like to thank most sincerely the Solomon R. Guggenheim Foundation, the Terra Foundation and all the Chinese and American institutions and individuals who have supported and aided this exhibition. We greatly appreciate the support and sponsorship accorded to this significant exhibition by Shanghai General Motors Corporation and the Cadillac Company. I must especially thank Minister of Culture of the People's Republic of China, Sun Jiazheng, who has remained attentive to this exhibition for many years, directing the National Art Museum of China and these American colleagues to work together to organize this exhibition in Beijing. It is truly this commitment on the part of the Chinese and American organizers to use this exhibition as a way of promoting a consciousness of mutual understanding and appreciation through cultural exchange that has allowed us to grasp this historic opportunity.

Fan Di'an
Director
National Art Museum of China

中 国 美 术 馆
N A M O C

On July 4, 1776, a new country that would have enormous influence on the course of human history was born on the other side of the Pacific. As the new nation grew politically and economically, the flowers of art gradually spread and blossomed across the wide expanse of North America. Since then, American art has become an important part of art history and, especially since the 1950s, its development has attracted great attention.

For this exhibition, the Solomon R. Guggenheim Foundation and the Terra Foundation have selected from the resources of several dozen great American artistic institutions, organizing a captivating spread of 120 representative works ranging from the colonial period of the late seventeenth century through contemporary works of the early twenty-first century. This is the first major survey of American art in mainland China, and provides a critical opportunity for us to encounter and understand American culture.

The preparation of this exhibition exemplifies the maxim that the road to happiness is strewn with setbacks. Its realization, from initial planning to the present, has taken nearly a decade. It is worth celebrating all parties involved, as it is through their great diligence that the exhibition has now finally crossed the broad ocean to come face-to-face with Chinese viewers.

The Shanghai Museum's own collection focuses on ancient art, but we welcome with open arms the outstanding results of human artistic production in any form and from any era. We have devoted all three special exhibition halls to *Art in America: Three Hundred Years of Innovation*, which will be surrounded by some of the greatest works from five thousand years of fascinating and wide-ranging Chinese civilization. The old, the new, China, and America will thus be brought together in a fortuitous intersection of time and space. We wish the exhibition the greatest success. I represent the Shanghai Museum in expressing the deepest gratitude to all those who have worked so hard to make this exhibition happen.

Chen Xiejun
Director
Shanghai Museum

Art in America: Three Hundred Years of Innovation is a symbol of the evolution and transformation through which the United States has passed since the decades leading up to independence. More recently, as the global economy began to make forward strides after the conclusion of World War II, America, stimulated by wave after wave of new artistic styles that found inspiration in the past, took its place as the leader of international cultural development. The Asian art world thus treats catering to the West as equivalent to identifying with American culture. Furthermore, identifying with American culture is viewed as a necessary means of catching up with the times; for it is thought that only thus can Asia possess avant-garde art. However, owing to the random nature of historical destiny, the effect of America on the art world as a whole did not reach China during the last century. Thus, the Guggenheim Museum's and the Terra Foundation's exhibition *Art in America* in China is significant: on the one hand, it bears witness to the stimulating interaction and communication between Chinese culture and the rest of the world in this new century; and on the other, it serves as an indication of the maturity and self-confidence now exhibited by Chinese art.

From its roots in Abstract Expressionism, which developed after World War II, American contemporary art grew through the Neo-Dada and Pop art movements, ultimately entering an era in which Conceptual art become the dominant art form. In the late 1970s, Americans began to recognize and appreciate the many cultures and coexistent realities found within their country's borders, and to realize that their own "majority" culture is, in fact, composed of multiple immigrant "minorities." In the 1980s, the diverse viewpoints that had been opened by this "multiculturalism" gradually developed into the expectation of "political correctness." This phenomenon, however, also unlocked paths and spaces for expression from ethnic groups that were formerly seen as "marginal cultures." At the end of the twentieth century, great advances in digital technology caused the interactive relationships between high technology and art to grow faster, closer, and more complex.

As the relationship between technology and the development of contemporary art becomes more intimate, clear boundaries cease to exist between art's application and life's functionality. As soon as humankind entered an age of visual information, originality came to be seen as a way of penetrating the massive information exchange effected through these multiple, diverse pipelines, where a continuous stockpiling and compiling of information has caused digital technology to become a commonly used medium of information in people's daily lives. Within the worldview of the internet, art has subverted traditional national borders and conceptions of cultural blocs; indeed, it could transcend the perception of otherness that separates nations.

Since the advent of Postmodernism, the voice of global culture has taken the form of a multipart chorus. By exhibiting *Art in America* in our museum, we will shed light upon the American contemporary art context, illustrating the important rôle it plays in the art world, similar to that fulfilled by a soprano soloist in that chorus. For Chinese viewers, this will indeed be an enlightening experience that will provide fresh ideas for consideration. Likewise, it is a great honor for our contemporary art museum to provide a venue for the Guggenheim Museum's and the Terra Foundation's *Art in America,* an exhibition of such great and timely importance.

Samuel Kung
Chairman/Director
Museum of Contemporary Art Shanghai

Foreword

The Terra Foundation for American Art is proud to partner with the Solomon R. Guggenheim Foundation to present *Art in America: Three Hundred Years of Innovation*, the most significant display of American art ever to be presented in the People's Republic of China. *Art in America* examines the issues of identity, innovation, and scale, all of which are integral to the American as well as the Chinese consciousness. Although the United States of America is a young country by Chinese standards, it is our hope that this exhibition will reveal the complexities of America's history and visual culture.

The Terra Foundation for American Art has made it a priority to foster innovative projects that emphasize multinational perspectives and participation. Throughout its twenty-seven-year history, the Terra Foundation has supported exhibitions, scholarship, and educational programs designed to engage individuals around the globe in an enriched and enriching dialogue on American art. Currently, the Foundation operates the Musée d'Art Américain Giverny, initiates and gives grants to exhibitions and projects in the field of American art, and actively acquires works of art to augment its collection.

The Terra Foundation's collection of American art spans the colonial era through 1945, and includes more than seven hundred works by such artists as Thomas Hart Benton, Mary Cassatt, Thomas Cole, John Singleton Copley, Marsden Hartley, Edward Hopper, and Reginald Marsh, many of whom lived and worked outside America. Marsden Hartley in particular believed that such travels brought the United States into perspective and allowed him to blend disparate identities into his art, as depicted in his Native American series. The Terra Foundation provides opportunities for interaction with works in its collection by actively lending objects to national and international exhibitions that advance American art scholarship, including a multiyear loan to the Art Institute of Chicago's expanded American Galleries. Comprehensive information about the Foundation's entire collection can be found on the Terra Foundation's website.

The Terra Foundation's expanded grant program is designed to respond to and support worldwide needs in American art. The Foundation has awarded grants to exhibitions and programs that explore American art in Europe, Canada, Latin America, and, now, Asia. In an effort to make scholarly resources more available worldwide, from Beijing to Buenos Aires, the Terra Foundation recently gave a substantial, multiyear grant to the Archives of American Art to make their most frequently requested items available online. In addition, the Foundation supports scholars through residential fellowships at the Smithsonian American Art Museum, as well as through travel grants offered through the Courtauld Institute of Art in London, the John-F.-Kennedy-Institut für Nordamerikastudien in Berlin, and l'Institut national d'histoire de l'art in Paris.

On behalf of everyone at the Terra Foundation for American Art, we would like to thank Thomas Krens and the Solomon R. Guggenheim Foundation for the opportunity to share the art and history of the United States with audiences in Beijing and Shanghai. Also, we would like to thank the curators, lenders, and host institutions in China for joining us in this historic effort. To further its international mission, the Terra Foundation for American Art will continue to develop strategic partnerships that foster the interpretation and enjoyment of American art worldwide, because implicit in all activities of the Foundation is the belief that art has the potential both to distinguish cultures and to unite them.

Marshall Field V
Chairman, Board of Directors

Elizabeth Glassman
President and Chief Executive Officer

Preface

It is with immense pleasure that the Solomon R. Guggenheim Foundation and the Terra Foundation for American Art have co-organized *Art in America: Three Hundred Years of Innovation*, the most significant display of American art ever exhibited in China. The exhibition aims to illustrate how American art has contributed to and reflects the nation's complex historical, social, and visual narrative, which is marked by conflict, diversity, and achievement. Comprised of a compelling selection of 120 artworks, the exhibition is organized into six chronological sections, dating from the colonial period to the present.

Art in America continues a rich dialogue between the Guggenheim Foundation and China, which began in 1997 when we organized the traveling exhibition *Masterpieces from the Guggenheim Museum* for presentation at the Shanghai Museum. This was the first exhibition in the People's Republic of China to provide a coherent and dramatic overview of modern and contemporary Western art. In 1998, the Guggenheim Museum presented *China: 5000 Years* at its own museums in New York and Bilbao, Spain. That landmark exhibition brought together artworks ranging in date from 3000 BCE to the modern era. It was complemented by a concurrent show at the Guggenheim entitled *A Century in Crisis: Modernity and Tradition in the Art of Twentieth-Century China*, which offered the first systematic exploration in the West of the past one hundred and fifty years of Chinese art. The history of the Guggenheim's engagement with Chinese art also includes *Dawn: Early Chinese Cinema* in 1998, a film festival of rarely seen masterworks produced between 1926 and 1949, which was held in the theater of the Guggenheim in New York. Other exhibitions organized by the Guggenheim over the past decade have allowed us to feature the work of many important contemporary Chinese artists, including Cai Guoqiang, Huang Yongping, and Yang Fudong. It is with enthusiasm that the Guggenheim will organize a forthcoming retrospective of Cai's œuvre, to be presented in New York in 2008, the year that China hosts the Olympics.

The Guggenheim shares with the Terra Foundation a vision of fostering Sino-American cultural exchange by bringing treasures of American art to audiences in two of today's most dynamic urban centers, Beijing and Shanghai. The year 2007, when *Art in America* opens in China, also marks the four hundredth anniversary of the landing at Jamestown, the first successful colonial settlement on the nation's shores. Thirteen years before the pilgrims landed at Plymouth Rock, England's King James I granted a charter to the Virginia Company (a group of London entrepreneurs), whose principal charge was to settle the land, find gold, and, above all, establish a water route to the Orient—in keeping with the Old-World belief that by sailing west one would reach the East. The indomitable will of the 180 settlers to survive the horrible first years after their landing on May 14, 1607, was matched only by the will of the cultures they encountered: the Virginia Indians (Algonquian, Siouan, and Iroquoian) and later the Africans (who arrived as indentured servants on a Dutch ship in 1619). Three continents of diverse peoples brought together by life's circumstances, and bringing together differing beliefs, values, ingenuity, and customs, became the very foundation from which the country has evolved for four hundred years.

The earliest settlers produced little art of consequence; thus, *Art in America* takes as its starting point the decades leading up to the signing of the Declaration of Independence in 1776, a period when the arts flourished and a distinctly American artistic style began to emerge. While the three hundred years of artistic achievement revealed in this exhibition is representative of a relatively young culture—one that certainly cannot match the five thousand years of continuous cultural tradition in China—we are nonetheless proud to chart America's independent path as a leader in the arts.

Art in America is in many ways a cultural expression of gratitude to the Chinese people, who parted with innumerable rare treasures from their archeological sites and national museums for the *China: 5000 Years* exhibition. What better way to offer the Guggenheim's appreciation for their generosity than to share with them the glories of our American heritage? When I was Director of the Williams College Museum of Art in Williamstown, Massachusetts, my mentor, the esteemed late curator Lane S. Faison, organized a thematic

exhibition entitled *The New England Eye: Master American Paintings from New England School, College, and University Collections* in 1983 that brought together seventy-five historical canvases. The visual impact of that modest assessment has served as my touchstone as we tell the history of our nation through its art. To that end, I enlisted the curatorial expertise of Nancy Mowll Mathews, Eugénie Prendergast Senior Curator of 19th and 20th Century Art, Williams College Museum of Art, to work with me on assembling a preliminary checklist for *Art in America* that exceeded Faison's concept and attempted to respond to the significant bodies of art lent for *China: 5000 Years*. Thus, since 1998 the two exhibitions have been inextricably linked, and I am honored to have been part of such a project, which has now come to fruition.

The financial seeds for our ambitious project had a long and tolerant sowing with the Henry Luce Foundation. Co-founder of *Time* magazine and editor-in-chief of all Time Inc. publications, the American publisher Henry R. Luce (1898–1967) was born and educated in China. The foundation that bears his name focuses its considerable wealth on furthering causes related to the interdisciplinary exploration of higher education, increased understanding between Asia and the United States, the study of religion and theology, scholarship in American art, opportunities for women in science and engineering, and environmental and public policy programs. It was natural, therefore, that the Luce Foundation would become the first supporter of *Art in America*. We are highly indebted to the Luce Foundation's unwavering endorsement of our efforts, and, in particular, to Ellen Holtzman, Program Director for the Arts, who has supported us at every stage, including bringing the Terra Foundation for American Art into this project.

Above all, this exhibition is the result of the unique collaboration between the Solomon R. Guggenheim Foundation and the Terra Foundation for American Art. Our expressions of gratitude go first to the Terra's dedicated Board of Trustees, who enthusiastically embraced the Guggenheim's vision for *Art in America*. The Terra's mandate to broaden the appreciation of American art globally parallels the Guggenheim's ongoing educational mission. We have benefited from the Terra's financial support, but most significantly from its curatorial expertise and the loan of fine examples from its collection of late nineteenth and early twentieth-century American art, which was first assembled under the refined eye of the late Daniel J. Terra (1911–1996), who was Ambassador-at-Large for Cultural Affairs under President Ronald Reagan. In particular, we are indebted to Elizabeth Glassman, President and Chief Executive Officer, whose passion for and dedication to encouraging the reconsideration of American art is currently transforming the Terra Foundation; Amy Zinck, Vice President, for managing the amiable relationship between the two foundations; and Elizabeth Kennedy, Curator of Collection, whose devotion to the field of American art is of the highest professional and personal standards. Additionally, we have enjoyed a productive working relationship with Donald H. Ratner, Executive Vice President and Chief Financial Officer; Jennifer Siegenthaler, Director of Education; and Catherine Ricciardelli, Registrar of Collection.

We are also deeply indebted to Alcoa and Alcoa Foundation, our lead sponsors, without whom this exceptional cultural exchange would not have been possible. The participation of Alcoa Foundation and Alcoa builds on an existing relationship with the Guggenheim, which reaches back to their sponsorship of the seminal *RUSSIA!* exhibition held at the Guggenheim in New York in fall 2005. At every turn in the planning of *Art in America*, we have been impressed by the deep and longstanding commitment of those at Alcoa Foundation and of the Alcoa leadership to promoting an understanding of the heritage and culture of China, in which country the company has long had operations and business partnerships. Alcoa's unwavering enthusiasm for this exhibition has been led by Alain J.P. Belda, Chairman and CEO, with Barbara Jeremiah, Jake Siewert, Helmut Wieser, Lloyd Jones, President, Alcoa Asia, and the Alcoa China team, and Meg McDonald and the Alcoa Foundation team. We look forward to continuing to deepen this productive association in the years ahead.

Hugo Boss has also been a steadfast supporter of the Guggenheim Foundation since the start of our collaboration in 1995,

which led to the inception of the Hugo Boss Prize in 1996. We are enormously thankful for their sponsorship of the Shanghai MoCA presentation of *Art in America*. Time and again Hugo Boss makes possible the most powerful manifestations of contemporary visual culture, a tendency that stretches beyond their visionary support of the Hugo Boss Prize. In Shanghai, Hugo Boss helped underwrite the exhibition's stunning contemporary installations at Shanghai MoCA, and in particular, I would like to recognize Dr. Bruno Sälzer, Chairman and CEO, and Dr. Hjördis Kettenbach, Head of Corporate Communication and Arts Sponsorship, for their innovative spirit, leadership, and friendship, as well as the Director of Communication, Philipp Wolff, for such effective support in publicizing our joint endeavors.

We are indebted to Ford Motor Company Fund for its dedication to this landmark exhibition. Additionally, we acknowledge Chairman Bruce McLean and his partners in Beijing, Moscow, and the thirteen other worldwide offices of Akin Gump Strauss Hauer & Feld LLP, one of America's great law firms. Through this exhibition, McLean and his partners are celebrating their new presence in Beijing and the continuing success of their Moscow office. We appreciate their enlightened support.

On behalf of the Trustees and our exhibition partners, I would like to express my gratitude to Clark T. Randt, Jr., United States Ambassador to the People's Republic of China, and Mrs. Randt, and to Minister Sun Jiazheng of China's Ministry of Culture, for serving as Co-Chairs of the Honorary Committee for *Art in America*. Their leadership endorses the importance of this initiative for US–China relations and cultural exchange.

A project of this magnitude requires considerable support from our Chinese colleagues. Without the full endorsement of the exhibition through the Chinese Ministry of Culture, Minister Sun Jiazheng and Vice-Minister of Culture Meng Xiaosi, the Guggenheim and Terra Foundations would not have been able to mount this seminal presentation of American art in China. I would like to thank Fan Di'an, Director, National Art Museum of China, Beijing, for making his remarkable facility available to us, and in particular to his staff,

Ma Shulin, Deputy Director; Quo Yurong, Deputy Director, International Program; Han Shuying, Director, International Program; Wang Lan, Director of Exhibitions; and Zheng Yan, International Program. In Shanghai, the exhibition will be presented in a two-part installation at the Shanghai Museum and the Museum of Contemporary Art Shanghai, beginning in April 2007. I offer my thanks to Chen Xiejun, Director, Shanghai Museum; Chen Kelun, Vice Director; Li Zhongmou, Head of Exhibitions; Li Rongrong, Head of Design; Li Feng, Head of Publicity; and Guo Qingsheng, Head of Education, for their engagement with the exhibition, and to Samuel Kung, Chairman/Director, Museum of Contemporary Art Shanghai; Victoria Lu, Creative Director; Miriam Sun, Administrative Director; and Wenny Teo, Assistant Curator, for their openness and receptiveness.

In addition to the exhibition's talented curators—Susan Davidson from the Guggenheim, Elizabeth Kennedy from the Terra Foundation, and Nancy Mowll Mathews from Williams College Museum of Art— the intellectual underpinning for *Art in America* was provided by an advisory team of three distinguished American art scholars: John Wilmerding, Christopher B. Sarofim Professor of American Art, Princeton University, and a trustee of the Solomon R. Guggenheim Foundation; Robert Rosenblum, Professor of Fine Arts, New York University, and Stephen and Nan Swid Curator of Twentieth-Century Art, Solomon R. Guggenheim Museum; and Michael Leja, Professor of Art History, University of Pennsylvania, Philadelphia. We are honored to have been able to count on the guidance of such an esteemed group of scholars.

This fully illustrated color catalogue accompanies the exhibition and is published in English and Chinese. It contains essays by members of the curatorial and advisory teams and other leading scholars of American art. Michael Leja's comprehensive text considers the paradoxes in American art from its birth through to the present day. Chapter texts for each chronological section have been contributed by Margaretta M. Lovell, Professor of Art, University of California, Berkeley, who examines colonial expression in American art; David M. Lubin, Charlotte C. Weber Professor of Art, Wake Forest

University, Winston-Salem, North Carolina, who addresses the cultural impact of the American Civil War on the nation's art; Justin Wolff, Joanne Leonhardt Cassullo Assistant Professor of Art History, Roanoke College, Salem, Virginia, who studies the political and social ramifications of the interwar period in America; Robert Rosenblum, who articulates the innovative moments in postwar American art; and Susan Cross, formerly Associate Curator at the Guggenheim Museum and currently Curator at Mass MoCA, North Adams, Massachusetts, who addresses the last decades of the twentieth century and the issues of American art nationally and globally. In shorter texts, Patricia Johnston, Professor of Art History, Salem State College, Massachusetts, and Jessica Lanier, Bard Graduate School for Studies in the Decorative Arts, New York, focus on the Chinese presence in early American culture, and Anthony W. Lee, Associate Professor of Art History, Mount Holyoke College, South Hadley, Massachusetts, offers a brief history of Chinese painting in America. Their learned contributions have greatly enriched our understanding of American art.

I am most grateful to the Guggenheim staff named in the curators' acknowledgments for all their hard work and dedication. In particular, the complex history of this project has benefited enormously from the expert knowledge of Susan Davidson, Senior Curator; Karen Meyerhoff, Managing Director for Exhibitions, Collections, and Design; Min Jung Kim, Director of Strategic Development, Asia; Nick Simunovic, Director of Corporate Development, North America; and Zhou Zhitsong, Consultant for Special Projects, China.

This ambitious endeavor draws significantly upon the collections of the Guggenheim and Terra Foundations, while also relying on the cooperation of fellow institutions across the United States and elsewhere. We have been fortunate in borrowing important examples of American art from numerous museums throughout the country and abroad. These institutions must be commended for their thoughtfulness in granting our loan requests; in many instances this exhibition marks the first time their works have been sent outside the United States. I am most appreciative of the generosity of all the lenders. The directors and curators are thanked individually in the curatorial acknowledgments that follow.

Art in America presents a singular opportunity for exchange between cultural organizations in the United States and China. It is our hope that the exhibition will serve as a diplomatic mission, demonstrating the richness of American art and its formidable contributions to an increasingly global culture.

Thomas Krens
Director
Solomon R. Guggenheim Foundation

Acknowledgments

Art in America: Three Hundred Years of Innovation presents the United States' history and culture through its art. The exhibition is organized in six chronological sections, marking significant phases of the country's development. Although the focus is primarily on advances in painting, later sections of the exhibition include other modes of expression: conceptual sculpture, installation, and video. In realizing this multi-venue project, we have relied on the cooperation of countless colleagues.

To begin, we extend our most sincere gratitude to all of the institutions and individuals who were generous in lending treasured artworks from their collections: Albright-Knox Art Gallery (Louis Grachos and Laura Fleischmann); Alturas Foundation and Aptekar Arts Management; Arkell Museum at Canajoharie (Diane E. Forsberg, James Crawford, and Emily Spallina); Matthew Barney; Berkshire Museum (Stuart A. Chase and Leanne Hayden); Bowdoin College Museum of Art (Katy Kline and Laura J. Latman); Eli and Edythe Broad Collection (Joanna Hyland and Vicki Gambill); Amon Carter Museum (Ron Tyler, Rick Stewart, Rebecca Lawton, and Melissa Thompson); Chrysler Museum of Art (William J. Hennessey and Catherine Jordan Wass); Sterling and Francine Clark Art Institute (Michael Conforti and Monique Le Blanc); Columbia University (Lee Bollinger and Sally Weiner); Columbus Museum of Art (Nannette V. Maciejunes); Paula Cooper Gallery (Joelle LaFerrara); Crocker Art Museum (Lial A. Jones and John Caswell); Daros Collection (Walter Soppelsa); Li-lan; Gibbes Museum of Art (Todd Smith, Angela D. Mack, and Zinnia Willits); Gilcrease Museum (Joseph B. Schenk and Tobie Anne Cunningham); Guggenheim Museum Bilbao (Juan Ignacio Vidarte); Peggy Guggenheim Collection (Philip Rylands and Sandra da Vari); High Museum (Michael Schapiro, Philip Verre, and Sylvia Yount); Howard University Gallery of Art (Tritobia Benjamin and Eileen Johnston); Hunter Museum of American Art (Robert Kret and Ellen Simak); Herbert F. Johnson Museum of Art (Franklin W. Robinson and Matthew J. Conway); Mildred Lane Kemper Art Museum (Sabine Eckmann, Mark S. Weil, and Sara Hignite); Atwater Kent Museum of Philadelphia (Jeffrey Ray); Marion Koogler McNay Art Museum (William J. Chiego and Heather Lammers); Midwest Museum of American Art (Jane Burns); Milwaukee Art Museum (David Gordon); Modern Art Museum of Fort Worth (Marla Price and Michael Auping); Montclair Art Museum (Patterson Sims, Gail Stavitsky, and Erica N. Boyd); Musée d'Art Contemporain, Lyon (M. Thierry Raspail, Hervé Percebois, and Gaelle Philippe); Museum of the City of New York (Susan Henshaw Jones, Andrea Fahnestock, and Sloane K. Whidden); Museum of Fine Arts, Boston (Malcolm Rogers, Erica Hirschler, and Kim Pashko); National Academy of Design (Annette Blaugrund and Mark Mitchell); National Gallery of Art (Earl A. Powell, Franklin Kelly, Nancy Anderson, Jeffrey Weiss, and Alicia Thomas); New Britain Museum of American Art (Douglas Hyland, James Kopp, and Dan Fulco); Pennsylvania Academy of Fine Arts (Lynn Marsden-Atlass and Robert Harman); Lois Plehn; Richard Prince and Barbara Gladstone Gallery; The Project (Giovanni Garcia-Fenech); Putnam County Historical Society (Mindy Krazmien); Reynolda House (Allison Perkins and Rebecca Eddins); Rhode Island School of Design Museum (Hope Alswang and Maureen O'Brien); Tony Shafrazi Gallery; Sonnabend Collection (Illeana Sonnabend and Antonio Homem); Tate (Sir Nicolas Serota, Alex Beard, and Nicole Simoes da Silva); United States Naval Academy Museum (J. Scott Harmon and Donald Leonard); Yvonne Force Villareal; Wadsworth Atheneum Museum of Art (Willard Holmes); Walton Family Foundation (Bob Workman and Liz Workman); Kehinde Wiley and Rachel Kohn; Williams College Museum of Art (Lisa G. Corrin and Diane M. Hart); Winterthur Museum (Leslie Bowman and Anne Verplanck); The Wonderful Fund (Prue O'Day and Anatol Orient); and those private collectors who wish to remain anonymous.

For their vision, unwavering commitment, and strong leadership throughout all stages of this project, we thank Thomas Krens, Director, Solomon R. Guggenheim Foundation, and Elizabeth Glassman, President and Chief Executive Officer, Terra Foundation for American Art. We have also benefited from the important counsel of Lisa Dennison, Director, Solomon R. Guggenheim Museum; Ellen Holtzman; Michael Leja; Robert Rosenblum; and John Wilmerding.

At the Guggenheim, which shouldered the organizational responsibilities for realizing the exhibition, we acknowledge Karen

Meyerhoff, Managing Director for Exhibitions, Collections, and Design, who deftly handled the myriad logistics; Meryl Cohen, Director of Registration and Art Services, Kathy Hill, Project Registrar, and Seth Fogelman, Associate Registrar for Collective Exhibitions, who led us through the extremely complex shipping arrangements; Gillian McMillan, Senior Conservator, Collections; Julie Barten, Conservator, Exhibitions and Administration; Nathan Otterson, Conservator, Sculpture; and Paul Schwartzbaum, Chief Conservator and Technical Director for International Projects, who offered advice and care for the works presented; Anthony Calnek, Deputy Director for Communications and Publishing, and Betsy Ennis, Director of Public Affairs, who ably publicized the project; David Bufano, Manager of Art Services and Preparations, and his crew, Jeffrey Clemens, Hans Aurandt, Chris Williams, and Colin Kennedy, who readied the works; Ana Luisa Leite, Manager of Exhibition Design, who collaborated with us on all aspects of the design and installation; and Anne Bergeron, former Director of Institutional and Capital Development; Nick Simunovic, Director of Corporate Development, North America; Min Jung Kim, Director of Strategic Development, Asia; Nic Iljine, Director of Corporate Development, Europe and the Middle East; Renee Schacht, Manager of Institutional and Capital Development; and Lisa Brown, Corporate Development Associate, who worked tirelessly in obtaining funding. Zhou Zhitsong, Consultant for Special Projects, China, expertly facilitated all of our interactions with our Chinese colleagues.

We received invaluable curatorial input from Nancy Spector, Curator of Contemporary Art and Director of Curatorial Affairs; Alexandra Munroe, Senior Curator of Asian Art; Alison Gingeras, Adjunct Curator; Tracey Bashkoff, Associate Curator for Collections and Exhibitions; Ted Mann, Assistant Curator for Collections; and Valerie Hillings, Assistant Curator. In addition, we extend a special acknowledgment to Robin Kaye Goodman, Project Curatorial Assistant, who shared many of the curatorial decisions with us as we formed the checklist and sought loans. Helen Hsu, Project Curatorial Assistant, continued the same high level of engagement. Megan Fontanella, Curatorial Assistant, and Kevin Lotery, Project Curatorial Assistant, offered timely and much-needed support, while curatorial interns Katherine Barone, John Vincent Decemvirale, Elizabeth Fodde-Reguer, Sara Fontanella, and Melissa Passman worked intensively on our behalf.

In conjunction with the exhibition, an international symposium addressing select themes in American art has been organized in Beijing in order to provide an opportunity for a true exchange between Asian and Western scholars, educators, and artists. At the Guggenheim, Kim Kanatani, Gail Engelberg Director of Education, Christina Yang, Senior Manager of Public Programs, and Sharon Vatsky, Senior Manager of School Programs, have benefited greatly from conversations with the Terra's Director of Education, Jenny Siegenthaler, as well as with Jane Debevoise, Qing Pan, He Lin (National Art Museum of China), George Chang and Katherine Don, and Ralph Samuelson (program officer, Asian Cultural Council).

Elizabeth Levy, Director of Publications, led a dedicated staff who produced a beautiful and scholarly publication and included Elizabeth Franzen, Managing Editor; Stephen Hoban, Assistant Managing Editor; Melissa Secondino, Production Manager; and Edward Weisberger, Senior Editor. The publication has been designed by Gary Tooth, Empire Design Studio, who applied his fine eye to every detail. Hugh Merrell and Nicola Bailey, Art Director, as well as the rest of the staff at our co-publisher, Merrell Publishers, deserve recognition for helping us to realize our vision. We are also grateful to the project editors and translators and to Philip Tinari at Bao for their work on the Chinese edition.

Susan Davidson
Senior Curator, Solomon R. Guggenheim Museum

Elizabeth Kennedy
Curator of Collection, Terra Foundation for American Art

Nancy Mowll Mathews
Eugénie Prendergast Senior Curator of 19th and 20th Century Art, Williams College Museum of Art

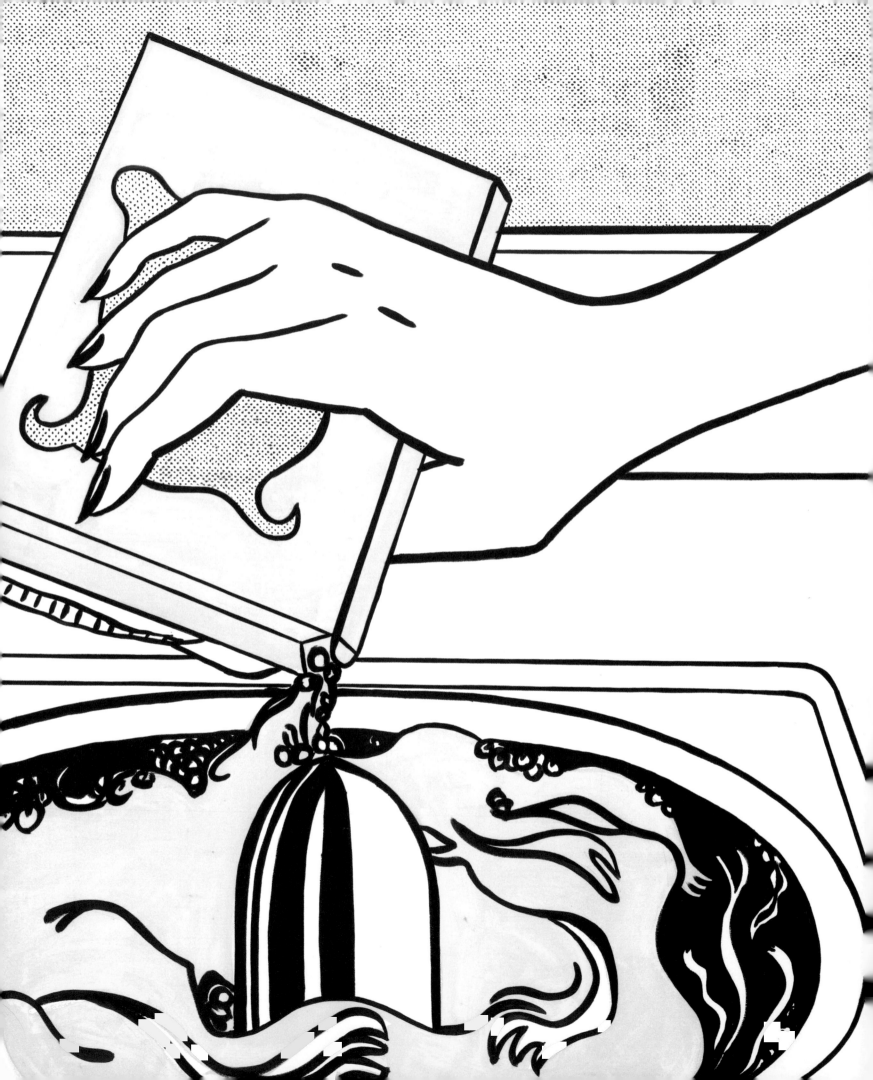

Paradoxes in American Art

Michael Leja

NEW WORLD AND OLD WORLDS

The immigrants from Europe who established colonies in central North America in the sixteenth and seventeenth centuries thought they were bringing civilization to the wilderness. In fact, their "new world" was an old one in which art and culture had been flourishing for millennia among native peoples. The diversity of the peoples collected under the terms "Indian" and "Native American" is evident in the forms and materials of their arts: wooden and stone tobacco pipes carved to resemble the animals believed to embody natural forces and spiritual protection; carrying bags, belts, and articles of clothing with practical and symbolic value fashioned from leather, feathers, and seashell beads; elaborate drawings on bison hides recording important events and battles; sand paintings designed to collect healing energies and transmit them to a sick person; elaborate wooden masks, totem poles, and blankets decorated with stylized animals; wall paintings in dwellings and canyons of the Southwest; and the ancient earthen burial mounds, in the shape of animals, located in the central parts of the territory.

In art as in so many other fundamental areas, the beliefs of European immigrants and native inhabitants were incommensurable. Just as the Europeans' belief in private property and in an individual's moral responsibility to improve the land and make it productive conflicted with the natives' sense of nature as beyond possession or mastery, their arts engaged and represented nature in diametrically opposed ways.[1] In England, a new form of painting was becoming popular as the colonists were departing for America: the "conversation piece," which featured small-scale, full-length portraits, often an entire family, posed gracefully and dressed in modern clothing, situated in their well-appointed home or the spacious grounds surrounding it, accompanied by possessions, pets, and servants (fig. 1). Familial identity and social position were established

through signs of wealth, elegant manners, fecundity, and accumulation. Similarly, native arts often placed the wearer or user in a complex social system, but that system encompassed animals and nature spirits as kin. Furthermore, native works often physically highlighted the natural materials from which they had been fabricated.[2]

The different European nations that appropriated the territory and resources of central North America pursued different strategies of colonization.[3] The Dutch and English favored relatively autonomous settlements on land acquired from the natives through purchase and trade. The French at first deliberately limited settlement in pursuit of commercial profit. The Spanish established missionary outposts and military rule, enslaving local natives for labor in farming and construction projects. Most of these nations brought slaves from Africa to assist with the labor of settlement and farming, especially on cotton, sugar, and tobacco plantations in the South. These different arrangements permitted different degrees of intermingling among European, native, and slave cultures and artistic traditions. Spanish churches built and decorated by Spanish and native Pueblo craftsmen working together sometimes displayed highly synthetic styles. British and Dutch colonists, on the other hand, looked past local native artifacts, which they disdained as heathen and primitive, and closely emulated the familiar traditions of their homelands.

The paired portraits by an anonymous painter of John and Elizabeth Freake and their baby Mary document the efforts of British colonists to identify themselves with the old-world traditions of their homeland.[4] In 1671, when the paintings were first done, John Freake was a wealthy Boston merchant and lawyer, and his wife, Elizabeth, was the daughter of another successful Boston merchant. Both were members of the Puritan Church, a Christian sect that tempered pride in material success as a sign of divine blessing with strictures on the use of art and the display

of wealth. John Freake's brown jacket, lace collar, gloves, muslin shirt, and silver buttons follow the latest styles worn by the English peerage and claim a particular social, religious, and economic identity for him. Elizabeth's clothing is made from fine imported textiles: taffeta from France, lace from Spain or Venice, brocade from England. Her elegant jewelry is also imported: the pearls from the Orient, the garnets from India. Technical analysis of the paintings reveals that they were updated three years after being first completed, when the artist added the couple's new daughter, Mary, born in 1674 (Elizabeth's hands were originally on her lap, holding a fan), and included more lavish markers of status and taste (fig. 27). John's gold ring and Elizabeth's pearls, bracelet, and ring were among the additions. The Freakes were evidently much less interested in preserving the pictorial qualities of their original portraits than in documenting their rising fortunes.

The unknown artist was probably trained in England, to judge by the use of the Elizabethan style, which developed there in the sixteenth century, featuring delicate linearity, restrained modeling, schematic rendering, and surface patterning. Materials and objects are evoked through abstract signs rather than the tactile and spatially vivid illusionism of contemporary Baroque painting. Disembodied forms are a concession to Puritan values and satisfy the demand for restraint imposed by the Freakes' religion. No less than the fashions and demeanors of the sitters, the style of the painting established connections to codes and traditions of English society and culture transplanted across the Atlantic.

As Britain's demands on its American colonies became increasingly burdensome, some colonists began to see themselves as an oppressed, exploited population. They came, in other words, to identify themselves as colonized subjects, displacing the Native Americans in that rôle. This shift in identities and in relations between colonists and the mother country can be discerned in two pictures made at almost the same time.

The painting *Penn's Treaty with the Indians* by Benjamin West (1738–1820), painted in 1771–72, portrays a legendary event of the 1680s. Colonists and merchants, led by William Penn (1644–1718), founder of the city of Philadelphia and the province of Pennsylvania, negotiate with natives, offering fabrics and unspecified manufactured goods in return for

land. The apparent subject of the painting is the peaceful relationship between the colonists and the natives, who are mutually engaged in lawful, commercial transactions that would transfer much of the territory of Pennsylvania to the colonists (p. 57).

But the painting carries other meanings as well. It was commissioned by Penn's son Thomas (1702–1775), who was administering his extensive holdings in Pennsylvania from his British estate.[5] A greedy, mean-spirited, and unprincipled governor, Thomas was known for taking advantage of the natives to acquire more land for settlers and for inciting the latter to violence against the former. His behavior motivated some colonists to oppose his authority, prominent among them the respected Philadelphia intellectual and politician Benjamin Franklin (1706–1790). In the context of Thomas's unscrupulous leadership and the challenges it provoked, the painting would have served him by reminding those who saw it (or one of its engraved copies) of his distinguished father's work and his own inherited right to authority over Pennsylvania territories. The painter, West, was born in Pennsylvania but had emigrated to England; he was also a member of the Quaker religious sect heavily represented in Penn's province. West was rising to prominence in London; he would soon earn the distinction of being named painter to the king. Historical paintings were his specialty, done in the Neo-classical style, which favored themes of heroic virtue presented in clear and forceful theatrical compositions invoking models drawn from Classical Greek and Roman art.

Penn's Treaty, then, visualizes as a scene of fair trading a series of exchanges in which natives participate in the colonists' industrial economy and its market for fine manufactures. Some of the natives in West's painting are already wearing textiles like those being offered in trade, and one carries a bolt of cloth away from the scene. They are represented as having an appetite for the world of superior goods that the colonists control.[6] In this way, the painting construes colonization as the natural and inevitable expansion of a market economy. Moreover, the painting uses this first contrivance as cover for another: disguising the exploitation of American colonists by administrators in England. The ambiguous period of the painting, oscillating between the late eighteenth and late seventeenth centuries through the costumes, the setting, and the

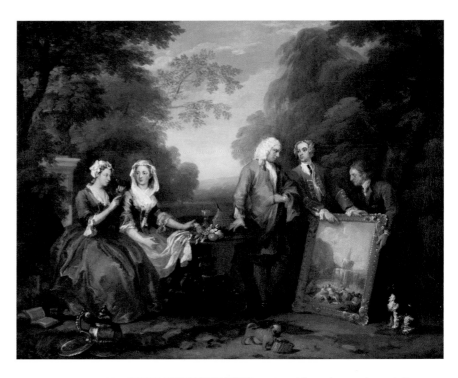

Fig. 1 (right) **William Hogarth (1697–1764)**

Conversation Piece (Portrait of Sir Andrew

Fountaine with Other Men and Women),

c. 1730–35

Oil on canvas, 18¾ × 23 in. (47.6 × 58.4 cm)

Philadelphia Museum of Art, The John

Howard McFadden Collection, 1928

Fig. 2 (left) **Paul Revere (1735–1818)**

The Bloody Massacre Perpetuated in

King Street Boston, 1770

Engraving, 7¹³⁄₁₆ × 8¹³⁄₁₆ in. (19.9 × 22.4 cm)

Courtesy of The American Antiquarian

Society, Worcester, Massachusetts

particular individuals included in the scene (West adds his own father and half-brother, as well as buildings representing the future city of Philadelphia), is one sign of the complex interests informing it. As a political statement, *Penn's Treaty* calls attention to a growing opposition between Englishmen and their representatives in the New World colony.

In the engraving of the Boston Massacre by Paul Revere (1735–1818; fig. 2), the economic exploitation that is the subtext of West's painting explodes into violent confrontation between colonials, protesting onerous taxation, and British military authority. Growing antagonism between the residents of Boston and the British troops quartered there to protect British interests erupted one day in a snowball fight. After being pelted for some time by snowballs and rocks thrown by the rowdy citizens, one of the twenty British soldiers standing guard at the Customs House became impatient and fired into the crowd. Other soldiers followed, and three colonists were killed, two others mortally wounded. In Revere's print the chaotic incident has been resolved into a clear opposition, and the evolution of the American colonists into the oppressed victims of colonization is now complete.

In the War of Independence (1776–83) and the pictures associated with it, ties between New World colony and Old World homeland were broken. The United States emerged as a country detached from the history of the land and the peoples who had inhabited it for centuries, and from the history of the imperial European nations that shaped and governed the colonies. The new nation envisioned itself liberated from these pasts and even from world history. This obscuring of its relation to the past helps to explain the intensity of conflicts that survive into the present: between self-identification with a progressive future and strict adherence to the principles and documents of the country's founders. The art of the United States, like its culture at large, negotiates the conflict between radical invention and affirmation of tradition.

DEMOCRACY AND AUTHORITY

With the beginning of the fight for independence from Britain, colonial leaders faced the problem of converting a group of diverse colonies and administrative entities into a unified nation. The practical and ideological dimensions of this challenge involved identifying principles on which the nation's laws and self-image would be based. Foremost among these were freedom and equality: in the words of the Declaration of Independence, "we hold these truths to be self-evident, that all men are created equal, that they are endowed by their Creator with certain inalienable rights, that among these are life, liberty, and the pursuit of happiness." The principal author of these words was Thomas Jefferson (1743–1826, president 1801–1809), one of the most influential thinkers and politicians of the new nation, and in his writings he posited the independent yeoman farmer as the ideal citizen and cornerstone of the American republic. The rights articulated in the founding documents of the nation were not extended to all Americans—slaves, women, and Native Americans lacked some or all; despite these contradictions, the ideals took deep root.

For some of the founders, commitment to democracy, equality, and liberty was incompatible with support of the fine arts. They believed painting and sculpture flourished alongside wealth and luxury, which were understood to be associated with inequality and exploitation. For those who wished to define the new nation as the antithesis of Europe, with its decadent aristocracy, powerful clergy, history of oppression, class conflict, religious persecution, frequent wars, and grand art traditions, art had to be handled very carefully, perhaps avoided completely.

As one former president, John Adams (1735–1826, president 1797–1801), wrote to another, Jefferson, in 1816: "The fine arts which you love so well and taste so exquisitely have been subservient to Priests and Kings, Nobles and Commons, Monarchies and Republicks. . . . From the dawn of history they have been prostituted to the service of superstition and despotism."[7] In the margins of a book, near a passage describing the ancient Romans' use of art to promote history and virtue, Adams wrote, "The fine arts . . . promote virtue while virtue is in fashion. After that they promote luxury, effeminacy, corruption, prostitution."[8] Like many leading citizens of the new nation, Adams saw art as a corrupting influence. As religion had constrained the visual arts in the colonies, so did political ideology in the young nation.

To survive in the early republic, the fine arts had to justify themselves as useful and compatible with democracy. This challenge was readily met.

Despite being under suspicion, art found public purpose in helping to establish the authority and legitimacy of the new nation. Some founders recognized that art was not simply necessary for the construction and decoration of public buildings; it had an indispensable part to play in instilling a sense of unity and commitment in a diverse population. It could help to create a vivid and memorable identity for the country by picturing a collective history, a pantheon of heroes, and national symbols and emblems. One writer articulated this function in 1810: "The prosperity and even the existence of a republic depends upon an ardent love of liberty and virtue; and the fine arts, when properly directed, are capable in a very eminent degree, to promote both."[9]

Such painters as John Singleton Copley, Charles Willson Peale, and Gilbert Stuart specialized in portraits of the nation's founders and holders of public office. Copley (1738–1815) was the premier portraitist in Boston, and his vivid images of that city's élite include some who were undergoing the transformation into advocates for independence from England. He portrays Samuel Adams (1722–1803), for example, in the wake of the Boston Massacre, adamantly pointing to the Massachusetts charter as his defense against the repressive actions of the British government. Although he was a loyalist who moved to England at the outbreak of war, Copley shows Adams's indignation sympathetically. In Philadelphia, Peale (1741–1827) was the leading portraitist and a vigorous advocate for independence from Britain. His portrait of John Beale Bordley (1727–1804), a judge and politician as well as a plantation owner, shows him as a defender of American liberty, standing firm against the expansion of Parliamentary power. The book is open at a passage that reads "We observe the laws of England to be changed." At the right, at the base of a statue that symbolizes both justice and liberty, Peale has placed some jimson weed, a poisonous plant signifying the danger of encroaching on the liberties of the colonists. Peale gives less emphasis than Copley to sensuous textures, fine surfaces, and fancy goods in his portraits. Whereas Copley insists on the substance and tactility of the objects in his paintings as the ground of the sitter's status and taste, Peale emphasizes the virtues of his subjects: wisdom, humanity, strength, trustworthiness. He employs a Neo-classical style featuring simplified compositions, strong outlines, even and clear lighting, and precise drawing (fig. 3). Many of his portraits of notable national figures were included in a gallery of illustrious leaders and war heroes exhibited first in his display room and later in the nation's first museum, which he founded in Philadelphia (fig. 5). Each portrait was designed to serve as an "*exemplum virtutis*" (virtuous example), a model that citizens would learn to admire and emulate. Later Mathew Brady (*c.* 1823–1896) would open in New York a photographic gallery of illustrious Americans for very much the same purpose.

Peale was the first artist to supply portraits of George Washington (1732–1799, president 1789–97) to a country hungry for images of its victorious military leader and first president. But a younger painter, Gilbert Stuart (1755–1828), succeeded in producing what would be the canonical portrayals of Washington: the smaller "Athenaeum" and the full-length "Lansdowne" portraits (so called after prominent owners of the paintings). The latter followed the conventions of stately portraits of kings and nobles and gave Washington power and authority through the depiction of his features, posture, and the accoutrements of his office (fig. 4). It appealed especially to one faction in government, the Federalists, who felt that strong political authority and a powerful leader were needed to avoid such democratic excesses as those of the French Revolution. The Lansdowne portrait evinces the growing desire for an art able to instill respect for institutions and authority rather than commitment to democracy and equality.

The same turn is evident in the design for an official seal of the United States. This seal, designed by multiple contributors over several years, incorporates traditional symbols associated with powerful authority in Europe, some from notoriously oppressive monarchies. The eagle had been a sign of imperial power since antiquity, and the American version was adapted from that used by the Habsburg emperor Charles V in the sixteenth century. The olive branches and arrows in its talons suggest peace through strength (fig. 6). The eye of providence in a triangle hovering over an incomplete pyramid draws upon imagery associated with the Freemasons, a secret brotherhood that originated with the builders of medieval cathedrals and became very popular among the

Fig. 3 **Charles Willson Peale (1741–1827)**

John Beale Bordley, 1770

Oil on canvas, 79¹/₁₆ × 58 in. (200.8 × 147.4 cm)

National Gallery of Art, Washington, D.C.,

Gift of The Barra Foundation, Inc., 1984.2.1

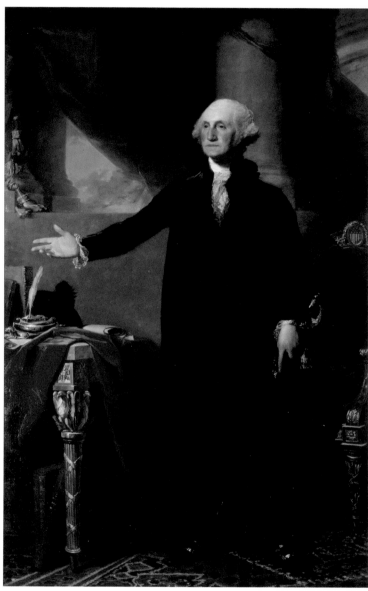

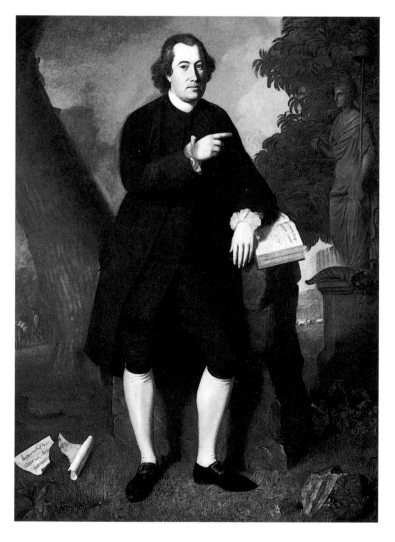

Fig. 4 **Gilbert Stuart (1755–1828)**

Portrait of George Washington

(The Lansdowne Portrait), 1796

Oil on canvas, 97¹/₂ × 62¹/₂ in. (247.7 × 158.8 cm)

National Portrait Gallery, Smithsonian

Institution, Washington, D.C., Acquired as

a gift to the nation through the generosity

of the Donald W. Reynolds Foundation

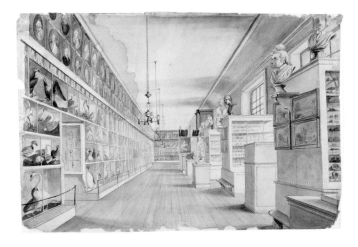

Fig. 5 **Charles Willson Peale (1741–1827)**

and Titian Ramsay Peale (1799–1885)

The Long Room, Interior of Front Room

in Peale's Museum, **1822**

Watercolor over graphite on paper

14 × 20¾ in. (35.6 × 52.7 cm)

Detroit Institute of Arts, Founders Society

Purchase, Director's Discretionary Fund

politicians who founded the United States (fig. 7). It was an ominously hierarchical symbol for the new, supposedly horizontal social organization of the republic. The mottoes on the seal emphasize the newness of the state ("*annuit coeptis,*" bless this beginning; "*novus ordo seclorum,*" new order of the ages) but the use of Latin signifies the traditional learning of an élite. The imagery of the seal stresses unity as a source of strength; this theme is found in the numerous references to the thirteen colonies (the number of berries and leaves in the olive branch, the arrows, stripes, stars, layers in the pyramid, reinforced by the motto "*E Pluribus Unum,*" one from many).

The seal shows the new state seeking to establish authority and convey an impression of power through previously established and respected symbols, even if these were tainted by association with antidemocratic regimes. As art historian Frank Sommer has put it, "What had been the learned toy of one of the most autocratic of aristocrats, Charles V, became the official symbol of one of the greatest of anti-monarchial nations. At the same time, the emblems were obscure, enigmatic, and far beyond the comprehension of all but the middle and upper-class gentlemen who had invented them and voted on them in approval."[10] As in the Lansdowne portrait of Washington, no signs or symbols in the seal signify liberty or equality.

Yet another type of work negotiating the conflicting attractions of democracy and authority was history painting. The pre-eminent artist in this category was John Trumbull (1756–1843), who portrayed numerous scenes from the War of Independence and the founding of the new government. Born into a prominent Connecticut family, Trumbull graduated from Harvard and fought in the War of Independence before he took up painting. He secured the first major public commission for history paintings in the United States: four murals for the rotunda of the Capitol Building in Washington, D.C. Trumbull's prior service to the nation, military and political, and his personal friendship with some of the most powerful men in government made this contract possible.

State sponsorship of art could be a more democratic form of support than patronage by monarchs, aristocrats, and clergy; moreover, Trumbull's Neo-classical style of painting suited democratic objectives for art.

However, the history Trumbull portrayed was shaped by military and political leaders, not the people. His four large murals in the Capitol show scenes of the stately surrender of British generals, the signing of the Declaration of Independence, and Washington resigning his military commission and, thereby, insuring civilian rule (fig. 8).

Suspicion of art in America persists to the present day. During presidential elections, candidates are often asked which books have had the greatest influence on them. Almost never are they asked which paintings, sculptures, or art exhibitions have been meaningful to them. Such a question would seem gratuitous to much of the electorate; many Americans do not want their president to be too conversant with the visual arts (or poetry, or serious music). Such knowledge can be associated with class privilege and construed as a sign of élitism and over-refinement. Public funding of the arts, already meager by European standards, is often threatened with further cuts or is channeled away from professional artists and into community arts organizations. Yet art has often been enlisted into government and public service for circulation abroad as a sign of the strength and freedom of American society and culture. Its power to carry political and cultural authority rests in part on its ability to signify democratic freedom of expression.

UNITY AND DIFFERENCE

In the middle of the nineteenth century, paintings of American landscapes and scenes of ordinary people engaged in routine activities emerged as popular subjects for American artists and audiences. Such pictures appealed to a broad public for many reasons. They were democratic in the sense that they could be understood and appreciated on the basis of common knowledge and experience; moreover, they often took ordinary individuals and familiar locales as appropriate subjects for art. They were also nationalist in the sense that they produced an image of the people and territory of the United States. Commentators singled out for special praise those paintings they felt could only have been done by an artist completely familiar with the behaviors and geographies of American life. This national character meant that such pictures would be rallying points around which Americans could unite in recognition of themselves and

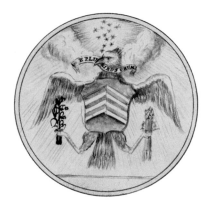 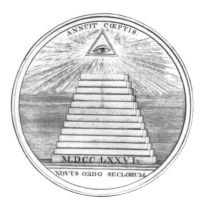

Fig. 6 *Design for the Verso of the Great Seal of the United States*, 1782
National Archives, Washington, D.C.

Fig. 7 Detail from an engraving of the *Reverse of the Great Seal of the United States*, illustrated in *The Columbian Magazine*, 1786
Library of Congress, Washington, D.C.
Rare Book and Special Collections Division
LC-USZ62-45509

their homeland. Those paintings would assist in the process of developing a national consciousness among the country's disparate people.

One idea widely embraced at this moment held that the bountiful land of central North America—rich in natural resources, dramatically varied in topography, picturesque and sublime by turns—was a mark of divine blessing for the new nation. Nature and geography became central to American identity, and landscape painting became a cornerstone of the nation's art.

The story of American landscape painting begins with Thomas Cole (1801–1848). Arriving in the United States from England in 1818 at the age of seventeen, he trained for two years at the Pennsylvania Academy and then moved to New York, where his paintings of scenery along the Hudson River attracted the attention of respected artists and writers. Cole's pictures of New York and New England landscapes revealed a pristine and dramatic topography, an abundant world of forests, lakes, mountains, waterfalls, and fields. His paintings highlight the grandeur of the American wilderness through such romantic devices as dramatic lighting and elevated viewpoints. Although tourism and industry had already begun to invade this wilderness, Cole edited them out of his scenes. In place of tourist hotels and viewing platforms, he inserted tiny Native-American figures among the flora and fauna to secure identification of place and give that place a "pre-civilized" character (p. 109). His paintings were an implicit critique of changes in the land being wrought by industrialization, materialism, and progress. Cole's landscapes suggested divinity in their light and fecundity as well as in explicit religious symbols. Signs of the supernatural became more prominent and fantastic in his landscapes as his work evolved.

Frederic Edwin Church (1826–1900) began as a follower of Cole and became one of the most successful American landscape painters of the nineteenth century. He embraced the idea of the bountiful land as evidence of divine favor and the source of American unity, and his often large paintings used heightened drama and spectacle to convey this message. His painting of Niagara Falls (1857; pp. 120–21) attracted an exceptionally large audience and was widely celebrated as a magnificent emblem of the nation. Church conveyed the majesty of nature in

minutely detailed yet sweeping panoramas punctuated by eagles, rainbows, and other signs of America and its special blessing.

However, political and ideological divisions within the country carried implications for depictions of the landscape. As the country moved closer to civil war over the enslavement of Africans, geography too acquired divisive aspects. Which part of the diverse American landscape could best sustain a claim to represent the nation as a whole? As opposition intensified between the industrialized northeastern regions, where opposition to slavery was concentrated, and the southern states, where owners of large plantations relied heavily on slaves, the problem for landscape painters became more acute. Given such conflicts, how could any landscape painting offer unifying symbols of the nation's values?[11] The fragmentary, additive quality of Church's painting *New England Scenery*, for example, is evidence of a struggle to remake a particular place into an acceptable symbol (fig. 9). Various elements characteristic of the New England landscape—lake, bridge, mill, village, church, mountains—are joined into a totality that does not quite cohere spatially. Moreover, this composite portrait of New England contains elements associated with other regions, such as the Conestoga wagon used in westward migration. The painting makes evident the difficulty of producing a national landscape at this moment. Even that art best suited to promoting national unity could not escape or counteract the rising sectionalism that divided the country.

Among painters of scenes of ordinary life, William Sidney Mount (1807–1868) took as his central subject the yeoman farmer who was Jefferson's ideal citizen of the republic. Mount's *Long Island Farmer Husking Corn* from 1833–34 proved a powerful and enduring image of this type. The well-dressed countryman at the edge of his abundant cornfield smiles as he examines the fruit of his labors. He stands erect and dignified, obviously enjoying the work of cultivating this distinctly New World grain and unfatigued by it—neither peasant nor gentleman but yeoman citizen.[12] This picture was widely circulated since it was engraved on more than twenty-five denominations of currency in over ten states.[13] Another of Mount's popular paintings, *Farmer's Bargaining* of 1835, shows two laconic farmers negotiating a price for the horse standing

near them, but seeming to be less interested in the negotiation than in their whittling (fig. 10). It too was widely reproduced in printed copies.

Mount's dignified citizen-farmer was appreciated by audiences as an "essential American type" revealing "true American character." However, his paintings also deflated the noble image of the farmer for comic effect and to appeal to urban audiences. Making use of comic caricatures found also in contemporary literature, theater, and vernacular speech, Mount's paintings appealed to the condescension of city sophisticates and thus spoke to social differences among viewers. The image of the Yankee farmer whittling while bargaining, shrewdly sizing everything up while feigning lack of interest, for example, was a cliché at the time, appearing commonly in the entertainments produced primarily but not exclusively for urban audiences.

Race was necessarily a charged and polarizing subject in paintings of everyday or popular life at mid-century. Supporters of slavery were attracted to pictures that caricatured African Americans as comic inferiors or that showed them perfectly content with the conditions of life on the plantations (fig. 26). Those seeking to abolish slavery preferred images of fully humanized figures dedicated to home and family, and desirous and deserving of liberty and equality. Even politically progressive images harbored unconscious racial stereotypes and tended to assimilate African Americans to the values and ideals of the dominant white culture.

However, one painting of African Americans managed to achieve broad popular success in this period. *Negro Life at the South*, painted in 1859 by Eastman Johnson (1824–1906), shows the small backyard of a dilapidated house in which groups of Negro adults and children play music, dance, flirt, cook, and watch from a window (fig. 52). The ramshackle condition of the house and yard contrasts with the stately, walled-off mansion next door, from which a white girl, followed by a black servant, emerges to peer at the Negroes. The girl is a surrogate for the artist and for white viewers of the painting seeking to see the truth of Negro life. The inquisitive gaze of the white girl is met by that of a light-skinned black girl. This vignette, in which girls of different races and classes examine one another across the frame of a wooden door, acknowledges the social processes in which the painting itself was implicated.

Most commentators recognized the figures in Johnson's painting as familiar caricatures of Negro life; they noticed as well that Johnson had recast those clichés sympathetically. One noncommittal writer noted that the painting, "a scene of Slave State life, not of the whipping-post nor of the auction-block, but of a quiet interior, of a slip-shod household, of a pair of young Negro lovers, not caricatured, but of a kind familiar to common experience, admitted the prescribed race to the common sympathies of humanity."[14] Where critics differed in their responses to the painting was over the meaning of the ramshackle environment. Did it represent the oppressive living conditions of slaves and predict that slavery was destined to collapse? Or was it an accurate depiction of a typical Negro household, disheveled because Negroes tended to be lazy, irresponsible, and carefree? Because it could accommodate drastically different responses and interpretations, *Negro Life at the South* was able to elicit broad approval despite its divisive subject matter.

Just as unifying landscape images were inevitably enmeshed in sectional differences, so depictions of popular types were involved in social differentiation and power relations among whites and blacks, rich and poor, and urban and rural middle classes. Paintings apparently simple in style and subject, with direct appeal to emerging middle classes, participated in complex negotiations of social and political difference within national unity.

NATIONAL AND COSMOPOLITAN

In 1880, art critic and historian S.G.W. Benjamin (1837–1914) published a new history of American art in which he described what he saw as the dramatic changes taking place at the time he was writing. American artists and audiences had turned away from the nationalistic paintings of mid-century—which now appeared embarrassingly provincial—toward the latest styles in European art. Americans now wished to measure their art against that of the world, and Benjamin was not alone in seeing this as a remarkable change.[15]

To be sure, this shift had something to do with enlargement of the nation's ambitions worldwide. Although an active participant in the international expositions that flourished in Europe after London's Crystal Palace exhibition of 1851, the United States did not host its own ambitious

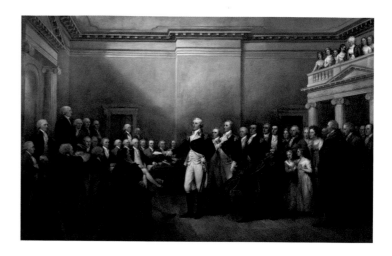

world's fair until 1876, the year of the Centennial Exposition in Philadelphia, which commemorated the signing of the Declaration of Independence. That exposition became a watershed event, in large part because it convinced many observers that America's cultural products were inferior to those of Europe and the rest of the world. In its wake, museums and schools were founded for the explicit purpose of providing design education for workers in all fields of manufacturing and handicraft. That the country now felt it necessary to measure its own cultural achievement by an international yardstick may suggest some insecurity, but other factors were in play as well. The economic significance of inferior art and design was not lost on American manufacturers competing for international markets, and the pride of a new class of wealthy industrialists was at stake as they sought greater prestige in international affairs and cosmopolitan society. Some used their new wealth to bring the cultural treasures of the world to America by forming lavish private collections and stocking metropolitan museums.

By the 1870s training at European art academies was already becoming indispensable for ambitious young American artists, and some expatriate painters, such as James Abbott McNeill Whistler (1834–1903) and Mary Cassatt (1845–1926), were attracting considerable attention internationally. Whistler's intense pursuit of artifice and refinement and his doctrine of art for art's sake made him an influential figure among European modernists in the period. He played an important rôle in drawing attention to the art of Japan and China through his extensive references and borrowings (fig. 11). Cassatt's variations on Impressionist subjects and styles, and her advocacy of modernist painting helped to stimulate interest in Impressionism among American collectors and curators.

The adoption and adaptation of European styles by American artists was rapid, and their success at integrating their art into cosmopolitan aesthetics was a cause for celebration among many critics and observers; however, it also incited alarm. As early as 1878 the *New York Times* expressed concern: "Many Americans have gone abroad as art students and remained as artists, ever after American only by birth and memory. We claim them as our countrymen and take pride in their achievements, but as artists there is nothing to distinguish them from Europeans. Others

return, but so full of the traditions and ideas that they found and so wedded to the teachings of some foreign master, that they are virtually aliens in the land of their birth."[16] Such worries about foreignness in the nation's visual arts were related to concerns about immigration in American cities, as jobs in growing industries attracted workers from all over the world: "To the sore plague of a swarming immigration of actual European peasants ... is added the weariness of painted ones— German, Italian, Dutch and French—who swarm over the walls of our exhibition rooms."[17]

The need for a distinctive national cultural identity did not fade as the desire for international cultural recognition grew. In this context, Winslow Homer (1836–1910) was widely appreciated for developing a type of painting whose subjects and style were distinctly national yet also internationally resonant and respectable. Homer's nostalgic pictures of rural life featuring farmhands at work with old-fashioned tools and children playing in fields and going to school struck deep chords in American viewers in the wake of the Civil War (fig. 12). These paintings also had a visual freshness and immediacy associated with their clear drawing and strong color. Homer's work was often praised as a true form of impressionism: it was attentive to light and atmosphere and seemed to have been painted on site, but it did not dissolve the image into a patchwork of brushstrokes as in French Impressionism. His painting *Snap the Whip* from 1872 illustrates this open-air naturalism in a scene of boys playing before a quaint one-room schoolhouse of the type that was rapidly disappearing (p. 131). The simplified and direct handling of paint and the firmly drawn forms were quite distinct from the dappled surfaces of Monet and Renoir, but the overall effects could be remarkably similar. Homer was appreciated for being "wholly en rapport with American life," as one critic wrote in 1879, injecting a French element into the statement much the way Homer's paintings did.[18] Homer's Americanness was increasingly admired and celebrated as European influence spread throughout the American art world.

Even the avowed cosmopolitan and expatriate American writer Henry James (1843–1916) found enough to like in Homer's work to overcome distaste for its nationalistic elements. Reveling in paradox, he wrote in 1875:

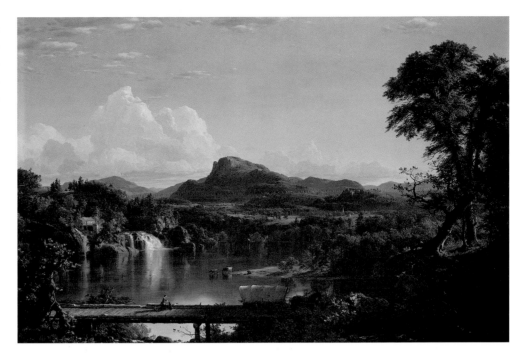

Homer is almost barbarously simple, and, to our eye, he is horribly ugly; but there is nevertheless something one likes about him. What is it? …We frankly confess that we detest his subjects—his barren plank fences, his glaring, bald, blue skies, his big, dreary, vacant lots of meadows, his freckled, straight-haired Yankee urchins, his flat-breasted maidens, suggestive of a dish of rural doughnuts and pie, his calico sun-bonnets, his flannel shirts, his cowhide boots. He has chosen the least pictorial features of the least pictorial range of scenery and civilization; he has resolutely treated them as if they *were* pictorial, as if they were every inch as good as Capri or Tangier; and, to reward his audacity, he has incontestably succeeded. …Mr. Homer has the great merit, moreover, that he naturally sees everything at one with its envelope of light and air.

James could not help but wish that Homer would break up his masses a bit more, making them more like French styles; this was one way he might become "an almost distinguished painter."[19]

Both cosmopolitan refinement and national qualities were necessary and desirable features of art as the United States expanded its interests and power in the late nineteenth century. The increasing attention to world cultures had an imperial quality that was noted at the time. Curator Charles M. Kurtz (1855–1909) wrote in 1898, the year of the Spanish–American War, when American victory gave it control over Spanish territories in the Caribbean and the Pacific islands: "It is a fact that our painters and sculptors have been winning victories in art exactly as the men composing our army and navy have been winning victories in war, and though the achievements of the former are less apparent to the multitude than those of the latter, they are none the less important, enduring, and for the good and glory of the Nation."[20]

CULTURE AND COMMERCE

As a nation committed to democracy and populism as well as to capitalism and marketing, the United States enthusiastically supported the new technologies that made possible the industrial production and mass distribution of art. From the middle of the nineteenth century, following the invention of the steam-driven printing press, electroplated woodblocks, lithography, and photography, various forms of inexpensive and accessible artworks, including illustrated newspapers and magazines, color lithographs, stereoscopic photographs, table sculptures, and posters, found ready entrepreneurs and markets. By the end of the century, new photomechanical printing processes enabled reproduction of photographs in mass-circulation publications, and the new moving images began to attract a large and diverse audience (fig. 13).

The dramatic growth of mass visual culture offered new opportunities to artists, who moved into the new fields, increasing and stabilizing their income.[21] Many worked quite comfortably across media, simultaneously producing popular illustrations and critically successful paintings.

Tensions between art and commerce were inevitable, however. The fine arts were understood to operate outside the world of commerce, enabling them to serve as correctives to the selfish and cut-throat world of business. An artist's freedom and individuality were not supposed to be compromised by contract stipulations or popular taste. As a result of these tensions, the fine and commercial visual arts occupied distinct and even antagonistic spheres by the early twentieth century.

Some artists resisted this separation. Most of the painters who made up the Ashcan school—known for gritty and unpicturesque views of New York—began as newspaper cartoonists and illustrators and continued as commercial artists well after taking up painting. They frequently portrayed the dynamic world of mass entertainments—such as movies, theatricals, night-club performances, and shop windows. In their work the city became a collection of visual spectacles; their pictures showed jostling crowds and urban voyeurs incessantly watching one another and the sights and commotion surrounding them.[22] *Vaudeville Act* by Everett Shinn (1876–1953; p. 189), *Stag at Sharkey's* by George Bellows (1882–1925; fig. 14), and *Election Night* by John Sloan (1871–1951; p. 185) testify to the range of this interest.

Other artists counterposed their work to the world of commerce and entertainment even when they drew upon that world for subject matter. Those who gathered around photographer Alfred Stieglitz (1864–1946) and his 291 Gallery in New York were committed to modernist innovation

through simplified and non-imitative pictorial form, self-expression, communication of emotional and spiritual content, reference to nature, and representation of the awesome character of the skyscraper city and modern technology (fig. 15). Although some of these artists took popular entertainments as their point of departure, they were aware of both the positive and negative dimensions of modern attractions. Joseph Stella (1877–1946) said of his painting of Coney Island, "I built the most intense dynamic arabesque that I could imagine in order to convey in a hectic mood the surging crowd and the revolving machines generating for the first time, not anguish and pain, but violent, dangerous pleasures."[23] The kaleidoscopic composition of his *Battle of Lights, Coney Island* highlights the overwhelming and chaotic frenzy of the scene (fig. 16).

Stieglitz saw himself and his colleagues in opposition not only to mass visual culture but also to the materialism, commercialism, sensationalism, and corruption of American society at large. They were less interested in working toward compromise with the tastes of the masses than in enlightening those willing and able to see the force of their work, however few they might be.

Another effect of the growth of mass and commercial visual culture in the nineteenth century was a shift in the relations of artists and audiences. As the visual arts became more deeply involved in commercial enterprises and mass marketing, viewers were increasingly addressed by pictures as targets for persuasion. Moreover, as pictures increasingly tried to influence viewers to believe, cherish, or buy something, or visualize something in a particular way, viewers learned to approach them with heightened caution, suspicion, and guile. Charges of fraud and deception multiplied as mass-produced pictures became part of the fabric of modern life. Chromolithographs (inexpensive, mass-produced color prints) were accused of being fake paintings, and illustrated magazines were charged with purveying generic images. Even photographs were revealed as capable of deceptive manipulation.[24] Although the visual arts helped to produce this skeptical orientation toward pictures, they also learned to respond to it.

Thomas Eakins (1844–1916) and William Michael Harnett (1848–1892) illustrate very different responses to this situation, although both would be classified as "realists." Eakins conducted extensive scientific

research into anatomy, perspective, reflection, and motion and sought to incorporate the knowledge thus gained into his paintings (fig. 17). His art was an ambitious attempt to remake realism for a world of illusions and deceptions. It strove to enhance the truthfulness of depictions by fortifying them with scientific principles, verifiable measurements, and knowledge of deep structures. Paintings by Eakins communicate this commitment through a combination of features: minutely detailed forms, figures and objects precisely positioned in illusionistic space, arrangements of tonal values evocative of photography, refusal of photography's unifying and homogenizing vision. Discontinuities and discrepancies in his compositions signal an additive, analytic, research-oriented process and a commitment to representing knowledge.

Eakins's suspicion of superficial appearances and his earnest pursuit of knowledge-based realism were counterbalanced by Harnett's playful exploration of illusion. His precise and detailed renderings of still-life objects arranged in shallow spaces highlighted surface appearances and physical textures. They invited skeptical viewers to admire the skills of the artist as an illusionist and to test their own wits against his. Harnett complicated this game by raising and lowering the threshold of illusionism and by including deceptive entry points into the illusionistic space: a partially open door, a keyhole, the underside of a clipping. However, the playful deceptiveness of his art was more than an idle game. It made pleasurable an experience ordinarily accompanied by anxiety: confrontation with the panoply of illusions in modern life. It also merged a wish to enter into the world of illusions and to learn their secrets with a desire for social contact in a world mediated by things. The objects rendered so substantially and palpably in Harnett's still lifes are almost always old and worn; they are endowed with the luster that comes from much handling, and strongly imply the presence of an individual who has collected and used them. His paintings conflate desire for the tactile gratification of touching a sensuous surface with desire for human contact at a moment when identities and social relations were increasingly mediated by material possessions. Harnett's paintings betray skepticism about the possibility of direct, fulfilling contact with people and things in a world of consumers and commodities.

Fig. 14 George Bellows (1882–1925)

Stag at Sharkey's, 1909

Oil on canvas, 36¼ × 48¼ in. (92.1 × 122.6 cm)

Cleveland Museum of Art, Hinman B.

Hurlbut Collection, 1133.1922

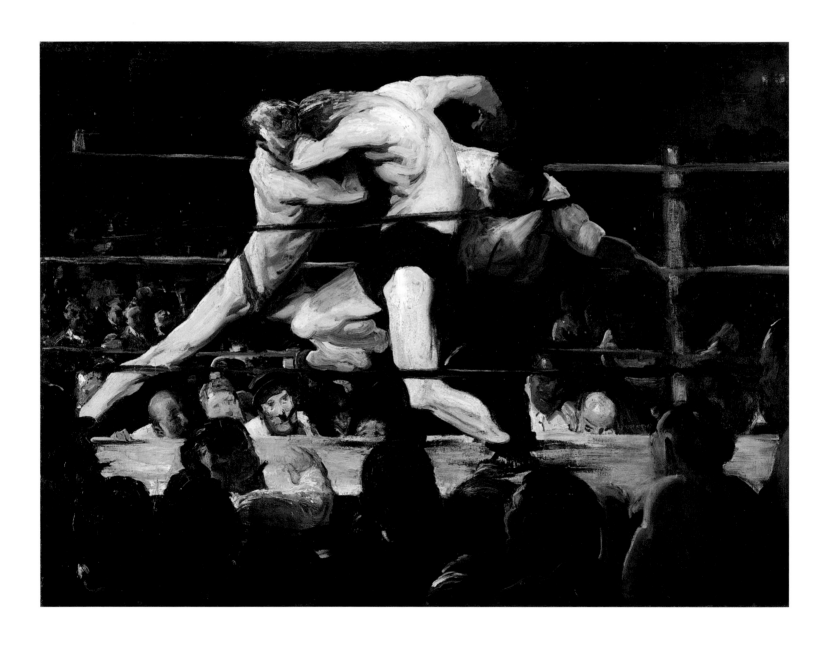

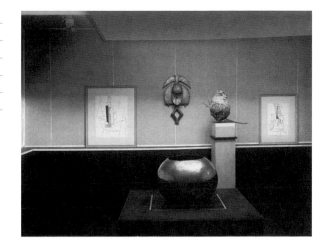

Fig. 15 **Alfred Stieglitz (1864–1946)**

Picasso-Braque exhibition at "291", 1915

Platinum print, 7"/₁₆ × 9"/₁₆ in.

(19.5 × 24.6 cm)

The Museum of Modern Art, New York

Gift of Charles Sheeler, 633.1941

The nation's energetic pursuit of capitalism and expanding markets has profoundly shaped its art in myriad ways, some more obvious than others. In the twentieth century, commercial mass culture and the fashion and advertising industries became so voracious and engulfing that any art hoping to carve out a space outside of them was forced to desperate measures.

POWER AND IMPOTENCE

In the years following World War II, a new kind of modernist art emerged in New York: Abstract Expressionism. The paintings of the central figures in this group—Jackson Pollock (1912–1956), Barnett Newman (1905–1970), Mark Rothko (1903–1970), Willem de Kooning (1904–1997)—do not much resemble one another, but they share a constellation of commitments and concerns and a point of departure from European modernist painting.

In the mid-1940s several of the future Abstract Expressionists converged on a shared artistic project: amalgamating two contradictory strands within European modernism. They sought to combine the systematic, deliberate, analytical work on form and structure exemplified in Picasso's Cubism with the irrational, unconscious, and chance devices developed by the Surrealists. This was a synthesis of opposites in terms of form and artistic philosophy. Technically, how could one combine the disciplined, rational work of making sophisticated modernist pictures with reliance upon irrational and chance procedures? Could one liberate the primitive and unconscious contents of mind and being and, moreover, use them to make fine advanced art that extended the modernist tradition? As these questions begin to indicate, this project was no dry, artistic exercise but took up matters of philosophical and historical import.

Jackson Pollock's work stages the act of painting as a battle between controlling and uncontrollable forces. Working on canvases laid out on the floor of his studio, he poured, dripped, and threw paint using sticks, brushes, and basting syringes, sometimes pouring directly from a container. To judge by photographs and films of his procedure and by his own accounts of it, as well as by the evidence of the paintings themselves, his pace was at times slow and deliberate, at others frenetic and violent (fig. 18). By design, this process prevented Pollock from controlling exactly the placement of the paint and the form it took on the canvas. Yet features that frequently appear in his paintings—regular and repeated forms, figurative elements, consistent density of lines, cubist structure—reveal that Pollock exerted much more control over the painting than his process would seem to allow. The painted marks suggest highly varied application: thin splashes, raised lines, smooth pools, brushed areas. Passages of wild, chaotic linear energy are placed alongside areas of precise, delicate, virtuoso control. Although the variety of markings may conjure an image of multiple artists working on each picture, close attention reveals evidence of a unifying will in repeated marks and overall effects (pp. 262–63).

Barnett Newman's paintings are quite different from Pollock's: large fields of color, sometimes evenly painted, sometimes highly agitated, are usually divided by narrow vertical bands, which also may be smooth or painterly (p. 259). Apparently tightly structured, the paintings have an internal order that is disrupted or undermined in subtle ways. Process is revealed in color strata exposed at the edges of a form, sometimes where masking tape preserving unpainted canvas has been removed. In this way a color field may reveal itself to have gone through many transitions and be composed of quite disparate elements. Sometimes the masking tape is left in place as if testifying to Newman's willingness to abandon a pre-established plan in the face of unexpected results. Sometimes forms diverge from the vertical and horizontal in violation of the structural regularity observed elsewhere.

Newman titled many of his paintings after figures and incidents from biblical or classical mythology, and he reinforced these references with related metaphors in his writings and statements. Several of his titles evoke the commands of the biblical creator ordering world and being into existence. Newman was fascinated by those powerful mythic speech acts that generated life and order, as he indicated with such titles as *The Word, The Command, The Voice*.[25] He also compared his art to the shout of an imaginary creature: "original man," yelling "in awe and anger at his tragic state, at his own self-awareness and at his own helplessness before the void."[26] This fictive moment of tragic realization was also something Newman apparently wished to capture in his paintings. He was not

troubled by the contradiction between his metaphors of power and impotence: "Man's first address to a neighbor was a cry of power and solemn weakness, not a request for a drink of water."[27] This rhetoric of simultaneous power and impotence, visualized in a relation of bands to fields and in disrupted structures, is the link between Newman's art and Pollock's, in which related conflicts emerge through fields constituted from lines, pools, and spatter.

Mark Rothko's paintings of stacked and nested rectangles of resonant color exploit variations and nuances in the handling of edges, layering, framing, and the dynamics of transparency and opacity. His compositions and color combinations provoke a rich variety of expressive allusions and associations, drawing on effects of light, landscape, atmosphere, and more (p. 257). Through the largely unconscious mediation of shifting and contradictory metaphors, such as celestial and hellish light, material and immaterial worlds, thresholds and dead ends, Rothko's paintings have often elicited from viewers the intense and conflicted responses he wanted. He hoped that viewers would experience acute emotional conflict before his works: calm and agitation, stability and instability, hope and despair. He reveled in paradox when telling an interviewer that his paintings had a "serenity about to explode."[28]

Rothko's statements reveal his objective to have been a tragic art: an art that conveyed the experience of helplessness in the face of cosmic events and human history. "I'm interested only in expressing basic human emotions—tragedy, ecstasy, doom, and so on—and the fact that lots of people break down and cry when confronted with my pictures shows that I *communicate* those basic human emotions."[29]

A defining feature of Abstract Expressionism was its attempt to devise an art that took full account of relatively new knowledge about human nature, mind, and the human condition—knowledge that was psychological, anthropological, and philosophical. It adapted European modernist traditions to representation of and by an individual whose mind and being were conflicted, soaked simultaneously in reason and irrationality, progress and primitive violence. The historical traumas of the 1930s and 1940s help to explain the appeal of such models of the human individual. Popular efforts to understand the rise of fascism, world war,

death camps, and the atomic bomb gravitated toward notions of the conflicted individual, subject to unconscious and primitive impulses, or the impotent individual, helpless before an overwhelming tragic fate.[30]

In the postwar period this art gained international influence and prestige greater than any American art before it. Abstract Expressionism was taken to be a high-cultural correlate of the country's military, economic, and technological rise to pre-eminence in the western hemisphere during and after World War II. Not only was it believed to mark the coming to maturity and independence of the visual arts in the United States, but it also stood as the quintessential artistic embodiment of the qualities and ideals that the nation's mainstream, middle-class culture holds dearest: individual freedom, boldness, ingenuity, grand ambition, expansiveness, confidence, power. Once its value as an emblem of American freedom and power was recognized, the State Department and other government agencies and affiliates sponsored extensive international exhibitions as part of a program of Cold War cultural diplomacy (fig. 19). The government continues to use art to promote an image of the nation to the world, and Abstract Expressionism remains the "gold standard" in these efforts.[31]

There is a paradox in the fact that this powerful art—both deeply affecting and diplomatically effective—drew heavily upon the individual's sense of impotence before traumatic world events. The work of Pollock, Newman, Rothko, and their colleagues spoke to the conflicted experience of power and impotence in the postwar period. These artists succeeded in making complex, beautiful, and strikingly original paintings that were deeply resonant for their audiences. Those anxieties have by no means faded, although the Abstract Expressionists' address to them now seems dated.

AFFIRMATION AND OPPOSITION

In 1962 Andy Warhol (1928–1987) held an exhibition that featured thirty-two paintings, each showing a single can of soup displaying the famous red and white label of the Campbell's Soup company, each differing from the others principally in the flavor of the soup, each can rendered in the simple, schematic language of advertising or comic strips (fig. 20). The

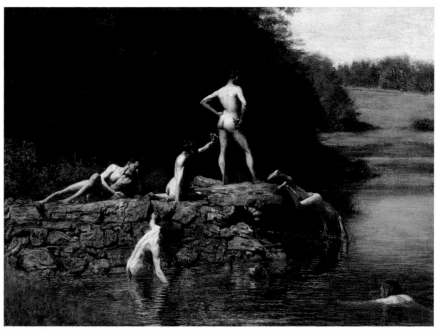

Fig. 16 (above left) Joseph Stella (1877–1946)
Battle of Lights, Coney Island, Mardi Gras
1913–14
Oil on canvas, 77 × 84¼ in. (195.6 × 215.3 cm)
Yale University Art Gallery, New Haven,
Connecticut, Gift of Collection Société
Anonyme

Fig. 17 (above right) Thomas Eakins
(1844–1916)
Swimming, 1885
Oil on canvas, 27⅜ × 36⅜ in. (69.7 × 92.4 cm)
Amon Carter Museum, Fort Worth, Texas,
Purchased by the Friends of Art, Fort Worth
Art Association, 1925; acquired by the Amon
Carter Museum, 1990, from the Modern Art
Museum of Fort Worth through grants and
donations from the Amon G. Carter
Foundation, the Sid W. Richardson
Foundation, the Anne Burnett and Charles
Tandy Foundation, Capital Cities/ABC
Foundation, Fort Worth Star-Telegram, the
R.D. and Joan Dale Hubbard Foundation,
and the people of Fort Worth, 1990.19.1

Fig. 18 (left) Hans Namuth (1917–1990)
Jackson Pollock with Lee Krasner, 1950
Black and white silver gelatin print
10 × 8 in. (25.4 × 20.3 cm)
Hans Namuth Ltd., New York

Fig. 19 **René d'Harnoncourt (right) at the press opening of *12 Modern American Painters and Sculptors*, Musée National d'Art Moderne, Paris, 1953** The Museum of Modern Art, New York

paintings were essentially painted and enlarged copies of the advertising image used by the Campbell company to promote its trademark commodity. To emphasize the paintings' full immersion in the world of advertising and commodity production, Warhol set each canvas on a small wooden shelf, simulating the supermarket shelves where real soup cans would normally be found. The paintings puzzled viewers and critics. Was Warhol erasing every kind of difference between a work of fine art and an advertisement or commodity? Was he finding artistic beauty in the banal imagery of commercial advertising and mass culture? Was he joking? Was he exposing this banality for the sake of analysis and criticism?

Interviewers asked the artist to clarify his intentions, but Warhol was elusive and coy. He claimed that he and his art were all there on the surface, that his art was about liking things, and that he wanted to be a machine, but he delivered these statements with a hint of a smirk that suggested he meant more, or other, than he was saying. He called his studio "The Factory," and he removed himself as much as possible from the process of making his paintings. Photographs he selected from newspapers and magazines were converted into silkscreens by commercial firms; the screens were then used to make prints largely by his studio assistants with varying amounts of assistance from Warhol. He chose images from the full range of commercial and mass visual culture: film stills of movie stars, tabloid photographs of car crashes, newspaper and magazine advertisements, dance diagrams, and do-it-yourself paintings.

At the same time, other artists were exploring contemporary mass and commercial visual culture as a subject for fine art. The paintings of Roy Lichtenstein (1923–1997) commented wryly on the highly abstract and schematic visual languages of commerce and entertainment. His paintings of golf balls, washing-machines, and jewelry worked with the notation systems of advertising and comic strips and savored their strangeness (fig. 21). Dots and lines carried multiple meanings, and a single image might use several techniques for rendering volume and depth. Lichtenstein also worked directly with comic strips as subjects, examining their visual conventions as well as their schematization of emotion, romance, and violence (p. 270). Like Warhol, he seemed both

to pay tribute to commercial visual culture and to parody it.

Pop art, the name given to the work of Warhol, Lichtenstein, James Rosenquist (born 1933), Tom Wesselmann (1931–2004), and others, was a shock to viewers habituated to the grand ambition and high seriousness of Abstract Expressionism. All too aware of the continued expansion of commerce and advertising into every area of culture and social life, they worried that Pop art represented the final capitulation of art to commerce. If fine art was one of the few remaining realms of experience with a plausible claim to having at least one foot outside the capitalist marketplace, in the hands of Warhol and Lichtenstein it was just another variety of commodity and commercial entertainment. Joining in the fun of the exuberant and effervescent commercial visual culture of the 1960s was preferable to occupying some imaginary moral high ground on the margins, their art seemed to argue. An alternative view stressed the critical implications of this art: that it provided a different type of resistance to commercial culture, one that made its case subtly through irony and humor. Critic Susan Sontag (1933–2004) aligned these features with a kind of detached amusement before exaggeration and artifice, associated with the homosexual subculture but which she also related to cultures of boredom and affluence.[32] Art historian Benjamin Buchloh argued that although Warhol's art marked the end of the great, critical avant-garde tradition, it shrewdly exposed the new situation in which artists worked in the 1960s.[33] As artist Allan Kaprow (1927–2006) famously wrote in 1964, "If artists were in hell in 1946, now they are in business."[34]

Pop art raises the question of whether there is any purpose, beyond social distinction, for an ambitious, "less-commercial" art in a society with an overheated and overwhelming visual culture of commerce and entertainment. Can fine art draw subject matter from mass culture without being swallowed up by it or forfeiting all claim to difference?

In the politically tumultuous late 1960s, when the movement for civil rights for African Americans and student uprisings against the Vietnam War were polarizing the country, some artists felt the need to introduce explicit political content into their work, and others who had been politically engaged for some time began to attract greater public attention.

Fig. 20 **Seymour Rosen (1935–2006)**
Photograph of Andy Warhol's exhibition
at the Ferus Gallery, Los Angeles, 1962
Courtesy of The Andy Warhol Museum,
Pittsburgh, and the Seymour Rosen Trust

Philip Guston (1913–1980) turned from the Abstract Expressionist work that had occupied him for over a decade to paintings in which cartoonish characters in white robes and hoods, identified with the Ku Klux Klan racist organization and sometimes spattered with blood, drove cars through cartoon cities, carried clubs, and smoked cigarettes in a landscape of desolation and sometimes death. Guston's style resembled that of R. Crumb (born 1943), an influential creator of underground comics popular among students and the "counterculture." The profound difference between Guston's comic-oriented paintings and Lichtenstein's was a matter not only of their distinct points of reference but also of the narrative ambiguity, painterly surface, nearness to expressionist abstraction, and explicit politics of Guston's works (fig. 23).

Betye Saar (born 1926) gave commercial imagery a sharp political twist in her work of the late 1960s and early 1970s. Her *Liberation of Aunt Jemima* from 1972 took the trademark figure for a commercial pancake mix, a black woman stereotyped to suggest the slave cook on a Southern plantation, and made her a militant civil rights activist carrying a broom in one hand and a rifle in the other (fig. 22).

Of the artists whose work was motivated by protest against the Vietnam War, Leon Golub (1922–2004) was positioned by experience to be a leading figure. His work had addressed antiwar themes since the 1950s, when political content was widely thought to be antithetical to art. Golub's paintings of brutalized figures were made to look charred and abraded through use of unconventional materials and an intensive process of painting and scraping. The canvas was often irregularly shaped, cut and torn, hanging unstretched, pinned with tacks to the wall, suggesting the conflation of painting and an abused body (fig. 24).

For all the complexity, richness, and ambiguity of their paintings, Guston, Saar, and Golub did not equivocate about their oppositional politics. For whatever reasons, cultural interest in their work was quite limited by comparison with Pop art. The Pop artists showed that the combination of affirmation of modern commercial culture with implicit parody or critique was an effective strategy for competing with the visual culture of commerce and entertainment, and that lesson has not been lost on the generations that followed them.

MULTICULTURE AND MONOCULTURE

Questions of unity and difference became pressing again in American art after the late 1960s. The social activism and political protests of that period initiated liberation movements for populations subject to discrimination, including women and homosexuals as well as African Americans, Asian Americans, Native Americans, and Hispanic Americans. Much of the American art of the late twentieth century sought to contribute to the cultural identities of these groups, which were unrepresented or caricatured in the mainstream culture. Such work is sometimes labeled "multiculturalist," suggesting acknowledgment of and respect for cultural differences within the American population with its diverse ethnicities, races, and sexual orientations. Some of this art also seeks to understand how identities have been produced for disempowered populations and to find ways of altering those stereotypes and the power relations they underpin; such concerns are sometimes referred to as "identity politics."

Some of the art of David Hammons (born 1943) is made from the debris of life among African Americans—hair clippings, types of food, sports paraphernalia—that references the reality and the clichés of African-American life. A sheet of paper marked by the repeated bouncing of a basketball calls to mind the practice routine of a teenage boy hoping to become a basketball star. The work's deceptively simple means provoke reflection on the limited options available to young black males and the effects of the entertainment culture on their aspirations and sense of identity. It is also a variation on a theme of the Dada artists, who worked with the physical traces of banal objects laid on light-sensitive sheets or driven along a scroll of paper.

Felix Gonzalez-Torres (1957–1996), who died of AIDS, produced work that addresses on multiple levels intersections of public and private spheres. A photograph of an empty double bed whose indented pillows suggest the recent presence of two heads—an image with intense personal content—was exhibited on commercial billboards throughout New York in 1992 (fig. 25). The image's suggestion of love and loss could be personalized and intensified by the knowledge that the bed was Gonzalez-Torres's own and that the picture was a private memorial to his lover who had died of AIDS. This information would have to be gained

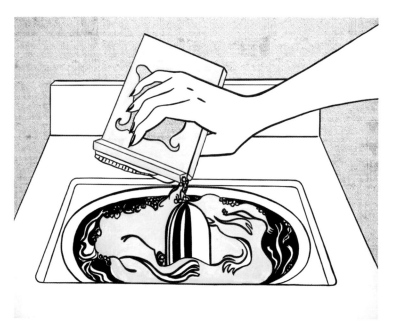

through research, however, since the billboards included no explanatory information. The artist may have seemed to be making private space public, but the Supreme Court had already done that when it ruled in 1986 that the space of personal privacy was not exempt from laws governing sexual practices.[35] The billboard photograph beautifully embodies the intersection of private and public through a subtle balance of the poetic and the political.

Barbara Kruger (born 1945) combines found photographs with text in ways that invite reflection on the mechanisms by which the images surrounding us address and position viewers and assign them identities. Her texts often employ first- and second-person pronouns—"we have received orders not to move," "your gaze hits the side of my face," "we will not play nature to your culture"—whose openness invites viewers to identify alternately with the speaker and with the addressee.[36] Many of her text and image combinations invite interpretation in terms of gender identities, but they also resonate with issues of political authority and state power (p. 309). Kruger frames the issue of an individual's sense of power and powerlessness more politically and less tragically or psychologically than did the Abstract Expressionists.

All viewers will find much to ponder and admire in the work of these artists, but each engages questions of identity as they relate to a particular population—African Americans, homosexuals, women. At times, asserting the cultural prerogatives of one group has entailed offending another, especially when strong sexual content or controversial handling of charged symbols is employed. Most often, the political form taken by the conflict has been the effort by conservative groups to deny public funding to exhibitions that contain works they deem immoral or un-American. A pattern has emerged in which art that seeks to advance the liberal reforms initiated in the 1960s and 1970s and multiculturalism is met by backlash from conservative groups promoting a unified, normative monoculture based on elements of Christianity, patriotic nationalism, and a style of middle-class domesticity. That art should be a battleground for these disputes may seem surprising, since its influence in the culture at large is limited; but this very feature makes it a low-risk target for politicians seeking to win political gains through divisiveness and scapegoating. Focus on multiculturalism, diversity, and identity politics has also had the effect of distracting public attention from serious economic divisions and class conflicts in the country.[37]

Art's rôle in social unification and differentiation has shifted dramatically since the nineteenth century. The days are long gone when Church's landscapes or Stuart's portraits of Washington could be expected to unite a diverse population. Cultural reformers in the nineteenth century tried to use such art as a means of healing social divisions and socializing and acculturating immigrants in national values and ideals. As I pointed out above, even these works could not overcome sectional or social differences in the country. Now, by contrast, there is little expectation that the visual arts will have unifying effects. When they do, it seems an aberration. *Vietnam Veterans' Memorial* by Maya Lin (born 1959) in Washington, D.C., is an exception that proves the rule. Violently opposed by veterans' groups when it was first dedicated in 1982, it now attracts hordes of admiring visitors and has become one of the most popular monuments in the country. Its elegant black granite panels are inscribed with the names of over 58,000 American soldiers killed or missing in the Vietnam War, merging text with visual forms in a way that evokes both modernist memorial and mass gravestone. This work is remarkable, possibly unique, among recent public art projects for having successfully negotiated the divisive politics and culture wars that have marked the country in the late twentieth and early twenty-first centuries.

From the beginning to the present, the art of the United States has had devoted advocates, practitioners, and critics who have insured its energy, beauty, ambition, and complexity. The virtues and achievements of the nation's art as well as its persistent conflicts and paradoxes are due largely to its unfolding within a diverse and contentious population with many truths to discover and illusions to preserve, within a relatively unfettered capitalist economy, and within a political system that functions principally to protect the market and its most powerful agents while proclaiming allegiance to the interests of the majority and the national ideologies of freedom and democracy. If the American system continues to become globalized, artists will have their work cut out for them, and paradoxes will proliferate.

Fig. 24 **Leon Golub (1922–2004)**
Mercenaries II (Section III), **1975**
Acrylic on linen, 76 × 72 in. (193 × 182.9 cm)
Courtesy of Ronald Feldman Fine Arts,
New York

Fig. 25 **Felix Gonzalez-Torres (1957–1996)**
"Untitled", **1991**
Billboard, Dimensions vary with installation
Installation at 31–33 2nd Avenue at
East 2nd Street, Manhattan, for "Projects 34:
Felix Gonzalez-Torres" at The Museum
of Modern Art, New York, 1992
Courtesy of The Andrea Rosen Gallery,
New York, and The Museum of Modern
Art, New York

Notes

1. William Cronon, *Changes in the Land* (New York: Hill and Wang, 1983).

2. Janet Berlo and Ruth Phillips, *Native North American Art* (Oxford: Oxford University Press, 1998).

3. Michael Warner, "What's Colonial about Colonial America," in Robert Blair St. George, ed., *Possible Pasts: Becoming Colonial in Early America* (Ithaca, NY: Cornell University Press, 2000).

4. Wayne Craven, *Colonial American Portraiture* (Cambridge, UK: Cambridge University Press, 1986).

5. Ann Uhry Abrams, *The Valiant Hero, Benjamin West and Grand Style History Painting* (Washington, D.C.: Smithsonian Institution Press, 1985).

6. Laura Rigal, "Framing the Fabric: A Luddite Reading of *Penn's Treaty with the Indians*," *American Literary History*, 2000, makes this argument and points out (p. 562) that "Native Americans did not simply participate actively, or in their own ways, in the global market; many openly resisted the way British technologies positioned them as consumers and spectators."

7. Quoted in Neil Harris, *The Artist in American Society* (Chicago: University of Chicago Press, 1966), p. 36.

8. *ibid.*, p. 36.

9. *Port Folio* magazine, 1810, quoted in William Gerdts, "The American 'Discourses': A Survey of Lectures and Writings on American Art, 1770–1858," *American Art Journal*, Summer 1983, p. 75.

10. Frank H. Sommer, "Emblem and Device," *Art Quarterly*, vol. 24 (1961), pp. 73–74.

11. This issue is developed in Angela Miller, *The Empire of the Eye: Landscape Representation and American Cultural Politics, 1825–1875* (Ithaca, NY: Cornell University Press, 1993). My discussion of Church's *New England Scenery* is drawn from this text.

12. Elizabeth Johns, "The Farmer in the Work of William Sidney Mount," *Journal of Interdisciplinary History*, vol. 17 (Summer 1986), p. 259.

13. John Muscalus, *Popularity of Wm. S. Mount's Art Work on Paper Money, 1838–1865* (Bridgeport, Pa.: Historical Paper Money Research Institute, 1965).

14. "American Artists," *Harper's Weekly*, vol. 11 (May 4, 1867), p. 274, quoted in John Davis, "Eastman Johnson's *Negro Life at the South* and Urban Slavery in Washington, D.C.," *Art Bulletin*, vol. 80 (March 1998), p. 87.

15. S.G.W. Benjamin, *Art in America: A Critical and Historical Sketch* (New York: Harper and Bros., 1880).

16. "American and Foreign Art," *New York Times*, November 9, 1878, quoted in Laura Meixner, *French Realist Painting and the Critique of American Society, 1865–1900* (Cambridge, UK: Cambridge University Press, 1995), p. 58.

17. Clarence Cook, writing in 1888 about the National Academy annual exhibition in *Studio* (New York), June 1888, p. 112.

18. *Appleton's Journal*, May 1879, p. 471; quoted in Margaret Conrads, *Winslow Homer and the Critics: Forging a National Art in the 1870s* (Princeton, NJ: Princeton University Press with Nelson-Atkins Museum of Art, 2001), p. 162.

19. Henry James, "Pictures Lately Exhibited," *Galaxy*, 1875; reprinted in John L. Sweeney, ed., *The Painter's Eye* (Madison, Wis.: University of Wisconsin Press, 1989), pp. 96–97.

20. Saint Louis Exposition and Music Hall Association, *Fifteenth Annual Exhibition, Catalogue of the Art Department Illustrated*, p. 5. Quoted in Julie Dunn-Morton, *Art Patronage in St Louis, 1840–1920*, PhD diss. (Newark, NJ: University of Delaware, 2004).

21. Michele Bogart, *Artists, Advertising, and the Borders of Art* (Chicago: University of Chicago Press, 1995).

22. Rebecca Zurier, Robert Snyder, and Virginia Mecklenburg, *Metropolitan Lives: The Ashcan Artists and Their New York* (Washington, D.C.: Smithsonian Museum of American Art, 1995).

23. Joseph Stella quoted in John Kasson, *Amusing the Million: Coney Island at the Turn of the Century* (New York: Hill and Wang, 1978), p. 88.

24. Michael Leja, *Looking Askance: Skepticism and American Art from Eakins to Duchamp* (Berkeley, Calif.: University of California Press, 2004).

25. Thomas Hess, *Barnett Newman* (New York: Museum of Modern Art, 1971).

26. Barnett Newman, "The First Man Was an Artist," *Tiger's Eye* (October 1947), p. 59.

27. *ibid.*, p. 59.

28. Interview with Ethel Schwabacher, November 7, 1954; quoted in James Breslin, *Mark Rothko: A Biography* (Chicago: University of Chicago Press, 1993), p. 356.

29. Selden Rodman, *Conversations with Artists* (New York: Devin-Adair, 1957), pp. 93–94. The emphasis is Rothko's.

30. Michael Leja, *Reframing Abstract Expressionism: Subjectivity and Painting in the 1940s* (New Haven, Conn.: Yale University Press, 1993).

31. "Here is something the State Department sent to me in 1989, asking me to submit work to the Art and Embassy Program. It has this wonderful quote from George Bernard Shaw, which says, 'Besides torture, art is the most persuasive weapon.' And I said I didn't know that the State Department had given up on torture— they're probably not giving up on torture— but they're using both. Anyway, look at this letter, because in case you missed the point they reproduce a Franz Kline [Abstract Expressionist painting] which explains very well what they want in this program. It's a very interesting letter, because it's so transparent." Felix Gonzalez-Torres, interview by Robert Storr, *Art Press,* January 1995.

32. Susan Sontag, "Notes on 'Camp,'" in *Against Interpretation* (New York: Dell, 1966).

33. Benjamin Buchloh, "Andy Warhol's One-Dimensional Art," in Kynaston McShine, ed., *Andy Warhol, A Retrospective* (New York: Museum of Modern Art, 1989).

34. Allan Kaprow, "Should the Artist Become a Man of the World?," *Art News*, 1964, reprinted in Kaprow, *Essays on the Blurring of Art and Life* (Berkeley, Calif.: University of California Press, 1994).

35. Anne Umland, *Projects: Felix Gonzalez-Torres* (New York: Museum of Modern Art, 1992).

36. Nancy Campbell, "The Oscillating Embrace: Subjection and Interpellation in Barbara Kruger's Art," *Genders,* Spring 1988.

37. Walter Benn Michaels, *The Shape of the Signifier: 1967 to the End of History* (Princeton, NJ: Princeton University Press, 2004).

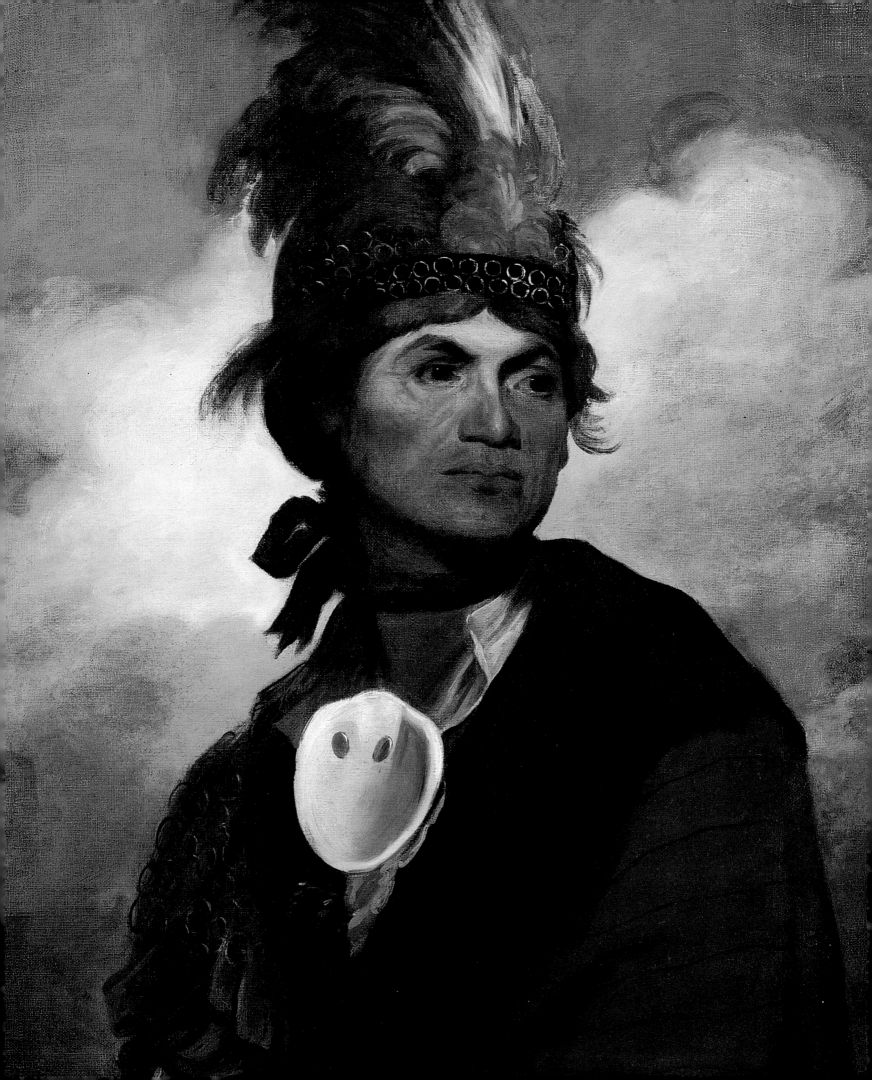

(1700–1830)

Colonization and Rebellion

Peaceable Kingdoms: Colonization and Rebellion

Margaretta M. Lovell

Transatlantic settlers, arriving in the part of the New World that in 1776 would become the United States, imported European languages, laws, and customs, as well as ideas about just government, social identity, and daily life. They also imported their ideas about art. Beyond the more obviously useful arts of city planning, architecture, and the production of artfully designed household equipment, immigrants brought with them ideas about painting in oil-based pigments on canvas, and about hanging these finished works in wooden frames on the walls of the principal rooms in their houses. There, as part of everyday experience in the hall or parlor where meals were prepared and eaten, the Bible was read, and business was conducted, these oil paintings functioned as instructional images within the households of those families that anticipated passing on wealth to the next generation.[1]

While in seventeenth-century England (and the less well-represented source cultures of Holland, France, and Sweden) domestic paintings included historical and religious subjects, landscapes, and still lifes, in the thirteen North American English colonies only portraiture flourished. Until the Revolution catapulted the colonials into a new relation to history and to the geomorphology of the continent, artists found their business focused on recording the identities and features of individuals, such as prominent ministers, merchants, and notable Native American leaders. Sometimes full-length, sometimes a partial figure, and often just the head, these portraits are a remarkable record of individual identity, costume, deportment, prescriptive behavior, and personal achievement. They were also designed as active vehicles of ideology. They were, therefore, useful within the culture that created and hung them, and they are useful to scholars today interested in understanding that distant period.

While European colonials sought to replicate much of their earlier experience, they also believed that a perfected version of the European world could and should be established in this new place. Many of the canvases painted during the years between 1670 and 1830 give us the sense of a quiet but persistent utopic vision, a hope that life in this environment might succeed where Europe had failed in establishing a place of order, peace, harmony, just government, and general prosperity. Colonial portraits, then, give us a glimpse of individual faces, of artistic skill in these distant outposts of empire, of cultural assumptions about class and gender, as well as the hopes of many in that society for achieving an ideal world.

Among the earliest paintings that have survived from the colonial period are a remarkable group of canvases picturing Massachusetts Puritans. Characteristic of this group, *Mrs. Freake and Baby Mary* (fig. 27) was executed by an unknown artist in Boston in 1671 and 1674.[2] As was so often the case throughout the colonial period, the portrait was commissioned as one of a pair, picturing a married couple. Often these were ordered at the time of marriage or the birth of a first child, or on the occasion of a singular achievement. On canvases of equal size, the husband and wife turn slightly toward one another, emphasizing the importance of marriage, family, and the movement of wealth to legitimate heirs in early modern British culture.[3] The pairing of these portraits suggests balance and harmony. The vertical posture of the Freakes and—more surprising to a modern eye—that of their child underlines the importance of literalizing "an upright life" among these radical Protestants. Presumed to be born in sin, Puritan children were understood to be "raw nature" that needed careful molding —both physical and spiritual—to become acculturated, and to become good. Like nature (valued primarily in the form of productive row crops in agricultural fields wrested from the forest), Puritan children were understood to be good in proportion to their orderly (and therefore productive) rectilinearity.[4]

Page 42

Gilbert Stuart (1755–1828)

Joseph Brandt (detail; see p. 72), 1786

Oil on canvas, 30 × 25 in. (76.2 × 63.5 cm)

New York State Historical Association

(Fenimore Art Museum),

Cooperstown, New York

Fig. 26 **John Lewis Krimmel (1787–1821)**

The Quilting Frolic, 1813

Oil on canvas, 25 × 30 in. (63.5 × 76.2 cm)

Winterthur Museum, Delaware

Museum purchase

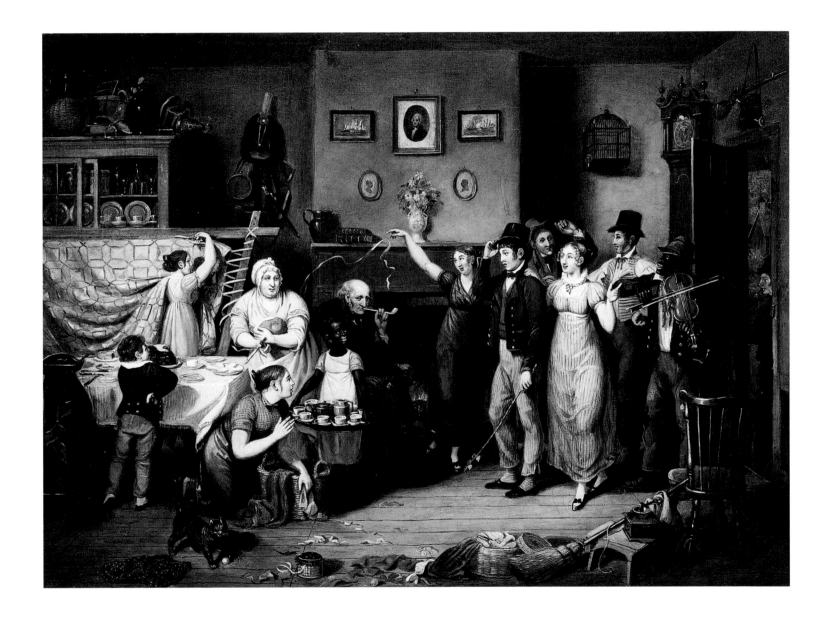

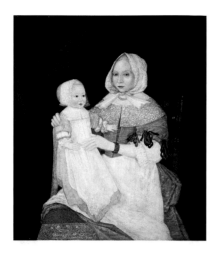

Fig. 27 **Unknown American artist**
Elizabeth Clarke Freake and Baby Mary, 1671,
1674
Oil on canvas, 42 × 36¾ in. (106.7 × 93.3 cm)
Worcester Art Museum, Massachusetts
Gift of Mr. and Mrs. Albert W. Rice

A century later, with the advent of the Romantic movement, wild nature began to be understood as positive, and parents would learn to value their children's natural behavior and postures. But in this earlier period a firmly swaddled baby Mary is held upright, and leading straps on the shoulders of her dress will enable her mother to help her stand straight just as soon as her legs are strong enough. Baby Mary, then, is exhibiting her potential for disciplined geometric regularity, that is, her potential for a useful life and even for spiritual grace.

The Freake-Gibbs painter (so called because he is also thought to have painted the Gibbs family at this time) incorporated in this work important ways of understanding nature, culture, parental responsibility, and ideal human behavior among the Puritan merchant élite of seventeenth-century Boston. He has also given us a document of how his contemporaries saw—that is, from the painting's surface, rich in decorative detail and in chromatic contrast, we understand that these visual qualities were sought and prized at that time and place. Because this work is painted in a style that was no longer popular in London in the 1670s, we can assume that its maker was trained in a provincial center where these visual qualities of overall sharp focus and flat areas of bright color retained their pre-eminence. The surface of this painting is inscribed with information about the sitters, indicating that the child is six months old and the mother is aged twenty-nine. Because new ideas about the picture plane as a field of illusion arrived shortly after this image was made, it was two centuries before such American painters as James Abbott McNeill Whistler (1834–1903), with his colophon signatures, would again begin to think of the two-dimensional canvas surface as a two-dimensional "writing-type" surface, that is, a surface on which an artist might combine figure and writing, as is so common in Asian art of the classic periods.

Superficially similar to *Mrs. Freake and Baby Mary*, *Self-portrait* by Thomas Smith (active *c.* 1650–1691), painted only a few years later in the same urban center, exhibits two important differences (p. 60). Stylistically, the Smith portrait shows much more attention to the roundedness of form we associate with the triumph of Renaissance illusionism in European art, lasting roughly from the fourteenth century

in Italy (or seventeenth century in northern Europe and its colonies) until the late nineteenth century. Secondly, while the earlier portrait tells a very positive, future-oriented tale about the integration of a youngster into her society, the Smith self-portrait presents an elderly man's meditation upon death in the form of a head, a poem, and a skull.[5] Specifically, the poem is a statement about the poet-artist's acceptance of death, and the skull functions as an exhortation both to the poet-painter-subject and to us, the viewers, to live well—to govern one's actions with an eye to Final Judgment and eternity. But the skull in this painting—and other skulls carved into the slate gravemarkers that stood clustered in the public space around the Meeting House at the center of town—also remind the viewer that individual physical identity and power of action dissolve absolutely with death. The portrait seeks to fix the recognizable features of a sitter with the knowledge that those features will change with time and disappear, retaining power only in the portrait or in the memory of those who knew the individual, or were acquainted with narratives handed down through text on gravestones or on paper. Smith's poem offers us a largely negative view of worldly existence; while it speaks of some "joys"—belittled immediately by the succeeding, rhyming "toys"— it basically describes a "World of Evils" characterized by conniving individuals' "wiles" and outright international and civil "wars." Christian faith promised Smith the possibility of contentment, grace, and glory (peace and utopic well-being) only in the afterlife.

A century later British culture in the colonies had shifted considerably to embrace first Enlightenment attitudes toward rationality, science, and human potential, and then Romantic ideas about nature, childhood, pleasure, and personal responsibility. Art, of course, reflects and embodies these changes. Charles Willson Peale's portrait of his own family gathered around a table suggests the kinds of changes that occurred in the century after *Mrs. Freake* and Smith's *Self-portrait*. These differences include the developing of a fully illusionistic, painterly style, new ideas about the nature of childhood, and the possibility of achieving both personal contentment and harmonic social context on this earth.

Peale (1741–1827) was among a talented group of artists who emerged in the colonies in the decades before the Revolution. In this

Fig. 28 Jeremiah Theus (1716–1774)

Colonel Barnard Elliott, Jr. (1740–1778), c. 1766

Oil on canvas, 61⁷⁄₁₆ × 51⁹⁄₁₆ in. (156 × 131 cm)

Gibbes Museum of Art, Charleston, South

Carolina, 1930.1.7

Fig. 29 Ralph Earl (1751–1801)

Elijah Boardman (1760–1823), 1789

Oil on canvas, 83 × 51 in. (210.8 × 129.5 cm)

The Metropolitan Museum of Art,

New York, Bequest of Susan W. Tyler, 1979

(1979.395)

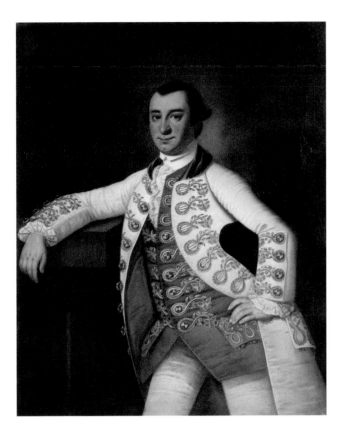

Fig. 30 John Singleton Copley (1738–1815)

Mrs. George Watson (Elizabeth Oliver), 1765

Oil on canvas, 49⁷⁄₈ × 40 in. (126.7 × 101.6 cm)

Smithsonian American Art Museum,

Washington, D.C.

large-scale work he portrays himself leaning over to instruct his brother in drawing. One of his sisters stands beside him with a furled landscape drawing in her hand; busts sculpted by Peale preside over the scene on the right, while a chalk drawing of three Graces shows the early stages of an ambitious artwork on an easel behind the painter. Art, in other words, is as much the subject of this painting as family. It exhibits the artist's capacity to render forms convincingly in space and to arrange them eloquently in relation to one another; it is, in other words, a demonstration of his capacity to handle adroitly chiaroscuro, foreshortening, perspective, composition, and color, all the elements of Renaissance painting. Peale executed this work in 1773, and hung it in his studio where it served as a sample of the artist's abilities for potential patrons to observe. By the time *The Artist's Family* was painted virtually all artists in the British colonies had adopted Renaissance illusionism. There were regional differences in treatment and costume—see, for instance, the lovely *Young Moravian Girl* painted in inland Pennsylvania by John Valentine Haidt (1700–1780) a few years before Peale executed his group in nearby but more urbane coastal Philadelphia—but there was general agreement that the picture should simulate "real" figures occupying "real" three-dimensional space.

An equally important dimension of Peale's *Family* is its complex diagramming of social relationships. Although we know Peale is the dominant figure in this household—literally responsible for its order, instruction, and prosperity—he spotlights his wife and toddler at the center of the painting, and appears to recede in shadow on the side, behind other figures. This counterintuitive diagramming of center-and-periphery social ordering was a common visual strategy in this period. As Romantic and revolutionary notions of the child's natural goodness overturned seventeenth-century precepts about the presumed sinful character of all infants, we see youngsters—and their primary caretakers, their mothers—given privileged positions in paintings. Fathers receded but only within the fiction of pictures; in all legal and social aspects they remained as confidently dominant as Brigadier General Samuel Waldo in his portrait of *c.* 1748–50 by Robert Feke (*c.* 1707–*c.* 1751; p. 63), a painting that exhibits the archetypal male posture of command up until the 1760s.

The last key aspect of Peale's family group is his articulated intention that it be understood as a tableau illustrating *"Concordia Animae"* (harmony of the soul).[6] In this it explicitly references the utopic theme evident in much American art of the colonial and antebellum periods. Harmony here is evident in the compositional balance of the figures, the color values, and the close social cohesion the painter has depicted among these family members. Harmony is suggested, in other words, in such rhyming forms as parallel gestures, but even more emphatically in the balance of opposites. Peale's *Benjamin and Eleanor Ridgely Laming* (pp. 74–75), for instance, suggests harmony in the inclination of these two very different figures toward one another: male and female, dark and light, one figure associated with manmade scientific devices such as a telescope and the other with peaches and natural sinuous forms. Together they describe a balanced unity just as the various figures in Peale's *Family* unite young and old, women and men into a single descriptive family.

As technically proficient as Peale in Philadelphia, John Singleton Copley (1738–1815) in Boston was celebrated in his own day as an artist whose portraits were such fine illusions that they could fool children into thinking the image lived.[7] His *Mrs. George Watson (Elizabeth Oliver)* (fig. 30) of 1765 shows characteristic verisimilitude of fabrics, flesh, and furnishings. Copley's patrons included New England's élites, and his works describe aspects of their material world of particular interest to cultural historians. Supporting the evidence of merchants' ledger books, port records, probate inventories, and similar listings of goods coming and going into the region's harbors and in use in homes, Copley's portraits show us an élite with very distant horizons. Mrs. Watson is wearing a silk dress, the fabric of which was possibly spun and woven in Asia, where the silk industry originated and was more advanced than in Europe or its colonies. The trims are French or Brussels lace. In her left hand she holds a blue and white vase that may be Chinese porcelain (or perhaps an English or Dutch imitation of Chinese porcelain) out of which an elaborate Dutch tulip emerges.[8] Far from the self-sufficient, modest economy of local wares that many assume prevailed in the colonies we see here an exuberant embrace of the extra-local. Bostonians were

Fig. 31 **Detail of Segesser II hide painting of the Villasur Expedition, Battle of August 13, 1720,** *c.* **1720–29 Courtesy of The Palace of the Governors (MNM/DCA), Santa Fe, New Mexico, 158345**

knowledgeable and discerning about goods whose workmanship or materials exceeded those available locally. The trade that supported and encouraged this early globalism is suggested in a portrait by Ralph Earl (1751–1801) of Elijah Boardman (fig. 29), a Connecticut textile merchant. His cupboardful of many colorful bolts of cloth competes with his figure for our attention while the ledger books recording his far-flung financial transactions occupy the bottom half of the portrait. The first fabricating process to be industrialized, the spinning and weaving of textiles used in eighteenth-century America was often done elsewhere (where labor was cheap) rather than locally, as housewives in New England and professional male weavers in the middle colonies could only with difficulty compete with cloth made in large automated mills in Great Britain or with cloth production in Asia.[9]

Tea, silk, and porcelain imported from Asia were of higher quality or cheaper cost than competing goods from elsewhere, so the colonists (like the Europeans) exerted themselves to engage in trading links that provided access to these things. One of the great boons of the Revolution to American merchants was direct access to Chinese ports. *A Dessert* (1814) by Raphaelle Peale (1774–1825) owes much of its magic to the conjunction of common fruits, locally grown (although in a hothouse), with a fine Chinese export porcelain dish. The softness of the citrus forms contrasts vividly with the pearly reflective body of the hard, shallow Chinese bowl and with the gleaming transparency of equally precious port glasses. A subtext of this image seems to revolve explicitly around issues of trade and transport as the glassware was probably imported from Great Britain, the parent fruit trees from Spain, and the raisins, almonds, and pecans from the southern states. Moreover, citrus played a crucial rôle in gathering this dessert, as its consumption prevented scurvy, a disease specifically associated with long months at sea.

Beyond the material goods Americans imported from Asia, they also imported aesthetic ideas. The contour of the vase that Mrs. Watson holds is a smooth S-curve, a design feature that had become extremely important not just in the design of imitative Western ceramics but in that of gardens, tables, chairs, silver teapots, and even bodies (fig. 28). Europeans found prototypes for this line in antique sculpture as well

as in Chinese ceramics, codifying it as the "line of beauty."[10] It found applications in a broad set of aesthetic categories. George Washington, for instance, in his full-length portrait by C.W. Peale, stands not in the theatrical posture of command of General Samuel Waldo (p. 63) four decades earlier, but in a more informal, relaxed, graceful, and contingent S-curve. The emphasis on hyper-verticality as an outward sign of self-control and acculturation in *Mrs. Freake and Baby Mary* and of power in *General Waldo* has dissolved by 1770 into poetic curvature. Not only an index of personal "naturalness" and gracefulness, Washington's easy posture and Mrs. Gage's even more relaxed pose in Copley's portrait of her of 1771 are offered to the viewer as outward signs of thoughtful composure and social grace. The hallmark of these new behaviors and ideologies is the S-curved line imported from China.

More closely imitating Asian painting, Americans in the eighteenth century decorated the surface of fine case furniture with pseudo-lacquerwork known as "japanning" (fig. 32).[11] Chinese figures, architectural fragments, and exotic animals were applied to these surfaces in a non-perspectival fashion that undercuts all Western precepts about the rendering of figures, creatures, and architectural space. Even more unusual, some wall-decorations survive from the early eighteenth century in Rhode Island that evidence a taste for "Chinese" painting (figs. 33, 34). Applied in fresco in the principal room of the Vernon house in the urbane seaport of Newport as early as the 1720s (and certainly before 1748 when they were encased in more traditional wooden paneling), these wall-paintings depict birds, rocks, mythical beasts, and figures moving in scaleless non-perspectival space.[12] But this is not the "japanning" of the period or the whimsical *chinoiserie* of later decades; these panels include scenes of judgment, torture, and hell that may have been copied from a Chinese scroll. Why and with what intent remains obscure. Among other things, these "Chinese" frescoed walls remind us that the flat, perspective-less character of seventeenth-century painting discussed earlier did not entirely disappear from visual practices in the eighteenth century. In spite of the triumph of pictorial illusionism there remained special usages in which the visual conventions and expectations of a two-dimensional surface remained two-dimensional: needlework pictures and grave

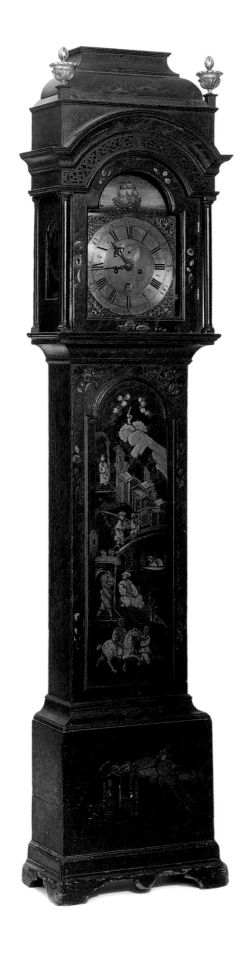

Fig. 32 (left) **Detail of Tall Clock**

Made by Gawen Brown (1719–1801)

Boston, Massachusetts, 1745–55

Pine, paint, gesso, and gilt brass

94¹⁄₂ × 22¹⁄₈ × 10⁵⁄₈ in. (240 × 56.2 × 27 cm)

Winterthur Museum, Delaware

Museum purchase

Fig. 35 Benjamin West (1738–1820)

Death on the Pale Horse, 1796

Oil on canvas, 23¹⁄₈ × 50⁵⁄₈ in. (59.5 × 128.5 cm)

The Detroit Institute of Arts,

Founders Society Purchase,

Robert H. Tannahill Foundation Fund,

79.33

markers, for instance, tended to eschew the new Italian Renaissance ideas about picture space, as do these curious and seemingly unique frescoes.

The mysterious Newport panels remind us that while most paintings surviving from the colonial period were portraits, other, rarer kinds of artworks were also made. While we do not fully understand them and they have not yet been integrated into the canon of "masterpieces," these exceptional works allow us to glimpse aesthetic achievements and links to other cultures that might otherwise be invisible to us. As unique and interesting as the Newport panels are a pair of paintings executed on large buffalo hides created on the other side of the continent during the same 1720–40 period. Known as the Segesser hide paintings because they were shipped to Switzerland in 1758 and remained in trunks in the Segesser family's property until the mid-twentieth century, these paintings depict in remarkably specific detail a military engagement that took place in what is now Missouri between Spanish soldiers (and their Native American allies) moving northward from Santa Fe, and French soldiers (and their Native American allies) moving south from Canada (fig. 31).[13] Painted for a Swiss Jesuit missionary, probably by clerics located in Santa Fe, the work displays knowledge of foreshortening, spatial recession, and study of the human form of the sort familiar in the European art schools and artist clubs that were established in the eighteenth century. The work is as ambitious as it is singular and is the result of a collaboration between two unknown hands, one wedded to flat forms on a flat ground and the other describing rounded figures turning vigorously in space. We will probably never learn the full story of the creation of this artwork but—like the Bayeux tapestry of many centuries earlier—it clearly was inspired by a wish to record in visual form, and in some detail, a decisive battle. Its job is to trigger memory and to instruct posterity. Today it retains its power to remind us not just of this specific scene of conflict but also of the fact that, in the early decades of the eighteenth century, it was by no means certain which of the three rival imperial European nations would "win" in North America and what that supremacy might mean for the continent.

More conventional records of significant events were narrated in history paintings, that is, paintings depicting important historical events on canvas with an eye to celebrating events, actions, and individuals that the community or nation sought to hold up as memorable. History painting in Europe at this time was understood to be the highest form of art; it was difficult because it involved knowledge of ancient and modern European history, knowledge of the history of art, the technical ability to position many figures convincingly in space, and the imagination to "tell" the culture a familiar tale in a way that was simultaneously recognizable and novel. History painting was judged to be important because of the ideological freight carried by these public tales in explaining who "we" were, what "our" values were, and which moments from the past should determine opinion and action in the present. Few artists born or working in America in the colonial period sought to become history painters; those who did traveled to London, where there were established venues to exhibit such works and established patronage systems to reward artists who succeeded in the genre. One of the first to pursue this route was Benjamin West (1738–1820), who was born in Pennsylvania, went abroad as a young man, rose to become president of England's Royal Academy, and welcomed into his London studio aspiring American artists throughout his long and successful career.

Mindful of his Pennsylvania heritage, West executed history paintings that drew on New World events including *Penn's Treaty with the Indians* of 1771–72, which imagines an event from a century before when William Penn, proprietor of Pennsylvania, established peaceable relations with the Indian nations in that region (p. 57). As popular culture remembered the event, West depicts an assemblage of sober Quakers meeting under a sheltering tree (henceforth the "treaty tree") with a group of peaceable family-oriented Native Americans. The medium of exchange that West emphasizes in this intercultural negotiation are bolts of textiles. Neatly ranked on shelves in Earl's *Elijah Bordman* and dramatically displayed on the bodies of Copley's *Mrs. Gage* and *Mrs. Watson,* the highly portable silks from China and Europe, wools and linens from Great Britain, beaver felt from North America, and cottons from southeast Asia circulated not just for money but as money throughout the globe in the colonial and early national periods. In this painting West uses cloth as an outward sign of the potential for mutually beneficial commercial and

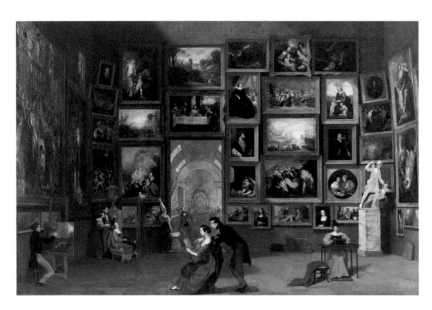

Fig. 36 Samuel Morse (1791–1872)

Gallery of the Louvre, 1831–33

Oil on canvas, 73¾ × 108 in. (187.3 × 274.3 cm)

Terra Foundation for American Art, Chicago

Daniel J. Terra Collection, 1992.51

Fig. 37 Charles Willson Peale (1741–1827)

The Artist in His Museum, 1822

Oil on canvas, 103¾ × 79 in. (263.5 × 200.7 cm)

Pennsylvania Academy of the Fine Arts,

Philadelphia, Gift of Mrs. Sarah Harrison

(The Joseph Harrison, Jr. Collection)

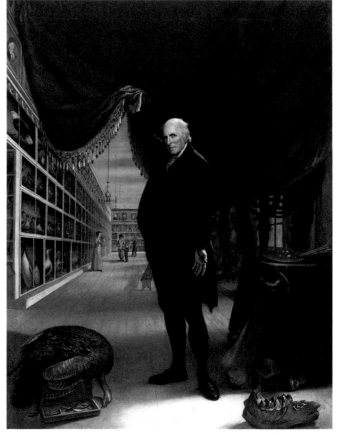

cultural exchange. Quakers, unlike other Protestant sects, made a point of establishing and maintaining amiable social relations. More radically, they professed the equality of humans, declining to recognize differences in degree, and muting gender and racial hierarchies. This painting, then, endorses a view of beneficent origins, historical justice, and a halcyon future for Pennsylvania. If Peale's *Family* is about an ideal of domestic life, this painting envisions an ideal public life where potentially hostile groups sit in conference and establish concord. We might be tempted to view this painting cynically, knowing that Penn's agents were not as fair-minded in their dealings with Native Americans as they might have liked to think, and that a century after West's depiction, and two centuries after the actual event, few Native Americans remained in Pennsylvania to enjoy the fruits of this memorable treaty. But it must be said that, at least in part because of Quaker square-dealing and efforts to achieve and keep a mutually beneficial peace, the bloody conflicts between European Americans and Native Americans that erupted throughout the seventeenth century in both Virginia to the south and New England to the north bypassed Pennsylvania.

A typical image of notable Native Americans from this Middle States area is *Tishcohan* of 1735, by Swedish portraitist Gustavus Hesselius (1682–1755), which stresses not only the subject's individuality and firm demeanor but also his eschewal of weapons, instead prominently including accoutrements—a tobacco pouch and pipe—that would have been associated with both ritual and informal peaceful sociability (p. 58). The distrust (among Native Americans) and wiliness (among Quakers) edited out of West's narrative of peaceable fair-dealing and mutual trust are suggested in the wary eyes of Tishcohan. This portrait and that of a second Delaware chief (p. 59) were commissioned not by the sitters but by the Penn family, and they seem to evoke a kind of wary but patient wisdom on the part of those who understood all too well that Penn's land purchases would dispossess their people. While most of the paintings discussed here were made as unique objects, commissioned by individuals for the domestic environment, and a few were created by artists as singular records of their own families and achievement intended for studio display, several (including West's *Treaty*) circulated widely in the form of small inexpensive engraved reproductions available for purchase in bookstores.

Painting in a "folk" context—in a circumscribed, small-scale, inland community seventy years later—Pennsylvania Quaker preacher and painter Edward Hicks (1780–1849) copied a print after West's *Penn's Treaty* painting (hence his image is reversed) to retell the story and to keep alive its lesson of ideal public behavior in his community. Unlike an academic painter such as West (a painter trained by other painters in the Renaissance tradition of the depiction of illusionistic rounded human forms situated in perspective space), Hicks did not seek originality in telling familiar tales and did not strive to mimic reality; rather he sought a painterly shorthand to communicate a single powerful prescriptive message. His best-known works are a series of dozens of paintings, all known by the title *Peaceable Kingdom*, that picture a biblical passage from the prophet Isaiah, "The wolf shall dwell with the lamb, and the leopard shall lie down with the kid, and the calf and the young lion and fatling together; and a little child shall lead them" (p. 112). The prophecy is about a moment when prey and predators, carnivores and herbivores, associate without aggression or harm. In the backgrounds of these works Hicks includes a small visual quotation of West's *Penn's Treaty*, underlining the human dimension of a wished-for utopia in which seemingly natural enemies do no harm to one another but associate peacefully and to mutual benefit. Hicks's paintings, like West's *Penn's Treaty*, are about history, but even more they are prescriptive and instructive, telling their viewers that their ancestors behaved well, exhorting their viewers to behave well, and promising them a prosperous peace if they do so.

Another ambitious West canvas, *Death on the Pale Horse* of 1796 (fig. 35), provides a dystopic version, before the fact, of Hicks's *Peaceable Kingdoms*. Here, amid a frenzy of aggressive action visualizing the apocalyptic moment from the Book of Revelation, West depicts a lion clawing a horse, wolves attacking a bullock, and dead and dying humans strewn across the front of the picture plane. Doves of peace—one dead, its mate fluttering defeatedly in the foreground—are beyond hope.[15] War, death, and apocalypse, West seems to assert, are the reverse side of peaceful coexistence, and are the penalty awaiting the breakdown of well-

managed human relations. An expression of the Romantic sublime and a topical comment on the Terror that succeeded the Revolution in France, this image is nevertheless also evidence of the periodically erupting darker possibilities and knowledges beneath the utopic visions Americans preferred to paint, exhibit, buy, and circulate. One has the sense that Hicks, seeing prints of these two grand statements by West in the form of history paintings, has taken the creatures (and toga-clad child) from *Death on the Pale Horse* to animate the foreground of his *Peaceable Kingdoms* while invoking his predecessor's *Penn's Treaty* directly in the background in order to give immediacy and local particularity to his vision of Isaiah.

The tales we tell ourselves about ourselves clarify both what we aspire to and what we fear. West's *Penn's Treaty* and his *Death on the Pale Horse* are answering texts about peace and war, about social (and natural) order and disorder, and about the importance of channeling cultural energy toward the construction of widely beneficial civic institutions, laws, and behaviors. As an experiment in the revival of an ancient form of government and as a confederation of disparate peoples, geographies, religions, and interests, the young United States had much to fear about civil discord but also much to hope for from collaboration. The import of John Krimmel's (1787–1821) *Fourth of July Celebration in Centre Square, Philadelphia* (p. 81) is that, on this day of national remembering, of daring to declare revolution against one of the most powerful empires on earth, Americans of multiple social classes can congregate without aggression or strife. They can cooperate to bring about a technically marvelous water system or mutually beneficial form of government. The overarching argument is simply that the young United States can take the best of the Old World and of history, the immense resources of the New World, and, with technological inventiveness, create the most livable of cultures. This seemingly modest scene of daily life actually makes large claims and offers grand promises to humankind.

Krimmel's painting describes a festive gathering in the central open space of the foremost city, a space given over not to a church or to a courthouse, that is, to buildings representing authority (as might be the case in Europe), but to a handsome mini-temple in which the engine pumping fresh water up from the river for distribution throughout the city is housed. This pump building is bracketed by an orderly row of poplar trees and its approach is punctuated by a fountain (centered in a geometrically precise round pool). A life-sized emblematic female figure in clinging classical draperies, representing the river and holding a bird on her shoulder, stands at the center of the pool; out of the bird's beak a high jet of water plays, emphasizing human mastery of this crucial natural element and the wedding of utility (a water system that will reduce disease and labor) with art. The near-nudity of the figure planted here in public was acceptable to an urban citizenry who understood it to represent the "noble simplicity" of virtuous classicism. Indeed, we note in the foreground of the picture women dressed in the new uncorseted "Greek" style, that is, in clinging diaphanous draperies evocative of ancient sculpture.

Krimmel's painting is of a type known as a genre painting or "subject picture," that is, a tableau of daily life as the artist's contemporaries would have known and recognized it, organized to make a comment on that life. Genre painting became increasingly popular as the nineteenth century evolved, as a way to create seemingly less self-consciously dogmatic works than history paintings but still comment on important public issues (fig. 26). As Krimmel describes it, for Philadelphians in the first two decades of the nineteenth century there was no discord or discontinuity between architecture and engineering, between classicizing sculpture and daily clothing, or between classes, as all united in mapping a future for the nation imagined into being on July 4, 1776.

Paintings are fictions that we use to tell ourselves truths and to design hoped-for futures. In two large works that depict a novel kind of public institution, a museum, artists in the 1820s set out inventories and agendas for the new nation. Samuel F.B. Morse's *Gallery of the Louvre* (1831–33) gathers into the grandest salon in that grandest of palaces the wealth of Europe's achievement in fine art (fig. 36). Among those Americans Morse (1791–1872) depicts learning from this assemblage are the novelist James Fenimore Cooper and his family, and Morse himself, pictured in profile in the center. This gathering of masterpieces, Morse

Notes

asserts, pictures the patrimony that Americans can claim: a deep and rich heritage of achievement and wisdom in the arts that can be tapped as art, untainted by the failures of European political, religious, and social systems. In a seemingly answering text C.W. Peale includes his own figure and collection in the *Artist in His Museum* of 1822 (fig. 37). Here, in an image describing the artist's extensive collection gathered in Independence Hall, Philadelphia, and open to the public, the New World's strong suit—natural history—is foregrounded, as is the system of science by which it is organized. Above the specimens the oval heads of those who distinguished themselves in the Revolutionary cause provide models of good judgment, rationality, military prowess—in short, a compendium of the virtues needed by the nation to unlock the secrets of science, technology, and art to produce a harmonic social and natural order. These are large claims, or rather, goals. Whether they were reachable is an open question, but the repeated theme of halcyon possibilities over the course of two and a half centuries suggests that believing in these goals may have been as important as achieving them.

1. Margaretta M. Lovell, *Art in a Season of Revolution: The Artist, the Artisan, and the Patron in Early America* (Philadelphia: University of Pennsylvania Press, 2005).

2. Jonathan Fairbanks and Robert F. Trent, eds., *New England Begins: The Seventeenth Century* (Boston: Museum of Fine Arts, 1982), 3 vols.; Worcester Art Museum: www.worcesterart.org/Collection/Early_American/.

3. Lovell, pp. 141–83.

4. Karin Calvert, *Children in the House: The Material Culture of Early Childhood, 1600–1900* (Boston: Northeastern University Press, 1992).

5. "Why why should I the World be minding/therein a World of Evils Finding./ Then Farwell World: Farwell thy Jarres/ thy Joies thy Toies thy wiles thy Warrs./ Truth Sounds Retreat: I am not sorye./ The Eternall Drawes to him my heart/ By Faith (which can thy Force Subvert)/ To Crowne me (after Grace) with Glory."

6. Lovell, ch. 2, n. 30.

7. Lovell, p. 58.

8. See Michael Pollan, "Desire: Beauty/Plant: The Tulip," in *The Botany of Desire: A Plant's Eye View of the World* (New York: Random House, 2002), pp. 59–110.

9. Laurel Thatcher Ulrich, *The Age of Homespun: Objects and Stories in the Creation of an American Myth* (New York: Alfred A. Knopf, 2001).

10. William Hogarth, *The Analysis of Beauty: Written with a View of Fixing Fluctuating Ideas of Taste* (London: J. Reeve, 1753).

11. Ethan W. Lasser, "Reading Japanned Furniture," in David Raizman and Carma R. Gorman, eds., *Objects, Audiences, and Literatures: Alternative Narratives in the History of Design* (Newcastle, UK: Cambridge Scholars Press, 2007).

12. Caroline Frank, "Architectural Japanning in an Early Newport House," *The Magazine Antiques*, vol. 170, no. 3 (September 2006), pp. 104–13.

13. Gottfried Hotz, *The Segesser Hide Paintings: Masterpieces Depicting Spanish Colonial New Mexico* (Santa Fe, N. Mex.: Museum of New Mexico Press, 1991).

14. Kenneth A. Lockridge, "Overcoming Nausea: The Brothers Hesselius and the American Mystery," *Common-Place*, vol. 4, no. 2, January 2004, www.common-place.org/vol-04/no-02/lockridge/.

15. Helmut von Erffa and Alan Staley, *The Paintings of Benjamin West* (New Haven, Conn.: Yale University Press, 1986); and Elizabeth Kennedy and Olivier Meslay, eds., *American Artists: the Louvre*, exhib. cat. (Paris: Louvre/Chicago: Terra Foundation for American Art, 2006), pp. 102–03.

COLONIZATION and REBELLION

Benjamin West (1738–1820)

Penn's Treaty with the Indians, 1771–72

Oil on canvas, 75½ × 107¾ in. (191.8 × 273.7 cm)

Pennsylvania Academy of Fine Arts,

Philadelphia, Gift of Mrs. Sarah Harrison

(The Joseph Harrison, Jr. Collection), 1878.1.10

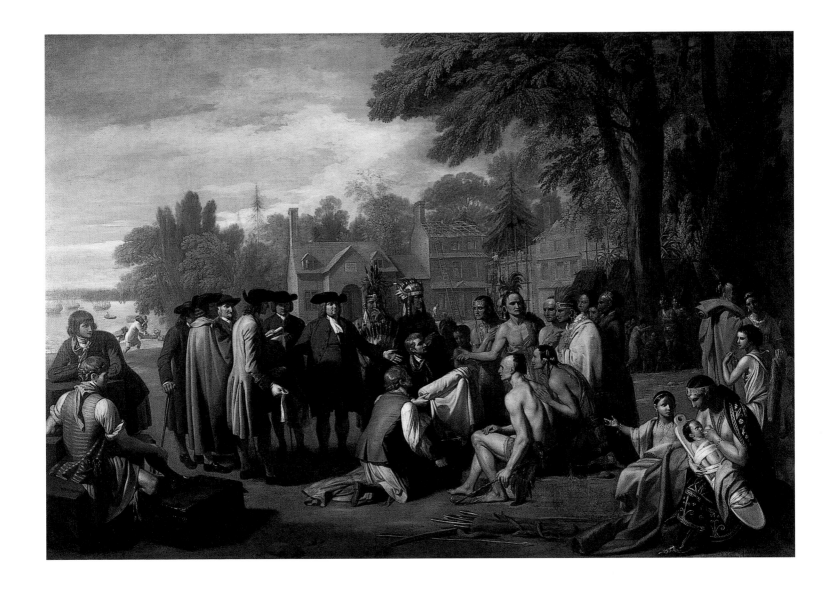

Gustavus Hesselius (1682–1755)

Tishcohan, 1735

Oil on canvas, 33 × 25 in. (83.8 × 63.5 cm)

Historical Society of Pennsylvania Collection,
Atwater Kent Museum of Philadelphia

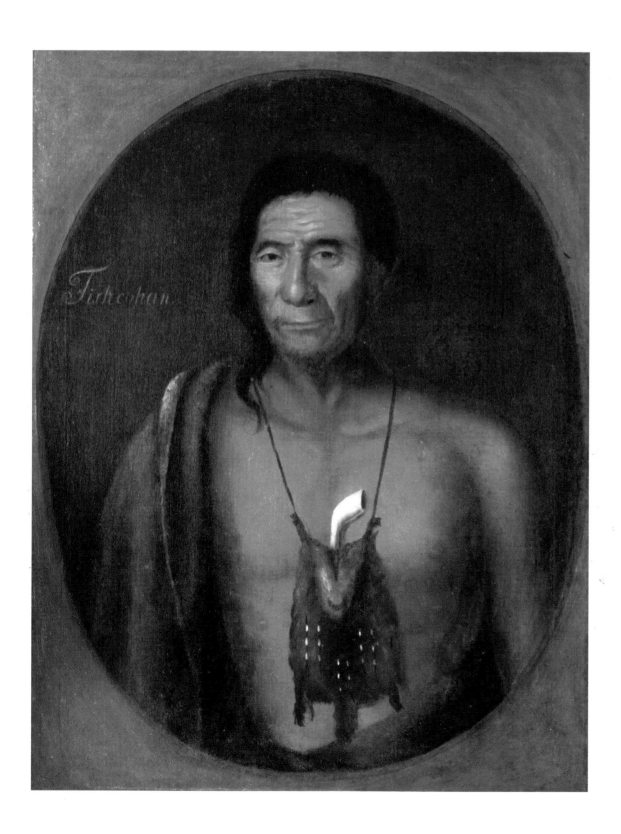

Colonization and Rebellion

Gustavus Hesselius (1682–1755)

Lapowinsa, 1735

Oil on canvas, 33 × 25 in. (83.8 × 63.5 cm)

Historical Society of Pennsylvania

Collection, Atwater Kent Museum of

Philadelphia, Gift of Granville Penn, 1835

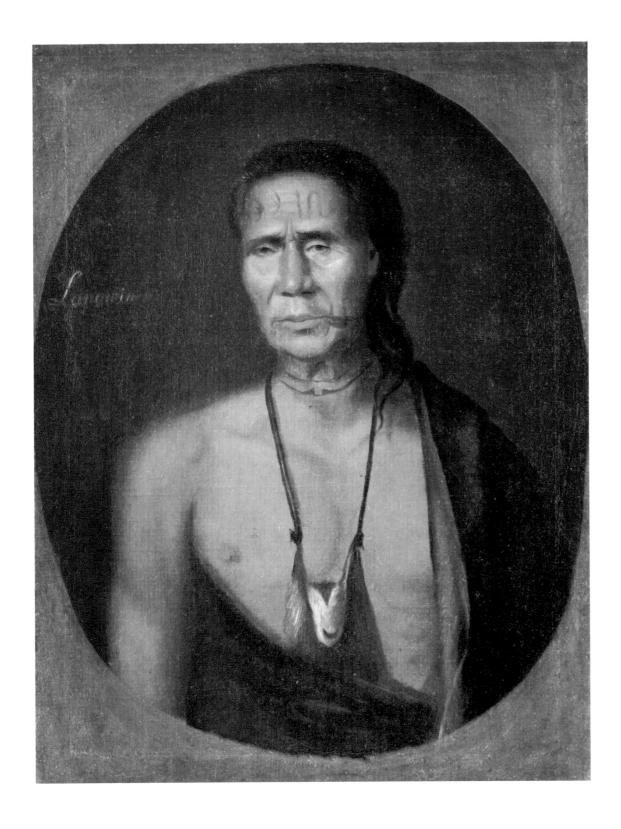

Thomas Smith (c. 1650–1691)

Self-portrait, c. 1680

Oil on canvas, 24¾ × 23⅞ in. (62.9 × 60.7 cm)

Worcester Art Museum, Massachusetts

Museum Purchase, 1948.19

Pieter Vanderlyn (1687–1778)

Mrs. Myndert Myndertse (Jennetje-Persen)
and Her Daughter, Sara, c. 1741

Oil on canvas, 39¼ × 32⅜ in. (99.7 × 82.2 cm)

Terra Foundation for American Art, Chicago

Daniel J. Terra Collection, 1992.138

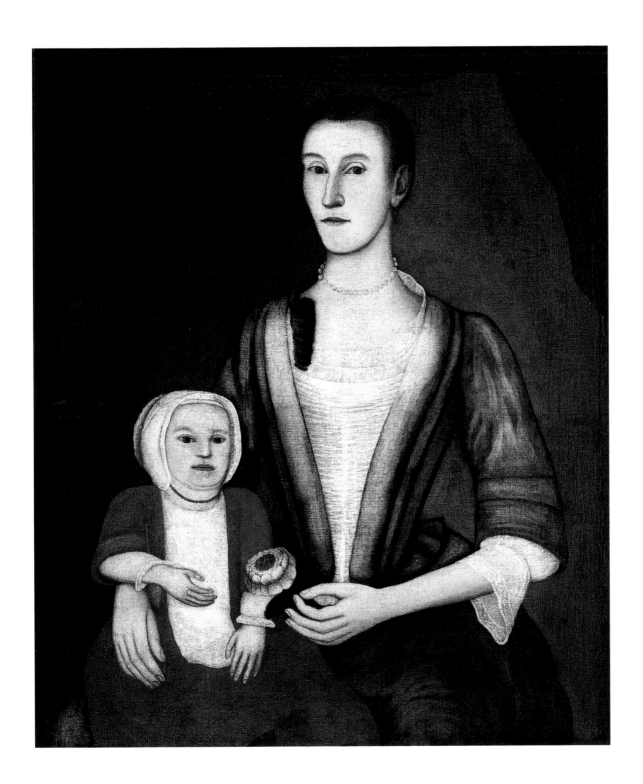

Pieter Vanderlyn (1687–1778)

Catherine Ogden, c. 1730

Oil on canvas, 57 × 37¼ in. (144.8 × 94.6 cm)

Newark Museum, New Jersey

The Members' Fund, Charles W. Engelhard

Bequest Fund, Anonymous Fund, 76.181

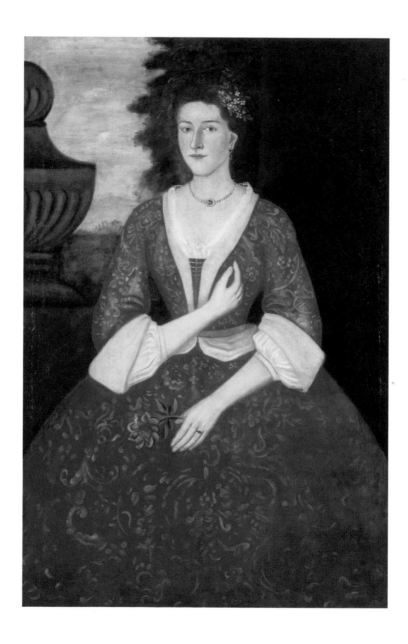

Robert Feke (*c.* 1707–*c.* 1751)

Brigadier General Samuel Waldo, c. 1748–50

Oil on canvas, 96⅝ × 60¼ in. (245.7 × 153 cm)

Bowdoin College Museum of Art,

Brunswick, Maine, Bequest of Mrs. Lucy

Flucker Thatcher, 1855.3

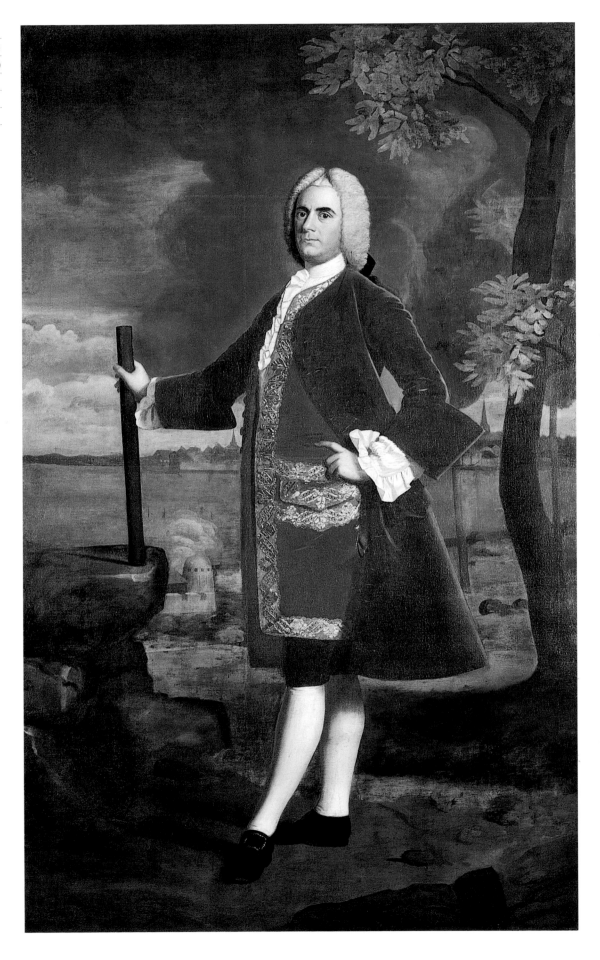

Joseph Blackburn (c. 1700–1780)

Isaac Winslow and His Family, 1755

Oil on canvas, 54½ × 79¼ in. (138.4 × 201.3 cm)

Museum of Fine Arts, Boston, A. Shuman

Collection, 42.684

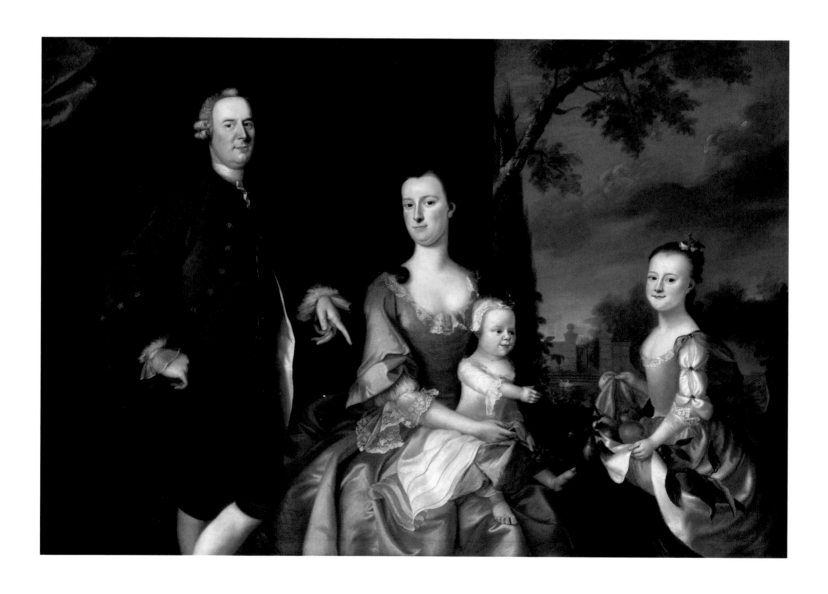

Colonization and Rebellion

Joseph Blackburn (c. 1700–1780)

James Bowdoin III and His Sister Elizabeth as Children, c. 1760

Oil on canvas, 36⅛ × 58 in. (93.7 × 147.3 cm)

Bowdoin College Museum of Art, Brunswick, Maine, Bequest of Mrs. Sarah Bowdoin Dearborn, 1826.11

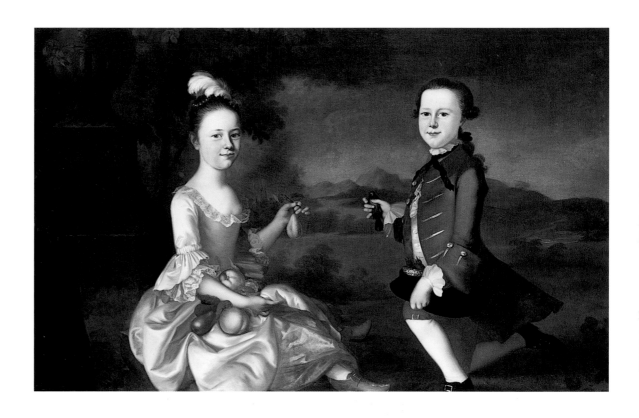

John Singleton Copley (1738–1815)

Paul Revere, c. 1768–70

Oil on canvas, 35 × 28½ in. (88.9 × 72.4 cm)

Museum of Fine Arts, Boston, Gift of

Joseph W. Revere, William B. Revere and

Edward H.R. Revere, 1930, 30.781

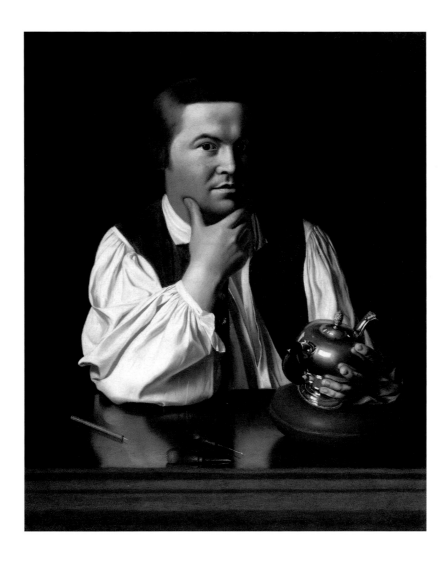

John Singleton Copley (1738–1815)

Portrait of a Lady in a Blue Dress, 1763

Oil on canvas, 50¼ × 39¼ in. (127.6 × 101 cm)

Terra Foundation for American Art, Chicago

Daniel J. Terra Collection, 1992.28

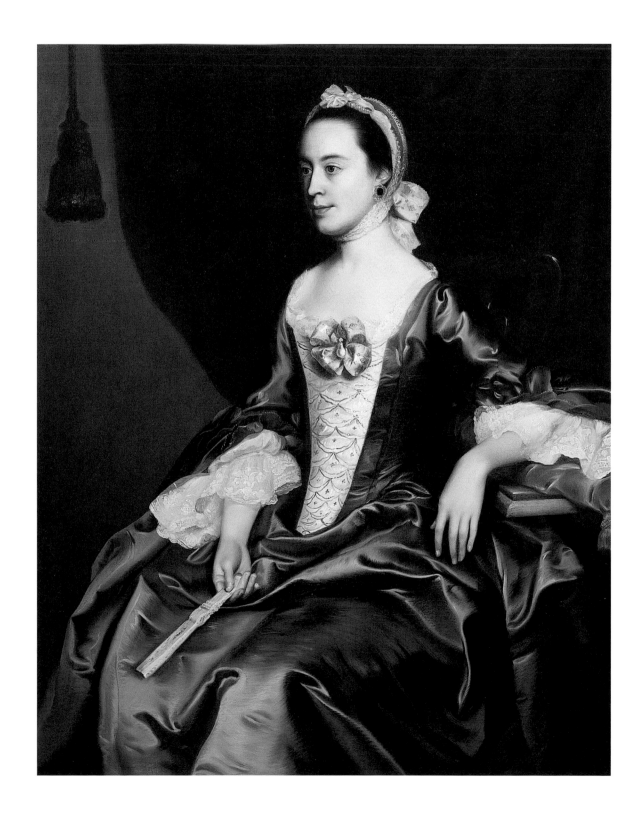

Colonization and Rebellion

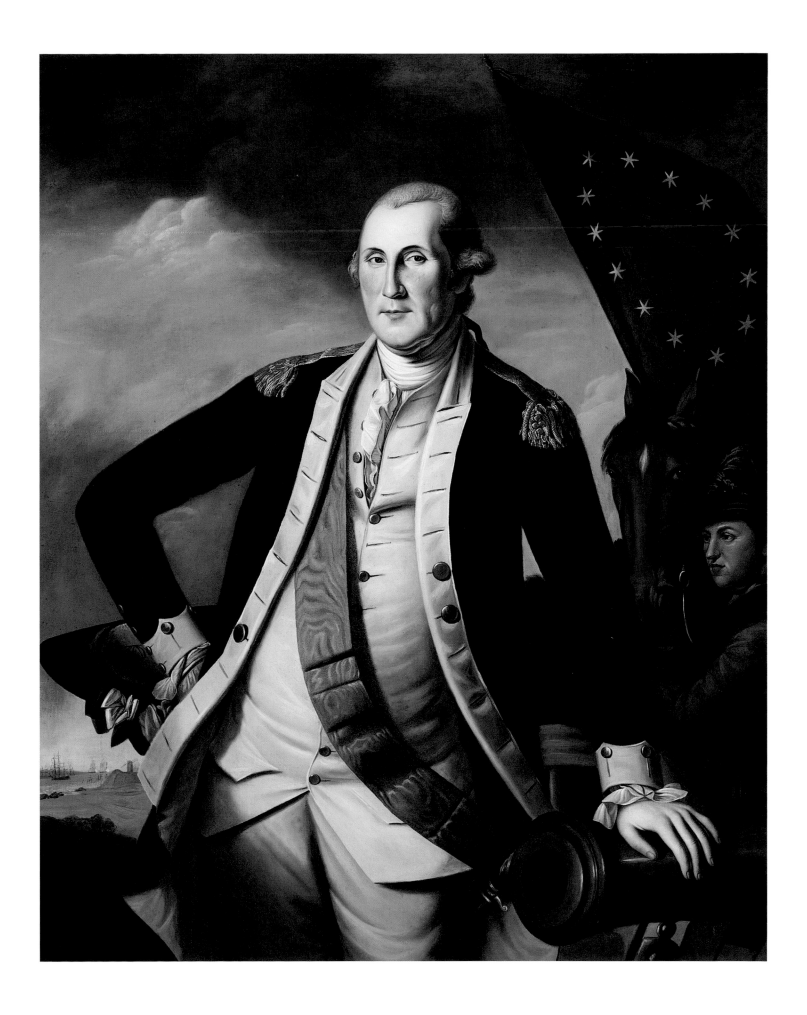

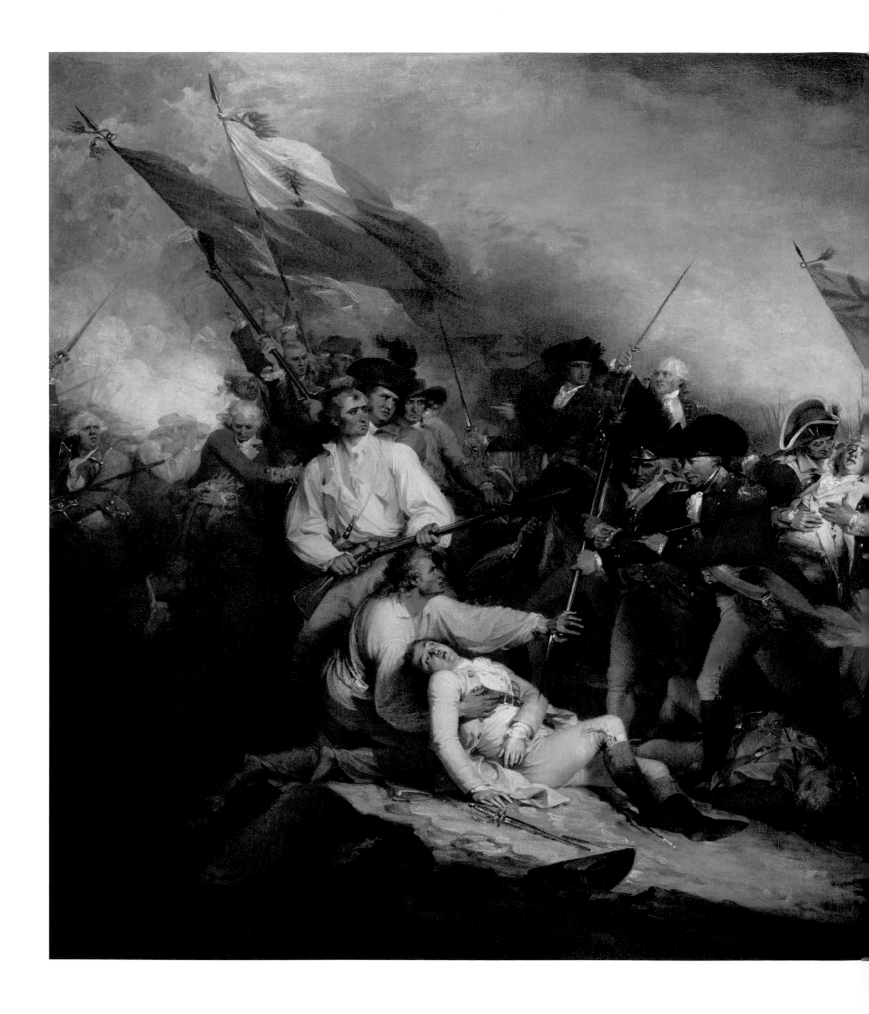

Colonization and Rebellion

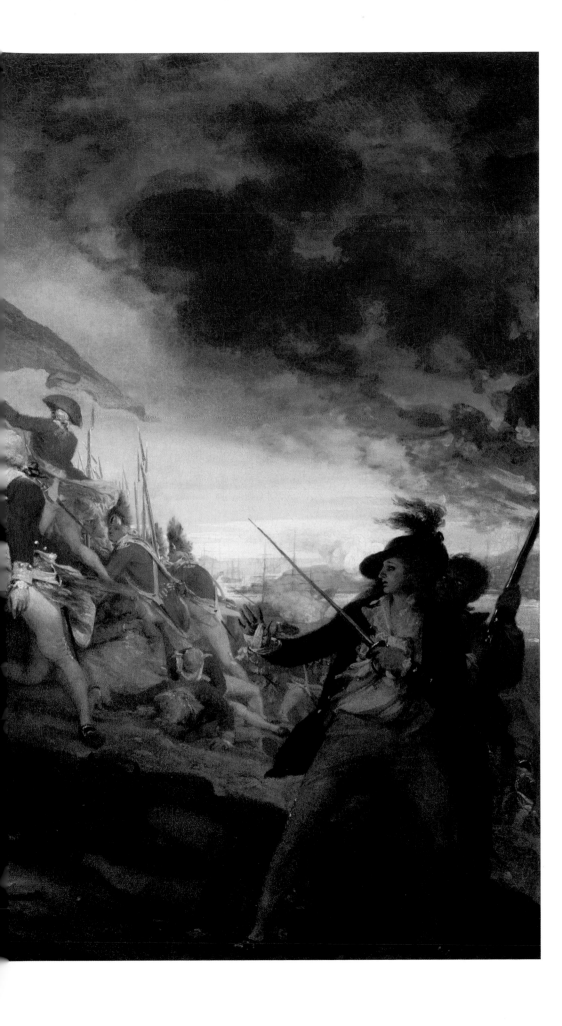

John Trumbull (1756–1843)
Death of General Warren at the Battle of Bunker's Hill, 1786
Oil on canvas, 25⅝ × 37⅝ in. (65.1 × 95.6 cm)
Yale University Art Gallery, New Haven, Connecticut, Trumbull Collection, 1832.1

Gilbert Stuart (1755–1828)

Joseph Brandt, 1786

Oil on canvas, 30 × 25 in. (76.2 × 63.5 cm)

New York State Historical Association

(Fenimore Art Museum), Cooperstown,

New York

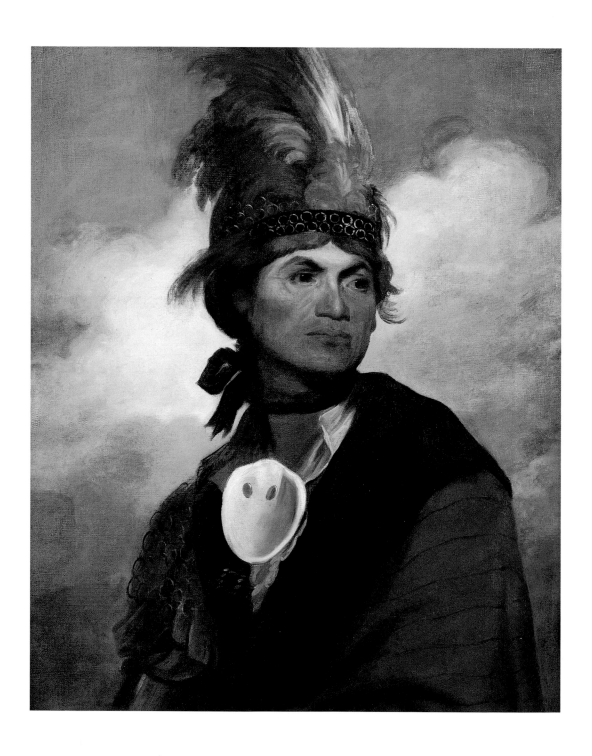

Colonization and Rebellion

Gilbert Stuart (1755–1828)

George Washington, after 1796

Oil on canvas, 28⅞ × 24 in. (73.3 × 61 cm)

Sterling and Francine Clark Art Institute,

Williamstown, Massachusetts, 1955.16

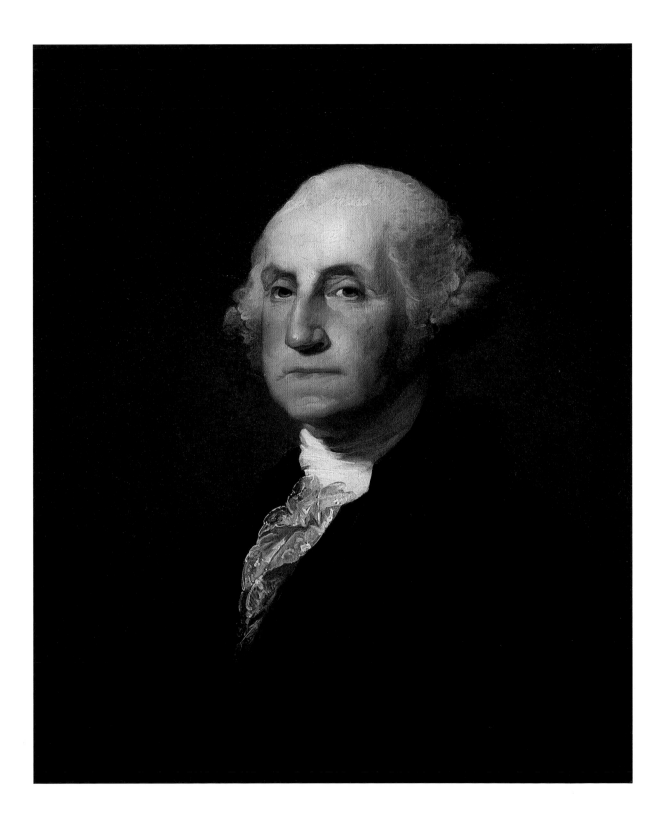

Charles Willson Peale (1741–1827)

Benjamin and Eleanor Ridgely Laming, 1788

Oil on canvas, 42 × 60 in. (106.7 × 152.4 cm)

National Gallery of Art, Washington, D.C.

Gift of Morris Schapiro, 1966.10.1

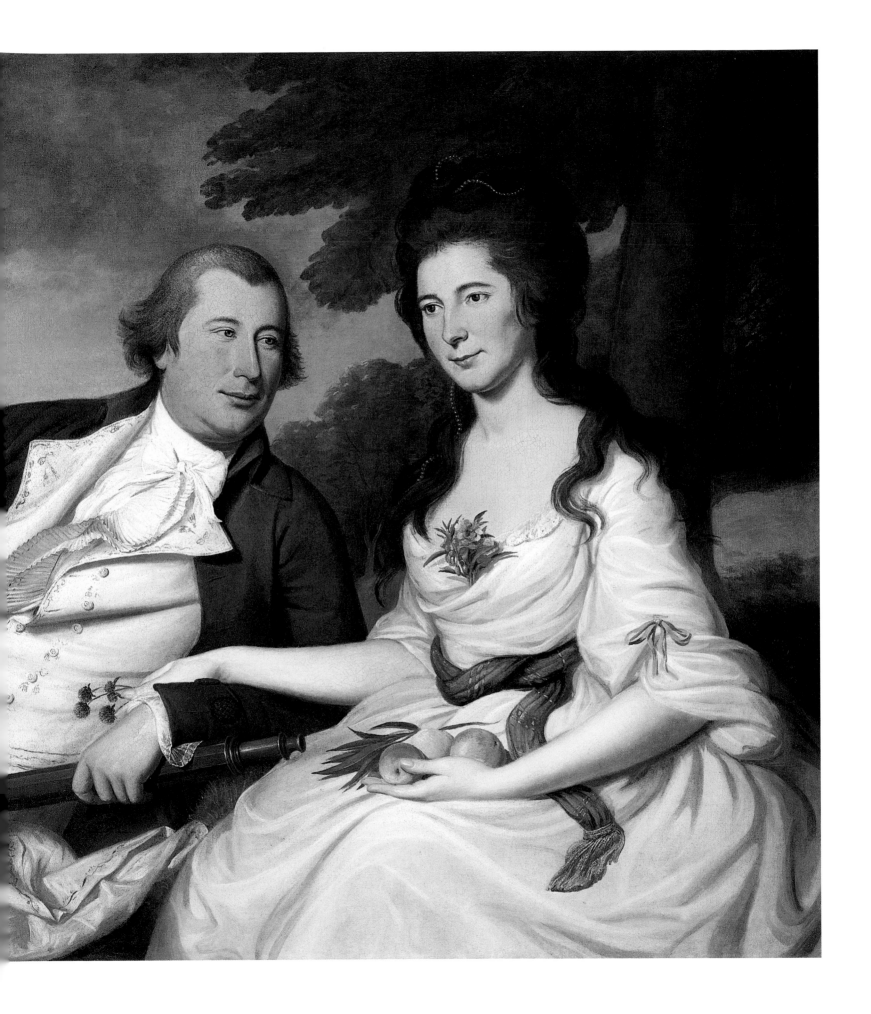

Ralph Earl (1751–1801)

Oliver and Abigail Wolcott Ellsworth, 1792

Oil on canvas, 76 × 86¼ in. (193 × 220.3 cm)

Wadsworth Atheneum, Hartford, Connecticut

Gift of the Heirs, 1903.7

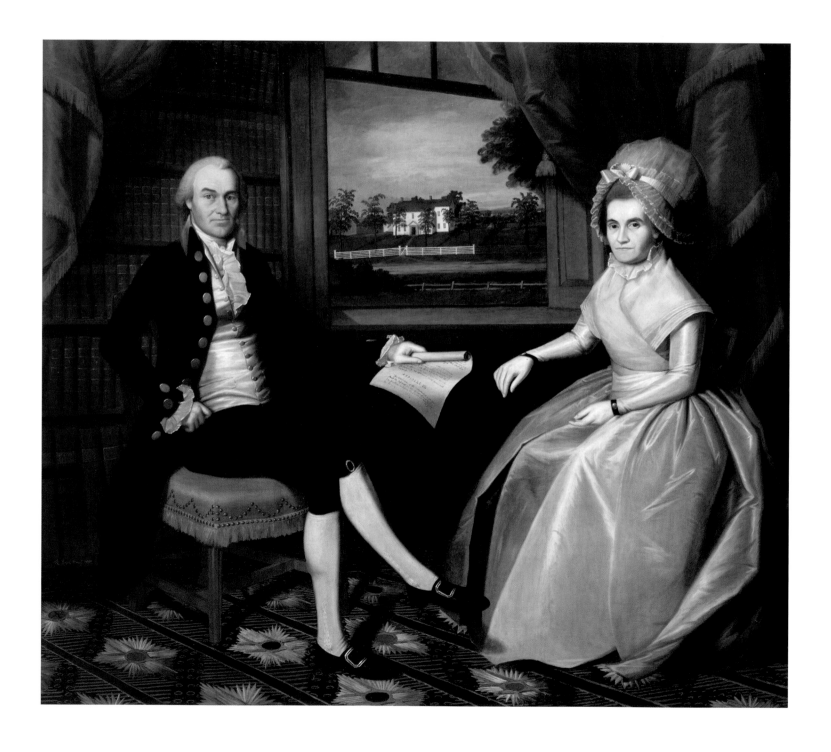

James Earl (1761–1796)

Rebecca Pritchard Mills (Mrs. William Mills)

and Her Daughter Eliza Shrewsbury, c. 1794–96

Oil on canvas, 40 × 50⅜ in. (101.6 × 127.9 cm)

Winterthur Museum, Delaware, Bequest of

Henry Francis du Pont, 1960.0554

Thomas Birch (1779–1851)

USS Constitution and HMS Guerriere, 1812

Oil on canvas, 46 × 54 in. (116.8 × 137.2 cm)

United States Naval Academy Museum,

Annapolis, Maryland, 1949.21

Fitz Henry Lane (1804–1865)

The USS Constitution in Boston Harbor

c. 1848–49

Oil on canvas, mounted on panel

15¾ × 21⅝ in. (40 × 54.9 cm)

Hunter Museum of American Art,

Chattanooga, Tennessee, Museum purchase

Thomas Sully (1783–1872)

Mrs. Robert Gilmor, Jr. (Sarah Reeve Ladson)

1823

Oil on canvas, 35⅞ × 28¼ in. (91 × 72.4 cm)

Gibbes Museum of Art, Carolina Art

Association, Charleston, South Carolina

42.10.4

Colonization and Rebellion

John Lewis Krimmel (1787–1821)

Fourth of July Celebration in Centre Square

c. 1814

Oil on canvas, 22³/₄ × 29 in. (57.8 × 73.7 cm)

Pennsylvania Academy of the Fine Arts,

Philadelphia, Purchase (from the estate

of Paul Beck, Jr.), 1845.3.1

The Chinese Presence in Early American Visual Culture

Patricia Johnston
Jessica Lanier

The *Empress of China* departed New York Harbor in 1784, inaugurating the trade with China that brought enormous wealth to the new American nation. The next year the *Grand Turk* sailed from Salem, Massachusetts, to Canton. Almost immediately voyages commenced from other key American ports, such as Philadelphia and Boston. The rapid emergence of American participation in a global maritime economy quickly transformed the struggling former colonies into wealthy players in the "East Indian" and China trades.

As a result of this trade, American visual culture became more international, both because of increased access to materials and because of new subjects for representation. Chinese visual arts became a major influence—whether they affected the structure and form of decorative arts, or provided new inspirations for surface patterning. Because so few Westerners visited China before the modern era, the depiction of China on imported paintings, porcelain, and fabric helped Europeans and Americans formulate their concept of the Celestial Kingdom. Most of these objects, however, were made specifically for Western markets and adapted Chinese styling to European and American tastes. Soon Westerners developed their own imaginative re-creations of Chinese environments and motifs (called *chinoiserie*), which further stimulated and fed the demand for Asian decorative sensibility.

While there was an explosion of Asian influence with the beginning of direct trade in the early republic, Americans had developed the taste for Chinese arts much earlier. From the mid-seventeenth century, British navigation laws forbade the American colonies from trading with all but British ships. Consequently, all Chinese products, including tea—the key commodity in Western trade with China—had to be transshipped via Britain under the auspices of the British East India Company, which held a monopoly on trade east of the Cape of Good Hope at the southern tip of Africa. Despite this limited access, and the high cost of such luxuries as tea, silk, porcelain, and lacquer, Americans developed a fascination, if not an established habit, for Chinese products during the colonial period.

Because lacquer was rare and fabulously expensive, and because they did not know the secret of its manufacture, European craftsmen developed the process known as "japanning," so-called because the first lacquer to reach Europe in the sixteenth century came from Japan. In 1612 Amsterdam artisan Willem Kick described his work as lacquering "after the fashion of the Chinese." About the same time both genuine and imitation lacquerware appeared in English households.[1] John Stalker and George Parker outlined a formula for simulating lacquer in their influential *Treatise of Japanning and Varnishing* (Oxford, 1688, and many later editions). By the eighteenth century the term "japanned" had lost any precise geographic significance beyond its association with a variety of processes intended to imitate true Asian lacquer (from the *Rhus vernicifera* tree).

Although colonial Americans were fascinated by lacquer's aesthetic qualities, they lacked the basic ingredients and knowledge needed to make genuine lacquer as well as the patronage necessary to fund such time-consuming work. In Boston, one of the key furniture-manufacturing centers of the colonies, there were at least ten japanners working before 1750. American craftsmen simplified the Stalker and Parker process by using fine-grained local hardwoods and applying plain oil colors rather than a mixture of pigments and varnish over gesso, thus achieving a lustrous black surface that imitated Asian lacquer in as few as six steps.[2]

The Winterthur Museum's *High Chest* (*c.* 1740–50), signed by cabinetmaker John Pimm (died 1773), is one of about three dozen surviving examples of japanned furniture made in colonial Boston (fig. 39). According to family tradition, Pimm made the chest for Joshua Loring (1716–1781), a captain in the Royal Navy and a hero of the French and Indian War. Pimm's high chest blends Asian-inspired surface design with traditional British high-style furniture forms, such as the finial centered in a broken pediment and the graceful cabriole legs terminating in unusual squared Spanish-style clawed feet. The unknown japanner employed a simulated tortoiseshell background (a vermilion base streaked with black) in combination with *chinoiserie* landscapes populated by imaginary and exotic beasts, a treatment unique to Boston. Layers of varnish protected and added depth to the surface. With its *chinoiserie* design of flat and raised ornament (created with whiting, a gesso-like material) in gold, the chest must have appeared to colonial eyes a reasonable facsimile of Asian lacquer.[3]

The exact source of the motifs used for American japanned decoration is rarely identifiable. Most likely the design on the Pimm high chest is based on a European interpretation, inspired by, rather than directly copied from, Chinese objects. Stalker and Parker's *Treatise of Japanning and Varnishing* included twenty-four plates of *chinoiserie* designs. Other available sources included Indian and Chinese textiles, Asian porcelain and its Western imitators, prints and illustrated travel accounts, as well as English japanning and actual examples of Asian lacquerwork. Several beasts on the Pimm high chest resemble but do not precisely match those found in Edwards and Darly, *A New Book of Chinese Designs* (London, 1754).[4] The garden pavilions, fences, robed figures, and simple boats seen here were also commonly found on Chinese porcelain.

By the mid-eighteenth century Chinese and European themes had been synthesized in the new, playful, whimsical taste known as the Rococo. Robert Sayer's *The Ladies Amusement; or the Whole Art of Japanning Made Easy* (1762) advised that "with Indian and Chinese Subjects greater Liberties may be taken, because Luxuriance of Fancy recommends their productions more than Propriety, for in them is often seen a Butterfly supporting an Elephant, or Things equally absurd; yet from their gay Colouring and airy Disposition seldom fail to please."[5] Thus Chinese motifs gave artisans freedom to abandon Renaissance rules of perspective and proportion and develop a free arrangement of design elements.

Craftsmen often learned of Chinese visual arts through pattern books. The enormously popular *The Gentleman and Cabinet-Maker's Director* (London, 1754) by Thomas Chippendale (1718–1779) provided templates for incorporating Chinese style into Euro-American furniture. Chippendale illustrated many styles of furniture design and ornamentation, from Neo-classical to Gothic revival, but he particularly recommended attention to "the present Chinese manner" because it offered "the greatest variety."[6] Fig. 41, one of three pages of Chinese-inspired chair designs in Chippendale's directory, depicts a series of options for craftsmen and clients; each chair illustrates different choices—carved legs or plain, arm or side chair, types of fretwork patterns. In addition to chairs, Chippendale included Chinese-inspired shelves, railings, mirror frames, beds, and case pieces. Even his "French Chairs" in the "Modern" style were shown upholstered in fabrics with Chinese figures and landscapes.

Chippendale's *Director* and its many imitators spread Chinese visual elements widely. Before 1800 the book was in the hands of prominent American furniture-makers, such as the Goddards in Newport, and Thomas Affleck and Benjamin Randolph in Philadelphia. Pattern books served as guides to fashion and good taste for the steadily growing consumer class in America. Westerners became enamored of Chinese chair design because it suited their evolving patterns of socializing and entertaining. Lightweight and easily moved, these delicately carved chairs gave home arrangements greater flexibility. Unlike traditional English oak, newly available fine-grained hardwoods, such as mahogany from the West Indies, which had similar properties to Asian hardwoods, were structurally suitable to these slim and graceful forms with their heavily pierced back-splats.[7]

Like Chippendale, most eighteenth-century Europeans and Americans casually mingled Chinese and Western designs. They were

not concerned with specific historical accuracy, or that much of the Chinese art exported to the West was adapted for that market. Sometimes they incorporated Chinese design into basic shapes, as in the case of Chippendale's Chinese chairs. More commonly, Chinese patterns graced the surface of wholly Western forms.

About the time of the American Revolution, a length of Chinese block-printed and hand-painted, golden-yellow silk taffeta was sewn into a highly fashionable woman's dress, now in the Metropolitan Museum of Art in New York (fig. 40). The two-piece ensemble consists of a "*robe à la polonaise*" overdress with a matching ankle-length petticoat, both with scalloped and serrated box-pleated self-trimming. The maker of the dress carefully arranged the floral pattern so that the peonies appear in the right-hand trimming, while the sprigs and butterflies appear on the left (fig. 38). This meticulous attention to the silk's pattern is evident throughout the dress: note the matching patterns in the sleeves and the placement of the peonies to either side of the bodice opening. Though the pattern is authentically Chinese, the dress form is up-to-the-minute European fashion.

In the colonial period, silk was worn at the most élite levels of society. The extent to which silk was valued in America is evidenced by the care with which silk dresses were preserved, reused, and remade across generations.[8] Family history associates this dress with Mrs. Jonathan Belcher, wife of the Colonial Governor of Massachusetts (1730–41) and later New Jersey (1746–57). However, the styling of the dress places it in the 1770s or 1780s. The Belchers, a merchant family with extensive English ties, probably imported the silk before the opening of American trade with China. The bodice of the dress shows evidence of later alteration, possibly for use as a fancy-dress costume in the nineteenth century.

Chinese taffetas, crisp and lightweight, were famed for their glossy sheen, which echoed the smooth shiny aesthetic qualities of porcelain—characteristics favored in the eighteenth century. The design, a series of five peonies surrounded by floral sprigs and a butterfly arranged in a straight line from selvedge to selvedge, was made by block-printing an outline and then filling in with hand-painted colors. This Chinese manufacturing technique allowed rapid production of an ostensibly hand-painted product. The motifs and palette, light and dark pinks, turquoise, light and dark purples, greens and olive, are similar to those found on mid-eighteenth-century "*famille rose*" Chinese-export porcelain. Most Chinese silk dress-goods were manufactured in Canton (Quangzhou), and although most porcelain was manufactured in Jingdezhen, like the silk it was painted in Canton.[9]

The importation of Chinese tea had a major impact on American design, bringing with it new forms—teapots, cups, tea tables, and other domestic items—and influencing social manners and customs. Chinese porcelain turns up surprisingly early in a variety of colonial settlements—archaeologists have excavated shards at the sites of English Jamestown, Virginia; French Mobile, Alabama; and some Spanish missions in California. The most élite members of colonial society were the first to own porcelain and delftware, its European imitator, but from the 1740s, both "china" and tea equipage appear in probate inventories with increasing frequency. Initially a luxury, tea became commonplace, the central commodity in the rapidly changing consumer society of late eighteenth-century Anglo-America. Because it functioned as a common denominator among the disparate populations of colonial America, tea was briefly transformed from a symbol of gentility into one of political oppression during Revolutionary boycotts to protest British taxation.[10]

Tea services were typically imported. Like lacquerware, knowledge of porcelain manufacture lagged far behind the European taste for it. Although Augustus the Strong of Saxony's alchemist Johann Friedrich Böttger discovered the secret of true or hard-paste porcelain early in the eighteenth century, and the French and English succeeded in creating commercially viable soft-paste versions by mid-century, their cost exceeded Chinese porcelain. American colonists hoped to compete with imported ceramics by developing their own porcelain formulas, but none succeeded until 1770, when Andrew Anthony Morris and Gousse Bonnin founded the short-lived American China Manufactory in Philadelphia, the only successful producer of porcelain in colonial times. During the two years they were in business, Bonnin and Morris produced blue and white soft-paste porcelain in imitation of British models, which had already thoroughly absorbed the Chinese influence.

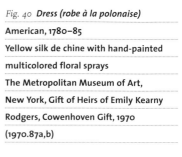

Fig. 39 **High Chest**
Made by John Pimm (d. 1773)
Boston, 1740–50
Maple, walnut, pine, mahogany, and brass,
85¼ × 42 × 25¼ in. (216.5 × 106.7 × 64.1 cm)
Winterthur Museum, Delaware
Gift of Henry Francis du Pont

Fig. 40 *Dress (robe à la polonaise)*
American, 1780–85
Yellow silk de chine with hand-painted
multicolored floral sprays
The Metropolitan Museum of Art,
New York, Gift of Heirs of Emily Kearny
Rodgers, Cowenhoven Gift, 1970
(1970.87a,b)

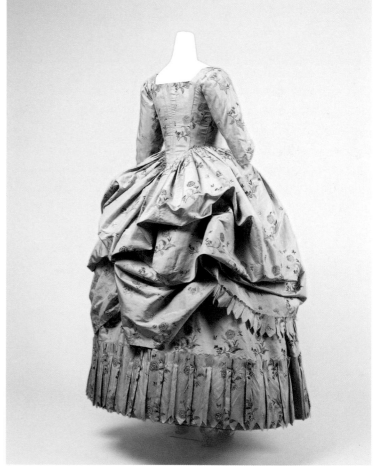

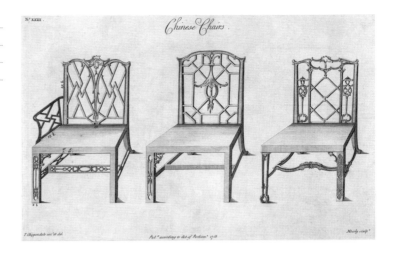

At the close of the Revolution in 1783, Americans anticipated direct commercial relations with China as one of the main benefits of peace. Trade with China had enormous symbolic as well as practical value to the nation's aspirations. Americans saw East Asia and China as "a place of great antiquity, splendor and riches." In the first volume of the *American Philosophical Society Transactions*, Charles Thomson wrote that with Asian imports "this country may be improved beyond what heretofore might have been expected. And could we be so fortunate as to introduce the industry of the Chinese, their arts of living and improvements in husbandry, as well as their native plants, America might in time become as populous as China."[11]

Preparation for the inaugural trade mission to China took on a national dimension. Investors Samuel Breck and Daniel Parker, and supercargoes (that is, chief mercantile agents) Samuel Shaw and Thomas Randall came from Boston, where the *Empress of China* had been built in 1783. Investor William Constable was based in New York. Both chief financier Robert Morris and Captain John Green were Philadelphians, but the *Empress of China* left from New York on Washington's birthday (February 22, 1784) because of fear that a frozen Delaware River would delay her departure from Philadelphia.

The *Empress* returned to New York in May 1785 along with the *Pallas*, an English ship chartered in China by Green, Shaw, and Randall for their private adventures. The return cargo, like subsequent voyages, consisted overwhelmingly of tea but included a panoply of Chinese decorative arts destined to become standards in the American China trade—porcelain, textiles, wallpaper, reverse painting on glass, silk window blinds with bamboo ribs, fans, umbrellas, and lacquer. Newspaper stories touted the voyage as one of "unprecedented economic importance for the new nation."[12] With the opening of direct trade with China, Americans had new opportunities for custom-ordering Chinese goods suited specifically for the American market.

The first recorded Chinese-export porcelain in an American pattern was the Society of the Cincinnati porcelain made for Samuel Shaw (fig. 44). The Society of the Cincinnati, formed at the conclusion of the American War of Independence, was composed of officers of the Revolutionary army who viewed themselves in the mold of the ancient Roman hero Lucius Quinctius Cincinnatus, who was twice called to lead Roman armies in defense of the republic, and each time refused the mantle of dictator, preferring to return to his farm as a simple republican citizen. At that time, society viewed George Washington, Commander-in-Chief of the Continental Army and the first President of the United States, as a latter-day Cincinnatus because he eschewed political power after winning the war in 1783 and after being elected president to two terms of office. Washington was the Society's President General from 1783 until his death in 1799. The Society asked Major Pierre Charles L'Enfant to design an appropriate emblem, and he supervised the production of a medal in the form of an eagle, which was suspended from a ribbon by its head. Shaw appears to have taken one of L'Enfant's sketches of the eagle to China, along with engravings of the classical figure Minerva. He asked the Chinese enamelers to assemble a complex decorative scheme, to be overglazed on an existing porcelain set, but was disappointed in the compositions. He then opted for a simple design of the winged Fame, trumpeting with her right hand, and holding with her left hand a blue bow and ribbon from which is suspended a copy of L'Enfant's eagle. The tiny figures were centered in a creamy field, and the porcelain form edged in blue.[13] Dozens of pieces from the original Cincinnati set were eventually acquired by Washington, who used them at his home in Mount Vernon.

The Society of the Cincinnati teapot, with its straight-sided cylindrical body in the Neo-classical taste and intertwining strap handle with floral terminals, was similar to English creamware examples. Chinese potters had long catered to Western tastes, combining traditional Chinese motifs with Western shapes and sets suited to Western dining and drinking practices. Forms originally introduced from China along with tea, such as wine pots, handleless cups, and bowls, had entered into a continual process of cultural interchange as Eastern and Western potters responded to the needs and desires of the European and American markets. The blue butterfly and honeycomb border, often referred to as a "Fitzhugh border," is among the most common borders found on Chinese-export wares between 1780 and 1820.

It was widely reproduced by English potters—most notably by the Spode factory.[14]

Porcelain was linked to other new beverages as well. The social aspects of drinking tea, coffee, chocolate, and punch were fostered by the mercantilism nurtured in the coffeehouses and taverns of the New World. Because they required specific equipage, these new luxury products presented opportunities for self-display through the material culture of the porcelain and the new repertoire of social rituals.[15]

Like tea parties, punch-drinking became an established social ritual, done at specific times and places with a recognizable code of rules. Tea's popularity was in part attributable to its status as an imported luxury item. Punch too was a combination of expensive imported ingredients—lemons, limes or oranges, sugar, and the main ingredient, rum. Punch, like tea, could be served hot and was considered as genteel as imported tea. However, tea was associated with women: private and domestic. Punch was public, political, and male.

In America the punchbowl achieved a symbolic importance not seen elsewhere. Central to communal drinking rituals, exemplified in elaborate toasting practices, it came to symbolize the common interest, the voluntary integration of the private individual into the social public sphere. This economic, social, and philosophical integration was of critical importance in America where the structure of society and a man's place in it were not based solely on birth. The punchbowl became a focus of male conviviality and an indispensable part of functions related to local government and law. It was used at a variety of gatherings in a century that saw a considerable increase in the formation of clubs and societies, and a merchant class that put particular emphasis on social drinking as integral to the conducting of business.[16]

The image on the Historic Deerfield-imported Chinese punch-bowl is a view of the *hongs* of Canton—a walled compound usually translated as "factories," but actually consisting of both warehouses and living quarters (fig. 43). By Chinese decree all trade with Europeans was limited to the single port of Canton, located twelve miles up the Pearl River from the ship anchorage at Whampoa. This view of the European commercial enclave at Canton graced innumerable souvenirs manufactured for the

export trade. By the second half of the eighteenth century, views painted for the export market exhibited a hybrid style incorporating Chinese landscape conventions adapted from scroll painting with fixed-point perspective adopted from Western painting. By slanting all the roofs in one direction, the painter of the *hong* bowl was able to retain the illusion of a single vanishing point along the bowl's continuously curving surface. The bright colors and decorative fusion of bowl and landscape scroll belie the didactic nature of the original source. Such depictions, topographic and factual, while retaining a certain exoticism, appealed to Western merchants' tastes.[17]

In addition to decorating porcelain, Chinese artists developed a range of paintings in Western formats aimed at a Western market. The American taste for portraiture has been well documented and many traders welcomed the distraction of having their portraits painted in Canton at reasonable prices. Other popular subjects acquired by American merchants included port scenes, ship paintings, copies after Western prints, and genre scenes depicting Chinese life, first in watercolor or gouache on silk and later reverse-painted on glass or oil on canvas. The rise of international commerce in the early republic generated a demand for knowledge of people around the globe, which was satisfied by representations in a variety of media.

In the 1790s a new emphasis on geographic education and an increasing desire for ethnographic and cultural information emerged. For instance, in Salem, Massachusetts, a major city in post-Revolutionary international trade, the East India Marine Society established a museum of "natural and artificial curiosities" in 1799. In addition to civic education, these objects from the South Seas and Asia functioned as a public display of the sea captains' global experiences and provided themes that eventually permeated American decorative arts.

For the opening of the East India Marine Society's enlarged museum in 1804, the Society commissioned Michele Felice Cornè (c. 1752–1845) to paint a suite of three fireboards representing the landscape and indigenous peoples of South America, Africa, and Asia. One of the fireboards represents the Cape of Good Hope though a pastoral view of Cape Town, South Africa, and the second

Fig. 42 Michele Felice Cornè (c. 1752–1845)
Foreign Factories at Canton, after an
engraving by James Moffat, 1804
Oil on panel, 33¼ × 53 in. (85.1 × 134.6 cm)
The Peabody Essex Museum, Salem,
Massachusetts

Fig. 43 (bottom) Punch Bowl with images
of foreign factories in Canton
Hardpaste porcelain, overglaze
polychrome enamels, and gilding
6 × 14¾ in. (15.2 × 37.5 cm)
Historic Deerfield, Massachusetts, HD 2772

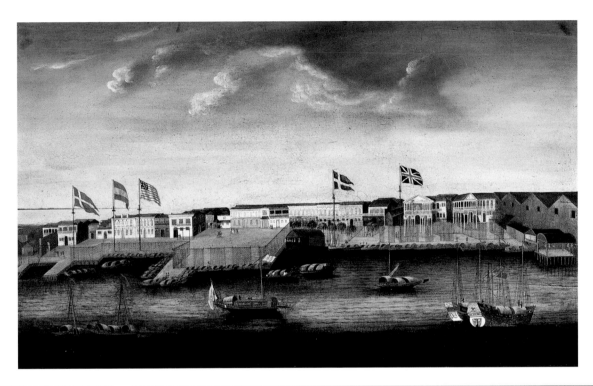

Fig. 44 (above) Society of the Cincinnati
Teapot, 1784–85
Chinese porcelain, from George
Washington's set
Courtesy of The Mount Vernon Ladies'
Association, Virginia

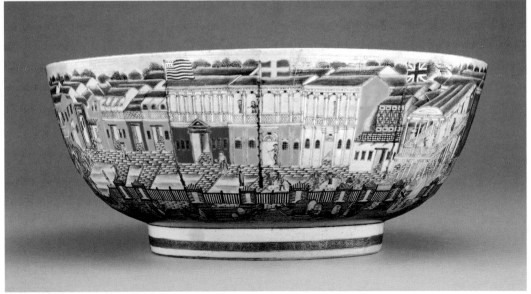

represents the indigenous peoples of Cape Horn (Tierra del Fuego, at the southern tip of Chile). The third is an image of the factories in Canton (fig. 42). The first two allude to the fact that the Society's membership was restricted to "persons who have actively navigated the seas beyond the Cape of Good Hope or Cape Horn," while the image of China represented their circumnavigation of the globe and the United States' greatest success as an independent trading nation. This iconographical program summarized Salem's centrality in maritime trade and translated the mariners' international knowledge into visual form.

Cornè, who had arrived in Salem from Naples in August 1800, probably trained as a decorative or sign painter, but he was familiar with European conventions of history painting. Cornè utilized classical stances and picturesque views, conventions of Euro-American art, to domesticate the global landscape for local viewers. He also copied specific sources: published illustrations documenting the voyages of Captain James Cook, and Chinese-export paintings of the 1790s. Views of Canton's skyline abounded in Salem in a wide variety of media on tourist items that mariners picked up for their families and friends: from fans to porcelain to Western-format paintings. Cornè's color palette for his view of Canton suggests that his source was a Chinese painting.

The importance of Chinese influence on American art has long been overlooked. From a trickle of rare and expensive luxury goods, the number of Chinese goods imported to America grew throughout the eighteenth century, driven by the fashionable aspirations and growing wealth of the American merchant class. The opening of the American trade with China brought Americans a flood of Chinese images, decorative arts, and consumer commodities and offered a more empirical, if still severely limited, view of Chinese culture. The integration of Chinese objects and motifs into American interiors, and their use by American artists, helped Americans see themselves in an international context. While historians have paid much attention to the development of nationalism in the early republic, little has been paid to how Americans came to see themselves as newly independent participants in global trade, trade that was critical to the success of the nation. Painted images, decorative arts, and other visual imagery derived from the China trade played key rôles in reinforcing a new American identity and in articulating the relationship between American citizens and their international trading partners.

Notes

1. Danielle Kisluk-Grosheide, "Lacquer and japanning in seventeenth-century Flemish and Dutch paintings," *Antiques* (October 2002); Hans Huth, *Lacquer of the West: The History of a Craft and an Industry, 1550–1950* (Chicago: University of Chicago Press, 1971).

2. John H. Hill, "The History and Technique of Japanning and the Restoration of the Pimm Highboy," *American Art Journal* 8, no. 2 (November 1976), pp. 62–64. For the documented craftsmen, see Esther Stevens Braser, *Antiques* (May 1943).

3. Nancy E. Richards and Nancy Goyne Evans, *New England Furniture at Winterthur: Queen Anne and Chippendale Periods* (Winterthur, Del.: Winterthur Museum; University Press of New England, 1997), pp. 307–08.

4. Hill, p. 77.

5. Quoted in Hill, p. 75.

6. Thomas Chippendale, *The Gentleman and Cabinet-Maker's Director: being a large collection of the most elegant and useful designs of household furniture in the Gothic, Chinese and modern taste* (London, 1754), vol. 8; on-line at The Digital Library for the Decorative Arts and Material Culture, University of Wisconsin Digital Collections, http://digicoll.library.wisc.edu/cgi-bin/DLDecArts/DLDecArts-idx?id=DLDecArts.ChippGentCab.

7. Lady Elizabeth White, "Influence of the British Pattern Book, 1740–1820," paper presented at *The Boston Furniture Symposium: New Research in the Federal Period* (November 14–16, 2003), Peabody Essex Museum, Salem, Massachusetts.

8. Natalie Rothstein, "Silks for the American Market II," *Connoisseur* 166 (November 1967), p. 155.

9. Leanna Lee-Whitman, "The Silk Trade: Chinese Silks and the British East India Company," *Winterthur Portfolio* 17, no. 1 (Spring 1982), p. 24.

10. Rodris Roth, "Tea Drinking in Eighteenth Century America: Its Etiquette and Equipage," in Robert Blair St. George, ed., *Material Life in America, 1600–1860* (Boston: Northeastern University Press, 1988), pp. 439–61. On the importance of tea in forming a common culture in America, see T.H. Breen, "Narrative of Commercial Life: Consumption, Ideology, and Community on the Eve of the American Revolution," *William and Mary Quarterly* 50, no. 3 (July 1993), pp. 471–501.

11. James C. Thomson, Jr., Peter W. Stanley, and John Curtis Perry, *Sentimental Imperialists: The American Experience in East Asia* (New York: Harper & Row, 1981), p. 6; Jonathan Goldstein, *Philadelphia and the China Trade, 1682–1846: Commercial, Cultural and Attitudinal Effects* (University Park, Pa.: Pennsylvania State University Press, 1978), p. 16.

12. Goldstein, pp. 30–33.

13. Homer Eaton Keyes, "The Cincinnati and Their Porcelain," in Elinor Gordon, *Treasures From the East: Chinese Export Porcelain for the Collector,* rev. ed., 1975 (reprint, Pittstown, NJ: The Main Street Press, 1984).

14. Robert Copeland, *Spode's Willow Pattern and Other Designs After the Chinese,* 3rd ed. (London: Studio Vista, 1999), pp. 95–96.

15. Roth, pp. 442, 445.

16. Lorinda B.R. Goodwin, *An Archaeology of Manners: The Polite World of the Merchant Elite of Colonial Massachusetts* (New York: Kluwer Academic/Plenum, 1999), pp. 101, 136–37. See also David W. Conroy, *In Public Houses: Drink and the Revolution of Authority in Colonial Massachusetts* (Chapel Hill, NC: University of North Carolina Press, 1995).

17. Kee Il Choi, Jr., "Hong Bowls and the Landscape of the China Trade," *Antiques* (October 1999), pp. 500–09.

Acknowledgments

Patricia Johnston thanks the National Endowment for the Humanities and Salem State College for support of this research. Jessica Lanier thanks Michele Major and the Metropolitan Museum of Art, New York, for the opportunity to examine the dress described herein, and the Bard Graduate Center for their support of this research.

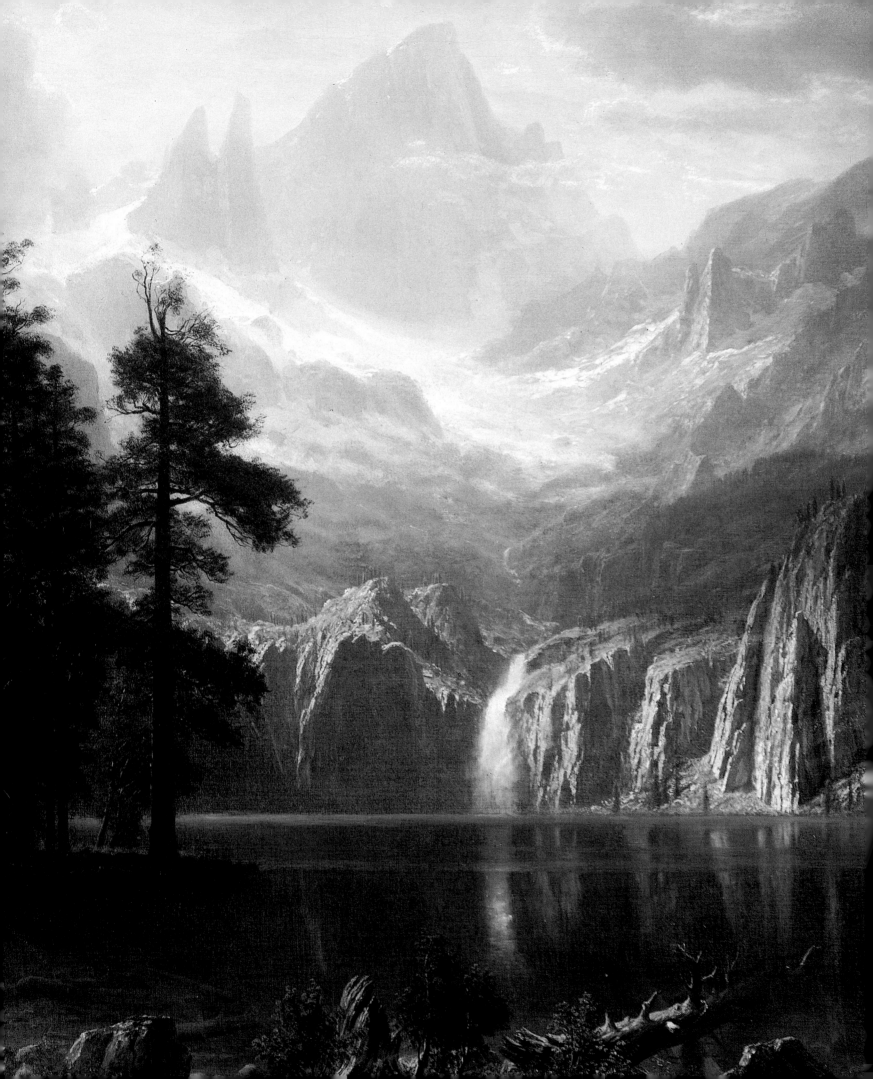

Expansion and Fragmentation

(1830–80)

Art in an Age of National Expansion: Genre and Landscape Painting

David M. Lubin

Dramatic and unprecedented growth beset the United States in the years between 1830 and 1880. It manifested itself in a variety of ways: in population and land mass, in wealth and productivity, in suffrage and literacy. With every burst of expansion came violent reaction. Rapid, unplanned growth in the economy led to a series of financial panics and outright depressions in what amounted to an uncontrollable "boom and bust" cycle that haunted the entire period. The great metropolitan centers, escalating in size, drained human resources from the countryside, leaving formerly healthy rural environments under-populated and unable to thrive. The extension of the political franchise to white working-class males, many of them immigrants and most residing in the North, and, simultaneously, the exportation of southern slavery to western states and territories led eventually to a cataclysmic civil war that cost the lives of 623,000 combatants, a figure almost equal to the total number of soldiers who have died in all the nation's other wars combined.

Great changes stirred in the cultural realm as well. With the growth of the cities, the movement west, the overall rise in population, the spread of literacy, and the swelling of the middle class, America's art, like its literature, no longer depended on the patronage of the aristocratic élite. As the demand for art increased, many more painters (ultimately, an oversupply of them) appeared on the scene to compete for commissions and sell their wares on the open market. Artists, collectors, and promoters organized art schools (most notably the National Academy of Design in 1826), art-distribution networks (the Apollo Association in 1839, the American Art-Union in 1844), art periodicals (such as

The Crayon, 1855), public art museums (Boston, 1870; New York, 1872; Philadelphia, 1876), and commercial art galleries and art fairs.[1]

A broader audience for art necessitated a broader range of artistic subjects. Portraiture had dominated the colonial and federal periods but now declined in importance, especially when photography, introduced in the 1840s, proved an efficient and inexpensive means of capturing individual likenesses for posterity. In general, consumers preferred paintings that described contemporary life in America (genre scenes) or celebrated the wilderness (landscapes). Portraits continued to be produced but now were more likely to draw on the techniques of genre or landscape painting, or both, to characterize sitters.

One of the most intriguing portraits of the era is *Pat Lyon at the Forge* (1826–27; fig. 47). It was commissioned by its subject, a wealthy Philadelphia inventor and businessman who as a working-class Irish youth had been imprisoned on a trumped-up charge for a crime he did not commit. Although the real culprit was eventually apprehended, city officials stubbornly delayed the innocent prisoner's release, presumably because they had little regard for those of his ethnic and economic background. Years later he commissioned the town's leading society painter, John Neagle (1796–1865), to picture him in a way that flaunts his working-class roots.[2] He stands before the viewer as a smith at his forge. Leather apron wrapped around his waist and shirtsleeves rolled high, he wields a hammer. Outside the window looms the cupola of the Walnut Street Prison, a reminder of an injustice that he could neither forget nor forgive.

Fig. 45 Emanuel Gottlieb Leutze (1816–1868)

Westward the Course of Empire Takes Its Way (Mural Study, US Capitol), 1861

Oil on canvas, 33¼ × 43⅜ in. (84.5 × 110.1 cm)

Smithsonian American Art Museum,

Washington, D.C.

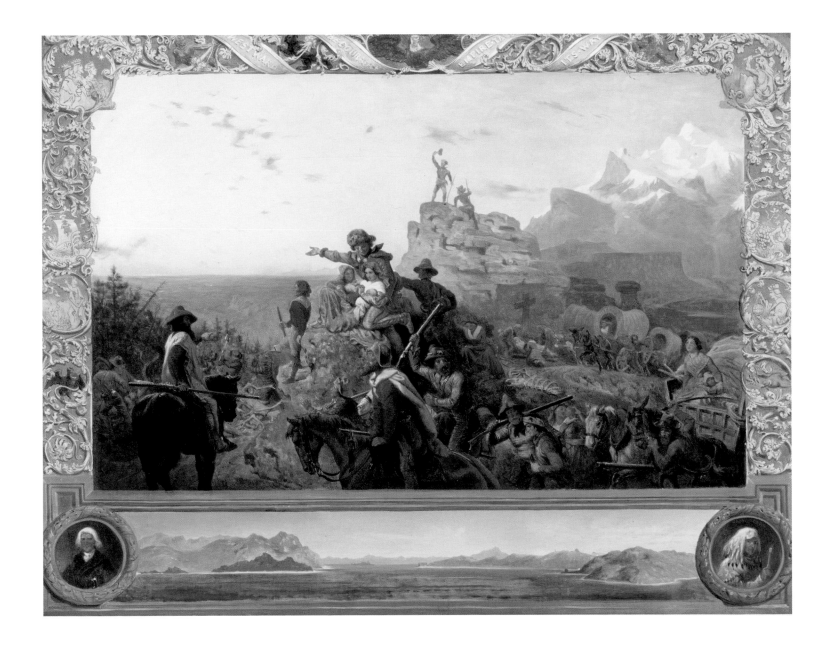

Fig. 46 Frederic Edwin Church (1826–1900)
Our Banner in the Sky, 1861
Oil paint over photochemically produced
lithograph on paper, laid down on
cardboard, 7¹/₂ × 11³/₈ in. (19 × 28.9 cm)
Terra Foundation for American Art, Chicago
Daniel J. Terra Collection, 1992.27

Ammi Phillips's *Girl in a Red Dress*, from about 1835, is a very different type of portrait (p. 113). We do not know the name of the sitter, and there is nothing within the painting itself to provide clues to her identity or that of her parents. The style of painting differs greatly from that of *Pat Lyon at the Forge*, which, despite its populist overtones, draws heavily on the European academic tradition and alludes to such Old Master paintings as Velázquez's *Vulcan's Forge* (1630; fig. 48). *Girl in a Red Dress*, on the other hand, displays no such European pedigree. Ammi Phillips (1788–1865) was an untrained itinerant portraitist, or limner, who plied his trade in rural Massachusetts, Connecticut, and New York. He is thought to have painted over 600 portraits in the course of a career that stretched from the War of 1812 to the Civil War.[3] Though he individualizes the faces of his sitters, he often standardizes their bodies and apparel. He traveled from town to town with a small stock of garments for outfitting his sitters. The red dress that figures in the portrait of this little girl shows up in portraits of at least three others.

Yet this repetition of forms and patterns, rather than detracting from Phillips's appeal today, has done much to secure it. His paintings delight the eye with bold colors, simple shapes, and strong designs. Here, for example, a pink-cheeked child dressed in scarlet holds a bright red berry beside her coral necklace. *Young Boy Holding a Bow and Arrow with a Drum on the Floor* by William Matthew Prior (1806–1873), from around 1856, is a similar sort of folk portrait, in which the flatly rendered accoutrements of the sweet-faced child serve to mark out his gender (p. 113).

The use of symbolic props and settings to characterize sitters was nothing new in portrait painting. Emblematic portraiture enjoyed a long history in America, going back to the seventeenth century. What was new, relatively speaking, was the emphasis on the common man or woman, the ordinary, non-élite child. (A memorable exception in eighteenth-century painting is John Singleton Copley's 1768–70 portrait of the rich silversmith Paul Revere as an artisan in work clothes, p. 66.) The 1828 election of the "man of the people" Andrew Jackson, the first president from what in those days was considered the West, over the incumbent John Quincy Adams, scion of New England aristocracy,

signaled not only a change in voter demographics but also, more broadly, a paradigm shift in American political thought and social ideology toward popular democracy.

Genre painting was among the most visible cultural expressions of this shift. It reveled in the humor, pathos, and simplicity of ordinary daily life. It celebrated the common person and the commonplace event. The goal of the genre painter was to draw forth laughs or nods of recognition from viewers who saw themselves or their neighbors reflected in the anecdotal scenes depicted.[4] The two leading genre artists of the era, the easterner William Sidney Mount (see p. 114) and the westerner George Caleb Bingham (see pp. 124, 125, 130), both of whose paintings were reproduced and widely distributed in inexpensive print editions, were particularly adept at eliciting both chuckles and nods for the scenes of country life they affectionately portrayed.

Mount (1807–1868), who was raised on then-rural Long Island, was the first American to earn a living as a genre painter. An early patron was the New York grocery store magnate and art collector Luman Reed, a self-made millionaire. Mount's nostalgia-tinged paintings of contemporary rustic life helped Reed and others like him recapture the bygone days of their youth. Though Mount worked in the city, he focused his attention on the day-to-day activities of his yeoman neighbors and childhood companions on Long Island: fishing, farming, dancing, horse-trading, card-playing, rabbit-trapping, music-making.[5]

His masterpiece is *Eel Spearing at Setauket*, a tranquil recollection of his own boyhood spent amid pastoral settings (p. 114). It shows a young white child, a pet dog by his side, using an oar to steady his skiff while his companion, a mature black woman wearing a red kerchief and a straw hat, leans over the prow to spear an eel. The painting is captivating because of its sheer optical beauty. The harmonies of the summer day are reflected in the water's mirror-like shimmer.

But its beauty is also social, in the sense that Mount has portrayed a moment of equilibrium between entities that were sometimes conspicuously at odds in antebellum America: children and adults, men and women, property owners (the boy, heir to the land in the background) and manual laborers (the woman), whites and blacks.

Fig. 47 John Neagle (1796–1865)

Pat Lyon at the Forge, 1826–27

Oil on canvas, 93¾ × 68 in. (238.1 × 172.7 cm)

Museum of Fine Arts, Boston, Henry H.

and Zoe Oliver Sherman Fund, 1975.806

Fig. 48 Diego Rodriguez Velázquez (1599–1660)

Vulcan's Forge, 1630

Oil on canvas, 87¾ × 114⅛ in. (222.9 × 289.9 cm)

Museo del Prado, Madrid

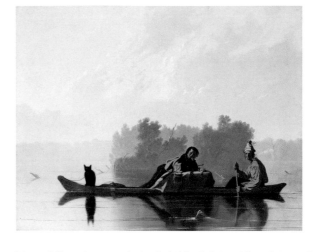

When Mount painted *Eel Spearing* in the mid-1840s, abolitionists were accused of stirring up discontent on the part of blacks in the North rather than encouraging them to be happy with their subservient but free status. Mount disapproved of abolitionism, which he considered destabilizing. His gemlike painting seems to envision a social order in which whites and blacks work together harmoniously even though they occupy segregated spaces in the ship of state, represented here by the small skiff gliding across peaceful water. The sentiment on offer may seem progressive but is actually patronizing, if not demeaning, for to achieve its racial balance the painting pairs a black adult with a white child.[6]

A later genre scene by Mount, *California News,* similarly addresses an issue of current concern. In this painting, a cross-section of Mount's contemporaries—most of them white adult men, but also a white woman, a black man, and a child—gather enthusiastically around a snappy fellow who reads aloud a newspaper report about the California gold rush of 1849. The anecdotal humor of the piece resides in the eyes and facial expressions of the various listeners. Except perhaps for the African American and the old man, both of whom stand to gain little from the venture, each is enraptured by his or her own private but collectively shared dream of going to California and making a fortune.[7]

Like Mount, George Caleb Bingham (1811–1879) had a gift for showing rural Americans in a humorous but genial manner that appealed to the rapidly growing urban middle class.[8] His paintings afforded easterners the pleasure of feeling at once mildly superior to the inhabitants of the frontier while also vicariously enjoying their carefree hedonism. He made his name with *Fur Traders Descending the Missouri,* an entranc-ing depiction of a father and son gliding down the glassy-smooth waters of a wilderness river (fig. 49). Like *Eel Spearing at Setauket,* it features a child and an adult (and a small animal of indeterminate species) on a boat in a beautiful natural setting, and it too seems laden with symbolism.

Smoking a long-stemmed pipe that leaves a puff of smoke behind him, a grizzled fur trapper looks in the viewer's direction as he pulls his paddle. His raven-haired child, clad in a blue shirt and maroon buckskin trousers, leans lazily over the covered cargo they are taking downriver to a frontier trading post. The harmony between father and son mirrors their harmony with nature itself (embodied not only by the landscape but also by the docile little animal in the bow) as they ply the river on a pristine morning.

The painting invokes a series of primal encounters in a positive light. One such encounter is generational, between child and adult, father and son. Another is racial (Bingham originally entitled the painting *French Trapper and His Half-breed Son,* ensuring that the son would be understood as part American-Indian in identity). A third encounter, more subtle, is between regions: the subjects of the painting are westerners, but the intended viewers were easterners (Bingham sent it to New York for exhibition), and the painting brings these disparate regional groups into implicit dialogue by having the figures in the boat look out of their own pictorial space into that of the observer, as if making eye contact.

After painting a series of pleasing pictures of flatboat men floating lazily down western rivers while smoking, playing cards, and dancing (see p. 130), Bingham turned his attention to electoral politics as practised on the frontier (see p. 124). Here he was more distinctly satirical. The masterpiece of the politics series, *The County Election,* shows an array of country types lined up in front of a rural courthouse, awaiting their turn to cast their ballots. Despite humorous vignettes of drunkenness, deception, and fraud, the painting ultimately affirms the American political system: the system's flaws, it seems to say, can be reformed by such practical safeguards as outlawing liquor sales on Election Day and strictly enforcing compliance with voting regulations.

Occasionally Bingham tried to merge genre painting with high-minded history painting, as with *Daniel Boone Escorting Settlers through the Cumberland Gap,* also known as the *Emigration of Boone* (p. 125).[9] Depicting the legendary Indian-fighter Daniel Boone leading a party of pioneers over the Appalachian Mountains to Kentucky in 1775, Bingham

Fig. 50 Severin Roesen (*c.* 1815–1872)

Still Life with Fruit, c. 1865

Oil on canvas, 33¼ × 43¼ in. (85.7 × 111.1 cm)

Delaware Museum of Art, Wilmington

Acquired through the bequest of

Miss Ellen Buckelew, 1970, DAM 1970-13

Fig. 51 Robert Spear Dunning (1829–1905)

Still Life with Fruit, 1868

Oil on canvas, 25 × 30¼ in. (63.5 × 76.8 cm)

Terra Foundation for American Art, Chicago

Daniel J. Terra Collection, 1999.49

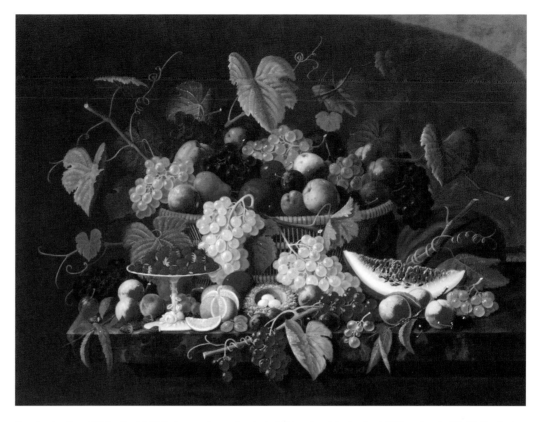

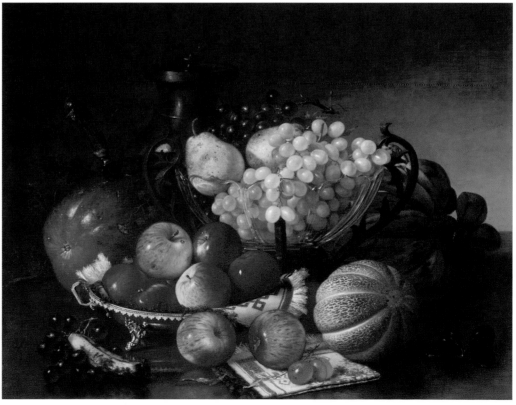

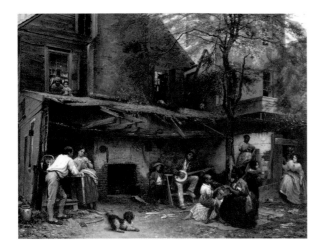

Fig. 52 **Eastman Johnson (1824–1906)**

Old Kentucky Home—Life in the South

(Negro Life at the South), 1859

Oil on canvas, 36 × 45¼ in. (91.4 × 114.9 cm)

Collection of the New-York Historical

Society, S-225

covertly addresses matters of personal concern to him at the time he painted it in 1851. After serving a two-year term in the Missouri legislature, he had recently lost his seat because of election fraud. Frustrated and embittered, he held up a squeaky-clean version of Boone as the model of honest, undeviating, and visionary leadership that was sorely lacking in the America of the time. The radiant light shining on the frontiersman and his party indicates God's blessing, and their epic journey calls forth associations with familiar biblical narratives, such as the flight into Egypt and Moses leading the Children of Israel through the wilderness.

Painted in the aftermath of the extraordinary land-grab known as the Mexican War, in which the United States forcibly "liberated" over 500,000 square miles of territory from the sovereign nation to its south, the *Emigration of Boone* counsels against rapaciousness, which Bingham believed was the chief characteristic of his political adversaries. Instead it pictures a dignified and peaceful incursion into the West by yeoman settlers guided by a man of rectitude and honor. It was wishful thinking, at best. The doctrine of Manifest Destiny—the belief that the United States was ordained by God to spill across the North American continent from sea to sea—legitimated for most Americans the territorial expansion of their country by any means necessary. Such paintings as *Westward the Course of Empire Takes Its Way ("Westward Ho!")*, which the German-American artist Emanuel Leutze (1816–1868) designed as a mural for the Capitol during the Civil War, glorify westward expansion as a helter-skelter affair that Bingham would have thought rambunctious and undignified (fig. 45).

The demand for genre painting continued to grow in the years leading up to the Civil War, and a new generation of genre painters took up the brush. Particularly noteworthy were Richard Caton Woodville, David Gilmour Blythe, Lilly Martin Spencer, and Eastman Johnson. The first of these to achieve recognition, Woodville (1825–1855), had a tragically brief career, dying at age thirty from an overdose of morphine medically administered during an illness.[10] His intricately composed scenes of daily life in his native Baltimore, showing men reading newspapers, arguing politics, or playing cards while waiting for the

stage to arrive, are intriguingly oblique in their satirical edge. He never comes right out and makes fun of his urban denizens but instead treats them with a cool detachment and irony.

David Blythe (1815–1865) was more direct—and corrosive—in his satirical depictions of daily life in Pittsburgh in the years leading up to and through the Civil War.[11] Like his French contemporary Honoré Daumier or the later political cartoonist Thomas Nast, Blythe made fun of pomposity, greed, and vice. He did not, however, restrict his barbs to the rich and powerful. Everyone was the object of his mockery, including women, children, and the poor. His view of mankind was too jaundiced to gain him wide popularity, and he died at age fifty, impoverished, embittered, and alcoholic.

Much lighter in her comedic view of humanity was Lilly Martin Spencer (1822–1902).[12] The daughter of immigrant French utopian socialists, Spencer was raised on a farm in Ohio. Her mother was an ardent feminist, but she herself was not. In her early twenties she moved to New York with her husband, a chronically unemployed handyman. She gave birth to thirteen children (seven of whom survived infancy) while supporting the family as a sometimes sentimental, often mildly humorous chronicler of middle-class family life. Her paintings, which circulated as low-cost prints, portrayed husbands fumbling with the groceries or spooking the children with bedtime tales, ham-handed servants chopping vegetables, and flirtatious maidens sassily engaging the viewer. *War Spirit at Home*, painted in 1866, shows the impact of the Civil War on family life. Cradling an infant on her lap, an anxious mother peruses a news report of a major Union victory, presumably one involving her absent husband, while her boisterous youngsters, oblivious to the human cost of war, parade around the parlor triumphantly blowing whistles and banging pots.

The New Englander Eastman Johnson (1824–1906) made his reputation before the Civil War with *Negro Life at the South* (fig. 52).[13] Known also as *Old Kentucky Home*, the painting sentimentally depicts an extended black family gathered in the ramshackle quarters of their master's plantation. Equally sentimental but more cognizant of the serious issues facing African Americans was Johnson's Civil War painting

Fig. 53 **Winslow Homer (1836–1910)**

***Prisoners from the Front,* 1866**

Oil on canvas, 24 × 38 in. (61 × 96.5 cm)

The Metropolitan Museum of Art, New York,

Gift of Mrs. Frank B. Porter, 1922 (22.207)

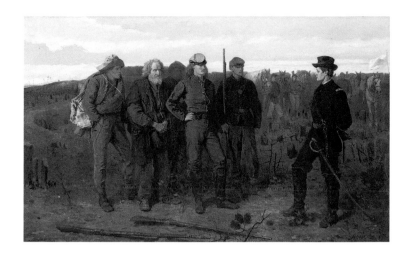

A Ride for Liberty—The Fugitive Slaves, which was based on an actual event that he witnessed (p. 126). Galloping on a horse through a foggy, moonlit countryside, three runaway slaves—father, mother, and child— seek refuge behind Union lines. As with Bingham's earlier *Emigration of Boone,* the painting alluded to the Flight into Egypt narrative beloved by readers of the New Testament and, in so doing, incites sympathy for its protagonists. Before the war, Johnson's northern audiences were reassured by his rendering of the sunnier side of southern slavery, but once the war was under way, such melodramatic images as *A Ride for Liberty* met their need for righteous indignation.

The most intellectually provocative genre painter of mid-century America, Winslow Homer (1836–1910), first gained attention as a Civil War artist.[14] After an apprenticeship as a lithographer in Boston, he found work as an illustrator for *Harper's Weekly* magazine. During the war, *Harper's* posted Homer to the Virginia front, and he sent back convincingly realistic sketches of camp life and battlefield skirmishes. While continuing to draw, he also produced a handful of unsentimental, non-heroic oil paintings of army life—enlisted men lingering over mail from home, a sharpshooter perched precariously in a tree, a rebel soldier defiantly inviting a shot from his distant adversaries. Some of these images, particularly the drawings intended for magazine consumption, played for cheap laughs by depicting black army teamsters, musicians, and cooks as gangly, wide-eyed, or lackadaisical children in adult bodies.

As Homer matured as an artist, he matured as an individual. His art became increasingly sympathetic, or at least intuitively understanding, toward those who found themselves on the losing side of history. His breakthrough painting, *Prisoners from the Front,* which won acclaim for him in New York after the war, shows a young Union officer accepting the surrender of three Confederate soldiers, each of whom conveys by body language his own particular response to adversity (fig. 53). In the mid-1870s, Homer returned to Virginia to paint scenes of African-American women toiling in the cotton fields or warily receiving a visit from their former mistress. These dejected field workers, like those defeated rebels he depicted earlier, exude quiet dignity.

War and race were not the only subjects touched on by Homer. During this period he portrayed promenaders at a fashionable resort, bathers at the beach, children in a one-room schoolhouse or at recess in the field, country girls heading to work in a mill, and woodsmen on a mountaintop. After 1880, his work grew increasingly dark and ominous as it explored the hostility or indifference of nature to humanity—and of humanity to nature—a theme that preoccupied such turn-of-the-century writers as Stephen Crane, Frank Norris, and Theodore Dreiser. With historical hindsight we can detect in his work of the 1860s and 1870s an emerging view of life as eternal conflict and struggle, even within otherwise sentimental sagas of pretty young women vying for the attention of an eligible male or of barefoot boys playing rough-and-tumble games in a grassy field outside the schoolhouse.

With Homer, American genre painting reached its culmination. Although artists continued to paint genre scenes for popular consumption, the form itself grew increasingly passé. As internationalism and its correlate ideology of art-for-art's-sake attracted the attention of sophisticated artists, viewers, and collectors, the rationale behind genre painting—art for the sake of amusement and edification—seemed to them woefully out of touch with the exigencies and opportunities of a new industrial age.

If Mount was the key figure in the foundation of American genre painting as a viable art form, his counterpart in landscape painting was Thomas Cole (1801–1848).[15] Born in an industrialized region of England, Cole emigrated to rural Ohio as a teenager, roamed the countryside as an itinerant portraitist, received formal art instruction in Philadelphia, and eventually settled in New York City. There he promptly won attention for a series of wildly romantic scenes painted from drawings he made on sketching expeditions in the Catskill Mountains. Nothing like these paintings had been seen in American art. They were dark, brooding, dramatic works, organized around swirling mists, impenetrable forests, crashing cascades, and what was to become Cole's signature motif, a blasted (lightning-struck) tree rising jaggedly from the foreground like a ghostly survivor of nature's wrath.

Fig. 54 Thomas Cole (1801–1848)

The Course of Empire: Destruction, c. 1836

Oil on canvas, 39¼ × 63¼ in. (99.7 × 160.7 cm)

Collection of the New-York Historical

Society, 1858.4

Fig. 55 Asher Brown Durand (1796–1886)

Kindred Spirits, 1849

Oil on canvas, 44 × 36 in. (111.8 × 91.4 cm)

Courtesy Walton Family Foundation

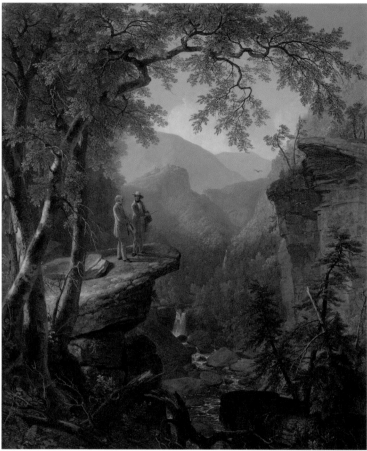

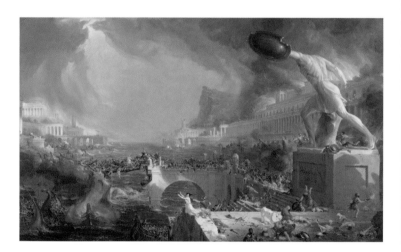

Fig. 56 Frederic Edwin Church (1826–1900)

The Andes of Ecuador, 1855

Oil on canvas, 48 × 75 in. (121.9 × 190.5 cm)

Reynolda House, Museum of American

Art, Winston-Salem, North Carolina

Original purchase fund from the Mary

Reynolds Babcock Foundation, Z. Smith

Reynolds Foundation, ARCA Foundation,

and Anne Cannon Forsyth

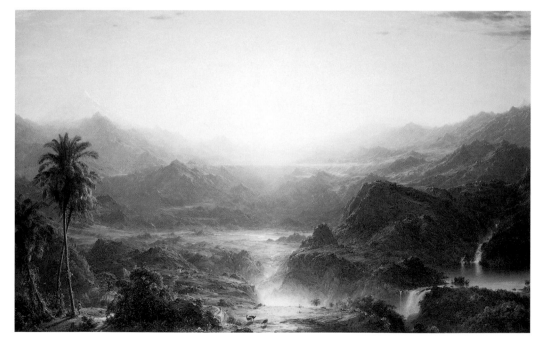

One of these early works, *Falls of Kaaterskill,* from 1826, offers a cross-section of a rugged geological formation in the Catskills. Beneath a narrow strip of dark and tumultuous sky, water spills over a cliff into a gaping hollow and re-emerges as a waterfall that pounds the rocks below. For Cole's contemporaries, this was a thrilling glimpse of primal nature, made all the more exciting by the appearance of a Native-American figure poised on a crag above the falls with a bow and arrow in hand. Little did it matter that the scene was pure invention. "Wild Indians" had been driven from the region decades earlier and Kaaterskill (also spelled Kauterskill) Clove, where the falls were located, was a popular tourist destination for visitors from downstate and was amply equipped with wooden staircases, guard railings, and an observation deck. What mattered instead was the sensation of awe that Cole's painting—like the double-tiered waterfall itself—inspired in them.

Drawing on biblical texts, such as the Expulsion from the Garden of Eden, and current adventure fiction, such as James Fenimore Cooper's *The Last of the Mohicans,* or on no sources at all beyond his imagination, Cole ably romanticized the mountainous landscape of the Hudson River Valley (leading a wag to refer to him and his followers as the Hudson River School, an appellation that has stuck; p. 109). In such works as these Cole provided his armchair admirers with a bounty of escapist vistas to ponder and enjoy. Later, after extensive travel and study in Italy, where he contemplated the meaning of Roman ruins, he produced a number of allegorical landscape paintings aimed at reforming his fellow Americans from what he believed was their perilous greed and materialism. Fearing that the United States would follow the same downward spiral as ancient Rome, he painted a five-part series, collectively entitled *The Course of Empire,* which showed a young nation emerging from the wilderness, enjoying arcadian bounty, achieving great commercial success, and finally, bloated, decadent, and torn by war, declining into oblivion (fig. 54).

When Cole died prematurely in 1848, his friend and fellow landscape artist Asher B. Durand (1796–1886) painted a loving memorial tribute, *Kindred Spirits* (fig. 55).[16] It pictures Cole, a sketch portfolio under his arm and a painter's stick in his hand, standing on a rock outcropping in the midst of Kaaterskill Clove while conversing with his companion, the "American Wordsworth," William Cullen Bryant. Durand has likened the two to priestly or pastoral figures mounted on nature's pulpit beneath a canopy of trees. With their shared love of untrammeled wilderness, the painter and the poet (and, by implication, the sympathetic viewer of the painting) are the kindred spirits invoked by the title.

The inherence of God in nature was a continual theme in Durand's work, both as an artist and as an art theorist. In such works as *Early Morning at Cold Spring* and *Reminiscence of the Catskill Clove,* he lavished attention on tranquil groves, mossy rocks, and intimate forest interiors, where light and shadow danced with one another or engaged in lively dialogue. In a series of essay-length letters that he published in the mid-1850s in *The Crayon,* a magazine devoted to the aesthetic ideals of the contemporary English art critic and moralist John Ruskin, Durand urged younger artists to seek the divine in the quiet and inconspicuous domains of nature.

Cole's student and successor, Frederic Edwin Church (1826–1900), did not abide by this advice.[17] A dazzling painter and audacious voyager, he set out to explore the most remote and spectacular scenery he could find. In 1853 he joined a scientific expedition to the Andes Mountains in Colombia and Ecuador and returned to New York months later armed with an array of detailed sketches, which he used as the basis for a series of panoramic landscape paintings, the most majestic of which was *The Andes of Ecuador* (fig. 56). Viewers were overwhelmed by this picture of the sun burning through the atmosphere above an infinitely variegated mountain realm. Durand quietly called attention to the presence of God in the tranquility of a forest glade, but Church trumpeted the glory of Creation with what seemed to his contemporaries the visual equivalent of the "Hallelujah Chorus." As one viewer noted, "Seldom has a more grand effect of light been depicted . . . it literally floods the canvas with celestial fire, and beams with glory like a sublime psalm of light." Another awestruck viewer said that the painting transported him to those distant mountain peaks and "billowy flood of hills" where "from the

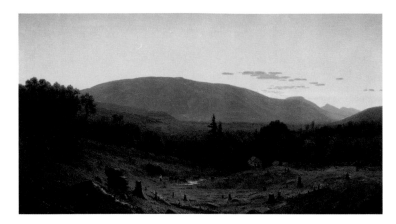

Fig. 57 **Sanford Robinson Gifford (1823–1880)**

Hunter Mountain, Twilight, 1866

Oil on canvas, 30⅝ × 54⅛ in. (77.8 × 137.5 cm)

Terra Foundation for American Art, Chicago

Daniel J. Terra Collection, 1999.57

rifted heavens the southern sunshine pours, like God's benediction upon my temples."[18]

In 1857, Church again astonished the public with the spectacle of divine creation, this time with his enormous rendition of a natural phenomenon closer to home, Niagara Falls, as seen from the Canadian side (pp. 120–21). Thousands of viewers lined up to experience at close range this surging, almost dizzying painting, which went on tour as one of the great blockbusters of the pre-cinema era. In the years leading up to the Civil War and then during the war itself, Church's extraordinary panoramas reassured viewers that the cataclysms and paroxysms of mankind were but hiccups in comparison to the power wielded by the Master of heaven and earth (fig. 46). After the war Church portrayed Niagara Falls once more, now from the American side and in a vertical rather than horizontal format. Part of the excitement of seeing the painting comes when the viewer discovers a small bearded tourist peering over a wooden platform built high into the side of a cliff, his size almost minuscule in comparison to the immensity of the falls.

Church's main rival in the production of hyperbolic mountain land-scapes was Albert Bierstadt (1830–1902), a German-trained American artist who specialized in views of the mountain ranges of the West.[19] In such works as *Rocky Mountains, "Lander's Peak"* and *Sierra Nevada* (pp. 132–33), he envisioned a pristine wilderness that seemed at once realistic and magical. Eighteenth-century English aesthetic theorists had observed that some landscapes please viewers by appearing peaceful, orderly, and harmonious, while others do so by seeming wild, savage, and terrifying. They called the first type of landscape beautiful and the other sublime. Bierstadt's best work combines the beautiful and the sublime. Vertiginous mountain peaks and jagged escarpments, theatri-cally lit by light flaring from the sky, are pocketed with green pastures. Roaring cascades, descending from great heights, feed calm mountain lakes at which a herd of elk or a tribe of Indians peacefully gather (fig. 97). City-bound easterners lavishly praised these paintings, which, in the days before transcontinental railroad travel, made the remote and dangerous West easily and safely accessible to them in imagination.

After Church and Bierstadt, the most acclaimed landscape painter

in Victorian America was Sanford Gifford (1823–1880).[20] He too specialized in mountain settings, but he was less interested in heroic grandeur than in the effects of light bathing the topography. His stunning 1862 take on Kauterskill Clove, a setting familiar from earlier masterpieces by Cole and Durand, transforms it into an empyrean realm of celestial gold. A haunting later work, *Hunter Mountain, Twilight* (fig. 57), shows a rugged Catskills summit softened by dusk and delicately poised between a still-luminous, pastel-tinted sky and a gloomy valley in the foreground, where boulders, tree stumps, grazing cattle, and a lonely farmhouse indicate man's inevitable encroachment on nature's paradise.

Like Bierstadt, Thomas Moran (1837–1926) made a career for himself painting the exotic West for eastern consumption.[21] And like Gifford, he devoutly admired the English landscape painter J.M.W. Turner, on whose technique he modeled his own. Turner's oil paintings melded light and color into evanescent atmospheric effects, transforming the intractable material substances of the world, such as mountains and seas, into ethereal, vaporous entities. The critic William Hazlitt had complained in 1816 that Turner's paintings were "representations not properly of the objects of Nature as of the medium through which they were seen," but to Moran, two generations later, this was all to his hero's credit. In 1871, accompanying a scientific and map-making expedition to Yellowstone, he completed a set of watercolors depicting strange natural phenomena perfectly suited to the Turner-inspired style that he employed: hot springs, geysers, and waterfalls. These vivid, eye-catching paintings were brought to the attention of members of Congress when they debated appropriating funds to set aside for America's first national park, and persuaded them to decide on Yellowstone as the place.

While on that initial expedition to Yellowstone and during subsequent voyages to the West, Moran passed through the Green River valley in Wyoming. Over the next three decades he often turned to that particular landscape as a preferred subject, editing out the railroad and busy little town that had arisen in the meantime so as to leave the valley's multicolored buttes majestically alone in their magnificence.

EXPANSION and FRAGMENTATION

19. Nancy K. Anderson and Linda S. Ferber, *Albert Bierstadt: Art & Enterprise,* exhib. cat. (New York: Brooklyn Museum of Art, 1990); Matthew Baigell, *Albert Bierstadt* (New York: Watson-Guptill, 1981); and Gordon Hendricks, *Albert Bierstadt: Painter of the American West* (New York: Harry N. Abrams, 1974).

20. Kevin J. Avery and Franklin Kelly, eds., *Hudson River School Visions: The Landscapes of Sanford R. Gifford,* exhib. cat. (New York: Metropolitan Museum of Art, 2003); and Ila Weiss, *Poetic Landscape: The Art and Experience of Sanford R. Gifford* (Newark, NJ: University of Delaware Press, 1987).

21. Nancy K. Anderson *et al., Thomas Moran,* exhib. cat. (Washington, D.C.: National Gallery of Art, 1997); and Thurman Wilkins, with the help of Caroline Lawson Hinckley, *Thomas Moran: Artist of the Mountains,* 2nd ed., rev. (Norman, Okla.: University of Oklahoma Press, 1998).

22. On Deas, see Carol Clark, "Charles Deas," *American Frontier Life: Early Western Painting and Prints,* exhib. cat. (Fort Worth, Tex.: Amon Carter Museum, 1987), pp. 57–77; and Dawn Glanz, *How the West Was Drawn: American Art and the Settling of the Frontier* (Ann Arbor, Mich.: UMI Research Press, 1982), pp. 44–50. On Remington, see Nancy K. Anderson, with contributions by William C. Sharpe and Alexander Nemerov, *Frederick Remington: The Color of Night,* exhib. cat. (Washington, D.C.: National Gallery of Art, 2003); and Alexander Nemerov, *Frederick Remington and Turn-of-the-Century America* (New Haven, Conn.: Yale University Press, 1995). On the West in American art, see also *Discovered Lands, Invented Pasts: Transforming Visions of the American West,* exhib. cat. (New Haven, Conn.: Yale University Art Gallery, 1992); and William H. Truettner, ed., *The West as America: Reinterpreting Images of the Frontier,* exhib. cat. (Washington, D.C.: National Museum of American Art, 1991).

23. On nineteenth-century American land-scape painting, see *American Paradise: The World of the Hudson River School,* exhib. cat. (New York: Metropolitan Museum of Art, 1987); Barbara Novak, *Nature and Culture: American Landscape and Painting, 1825–1875,* rev. ed. (New York: Oxford University Press, 1995); Miller, *Empire of the Eye,* John Wilmerding *et al., American Light: The Luminist Movement, 1850–1875,* exhib. cat. (Washington, D.C.: National Gallery of Art, 1980); and Andrew Wilton and Tim Barringer, *American Sublime: Landscape Painting in the United States, 1820–1880,* exhib. cat. (London: Tate Britain, 2002).

Notes

1. Neil Harris, *The Artist in American Society: The Formative Years, 1790–1860* (New York: George Braziller, 1966); and Rachel N. Klein, "Art and Authority in Antebellum New York City: The Rise and Fall of the American Art-Union," *Journal of American History,* vol. 81, no. 4 (March 1995), pp. 1534–61.

2. Robert W. Torchia, *John Neagle: Philadelphia Portrait Painter*, exhib. cat. (Philadelphia: Historical Society of Pennsylvania, 1989).

3. Stacy C. Hollander *et al.*, *Revisiting Ammi Phillips: Fifty Years of American Portraiture*, exhib. cat. (New York: Museum of American Folk Art, 1994).

4. See Elizabeth Johns, *American Genre Painting: The Politics of Everyday Life* (New Haven, Conn.: Yale University Press, 1991); also Patricia Hills, *The Painters' America: Rural and Urban Life, 1810–1910*, exhib. cat. (New York: Whitney Museum of American Art, 1974).

5. Alfred Frankenstein, *William Sidney Mount* (New York: Harry N. Abrams, 1974).

6. For other interpretations of this painting, see Albert Boime, *The Art of Exclusion: Representing Blacks in the Nineteenth Century* (Washington, D.C.: Smithsonian Institution Press, 1990), pp. 95–98; Hugh Honour, *The Image of the Black in Western Art*, vol. 4, part 2 (Cambridge, Mass.: Harvard University Press, 1989), pp. 69–70; and Johns, pp. 118–19. More generally on Mount's depiction of African Americans, see Karen C. Adams, "The Black Image in the Paintings of William Sidney Mount," *American Art Journal*, vol. 11, no. 2 (November 1975), pp. 42–59; and Bruce Robertson, "The Power of Music: A Painting by William Sidney Mount," Bulletin of the

Cleveland Museum of Art, vol. 79 (February 1992), pp. 38–62. For a survey of nineteenth-century representations of blacks in American art and popular visual culture, see Guy C. McElroy, with an essay by Henry Louis Gates, Jr., *Facing History: The Black Image in American Art, 1710–1940*, exhib. cat. (San Francisco and Washington, D.C.: Bedford Arts, in association with the Corcoran Gallery of Art, 1990).

7. See Elizabeth Johns, "Settlement and Development: Claiming the West," in William H. Truettner, ed., *The West as America: Reinterpreting Images of the Frontier, 1820–1920*, exhib. cat. (Washington, D.C.: National Museum of American Art, 1991), pp. 218–20.

8. On Bingham, see Nancy Rash, *The Paintings and Politics of George Caleb Bingham* (New Haven, Conn.: Yale University Press, 1991) and Michael Edward Shapiro *et al.*, *George Caleb Bingham*, exhib. cat. (St. Louis: St. Louis Museum of Art, 1990).

9. David M. Lubin, "Bingham's Boone," in *Picturing a Nation: Art and Social Change in Nineteenth-Century America* (New Haven, Conn.: Yale University Press, 1994), pp. 54–105; and J. Gray Sweeney, *The Columbus of the Woods: Daniel Boone and the Typology of Manifest Destiny*, exhib. cat. (St. Louis: Washington University Gallery of Art, 1992).

10. Justin P. Wolff, *Richard Caton Woodville: American Painter, Artful Dodger* (Princeton, NJ: Princeton University Press, 2002).

11. Bruce W. Chambers, *The World of David Gilmour Blythe (1815–1865)*, exhib. cat. (Washington, D.C.: National Collection of Fine Arts, 1981).

12. See Johns, *American Genre Painting*, pp. 160–175; Helen S. Langa, "Lilly Martin

Spencer: Genre, Aesthetics, and Gender in the Work of a Mid-Nineteenth Century Woman Artist," *Athanor 9* (1990), pp. 37–41; Lubin, "Lilly Martin Spencer's Domestic Genre Painting in Antebellum America," in *Picturing a Nation*, pp. 158–203; April F. Masten, "*Shake Hands?* Lilly Martin Spencer and the Politics of Art," *American Quarterly*, vol. 56, no. 2 (2004), pp. 348–94; and Jochen Wierich, "War Spirit at Home: Lilly Martin Spencer, Domestic Painting, and Artistic Hierarchy," *Winterthur Portfolio*, vol. 37, no. 1 (Spring 2002), pp. 23–42.

13. On Johnson, see Teresa A. Carbone and Patricia Hills, *Eastman Johnson: Painting America*, exhib. cat. (New York: Brooklyn Museum, 1999); and Patricia Hills, *Eastman Johnson*, exhib. cat. (New York: Whitney Museum of American Art, 1972). Specifically on *Negro Life at the South*, see John Davis, "Eastman Johnson's *Negro Life at the South* and Urban Slavery in Washington, D.C.," *Art Bulletin*, vol. 80, no. 1 (March 1998), pp. 67–92.

14. For a sampling of the voluminous recent scholarship on Homer, see Nicolai Cikovsky, Jr., and Franklin Kelly, *Winslow Homer*, exhib. cat. (Washington, D.C.: National Gallery of Art, 1995); Margaret C. Conrads, *Winslow Homer and the Critics: Forging a National Art in the 1870s*, exhib. cat. (Kansas City, Mo.: Nelson-Atkins Museum of Art, 2001); Elizabeth Johns, *Winslow Homer: The Nature of Observation* (Berkeley, Calif.: University of California Press, 2002); Bruce Robertson, *Reckoning with Homer: His Late Paintings and Their Influence*, exhib. cat. (Cleveland: Cleveland Museum of Art, 1990); Marc Simpson, *Winslow Homer: Paintings of the Civil War*, exhib. cat. (San Francisco: Fine Arts Museums of San Francisco, 1988); Peter H. Wood and Karen C.C. Dalton, *Winslow*

Homer's Images of Blacks: The Civil War and Reconstruction Years, exhib. cat. (Houston, Tex.: Menil Collection and University of Texas Press, 1988); and Wood, *Weathering the Storm: Inside Winslow Homer's "Gulf Stream"* (Athens, Ga.: University of Georgia Press, 2004).

15. William H. Truettner and Alan Wallach, eds., *Thomas Cole: Landscape into History*, exhib. cat. (Washington, D.C.: National Museum of American Art, 1994).

16. H. Daniel Peck, "Unlikely Kindred Spirits: A New Vision of Landscape in the Works of Henry David Thoreau and Asher B. Durand," *American Literary History*, vol. 17, no. 4 (Winter 2005), pp. 687–713. See also discussion of Durand throughout Angela Miller, *The Empire of the Eye: Landscape Representation and American Cultural Politics, 1825–1875* (Ithaca, NY: Cornell University Press, 1993).

17. Gerald L. Carr, *In Search of the Promised Land: Paintings by Frederic Edwin Church*, exhib. cat. (New York: Berry-Hill Galleries, 2000); John K. Howat, *Frederic Edwin Church, 1826–1900* (New Haven, Conn.: Yale University Press, 2005); David C. Huntington, *Landscapes of Frederic Edwin Church: Vision of an American Era* (New York: George Braziller, 1966); Franklin Kelly, *Frederic Edwin Church and the National Landscape* (Washington, D.C.: Smithsonian Institution Press, 1988); and Kelly, *Frederic Edwin Church*, exhib. cat. (Washington, D.C.: National Gallery of Art, 1989).

18. [Henry T. Tuckerman] "An Old Contributor", "New-York Artists," *The Knickerbocker* 48 (July 1856), p. 33; and "Pictures Canvassed," *Harper's Weekly*, 30 May 1857, p. 339; both as quoted in Kelly, *Frederic Edwin Church* (1989), p. 50.

Fig. 58 **Francis A. Silva (1835–1886)**

***On the Hudson Near Haverstraw*, 1872**

Oil on canvas, 18¼ × 30⅜ in. (46.4 × 77.2 cm)

Terra Foundation for American Art, Chicago

Daniel J. Terra Collection, 1993.16

Bierstadt and Moran were not the only artists to showcase the West. Such figure painters as the 1840s frontier artist Charles Deas (1818–1867), who portrayed gruff mountain men locked in mortal combat with Indians (fig. 60), and the 1890s magazine illustrator and sculptor Frederic S. Remington (1861–1909), who specialized in heroic images of cowboys, cavalrymen, and trail riders, did much to create the myths of the West that in the twentieth century readily found their way on to movie and television screens around the world (p. 135).[22]

Landscape painting followed a trajectory similar to that of genre painting in the decades before and after the Civil War.[23] It too burst on the scene around 1830, as the nation was undergoing a major economic and geographic growth spurt, occasioned by the initial phases of railroad travel and the opening of the Erie Canal. As genre painting during that same period told Americans pleasant or humorous things about themselves and their neighbors, landscape painting reassured them of the greatness of their nation and the omnipotence of the God who bountifully provided them with such an incommensurably ravishing land. As did genre painting, landscape painting reached its apotheosis during and shortly after the Civil War. By 1880 it too was largely spent as a revitalizing imaginative force.

Like genre painting, it no longer caught the pulse of the times. The continental borders of the United States were settled by 1890 and the frontier pronounced closed. After that date the country continued to expand both internally, especially in its ever-burgeoning cities, and externally, as a result of island territories wrested from Spain. But in the brave (or, as critics would charge, ignoble) new world that confronted Americans, genre painting and landscape painting alike lost their relevance. Artists were forced to find other means by which their imaginations could keep pace—or make peace—with the sober and challenging realities facing the nation.

Thomas Cole (1801–1848)

Landscape with Figures: A Scene from

"The Last of the Mohicans", 1826

Oil on panel, 26⅛ × 43 in. (66.4 × 109.4 cm)

Terra Foundation for American Art, Chicago

Daniel J. Terra Collection, 1993.2

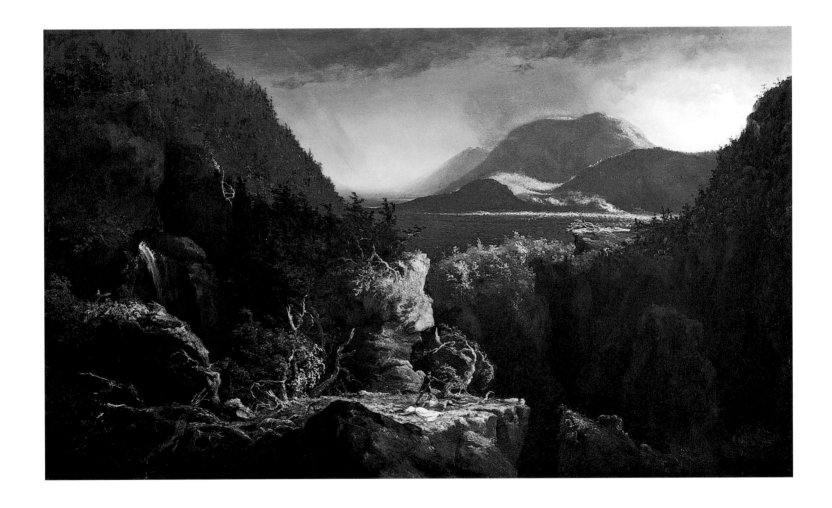

George Catlin (1796–1872)
The White Cloud, Head Chief of the Iowas,
1844–45
Oil on canvas, 28 × 22⅞ in. (71.1 × 58.1 cm)
National Gallery of Art, Washington, D.C.
Paul Mellon Collection, 1965.16.347

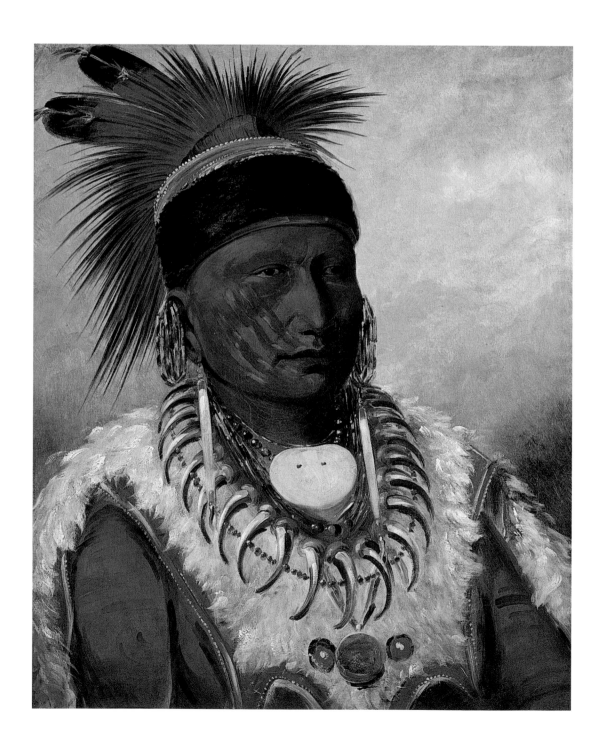

Henry Inman (1801–1846)

Yoholo-Micco, 1832–33

Oil on canvas, 30⅜ × 25⅜ in. (77.2 × 64.5 cm)

High Museum of Art, Atlanta

Anonymous Gift, 1984.176

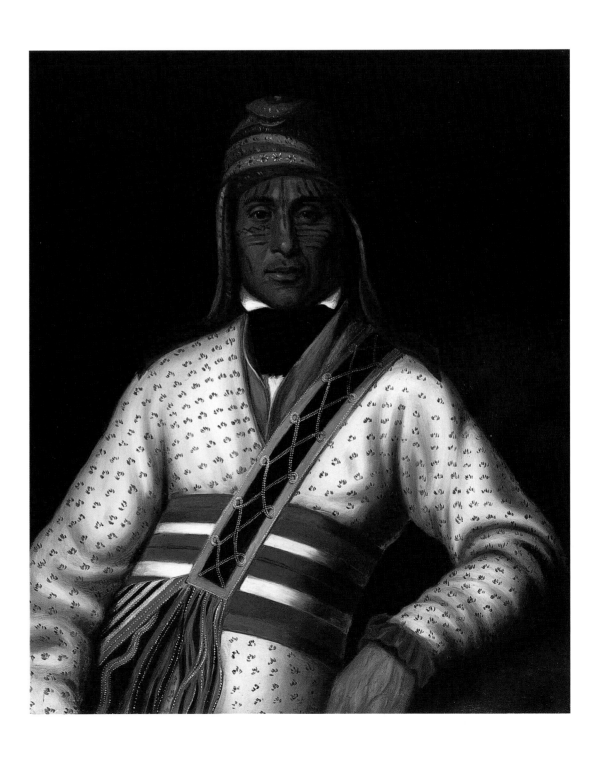

Edward Hicks (1780–1849)

A Peaceable Kingdom with Quakers

Bearing Banners, 1829/30

Oil on canvas, 17⅝ × 23⅝ in. (44.8 × 60 cm)

Terra Foundation for American Art, Chicago

Daniel J. Terra Collection, 1993.7

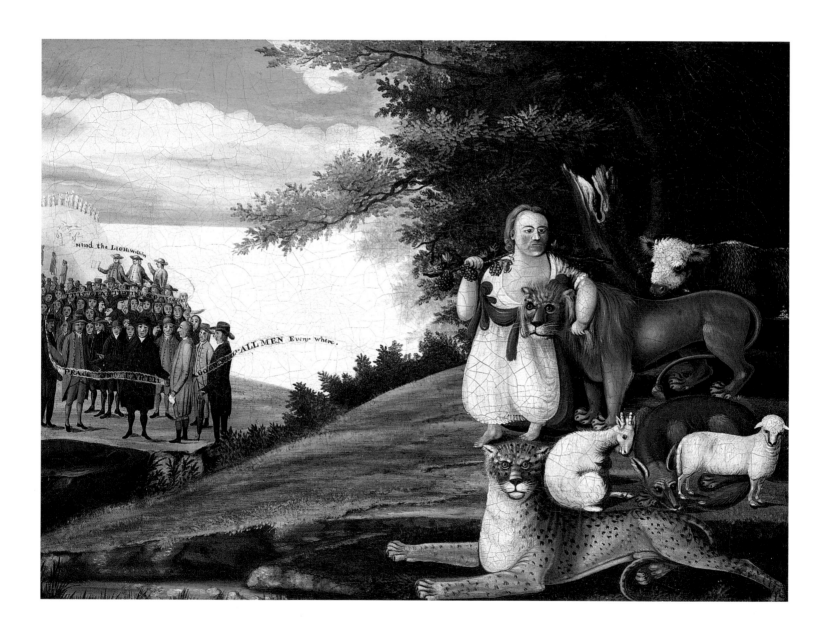

Expansion and Fragmentation

Ammi Phillips (1788–1865)

Girl in a Red Dress, c. 1835

Oil on canvas, 32⅜ × 27⅜ in. (82.2 × 69.5 cm)

Terra Foundation for American Art, Chicago

Daniel J. Terra Collection, 1992.57

William Matthew Prior (1806–1873)

and Sturtevant J. Hamblen (1817–1884)

Young Boy Holding a Bow and Arrow with

a Drum on the Floor, by 1856

Oil on canvas, 41¼ × 34¾ in. (104.8 × 88.3 cm)

Terra Foundation for American Art, Chicago

Daniel J. Terra Collection, 1992.123

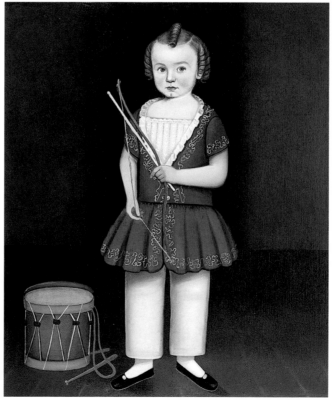

William Sidney Mount (1807–1868)

Eel Spearing at Setauket, 1845

Oil on canvas, 28¹/₂ × 36 in. (72.4 × 91.4 cm)

New York State Historical Association,

Fenimore Art Museum, Cooperstown,

New York, Gift of Stephen C. Clark

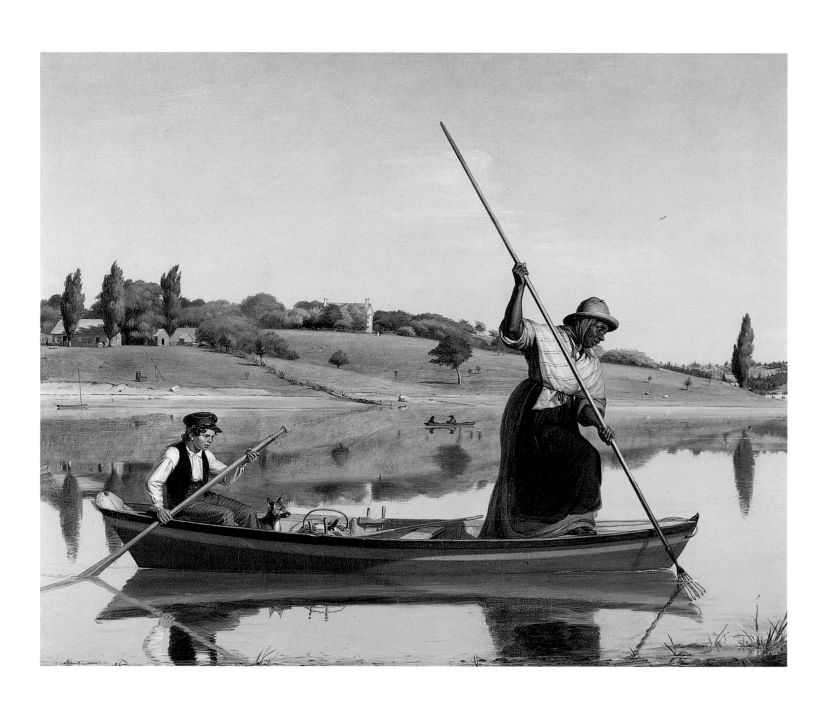

Christian Mayr (*c.* 1805–1851)

Reading the News, 1844

Oil on canvas, 30¾ × 26½ in. (78.1 × 67.3 cm)

National Academy Museum, New York

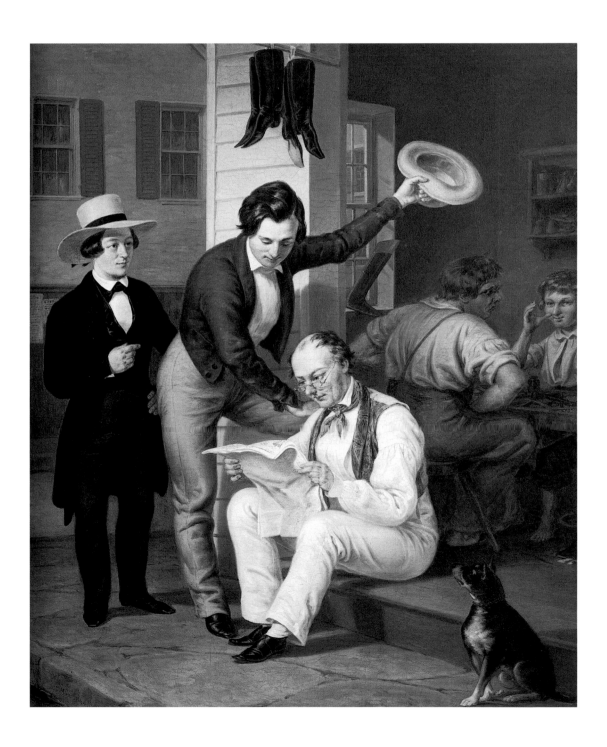

William Stanley Haseltine (1835–1900)

Rocks at Nahant, 1864

Oil on canvas, 22⅜ × 40½ in. (56.8 × 102.9 cm)

Terra Foundation for American Art, Chicago

Daniel J. Terra Collection, 1999.65

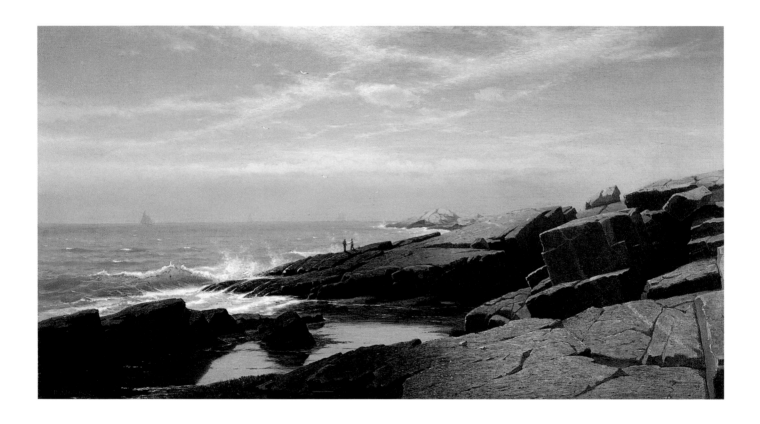

Expansion and Fragmentation

Martin Johnson Heade (1819–1904)

Newburyport Marshes: Approaching Storm,
c. 1871

Oil on canvas, 15¼ × 30⅛ in. (38.7 × 76.5 cm)

Terra Foundation for American Art, Chicago

Daniel J. Terra Collection, 1999.68

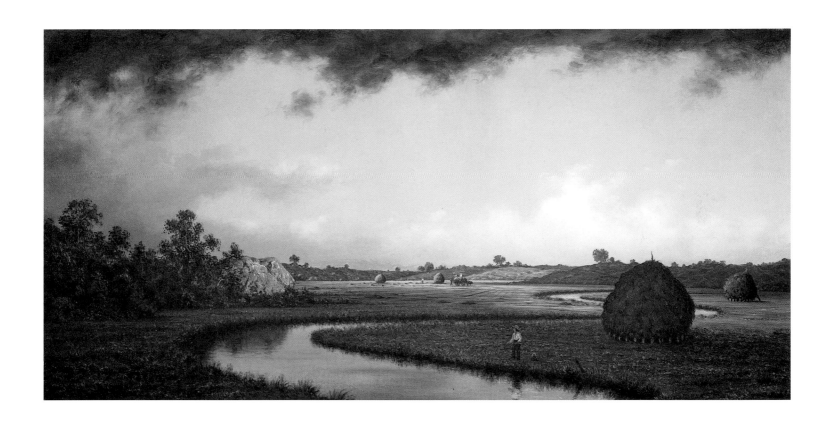

Asher B. Durand (1796–1886)

A Symbol, 1856

Oil on canvas, 39⅜ × 59⅜ in. (100 × 150.8 cm)

Hunter Museum of American Art,

Chattanooga, Tennessee, Museum purchase

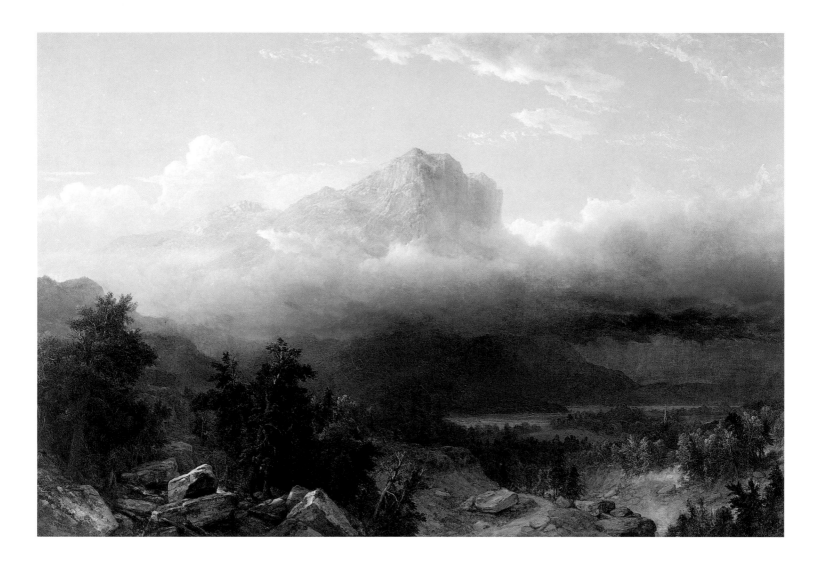

Expansion and Fragmentation

Frederic Edwin Church (1826–1900)

Twilight in the Wilderness, 1860

Oil on canvas, 40 × 64 in. (101.6 × 162.6 cm)

Cleveland Museum of Art, Mr. and Mrs.

William H. Marlatt Fund, 1965.233

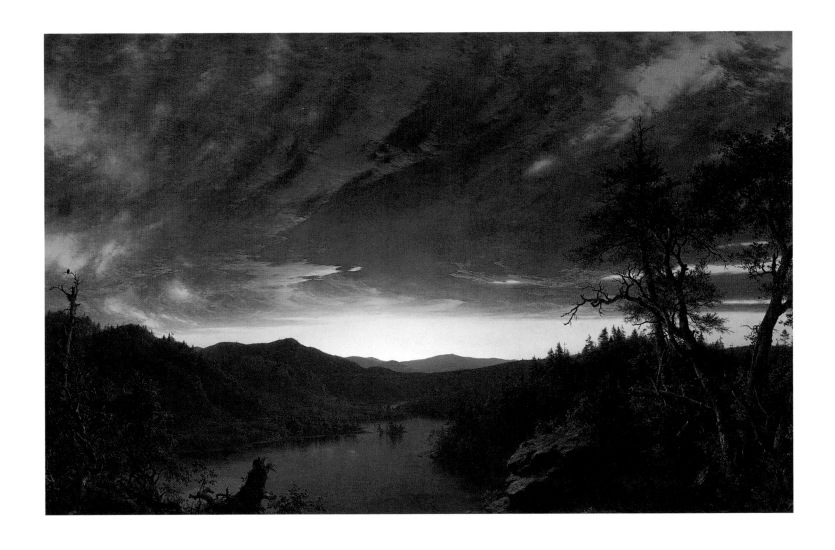

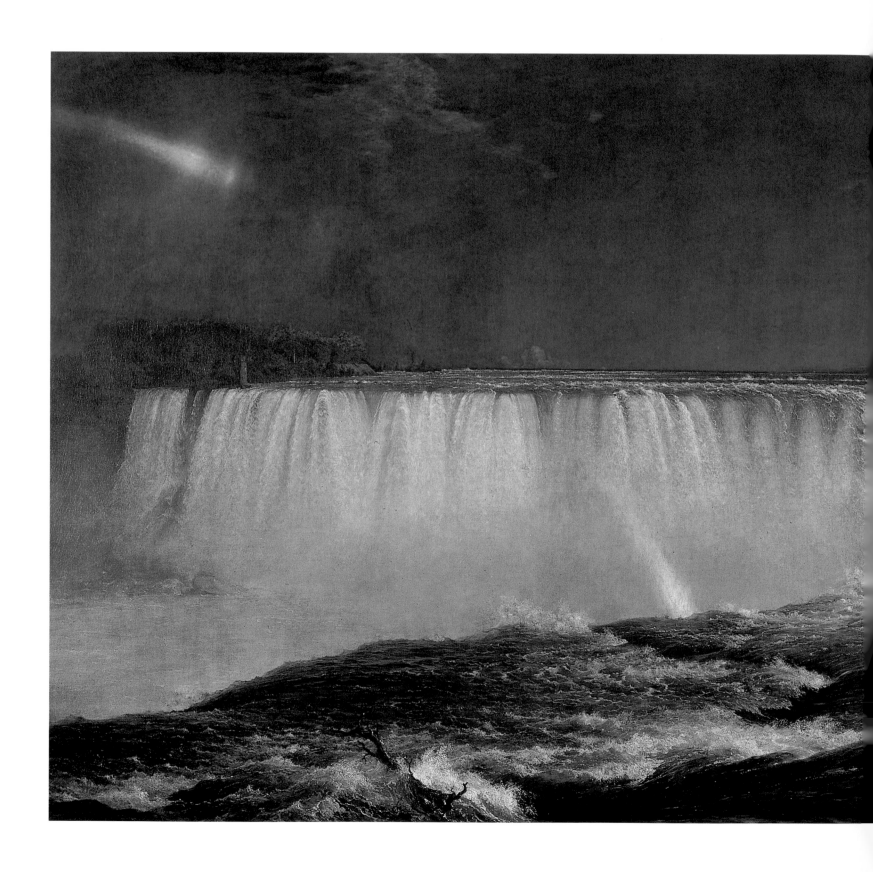

George Caleb Bingham (1811–1879)

The Verdict of the People, 1854–55

Oil on canvas, 46 × 55 in. (116.8 × 139.7 cm)

Saint Louis Art Museum, Gift of Bank

of America, 45.2001

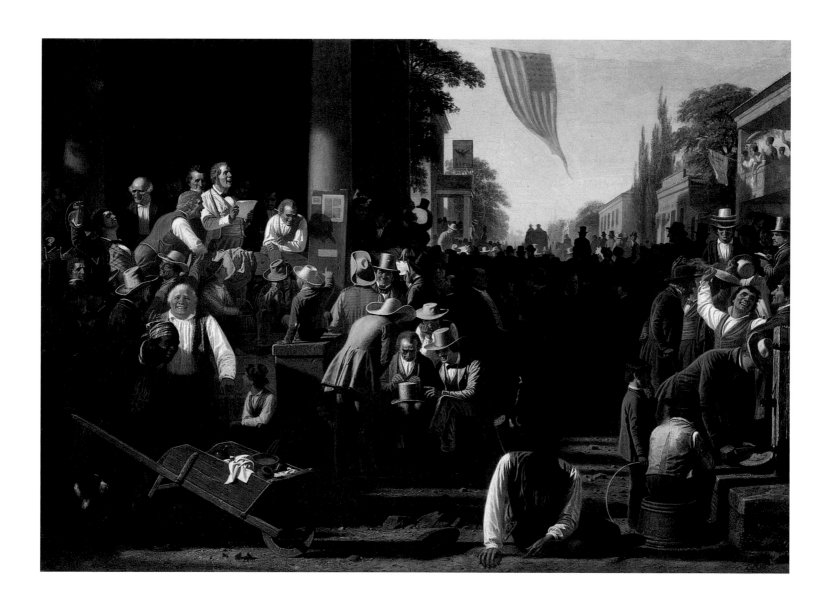

Expansion and Fragmentation

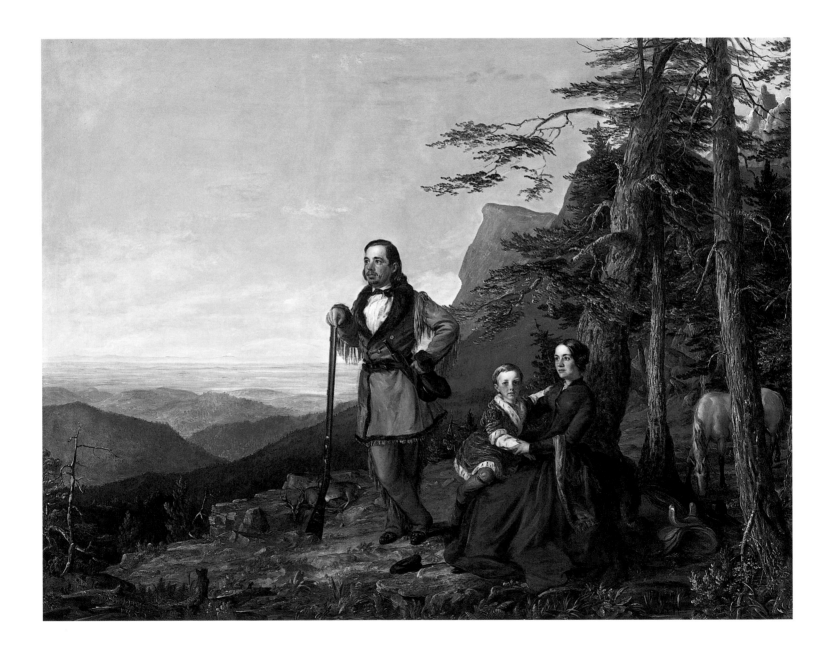

Alfred Jacob Miller (1810–1874)

The Trapper's Bride, 1845

Oil on canvas, 36 × 28 in. (91.4 × 71.1 cm)

Eiteljorg Museum of American Indians

and Western Art, Indianapolis

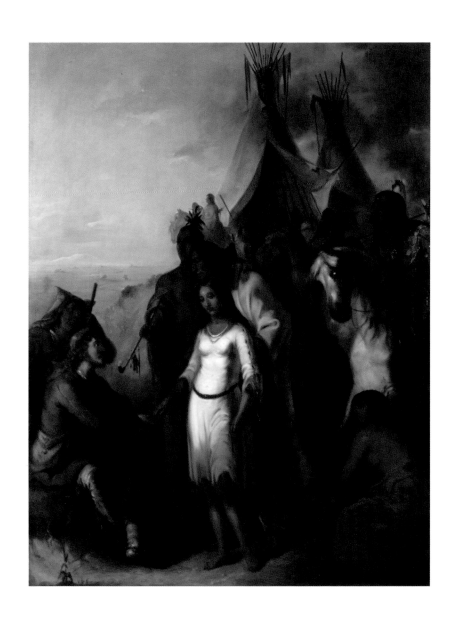

Expansion and Fragmentation

Frederic Edwin Church (1826–1900)

Niagara, 1857

Oil on canvas, 42⅛ × 90½ in. (108 × 230 cm)

Corcoran Gallery of Art, Washington, D.C.

Museum Purchase, Gallery Fund, 76.15

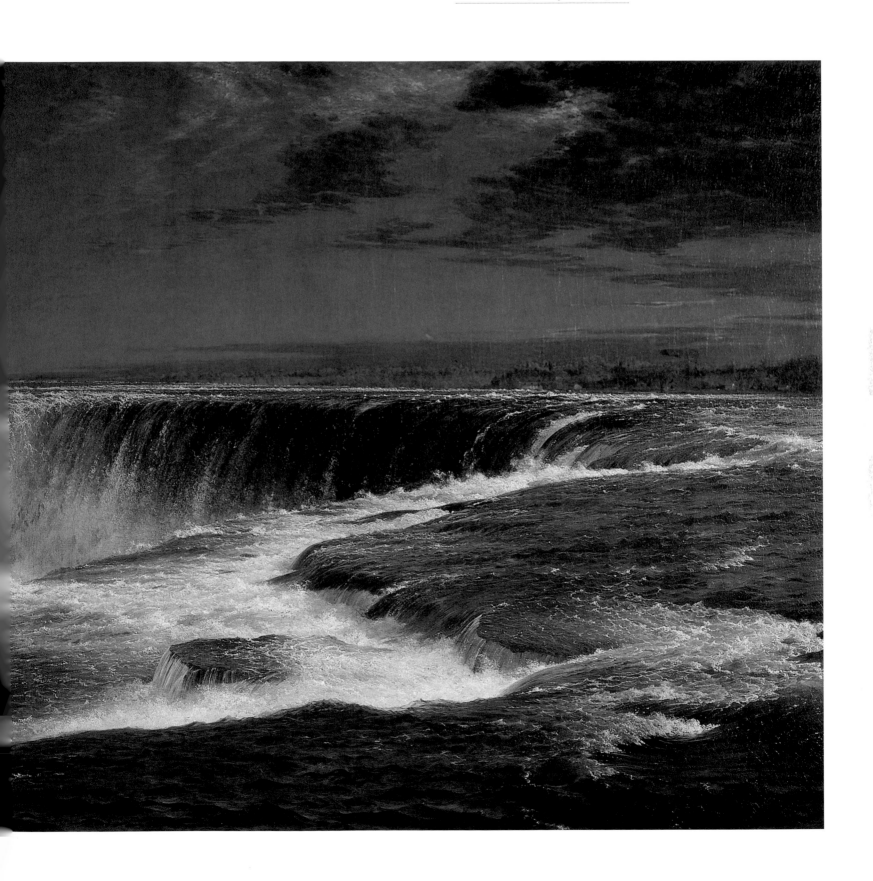

George Caleb Bingham (1811–1879)

Daniel Boone Escorting Settlers through

the Cumberland Gap, 1851–52

Oil on canvas, 36¼ × 50¼ in. (92.7 × 127.6 cm)

Washington University, Mildred Lane

Kemper Art Museum, St. Louis, Gift of

Nathaniel Phillips, 1890, WU 2171

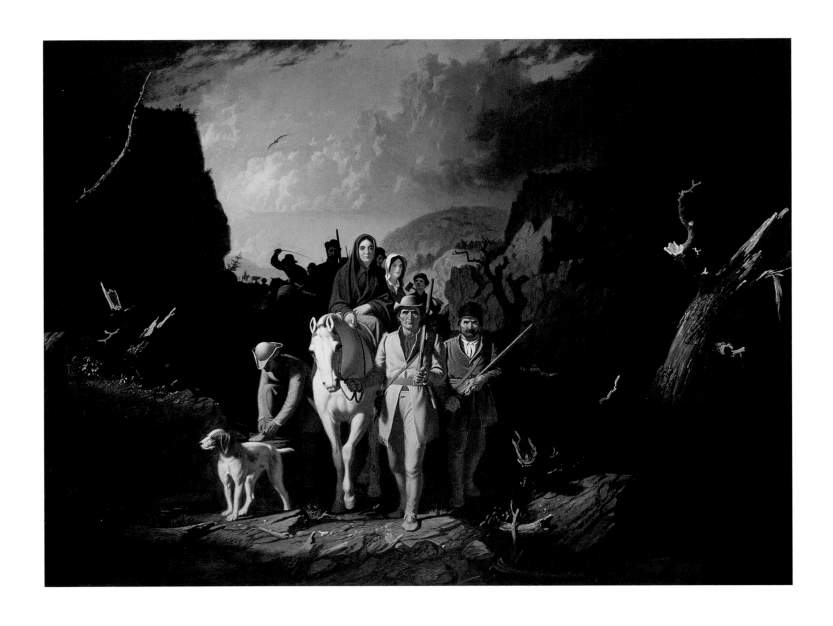

Eastman Johnson (1824–1906)

A Ride for Liberty—The Fugitive Slaves,
March 2, 1862, c. 1862

Oil on board, 21¼ × 26 in. (54.6 × 66 cm)

Virginia Museum of Fine Arts, Richmond

The Paul Mellon Collection, 85.644

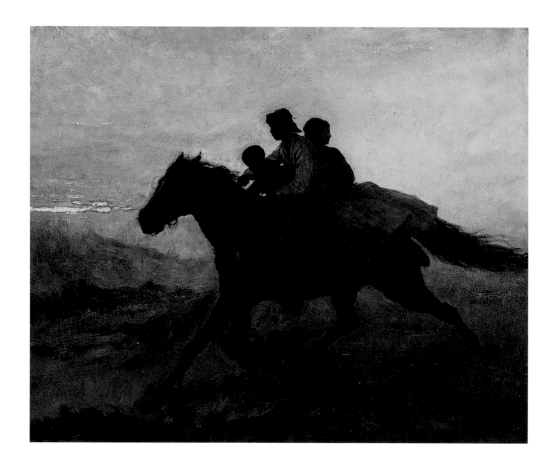

Dennis Malone Carter (1820–1881)

Lincoln's Drive Through Richmond, 1866

Oil on canvas, 45 × 68 in. (114.3 × 172.7 cm)

Chicago History Museum, Gift of Mr. Philip

K. Wrigley, 1955.398

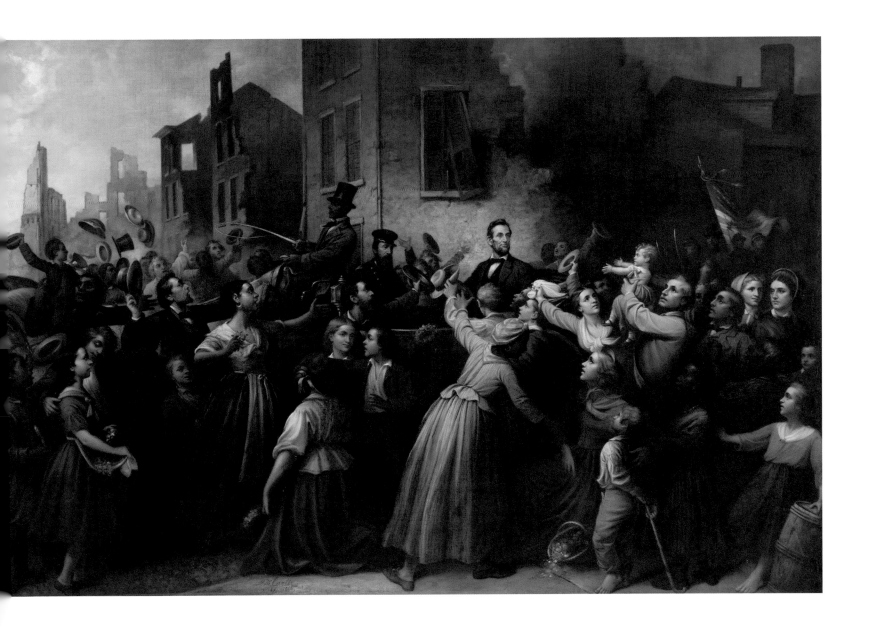

John Weir (1841–1926)

The Gun Foundry, 1866

Oil on canvas, 47 × 62 in. (119.4 × 157.5 cm)

Putnam County Historical Society and Foundry

School Museum, Cold Spring, New York

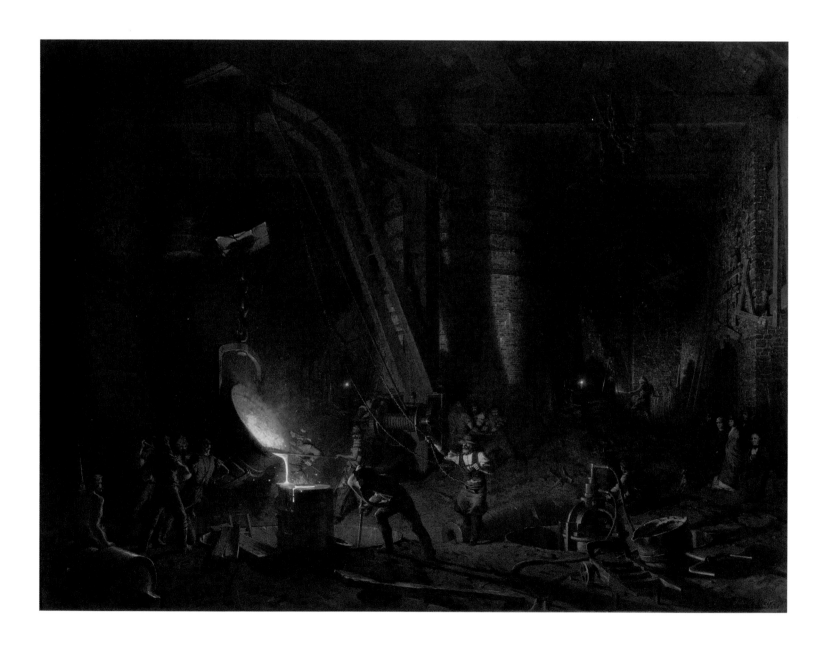

Winslow Homer (1836–1910)

Home, Sweet Home, c. 1863

Oil on canvas, 21½ × 16½ in. (54.6 × 41.9 cm)

National Gallery of Art, Washington, D.C.

Patrons' Permanent Fund, 1997.72.1

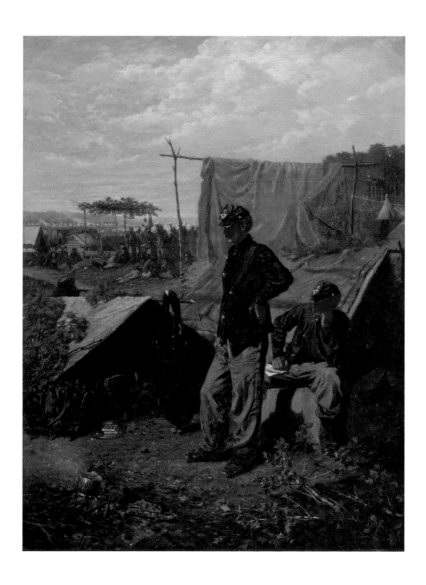

George Caleb Bingham (1811–1879)

Raftsmen Playing Cards, 1847

Oil on canvas, 28 × 38⅛ in. (71.1 × 96.8 cm)

Saint Louis Art Museum, Bequest of

Ezra H. Linley by exchange

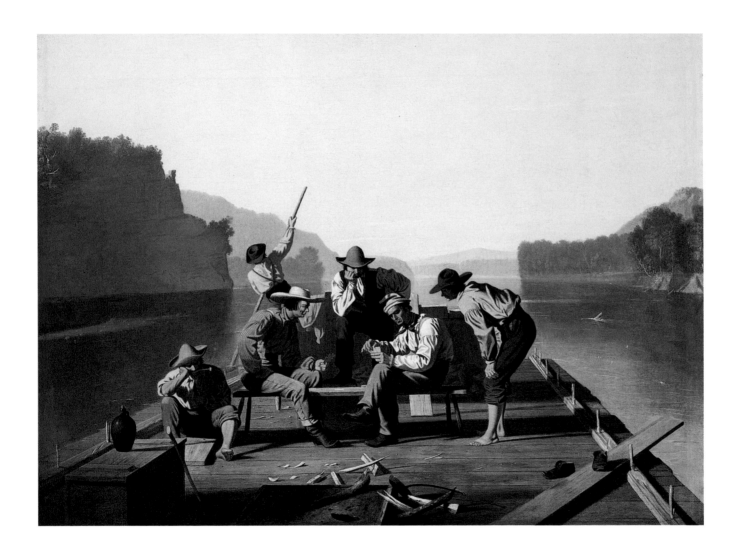

Winslow Homer (1836–1910)

Snap the Whip, 1872

Oil on canvas, 22 × 36 in. (55.9 × 91.4 cm)

Butler Institute of American Art, Youngstown,

Ohio, Museum purchase 919-0-108

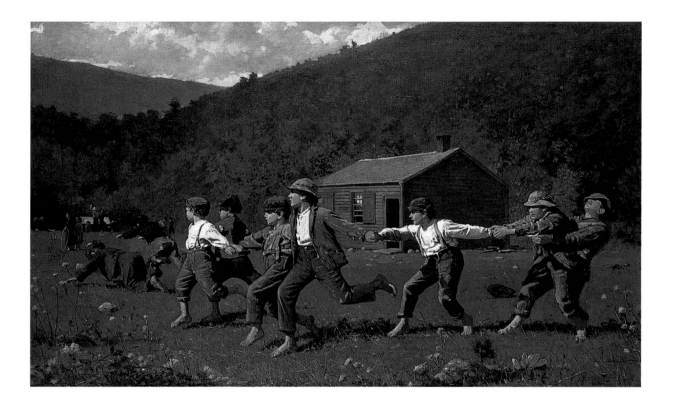

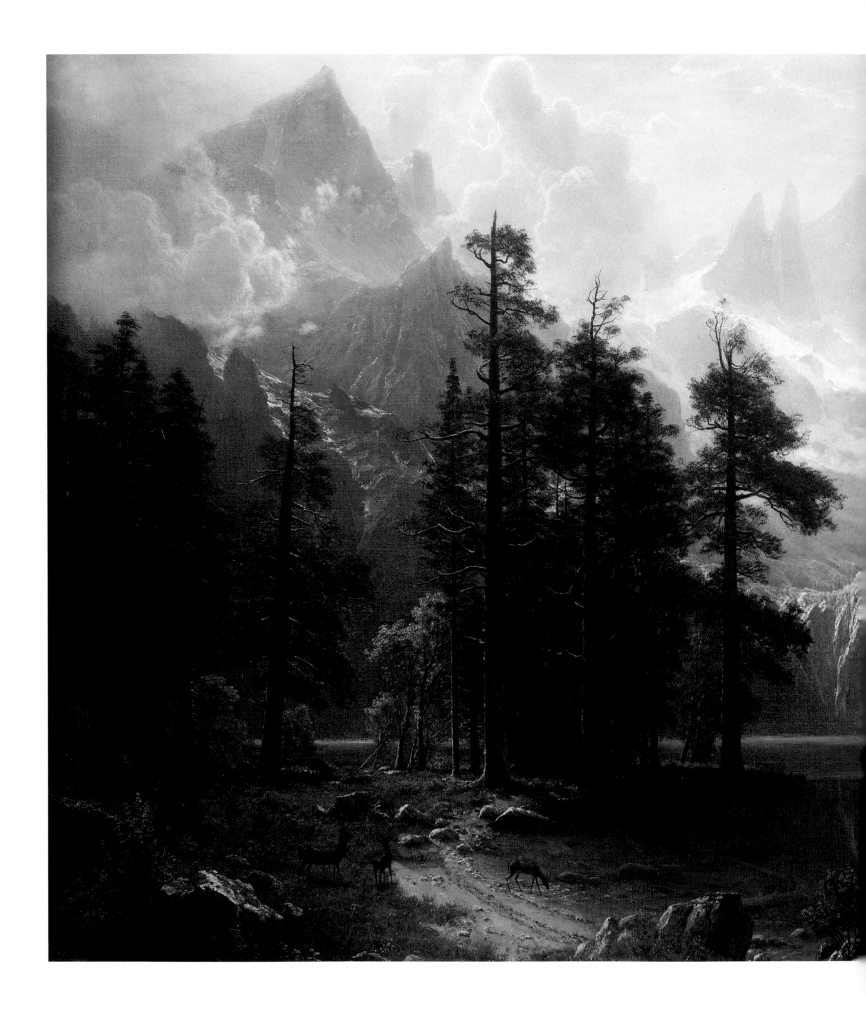

Expansion and Fragmentation

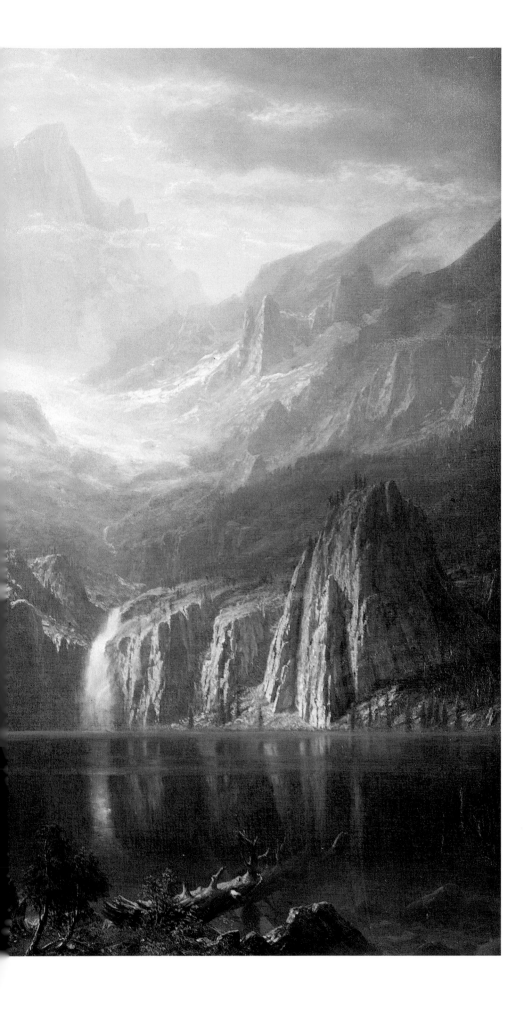

Albert Bierstadt (1830–1902)

Sierra Nevada, c. 1871

Oil on canvas, 38½ × 56½ in. (97.8 × 143.5 cm)

Reynolda House Museum of American Art,
Winston-Salem, North Carolina, Original
purchase fund from the Mary Reynolds
Babcock Foundation, Z. Smith Reynolds
Foundation, ARCA Foundation, and Anne
Cannon Forsyth, 1966.2.7

Charles M. Russell (1864–1926)

Loops and Swift Horses are Surer than Lead

1916

Oil on canvas, 30⅛ × 48⅛ in. (76.5 × 122.2 cm)

Amon Carter Museum, Fort Worth, Texas

Frederic S. Remington (1861–1909)

A Dash for the Timber, 1889

Oil on canvas, 48 × 84 in. (121.9 × 213.4 cm)

Amon Carter Museum, Fort Worth, Texas

Henry Farney (1847–1916)

The Song of the Talking Wire, 1904

Oil on canvas, 22⅛ × 40 in. (56.2 × 101.6 cm)

Taft Museum of Art, Cincinnati, Bequest of

Charles Phelps and Anna Sinton Taft, 1931.466

Eanger Irving Couse (1866–1936)

Making Pottery, 1912

Oil on canvas, 35¼ × 46¼ in. (89.5 × 117.5 cm)

Terra Foundation for American Art, Chicago

Daniel J. Terra Collection, 1999.33

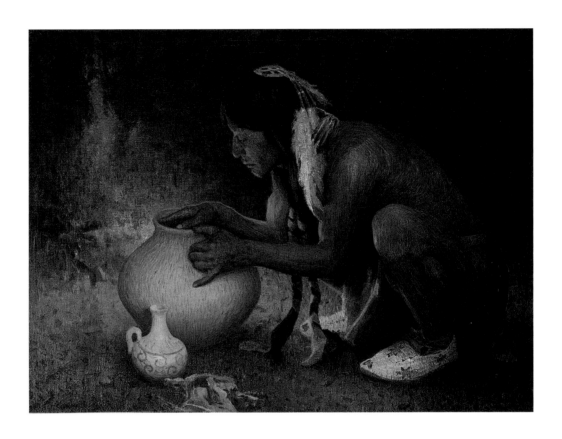

Terra Foundation for American Art, Chicago

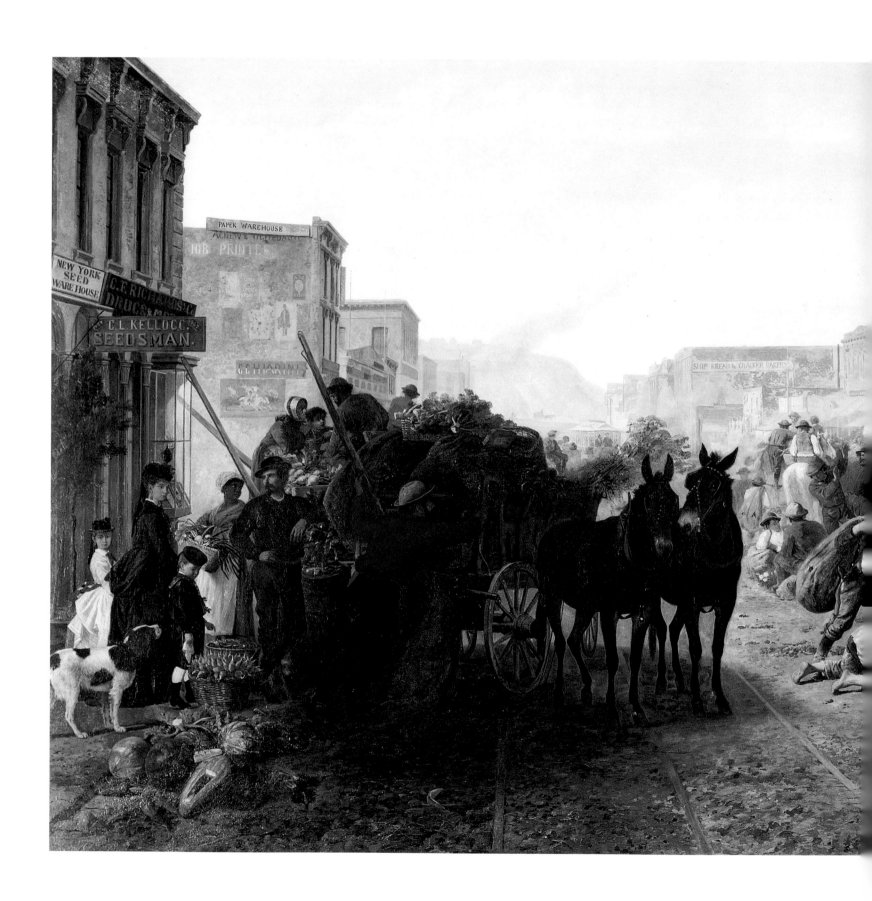

Expansion and Fragmentation

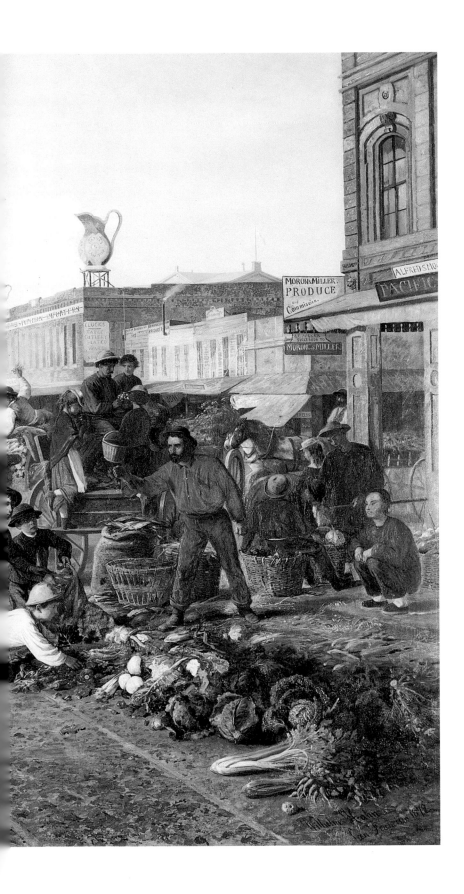

William Hahn (*c.* 1829–1887)

Market Scene, Sansome Street, San Francisco

1872

Oil on canvas, 60 × 96½ in. (152.4 × 245.1 cm)

Crocker Art Museum, Sacramento,

California, E.B. Crocker Collection, 1872.411

The American Cowboy's Destiny

Elizabeth Kennedy

Aeons of geological tumult bequeathed a legacy of scenic natural wonders to be discovered within North America's vast untamed wilderness. Struggling to describe this unfamiliar topography, the Pilgrims, a Puritan English religious sect whose members emigrated to the American colonies in 1620, and other European settlers equated the New World with the "Garden of Eden" or "the promised land," comforting themselves in the belief that their destination was a biblical utopia. Two centuries later, their descendants also found spiritual solace in nature: through Transcendentalism—the belief that God is immanent in nature and man. Transcendentalism dominated American intellectual life from the 1830s to around 1860, and inspired artists to portray their national landscape reverentially. The rhetoric of emerging nationalism, widespread in America and elsewhere in this era, inevitably fused patriotism with spiritual beliefs that exalted the national landscape and those who labored on native soil. These abstract notions of nationhood were represented in images not only of cultivated landscape but also of the sublime wilderness found from coast to coast: in the East, Niagara Falls, the awesome roaring cataracts on the New York–Canada border (pp. 120–21); and in the West, the majestic silence of the snowcapped Rocky Mountains (pp. 132–33). Portraying the national landscape offered American artists and their patrons a vehicle to express their deeply held conviction that the United States and its citizens were exceptional by virtue of their constitutional government and through their ideals of personal and economic freedom.[1]

Integrated within the belief in American exceptionalism is the concept of Manifest Destiny, the ideology of a divinely sanctioned mission to expand American democracy and freedom.[2] As early as 1630, when Pilgrim leader John Winthrop delivered his famous "City on a Hill" sermon, Americans were charged with providing an example of the virtuous life for the watching world. Pioneers migrating westward were depicted as embodying the ideals of Manifest Destiny, as for example by the midwestern painter George Caleb Bingham (1811–1879). Here, the artist transplanted into an American setting the religious iconography of the Holy Family's flight into Egypt with his image of the fabled frontiersman Daniel Boone leading a band of settlers to Kentucky, at that time a frontier territory (p. 125). Bingham's contemporaries heartily approved of such religious associations with westward expansion. In contrast to the reverential tone of his iconic image is the exuberance of *Westward the Course of Empire Takes Its Way* by Emanuel Leutze (1816–1868), commissioned for the rotunda of the Capitol Building in Washington, D.C., in which the surging procession of pioneers suggests the inevitability of American occupation of all lands from "sea to shining sea" (fig. 45).

The ultimate celebration of Manifest Destiny, an ideology still potent today, is found on a barren granite mountain cliff within the imposing landscape of the South Dakota Badlands. Mount Rushmore, begun in 1927 and substantially completed by 1948, commemorates the ideals of "life, liberty, and the pursuit of happiness" enshrined in the Declaration of Independence.[3] As conceived by sculptor Gutzon Borglum (1867–1941), the sixty-foot-high carved portraits of four American presidents personify the United States's exceptional place in the world as a flourishing democratic nation. The gigantic sculpture is an explicit tribute to Manifest Destiny as the impulse to spread American democracy and freedom throughout the world. Borglum selected these "great men" for their specific deeds and historic reputations associated with the creation and consolidation of the United States: George Washington (presidential term 1789–97), Thomas Jefferson (1801–09), Abraham Lincoln (1861–65), and Theodore Roosevelt (1901–09; fig. 62). It is

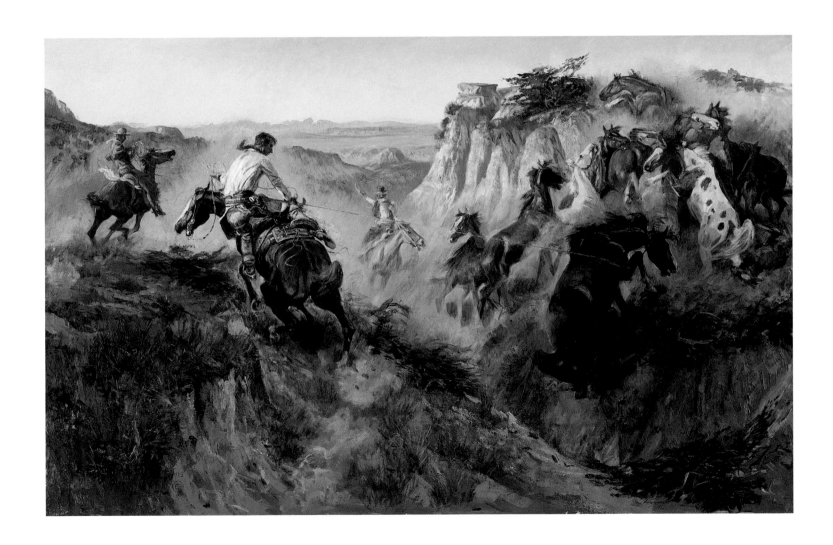

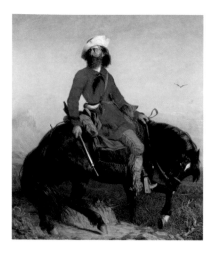

Fig. 60 **Charles Deas (1818–1867)**

Long Jakes, The Rocky Mountain Man, 1844

Oil on canvas, 30 × 25 in. (76.2 × 63.5 cm)

Denver Art Museum, Denver, Institute of

Western American Art, Purchased in memory

of Bob Magness with funds from 1999

Collectors' Choice, Sharon Magness, Mr. &

Mrs. William D. Hewit, Carl & Lisa Williams,

Estelle Rae Wolf–Flowe Foundation and

the T. Edward and Tullah Hanley Collection

by exchange. Other contributors are Marcy

& Bruce Benson, Joy Burns, Denver Broncos,

Mr. & Mrs. Cortlandt S. Dietler, Diane &

Charles Gallagher Family Fund, Mr. & Mrs.

Frederic C. Hamilton, Mr. & Mrs. Mark Hayden,

A. Barry & Arlene Hirschfeld, Lisa & George

Ireland, Kay Lawrence, Kalleen & Bob Malone,

Jan & Frederick Mayer, Carol & Larry A. Mizel,

Victoria & Trygve Myhren, Mr. and Mrs.

Thomas A. Petrie, Daniel Ritchie, Timet

Corporation, Jack A. Vickers Foundation, Mr. &

Mrs. Fred Vierra, Jim & Mary Beth Vogelzang,

and the citizens who support the Scientific

and Cultural Facilities District

significant that this monument is located in the West and that it is carved (actually jack-hammered) into the mountain: no polished marble sculpture is adequate to convey this potent national mandate.

The beckoning wilderness and the vision of great leaders were not enough to implement Manifest Destiny: that required hundreds of thousands of average Americans undertaking westward migration. Perhaps the least studied symbol to join the sublime landscape and visionary leaders in the pantheon of icons representing national beliefs is the archetypal American. Yankee Doodle, the political cartoon figure who emerged during the Revolutionary War era and later evolved into Uncle Sam, is still recognizable as a symbol of the American body politic, but what type of ordinary American could embody the nation's unique identity?

THE CITIZEN-FARMER

The need to develop a new national identity after the American Revolution (1775–83) encouraged a discourse on defining what it meant to be an American. In 1782, French aristocrat J. Hector St. John de Crèvecoeur, who spent several years in the British colonies as a landowner, published his *Letters from An American Farmer,* in which he queried:

> What attachment can a poor European emigrant have for a country where he had nothing?... He is an American, who, leaving behind him all his ancient prejudices and manners, receives new ones from the new mode of life he has embraced, the new government he obeys, and the new rank he holds. He has become an American by being in the broad lap of our Alma Mater. Here individuals of all races are melted into a new race of man, whose labors and posterity will one day cause great changes in the world. Americans are the western pilgrims.[4]

Crèvecoeur also argued that the ability to acquire land, plentiful as you traveled west, was critical to defining the ideal American. The United States's incorporation of vast lands on the western frontier was President Jefferson's contribution to Manifest Destiny. America's third president, placed between Washington and Roosevelt on Mount Rushmore,

negotiated the Louisiana Purchase with France in 1803, dramatically increasing the size of the nation beyond the original thirteen states. Jefferson also commissioned the Corps of Discovery, under the leadership of Meriwether Lewis and John Clark, to explore the western territory, the first of several westward explorations under the auspices of the federal government. The exotic frontier types pictured in paintings by Charles Deas (1818–1867; fig. 60) and Alfred Jacob Miller (1810–1874; p. 122) fascinated an American public, but these figures were never considered typical Americans or particularly heroic.

In addition to championing westward expansion, Jefferson resolutely concurred with Crèvecoeur's earlier assessment that the average American benefited from the liberal tenets of democracy, ". . . where is that station which can confer a more substantial system offelicity [*sic*] than that of an American farmer, possessing freedom of action, freedom of thoughts, ruled by a mode of government which requires but little from us?"[5] It was Crèvecoeur's "western pilgrim" and Jefferson's vaunted farmer who would transform a "virgin land" into a nation. Generations of Americans since have celebrated the man of the land as the true American.

In America's experimental democracy, only adult, white men who owned property were entitled to vote. Most of the founding fathers were gentleman farmers who owned large tracts of land. However, it was the self-sufficient yeoman farmer, a small landholder, who was considered the model citizen, representing the economic doctrines of individualism and entrepreneurialism. New Yorker William Sidney Mount (1807–1868) is one of the few painters to have specialized in portraying the American farmer at work.[6] By the time of President Andrew Jackson's administration (1829–37), property ownership was no longer necessary for white male enfranchisement, although political rhetoric continued to promote the farmer as a symbol of democratic values and American individualism. Transcendentalist writer Henry David Thoreau's unromantic view of pre-industrial farmers experiencing "lives of quiet desperation" burdened by "acres of land, tillage, mowing, pasture, and wood-lot" was shared by a growing urban American population.[7] The success of American agribusiness—the mechanical reaper that Cyrus H. McCormick invented in 1834 was available internationally within twenty

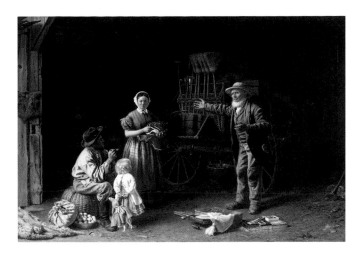

Fig. 61 **Thomas Waterman Wood (1823–1903)**

The Yankee Pedlar, 1872

Oil on canvas, 28 × 40 in. (71.1 × 101.6 cm)

Terra Foundation for American Art, Chicago

Daniel J. Terra Art Acquisition Endowment

Fund, 1998.3

years—further encroached on the reality behind the picturesque vision of the contemporary farmer. Moreover, during the escalating sectional strife of the late 1840s over slavery in the southern states and its potential expansion into western territories, the positive political aura that surrounded the farmer faded. It would re-emerge with the Homestead Act of 1862, an important, if ultimately unsuccessful, campaign to grant land in the western territories to individuals who would improve it.

After the calamity of the Civil War (1861–65), the pictorial revival of the citizen-farmer as hero, the embodiment of the national democratic ideal, lost its potency once again. Nevertheless, nostalgic views of rural inhabitants occasionally appeared. More than mere records of rural mannerisms, these paintings celebrate the success of a free-market economic system where Yankee values of frugality, industry, and a healthy skepticism are rewarded with tempting material goods, as depicted by Thomas Waterman Wood (1823–1903) in *The Yankee Pedlar* (fig. 61). Toward the end of the nineteenth century, respect for the rural population diminished despite the continuous flow of people westward, and American artists only occasionally depicted farmers for an urban audience.

THE CITIZEN-SOLDIER

The republican exemplum of the farmer as citizen-soldier grew out of the eighteenth century's cult of the farmer as a national symbol. No less than George Washington was a founding member of the Society of Cincinnatus, organized in 1783 by retiring officers of the Continental Army. This fraternal, non-political organization took as its ideal the ancient Roman patrician who reluctantly left his farm to lead the army against Rome's enemies. Artist and polymath Charles Willson Peale (1741–1827) invokes this ideal in his portrait of General Washington at the battle of Princeton (p. 69) by referencing the actual site in the landscape background. Likewise, on Mount Rushmore, Washington is imbedded in the granite boulders, insuring that America's most distinguished soldier is indelibly associated with the nation's landscape.

Although Washington's image is ubiquitous in popular culture, thanks to his visage on the American currency, portrayals of the average citizen-soldier are rare. A notable exception is *The Minute Man* by

sculptor Daniel Chester French (1850–1931), an image of an archetypal farmer-soldier of the Revolutionary War created in 1874, a century after such individuals were called on to forge a new republic. Despite its magnitude and great number of casualties, America's Civil War generated surprisingly few war memorials. Sculptors were commissioned by regional patrons to create statues of individual generals, usually set up in public places, and generic images of the common soldier for battlefield cemeteries or in the public squares of small towns. Assassinated almost immediately after the end of the fratricidal conflict, President Lincoln emerged as the nation's martyred hero. His grand memorial in Washington, D.C. became the principal mourning site for a nation determined to reconcile its divisions. In contrast, the Civil War's citizen-soldier was deliberately de-emphasized as a symbol of the ideal American, as political leaders of the once-divided country sought anew for unifying national symbols.[8]

On Mount Rushmore, Lincoln warranted his place alongside the founding fathers for his efforts to preserve the Union and, in 1865, for securing congressional approval of the Thirteenth Amendment to the Constitution, which abolished slavery. America gained thousands of new citizens of African descent, who after generations of dehumanizing treatment finally realized one of the nation's most treasured principles— freedom. Freedom brought displacement for many African Americans, while defeat brought dislocation for many Confederate soldiers and their families. America's western frontier offered these individuals a new beginning, at the same time holding the promise of renewal for a nation poised for spiritual as well as economic recovery.

THE CITIZEN-COWBOY

If neither the farmer nor the soldier was suitable as the ideal American, what type could personify mythic national qualities? In the 1880s, the Western, a genre that had emerged in dime novels during the Civil War, found its way into American literature and the fine arts.[9] In an era when tensions were escalating between free-market entrepreneurs and a largely immigrant, urban labor force, and sectional strife still simmered beneath the national surface, the cowboy came riding across the prairie to

Fig. 62 **Mount Rushmore, South Dakota,
Courtesy of The United States National
Park Service**

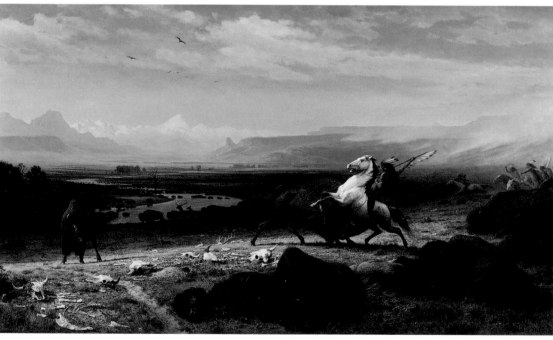

Fig. 63 **Albert Bierstadt (1830–1902)**
The Last of the Buffalo, 1888
Oil on canvas, 71⅛ × 118¾ in.
(180.7 × 301.6 cm)
Corcoran Gallery of Art, Washington, D.C.
Gift of Mary (Mrs. Albert) Bierstadt, 09.12

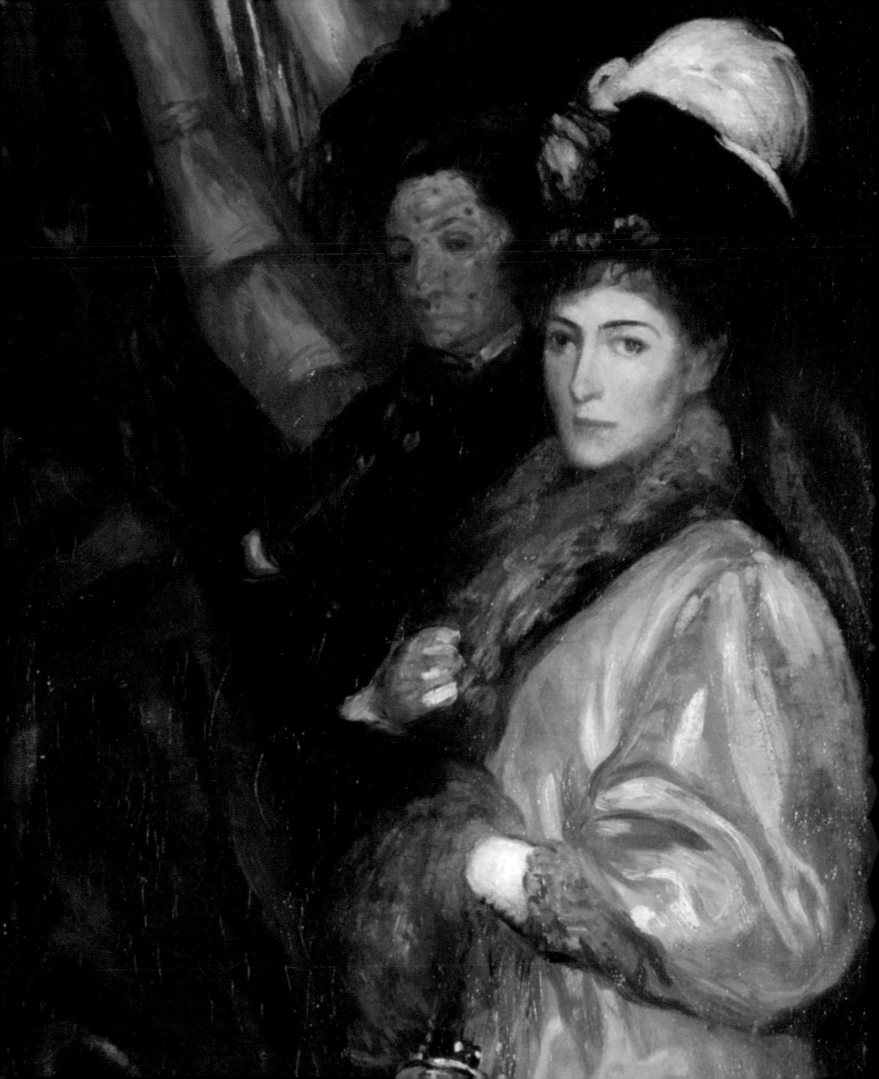

Notes

1. French writer Alexis de Tocqueville is credited with the expression "American exceptionalism." Writing in 1831, he was responding to the perception that the United States differed qualitatively from other developed nations because of its unique origins, historical evolution, and distinctive political and religious institutions.

2. The phrase "Manifest Destiny" was coined by influential editor John L. O'Sullivan in 1845. First used to promote the annexation of the western territories, the concept was revived in the 1890s as a theoretical justification for expansion outside the territorial boundaries of the United States.

3. On the history of Mount Rushmore, see Rex Alan Smith, *The Carving of Mount Rushmore* (New York: Abbeville Press, 1985).

4. J. Hector St. John de Crèvecoeur, *Letters From an American Farmer* (New York: Fox, Duffield, 1904), pp. 54–55.

5. *ibid.*, p. 24.

6. The importance of the Yankee farmer in American art is discussed in Elizabeth Johns, *American Genre Painting: the Politics of Everyday Life* (New Haven, Conn.: Yale University Press, 1991), pp. 24–59.

7. Henry David Thoreau, *Walden* (1854), quoted in Harold Spencer, "J. Alden Weir and the Image of the American Farm," in Nicolai Cikovsky, Jr., *et al.*, *A Connecticut Place: Weir Farm, an American Artist's Rural Retreat* (Branchville, Conn.: Weir Farm Trust and National Park Service, 2000), p. 47.

8. In contrast, in the aftermath of later wars, Americans have been noticeably reluctant to glorify battle through war memorials to specific individuals, preferring to remember the fallen collectively.

9. For the history of the Western genre, see Christine Bold, *Selling the Wild West, 1860–1960* (Bloomington, Ind.: Indiana University Press, 1987).

10. The substitution of the American cowboy for the farmer as a symbol of economic freedom is discussed in Elizabeth Kennedy, "American Images of Labor: The Iconic and the Invisible," *The People Work: American Perspectives, 1840–1940* (Chicago: Terra Foundation for the Arts, 2003), pp. 15–25.

11. Richard Slotkin, *Gunfighter Nation: The Myth of the Frontier in Twentieth-Century America* (New York: HarperPerennial, 1993), pp. 63–87. Delivered on July 12, 1893, at the American Historical Association meeting, Turner's paper was published in the *Annual Report of the American Historical Association for the Year 1893* (Washington, D.C., 1894), pp. 199–227; and as the first chapter in Turner's *The Frontier in American History* (New York: Henry Holt, 1920). The exhibition catalogue *Buffalo Bill and the Wild West* (Philadelphia: Falcon and the Brooklyn Museum of Art, 1981) surveys the impact of Buffalo Bill's interpretation of the Frontier Myth.

12. Theodore Roosevelt, *Ranch Life and the Hunting Trail* (1888), quoted in William W. Savage, Jr., *The Cowboy Hero: His Image in American History and Culture* (Norman, OK: University of Oklahoma Press, 1979), p. 98; and for Roosevelt's views on the cowboy, see Sarah Watts, *Rough Rider in the White House: Theodore Roosevelt and the Politics of Desire* (Chicago: University of Chicago Press, 2003).

13. See Marshall W. Fishwick, "The Cowboy: America's Contribution to the World's Mythology," *Western Folklore*, no. 11 (1951–52), pp. 77–92, and William H. Goetzmann and William N. Goetzmann, *The West of the Imagination* (New York: W.W. Norton Company, 1986).

14. Marlboro, introduced in the 1920s as a premium brand of cigarettes for women, was successfully rebranded for men with images of ultra-manly types in its advertisements in the late 1950s. Combining images of actual cowboys—not actors—with the musical theme from the 1960 movie *The Magnificent Seven*, the ad campaign that began in 1964 firmly established the Marlboro Man as the most powerful brand image of the century. See "The Marlboro Man, Present at the Creation," aired on National Public Radio on October 21, 2002, at www.npr.org/programs/morning/features/patc/marlboroman/.

15. For the Taos and Santa Fe, New Mexico, artists' colonies, see Charles C. Eldredge, *et al.*, *Art in New Mexico, 1900–1945: Paths to Taos and Santa Fe* (New York: Abbeville Press, 1986).

marketing by the Philip Morris company, Marlboro cigarettes, introduced in 1955 and now one of the world's most popular brands, have made the cowboy a universal symbol. The Marlboro Man emerged as the ultimate macho icon, ensuring that the cowboy rides on into the twenty-first century.[14]

While twentieth-century movie and television Westerns forever linked "cowboys and Indians," neither the savage nor the domesticated version of the Native American was ever considered a candidate for a new pastoral American hero in the context of entrepreneurial capitalism. In the nineteenth century, the extinction of the Plains tribes was equated with that of the buffalo, as for example in the eulogistic *The Last of the Buffalo* by landscape painter Albert Bierstadt (1830–1902; fig. 63). At the turn of the twentieth century, artists increasingly identified the picturesque possibilities of the Southwest's "primitive" indigenous peoples for providing a recognizably American subject.[15] Captivated by the Native Americans' spiritual attachment to their pueblo communities, which had existed on the same sites for hundreds of years, the Anglo artists also found the Indians' agricultural life and colorful costumes and ceremonies entrancing artistic subjects (p. 137). Pueblo men, farmers as well as artisans then as now, were presented by Anglo artists as spiritually connected to the land through their direct contact with the soil. However, these domesticated natives were too tame to appeal as symbols of American enterprise.

A more recent acknowledgment of the Indian's iconic power is the equestrian effigy of Crazy Horse, a renowned chief of the Plains Lakota tribe; the first fifty years of its construction were celebrated in South Dakota in 1998. When the monumental sculpture is complete, the mountainside portrait of an Indian warrior will balance the history epitomized in Mount Rushmore's tribute to four white men. American Indians have raised national consciousness of their contribution to American values, and this belated memorial to a Native American suggests that an alternative to the cowboy as the national icon is possible.

Since the founding of the nation, the symbolic supremacy of the (white, male) rural independent worker in American culture—the political ideal of the voting citizen in America's early democracy—has long carried such ideological importance in the fine arts that other representations of rural laborers as a national ideal have yet to challenge it. African Americans, since emancipation conventionally presented in art as poor tenant farmers in the South, have been out of the question: images of former slaves not only prompted the memory of a discredited institution but also exposed unhealed wounds from the Civil War. All but undetectable in the fine arts before the 1940s are Asian immigrants, such as the thousands who worked on the transcontinental railroad system and on California's large-scale so-called bonanza farms, or Hispanic laborers, who were viewed less romantically than Native American neighbors by the dominant Anglo society. Tragically under-represented in the genre of the Western—in art, literature, and movies—are the hundreds of actual Black, Hispanic, Indian, and, occasionally, Asian male cowboys. Women also rode the range. None of these diverse ranch hands, however, has yet replaced the white cowboy, America's preferred national representative.

Paradoxically, as America's frontier faded, the charismatic cowboy came to dominate the national pictorial imagination. Perceived by most Americans as "noble", despite the negative connotations the word "cowboy" has assumed abroad, no other persona has so convincingly embodied Americans' view of themselves. Crevecoeur's western pilgrim became the American cowboy, a citizen attached to the land, whose dedication to freedom exemplifies the cherished democratic ideal.

regenerate America's mythology of rural national values.[10] Depictions of the robust American cowboy on horseback, enjoying unmitigated freedom in the hyper-masculine territory of the western frontier, soothed workplace conflict between labor and capital. Portrayed as a man who controlled his own destiny, the cowboy was particularly appealing to men, both the frustrated industrial manager and the frequently exploited wage earner.

While the heyday of the cowboy as a professional cattle drover lasted only a few decades (from the 1860s to the 1890s), the appeal of America's new pastoral hero is still current. The origin of the cowboy phenomenon, arguably, lies in the Wild West Show, a live entertainment tirelessly orchestrated by Buffalo Bill Cody and toured throughout the United States, England, and Europe from 1883 to 1916. At the 1893 World's Columbian Exposition in Chicago, Buffalo Bill's spectacle of cowboys and Indians wowed enthusiastic audiences spellbound by the whooping and hollering horsemen. Ironically, a few blocks away at a sparsely attended lecture, historian Frederick Jackson Turner lamented the demise of the western frontier in his address entitled "The Significance of the American Frontier."[11] Turner argued that the challenge of creating a civilization from the wilderness forged Americans' most prized characteristic: economic individualism, that is, personal freedom to exploit economic opportunity. Of equal importance were the strenuous conditions of frontier life, which promised to transform even the newly arrived European immigrant into a proper American citizen. Turner's frontier thesis added to the philosophical foundation of Manifest Destiny, while Cody's wildly successful entertainments cemented the image of the cowboy as the ideal American in the popular imagination.

Roosevelt, the one twentieth-century president featured on Mount Rushmore, was an unabashed lover of the West, and his place next to Jefferson links these two extraordinary champions of Manifest Destiny. By effecting the United States's acquisition of the trans-Mississippi western territory, Jefferson opened the way for western settlement. Roosevelt, who organized the Rough Riders, the equestrian troop that fought in Cuba during the Spanish–American War of 1898, expanded the concept of Manifest Destiny to embrace international conquest.

As a soldier, Roosevelt joins Washington as one of two presidents on Mount Rushmore who went into battle for their country. Yet it was Roosevelt's identification with the cowboy, whom he lauded for possessing "to a very high degree, the stern manly qualities that are invaluable to a nation," that is more frequently remembered.[12] Notwithstanding his political enemies' epithet "that damned cowboy," Roosevelt was the critical factor in elevating the cowboy from Wild West entertainer to national emblem. In his exceptional service to his country Roosevelt exemplified the citizen-soldier in the guise of the cowboy and thus validated the new American hero.

At the turn of the twentieth century, American society was preoccupied with redefining masculinity, rejecting the seemingly more effeminate qualities of the gentleman and the scholar to embrace such character ideals as honesty, sobriety, hard work, and civic service— attributes credited to the cowboy. Romanticized as the "knight of the plains," the unfettered cowboy was also a loner who employed violence when necessary. He became a symbol of national unity by fusing two national archetypes: the outdated pastoral laborer and the problematic soldier. By melding the freedom of the pastoral worker with the controlled violence of the soldier, the cowboy, a distinctly American contribution to popular culture, arose as the emblem of chivalrous behavior and personal liberty in a nation that prized entrepreneurship and laissez-faire capitalism.

By the 1880s, works by first-generation western artists Frederic S. Remington (1861–1909) and Charles M. Russell (1864–1926), praised for their commitment to authenticity and the portrayal of action, codified the image of the American cowboy (pp. 134, 135). While never a triumph with art critics, paintings of the cowboy and other western subjects were, and remain, immensely admired by the public. The legacy of the "reel cowboy," introduced into moving pictures in the innovative *Great Train Robbery* of 1903, firmly established a link between the American pastoral hero and the western landscape for national and international audiences. Renowned American film director John Ford studied paintings by Remington and Russell, translating their dramatic tension into his classic movie Westerns of the 1950s and 1960s.[13] Finally, thanks to international

(1880–1915) Cosmopolitanism and Nationalism

Nationalism and Internationalism

Nancy Mowll Mathews

Only a century after the Declaration of Independence, the United States had established itself as a world power. A generation or two after that, by 1915, the country had become the largest producer of goods and services in the world.[1] Wealth derived from both industrial and agricultural advances allowed its foreign-policy makers to temper their previous isolationism and become more aggressive in interactions with overseas nations to the west and to the east. The art that was produced during this thirty-five-year period stands as a visible sign of this change and of the new American internationalism.

John Singer Sargent's portrait of Mrs. Hamilton McKown Twombly of 1890 (p. 168) shows the cosmopolitan American with staggering wealth and the conspicuous display of both old and new standards of beauty. The trappings of an older, overseas culture are displayed in the sumptuous setting and pose, while the dress and the Impressionist painting style show an insider's grasp of "the new." There could be no better illustration of Thorstein Veblen's 1899 critique of American privilege, *The Theory of the Leisure Class*. To Veblen, it was the well-dressed woman who was the hallmark of American success: "Elegant dress serves its purpose of elegance not only in that it is expensive, but also because it is the insignia of leisure. It not only shows that the wearer is able to consume a relatively large value, but it argues at the same time that [she] consumes without producing."[2]

However, Sargent represents only one end of the spectrum of American art in the decades around 1900. Born and bred in Europe, Sargent (1856–1925) had the resources and inclination to picture wealthy Americans as the new lords of the universe. But the smugness of what would be called the "Gilded Age" was challenged by artists at the other

end of the spectrum. Mary Cassatt's *Girl Arranging Her Hair* of 1886 (fig. 68) emphasizes the stark "ugliness" of the model, as well as the new interest in Japanese prints and non-Western sources, and shows the spirit of rebelliousness characteristic of avant-garde painting in Paris. And after 1900, "ugliness" became a theme of American art, celebrating the dynamism of New York City with its steaming industry and struggling immigrants as in *Men of the Docks* of 1912 by George Bellows (1882–1925; p. 184).

These contradictions provide the era with its richness and complexity. The new international spirit that took Americans abroad in increasing numbers sparked massive immigration from all over the globe, which changed the character of the country. The success of Americans in international cultural centers, such as London and Paris, put increased pressure on them to find their own national identity and cultivate a sophisticated audience at home. The prominent American artists of the later nineteenth century, such as Sargent, Cassatt, Thomas Eakins, and Winslow Homer, not only traveled back and forth, but they made an effort to be visible in both European and American art circles. Their legacy in the early twentieth century was a new generation of artists informed by both European and Asian styles, but devoted to establishing an American art that stressed uniquely American subject matter or a uniquely American interpretation of modern art.

1880–1900

American presence on the world stage was strongly colored by the national enthusiasm for modern technology. The rise of the steamship for transoceanic travel, for instance, single-handedly transformed the

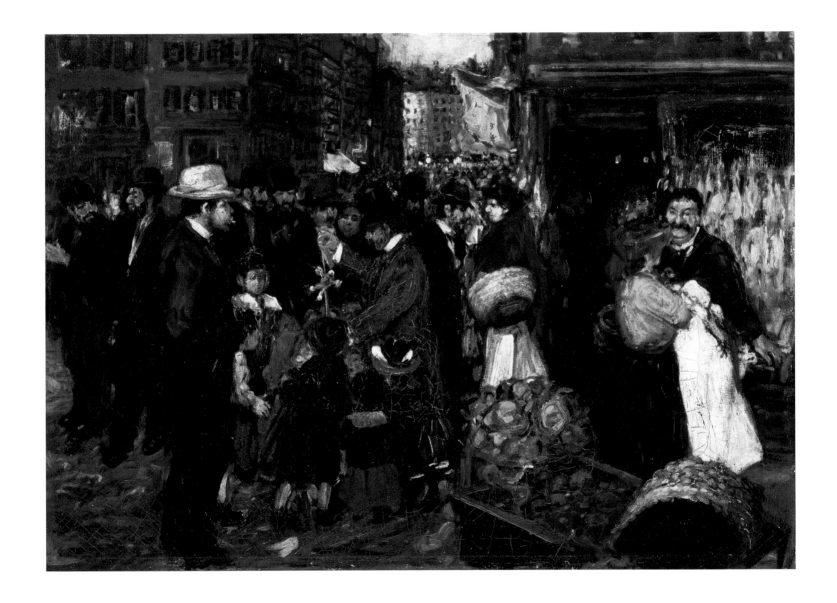

relationship of Americans to cultures on other continents (fig. 67). Steam engines dramatically sped up ocean travel, lessening the crossing time to Europe, for instance, from about fifty days to about ten. It is fair to say that before 1870, most people attempting the trip to and from the Americas had to be serious travelers; after 1870, when the scales tipped from sail to steam, they could be mere tourists. For artists and connoisseurs, the grand European museums and the exotic temples of the East became familiar haunts. As the railroad at mid-century had unified the country, so the steamship by 1900 had unified the world.

Steamships facilitated not only passenger travel, but the international exchange of goods. The flow of such luxury items as works of art increased steadily in the last decades of the nineteenth century as new American fortunes attracted the interest of art dealers from Europe and Asia. Wealthy American tourists in foreign countries took advantage of the new ease of shipping to bring back enormous collections of art for their private galleries and, increasingly, for the new public museums they helped found. Municipal museums, among them the Metropolitan Museum of Art in New York and the Museum of Fine Arts in Boston (both founded in 1870), as well as private collectors, such as Isabella Stewart Gardner, Henry Walters, and Charles Lang Freer, introduced a domestic viewership to the collections of world art they put on public display.

Art originating in the United States did not have a reciprocal market abroad, but it could be seen regularly in Europe, thanks to the popularity of international expositions, such as the Salons and the World's Fairs of 1867, 1878, 1889, and 1900, all held in Paris. Countries participating in the World's Fairs erected pavilions to showcase their own national schools, and most prominent American artists were chosen for this honor at one time or another. The combination of official arts organizations and commercial art galleries gave Americans international networks that allowed them not only to exhibit, buy, and sell art, but to keep abreast of the latest styles. Rather than the somewhat purposeful cultural isolation-ism of the first half of the nineteenth century, the later decades promoted a general sense of being connected as well as a new urgency to "keep up."

The master of the international art market of the late nineteenth century was the French dealer Paul Durand-Ruel (1831–1922). Not only did he grasp the changes fermenting in Paris with the Barbizon School and the Impressionists, but he began early on to cultivate an American audience for modern art. By the 1860s he was advertising in the élite newspaper the *American Register,* published in Paris for Americans. In the 1870s, Mary Cassatt was among the Impressionists he cultivated. Cassatt (1844–1926) was the most successful American artist in French avant-garde circles, and she bought works for her family and advised American friends, such as Louisine Havemeyer, to buy Impressionist art from Durand-Ruel.[3] By 1886 he was in a position to mount a major exhibition of Impressionist art in New York, and by 1890 he had founded a New York branch of his Paris gallery. Far from neglecting the large American audience in Paris, he mounted an exhibition of American art in 1891 that was juried by prominent American art notables in Paris and included such artists as Eakins (1844–1916), William Merritt Chase (1849–1916; fig. 72), Childe Hassam (1859–1935), and Theodore Robinson (1852–1896).

In New York, the repercussions of Durand-Ruel's entry into the American art market were felt immediately. Foreign dealers had always been present and active in what had previously been considered a fringe of the international art world; but now that the American art audience had grown so large, local dealers began to compete. Young gallery owners such as William Macbeth (1851–1917) took from Durand-Ruel the concept of identifying new trends in art and, in 1892, began to pit American artists against the French modernists that Durand-Ruel represented. The excitement that these dealers brought to the New York art world encouraged American artists to think of themselves as working in an international context even if they did not leave their own country. Macbeth promoted a uniquely American avant-garde group, later called the Ashcan school, in the decades after 1900. He would be joined in 1905 by the photographer and dealer Alfred Stieglitz (1864–1946), who was equally passionate about American artists working within an international context, but who concentrated on modernist rather than representational art.

In one small but very important arena of modern art in the late nineteenth century, Americans actually dominated the international

art scene. This was the development of photographic studies of motion, primarily that of animals and the human figure. Although chronophotography, as it was frequently known, was practised by photographers all over the world, it was Eadweard Muybridge (1830–1904), an Englishman working in the United States, who became its most celebrated proponent in international circles. Muybridge's approach to the technique was not just technical or scientific, as was typical of his counterparts elsewhere, such as Etienne-Jules Marey and Georges Demeny in France, and he vigorously argued its profound contribution to painting and sculpture.[4] Muybridge's lectures in Paris and London in 1881 and again in 1889 reverberated throughout the art studios of Europe, as artists struggled to come to terms with the realities of a world that moved so quickly only a camera could capture it. Muybridge's experimental photographs offered a new glimpse of reality.

Muybridge's lectures were made even more compelling by a specially adapted magic-lantern projector allowing him to show his photographs in a rapid sequence that presaged the moving picture. When Thomas Edison saw Muybridge's animated photographs, he was persuaded to take on the challenge of perfecting this preliminary concept into the film technology we know so well today.[5] Edison's first commercially available invention for showing moving pictures, the kinetoscope, was demonstrated in 1893 and installed worldwide by 1895. The passion for capturing the hitherto unseen stages of movement and having the world in motion at your fingertips was both an outcome of the artistic preoccupations of that late nineteenth-century period, and a stimulus for further change as the new century emerged.

An American who participated in the early stages of this exciting phenomenon was the Philadelphia artist Thomas Eakins (1844–1916). Eakins had studied in Paris in the late 1860s when the Realist style preached by Gustave Courbet and refined by Eakins's teacher, Jean-Léon Gérôme, was in vogue. Eakins took these powerful ideas back to Philadelphia where they influenced both his art and his teaching at the Pennsylvania Academy of the Fine Arts (fig. 66). He was instrumental in bringing Muybridge to Philadelphia, where the photographer embarked on a three-year project culminating in the 1887 publication of *Animal*

Locomotion, a massive volume reproducing over twenty thousand photographs of human and animal movement (fig. 65).[6] Despite its high price, *Animal Locomotion* entered the libraries of science and art academies around the world and is still used today.

Eakins's penetrating studies of people and their surroundings owe a debt to Muybridge's experimental and theoretical approach to Realism. Although he did not concentrate on movement *per se*, the understanding of human anatomy, even at rest, that informs such works as the portrait of *Miss Amelia Van Buren* (c. 1891) is still extraordinary. His use of chronophotography in the teaching of human motion had a lasting effect on his colleagues and students. Thomas Anshutz's *The Ironworkers' Noontime* of 1880–81 (fig. 69) is one example of how painters incorporated the cinematic effect of multiple images of a moving figure. Anshutz (1851–1912) succeeded Eakins as teacher at the Pennsylvania Academy, and a generation of students coming out of Philadelphia in the 1890s, such as Robert Henri, John Sloan, and George Luks, would bring movement to the forefront of American modernism.

Realism took another turn in the popular genre of *trompe l'œil* painting in the 1890s. Such artists as William Michael Harnett (1848–1892), John Frederick Peto (1854–1907), and Richard Goodwin (1840–1910; p. 174) pushed illusionism to the limit with their elegant still lifes of ordinary objects arranged seemingly on the flat surface of a wall or door. These virtuoso renderings of guns, pipes, newspapers, and other masculine accessories bridged the worlds of fine art and decoration and often hung in men's clubs, taverns, and other unusual venues for art.[7]

The international preoccupation with realism was clearly a great boon to figure and still-life painters, but it was not as useful to landscapists, previously a very powerful group in interpreting American values. The painters of the Hudson River School and of Western expansion had fallen out of favor, and the younger artists took on the subject with a different kind of intellectual experimentation for the new age.

The great interpreter of the American land at this time, Winslow Homer (1836–1910), was, like Sargent and Eakins, a master of the monumental statement in his paintings and a fitting representative of American aspirations on the world stage by 1900. He had found fame

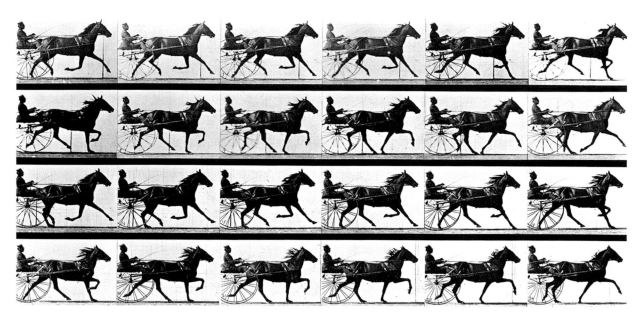

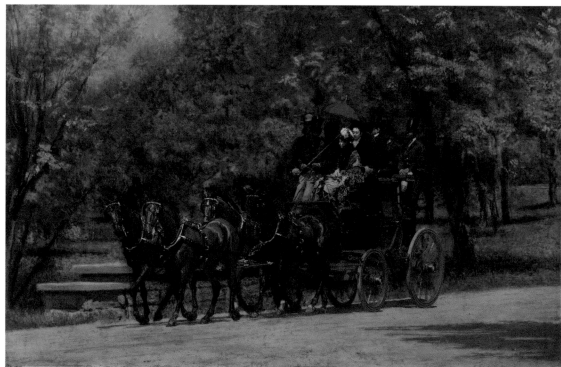

Fig. 65 Eadweard J. Muybridge (1830–1904)
"Lizzie M." trotting, harnessed to Sulky,
plate no. 609 in *Human and Animal*
Locomotion, 1887
24 Side views, 7¼ × 14⁷⁄₁₆ in. (18.4 × 36.7 cm)
California Historical Society, San Francisco
TN-6190

Fig. 66 Thomas Eakins (1844–1916)
The Fairman Rogers Four-in-Hand, 1879–80
Oil on canvas, 23¾ × 36 in. (60.3 × 91.4 cm)
Philadelphia Museum of Art
Gift of William Alexander Dick, 1930

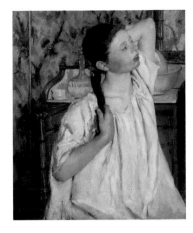

early in his career with his haunting paintings of the American Civil War (fig. 53; p. 129) and traveled to France and England, where his works were exhibited. In the 1870s he perfected a sophisticated form of rural genre (p. 131), and in the 1880s he turned toward the classic themes of men and the sea. By the 1890s he simplified his monumental compositions to abstract forms of the sea with a strong resemblance to Japanese prints (pp. 172–73). He publicly disavowed all suggestions of modern art[8] despite the subtle adoption of ingredients from Impressionism and other emerging abstract styles. Unlike Sargent and Eakins, he did not teach or strongly influence a school of landscape painting, but his work stood as a standard for all other landscape painters of his generation.

When Homer was in England in 1881–82, there was no more famous American artist in the world than the expatriate resident of London, James Abbott McNeill Whistler (1834–1903). Very close in age, the two men at that moment represented a curious harmony of interests that would yield very different results over the next few decades. Both were attracted to marine subjects, particularly those featuring the atmospheric effects of fog and rain (p. 165). Whistler openly imitated Asian art, both Chinese and Japanese, to break away from the specificity of European landscape traditions, while Homer's debt to Whistler or non-Western sources can only be inferred from the visual evidence. As time went on, Homer lessened his interest in subtle, misty effects in favor of stronger forms and colors, while Whistler became the model for a strong movement in American landscape painting called "Tonalism." Whistler's views of Venice and London from the years around 1880, often titled with such musical terms as "nocturnes," became widely known through his etchings of similar subjects as well as through the publicity he received from his notorious lawsuit against the English art critic John Ruskin (1819–1900) in 1878.[9] Whistler spread the word about his abstract landscapes through his own writings and his popular "Ten O'Clock Lectures," the first of which was delivered in 1885.

American artists based in the United States, such as George Inness (1825–1894) and Thomas Wilmer Dewing (1851–1938), shared with Whistler an interest in dematerializing the landscape. Each perfected a method of applying thin veils of color to transform the ordinary farm or forest into a magical apparition. Inness, particularly, sought to convey spiritual ideas as formulated by the Swedenborgian church (fig. 70). Dewing, on the other hand, used his misty effects to produce an abstract paradigm of modern beauty that was strongly influenced by English aestheticism. The delicate, otherworldly landscapes of the Tonalists in the 1890s were followed by the distinctive work of Albert Pinkham Ryder (1847–1917). Ryder divorced his painting from direct observation of nature, as in *Death on a Pale Horse* (1896–1908), which American audiences associated with European Symbolist painting.

Whistler's influence on American art was felt in many other ways. A theatrical personality, he defined for his countrymen back home the concept of the Bohemian artist. His dapper dress and pose, his colorful social life, and his rebellion against Western art traditions made him the quintessential "impressionist" artist. For American collectors far into the twentieth century, collecting Whistler was their entrée into modern art. The more daring Americans seeking to have their portraits painted abroad found their way to Whistler's studio for a series of unforgettable sittings for the master.

But although he was a radically experimental artist, Whistler was not an Impressionist as understood by the term applied to the small group of artists in Paris who began exhibiting together in 1874. He was friends with Edgar Degas, Claude Monet, Berthe Morisot, and Cassatt, but he never accepted their invitation to join the group, concentrating instead on the annual Salon as his showcase in Paris. Because he held the avant-garde art circles in France at arm's length, the steadily increasing numbers of American art students arriving in that country chose the classic Impressionist style of broken brushstrokes rather than Whistlerian Tonalism. Soon the American landscape was more French in inspiration, and by 1900 Impressionism, as interpreted by such artists as Hassam, became entrenched as the most important modern art style in New York (p. 166).

Americans studying abroad not only found a wealth of opportunities in Paris, but a privileged few had introductions to Cassatt, who in turn advised them and enabled them to find teachers. Cassatt had been working in Paris since 1865 and, of all American artists abroad, was

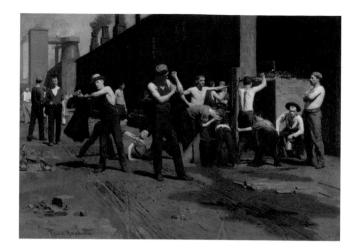

Fig. 69 **Thomas Pollock Anshutz (1851–1912)**

The Ironworkers' Noontime, 1880

Oil on canvas, 17 × 23⅞ in. (43.2 × 60.6 cm)

Fine Arts Museums of San Francisco

Gift of Mr. and Mrs. John D. Rockefeller III

1979.7.4

the most integrated into French intellectual circles. In the 1890s she was enticed back into the American art scene by an invitation to paint the monumental mural crowning the atrium of the Woman's Building, a pavilion of the Chicago World's Columbian Exposition of 1893. In 1895 and 1898 her dealer, Durand-Ruel, held exhibitions of her work in his New York gallery, and, until her death in 1926, she exhibited regularly in both Paris and New York.

The subject of Cassatt's mural was "modern woman," arguably the grand theme of late nineteenth-century American art. It was *sine qua non* for the portraitists—Sargent, Whistler, Eakins, and their younger counterparts Cecilia Beaux (1855–1942) and William Merritt Chase. But it was also an important feature of the landscapes of Homer and Dewing. Most visibly, the modern woman populated the new form of genre painting that had been reformulated by the Impressionists to celebrate the heroism of modern life (fig. 73). Impressionism preached that artists should use familiar subjects; so the bright, educated, and fashionable women of their own social circles quickly appeared in their paintings. Cassatt set the scene by incorporating her own mother and sister into her monumental compositions of interiors and elegant gardens. The nineteenth-century feminist movement portrayed women as strong and capable as well as beautiful, and both male and female artists by 1900 celebrated the heroic modern woman.

1900–1915

Since the heroic modern woman of the 1890s tended to be a product of the privileged classes, as were so many of the American artists of this period, she was susceptible to the shift in American social values that came to the fore when Theodore Roosevelt assumed the presidency in 1901. The rosy outlook stemming from the fact that American income levels in the late nineteenth century were higher than those in most parts of the world today also produced a keen sense of social injustice.[10] Influenced by the rise of socialist thought in Europe, Americans sought to redress the social ills that persisted despite the nation's prosperity and began to look to their art and literature to explore these themes. The American progressive movement put on steam throughout the first

decade of the twentieth century and was slowed only by the outbreak of World War I in Europe.

The style of American art that most closely embodied the ideals of the progressive movement grew out of Impressionist painting of modern life, and was dubbed the "Ashcan" school in 1916.[11] The artists of this New York group studied Degas and his depiction of the modern city, and revived Realism as it had first been preached by Courbet as a tool for social awareness and change. Many artists of the group, such as Robert Henri (1865–1929), George Luks (1866–1933), William Glackens (1870–1938), Everett Shinn (1876–1953), and John Sloan (1871–1951), had started their careers in Philadelphia, where the influence of Eakins was paramount for modern artists. But as they traveled to Paris to study and resettled in New York, they abandoned Eakins's surgical detail in favor of a slashing brushstroke that captured more of the dynamism of the city. Although by no means consistent from artist to artist, this group developed a recognizable body of work that was unique to New York and may be legitimately called the first truly American modern art.

All over the world, artists were practising a version of Impressionism that was interchangeable with American Impressionism. The impetus for the Ashcan school artists to go beyond that into a socially conscious realism, therefore, was partly a need to distinguish themselves and reject European influence after several decades of working within an international context. But it was also a response to the genuinely exciting new era of visual culture, developing in New York with more *éclat* than elsewhere. Typical of American cultural history, the new era was brought about by new technologies that changed forever the way pictures were constructed and viewed.

The first was the perfection in the 1890s of long-anticipated methods, such as photogravure and other photomechanical processes, of printing both photographs and color images in mass quantities. For the international art world, this meant the first regular appearance of reproductions of works of art in books and magazines. For American artists in particular, it provided a quicker, easier system of keeping up with the latest art styles from Europe—an innovation of equal or greater importance than the steamship. For everyone else, it meant that pictures

Fig. 70 **George Inness (1825–1894)**

Twilight, c. 1860

Oil on canvas, unframed: 36 × 54¼ in.

(91.4 × 137.8 cm)

Williams College Museum of Art,

Williamstown, Massachusetts

Gift of Cyrus P. Smith, Class of 1918,

in memory of his father, B. Herbert Smith,

Class of 1885, 79.66

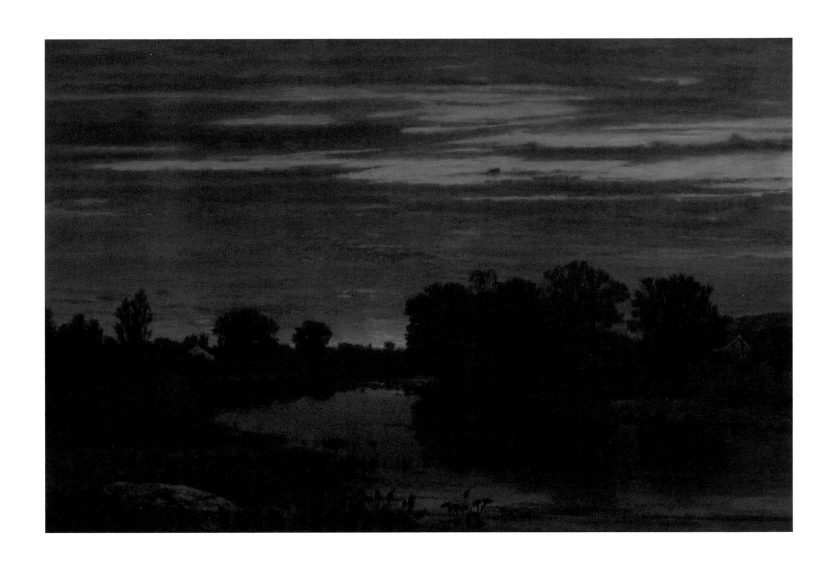

Fig. 71 **William Glackens** (1870–1938)

Far from the Fresh Air Farm, 1911

Pencil and watercolor on paper

25¹/₂ × 17 in. (64.8 × 43.2 cm)

Museum of Art, Fort Lauderdale, Florida

could now be a major form of mass communication, taking their place alongside text in daily newspapers and other periodicals. The addition of color in inexpensive mass media caused the market for newspapers to skyrocket after 1900. Pictures suddenly became journalistic, telling the tales of urban life on a daily basis.

It is no surprise to learn that most of the important artists of this period began their careers as newspaper artists and that all of them did illustration work for magazines throughout their careers as painters (fig. 71). Not only did they believe that their fine art should serve their progressive ideals, they believed in breaking down the hierarchy of the arts and recognizing the power of pictorial imagery no matter how democratic the medium. Through this practice, they learned to draw quickly and observe the telling details of a city growing constantly in population and productivity. Their paintings, like their drawings, chronicled the public rather than private life of a generation eager to be part of the grand narrative of New York as it became the most important city in the world.

Ashcan school painters even-handedly depicted all the social classes as they could be seen in public spaces around town. But they were most closely associated with the densely populated areas around 23rd Street, the heart of the commercial district at that time, and the areas further south: Greenwich Village and the area known now as the Lower East Side (fig. 64). These districts absorbed the waves of immigrants, numbering some thirty million, in the great Atlantic migration between 1820 and 1914. In 1900 alone, two million came from Germany, Italy, and Eastern Europe.[12] The industrial growth of the United States was fueled by labor provided by these immigrants, and, although the immigration process brought hardships, their arrival was a cause of celebration for all concerned. In the progressive spirit, settlement houses were established to help the newcomers learn the English language and become assimilated as quickly as possible. The Ashcan paintings of urban life in these crowded areas are uniformly sympathetic and spirited.

As influential as were the technological advances in the printing of pictures, yet another technology perfected in the 1890s had a transformative effect on the visual culture of the era—the moving picture.

The Edison Company's perfection of the kinetoscope in 1893 was only the first step in the evolution of early film; the second would be the invention of projection equipment that took the moving picture from the small scale of a photograph seen in a cabinet to the large scale of an image projected on to a "canvas" in the manner of a grand painting or mural. Since the image was usually shown with a gold frame surrounding the movie screen, the reference to high art was unmistakable.

In the later 1890s, the movie camera was quickly turned on scenes of the modern city, often reflecting the elegant Impressionist image of well-dressed people walking through spacious architectural plazas or parks. But after 1900, both films and paintings of the city shared an interest in the lower classes and the dynamism of modern transportation and industry (fig. 75). The similarity was partly due to the pervasive effect of progressivism on American cultural norms, but it may also have been due to the shared journalistic approach taken by artists and cameramen, both often hired by newspapers and working side by side. The idea of a pictorial image that captured movement over time and could be replayed for more intense scrutiny of the world than ever possible before would change the relationship of pictures to reality in countless ways as the new century unfolded.

The Ashcan artists were considered renegades by the established art world of the early twentieth century. They were rejected by the juries of the most prestigious annual exhibitions, such as that held at the National Academy of Design, and forced to find their own exhibition venues. Their greatest advocate was William Macbeth, a dealer of modern American art, who offered them his gallery for a large show in 1908. This exhibition of "The Eight"—the others were Arthur B. Davies (1862–1928), Maurice Prendergast (1858–1924), and Ernest Lawson (1873–1939)—received a great deal of attention in New York and was subsequently sent to a number of other venues around the country, a move that established them as America's avant garde. Many of the artists subsequently became influential teachers and held leading positions in the rapidly multiplying exhibition groups of New York.

But among the paintings of urban life in the 1908 exhibition were some small canvases by Prendergast that refuted the notion of

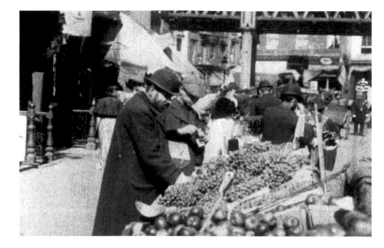

Fig. 75 *Move On*, 1903, film still
Producer: Edwin S. Porter
Camera: Alfred C. Abadie
Library of Congress, Washington, D.C.
Paper Print Collection

nationalistic modernism. These were painted in a brilliant, pointillist style, which he had just seen during his trip to Paris the summer before. Much to the chagrin of his colleagues, he had once more become intrigued with a foreign style that, in its abstract approach to color and form, had international appeal. Prendergast had never been a newspaper artist but became associated with the group because of his curiosity about new styles and his willingness to go out on a limb artistically. His experimental bent had drawn him to Post-Impressionism when he was studying in Paris in the early 1890s, and in recent years he had kept a close eye on Paul Cézanne. In 1907 he became acquainted with the work of Henri Matisse and the Fauves. He quickly grasped the implication of color and form divorced from visual reality and began painting in a style that one critic called "an explosion in a color factory"[3] (pp. 178, 179). Prendergast's entry of these canvases into the exhibition of The Eight provided the American audience with their first glimpse of the radical styles fermenting across the sea.

Soon afterward, Alfred Stieglitz would begin exhibiting some of the new French art in his gallery at 291 Fifth Avenue, providing a venue too for the radical work done by Americans studying in Paris (fig. 15). Encouragement came from such collectors as Gertrude and Leo Stein, and the Cone sisters, who were not only patrons of Pablo Picasso and Matisse in Paris but opened their Left Bank homes to Americans sharing their interests. The nationalistic style celebrated by the Ashcan school in 1908 was already under attack. In 1913 in New York a group of artists including Prendergast and Davies organized a massive survey of European modernist styles and their American counterparts. Known as the Armory Show, it once again proclaimed American citizenship in the international art world.

But the debate was not silenced. Until the mid-twentieth century, when World War II established American cultural leadership, artists seesawed between nationalism and internationalism as a theoretical stance. In the writing of history, the American art of the period from 1880 to 1915 suffered similar permutations. The great cosmopolitan artists of the late nineteenth century—Sargent, Whistler, Cassatt—rose and fell in stature as historians struggled with an isolationist perspective on American culture. A similar fate befell the American nationals—Eakins, Homer, and the Ashcan school—during the decades when American historians accorded primacy to European cultural leadership.

But regardless of the changes in cultural perspective, the work produced by American artists during this period remains rich in challenges and solutions for a country taking its place on the world stage for the first time. The great wealth of the United States allowed individual artists and collectors to make their mark abroad and display a truly cosmopolitan outlook. At the same time this outlook was shaped by the power of American technology and the pragmatic American approach to international commerce, even in the world of art. And finally, the nation itself was no longer a former British colony but a nation of global immigrants making such cities as New York more international than any other. The struggles of artists to confront the international and national complexities of their age resulted in one of the most diverse and contradictory periods of American art.

Notes

1. Stanley Engerman and Robert Gallman, *The Cambridge Economic History of the United States,* vol. 2 (New York: Cambridge University Press, 2000), p. 6.

2. Thorstein Veblen, *The Theory of the Leisure Class* (Boston: Houghton Mifflin Company, 1973), p. 121.

3. For a thorough treatment of the Cassatt and the Havemeyer collection, see Alice Cooney Frelinghuysen *et al.*, *Splendid Legacy: The Havemeyer Collection* (New York: Metropolitan Museum of Art, 2000). For Cassatt as advisor to American collectors, see Nancy Mowll Mathews, *Mary Cassatt: A Life* (New Haven, CT: Yale University Press, 1998).

4. Muybridge's argument was reported as early as 1881: "From the time of the first graven image to that of Rosa Bonheur, there had never been the true representation of an animal in motion." *New York Times,* February 19, 1881, p. 2.

5. For Edison and Muybridge, see Charles Musser, *Edison Motion Pictures, 1890–1900: An Annotated Filmography* (Washington, D.C.: Smithsonian Institution Press, 1997), p. 69.

6. Eadweard Muybridge, *Animal Locomotion: An electro-photographic investigation of consecutive phases of animal movements* (Philadelphia: published under the auspices of the University of Pennsylvania, 1887).

7. See John Wilmerding, *Important Information Inside: The Art of John F. Peto and the Idea of Still-Life Painting in Nineteenth-Century America* (Washington, D.C.: Icon, 1983), p. 153.

8. In 1903, when the director of the Carnegie Institute, John Beatty, asked Homer about his painting style, Homer insisted that he never used the color and brushwork experiments of the Impressionists or Post-Impressionists: "When I have selected the thing carefully, I paint it exactly as it appears," he emphatically declared. Beatty, "Recollections of an Intimate Friendship," published in Lloyd Goodrich, *Winslow Homer* (New York: Macmillan. 1944) and cited in John McCoubrey, *American Art 1700–1960: Sources and Documents* (Upper Saddle River, NJ: Prentice Hall, 1965), p. 157.

9. The libel suit was brought by Whistler in response to a review of his paintings in which Ruskin exclaimed that he had "never expected to hear a coxcomb ask two hundred guineas for flinging a pot of paint in the public's face." At issue was Whistler's painting style, which employed quick, abstract evocation of a scene. When asked by Ruskin's attorney whether he asked the public to pay two hundred guineas for two days' work, Whistler replied, "No;—I ask it for the knowledge of a lifetime." Whistler himself published excerpts from the trial in his book of critics' writings on his work and his own replies, *Gentle Art of Making Enemies* (1890). Cited in McCoubrey, pp. 181–82.

10. Engerman and Gallman, p. 21.

11. Van Wyck Brooks, *John Sloan: A Painter's Life* (New York: E.P. Dutton, 1955), p. 77.

12. John Steele Gordon, *An Empire of Wealth: The Epic History of American Economic Power* (New York: HarperCollins, 2004), p. 243.

13. Arthur Hoeber, "Art and Artists," *Globe and Commercial Advertiser* (February 5, 1908), p. 9.

COSMOPOLITANISM and NATIONALISM

Edward P. Moran (1829–1901)

The Unveiling of the Statue of Liberty

Enlightening the World, 1886

Oil on canvas, 49½ × 39½ in. (125.7 × 100.3 cm)

Museum of the City of New York, The J.

Clarence Davies Collection, 34.100.260

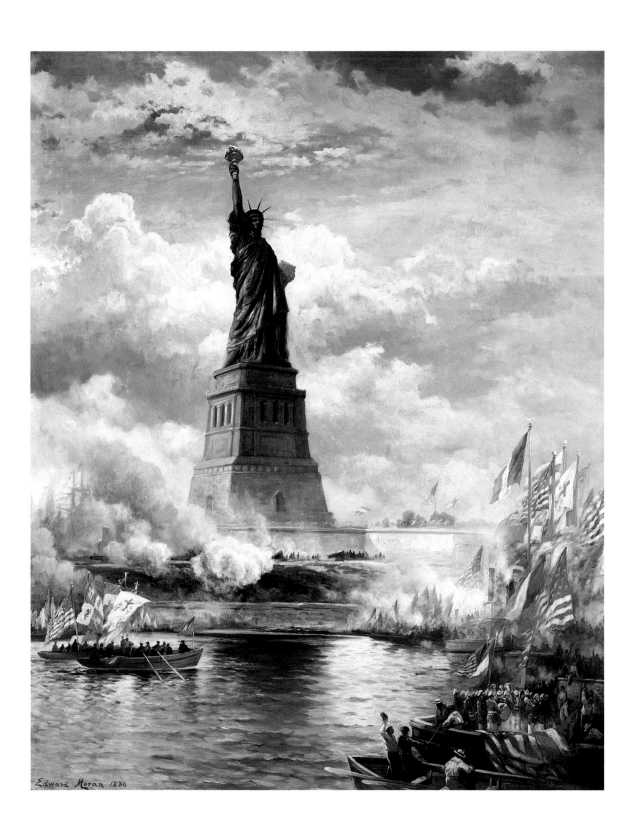

William Merritt Chase (1849–1916)

In the Studio, c. 1882

Oil on canvas, 28⅛ × 40⅛ in. (71.4 × 101.9 cm)

Brooklyn Museum, New York, Gift of Mrs.

Carll H. de Silver in memory of her husband

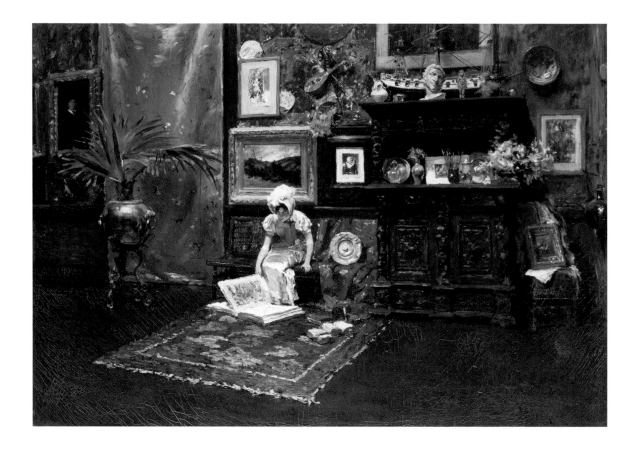

James Abbott McNeill Whistler (1834–1903)

Nocturne in Black and Gold, The Falling Rocket, 1875

Oil on wood, 23¾ × 18⅜ in. (60.3 × 46.7 cm)

The Detroit Institute of Arts

Gift of Dexter M. Ferry, Jr., 46.309

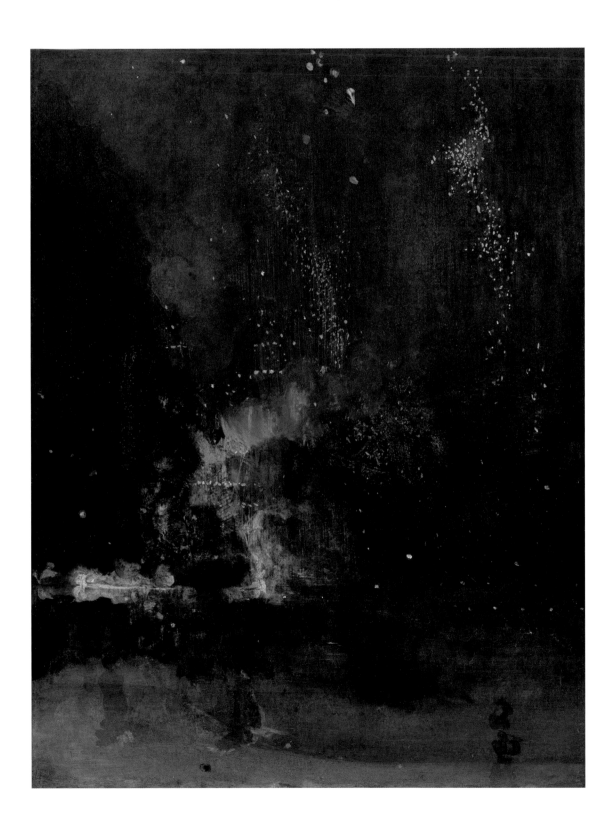

Childe Hassam (1859–1935)

Une Averse – rue Bonaparte, 1887

Oil on canvas, 40⅜ × 77½ in. (102.6 × 196.9 cm)

Terra Foundation for American Art, Chicago

Daniel J. Terra Collection, 1993.20

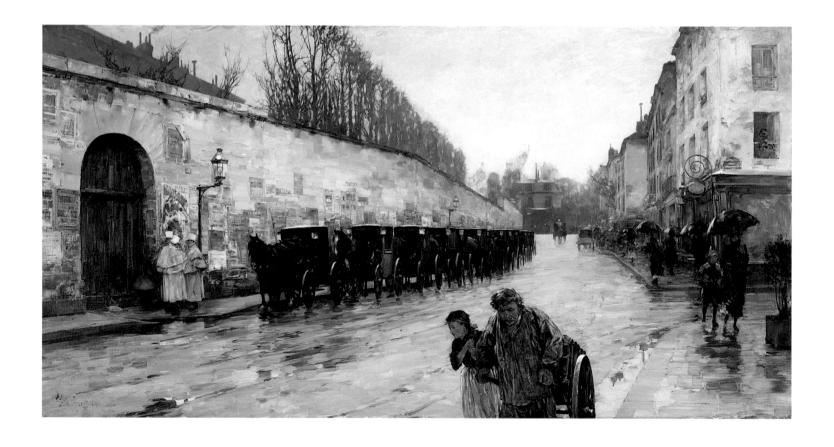

John Singer Sargent (1856–1925)

A Parisian Beggar Girl, c. 1880

Oil on canvas, 25⅛ × 17¼ in. (64.5 × 43.8 cm)

Terra Foundation for American Art, Chicago

Daniel J. Terra Collection, 1994.14

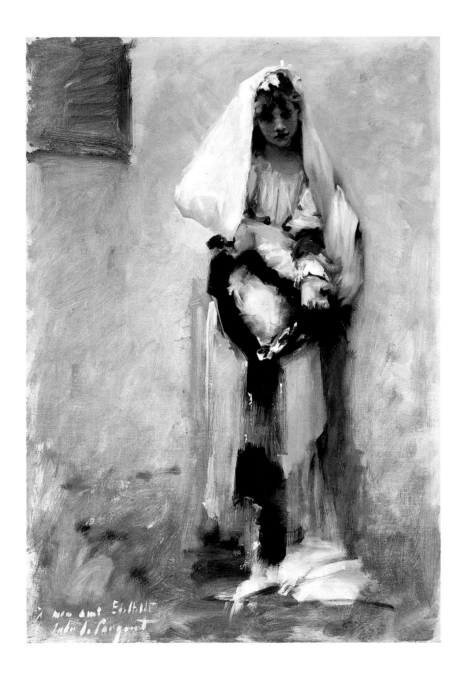

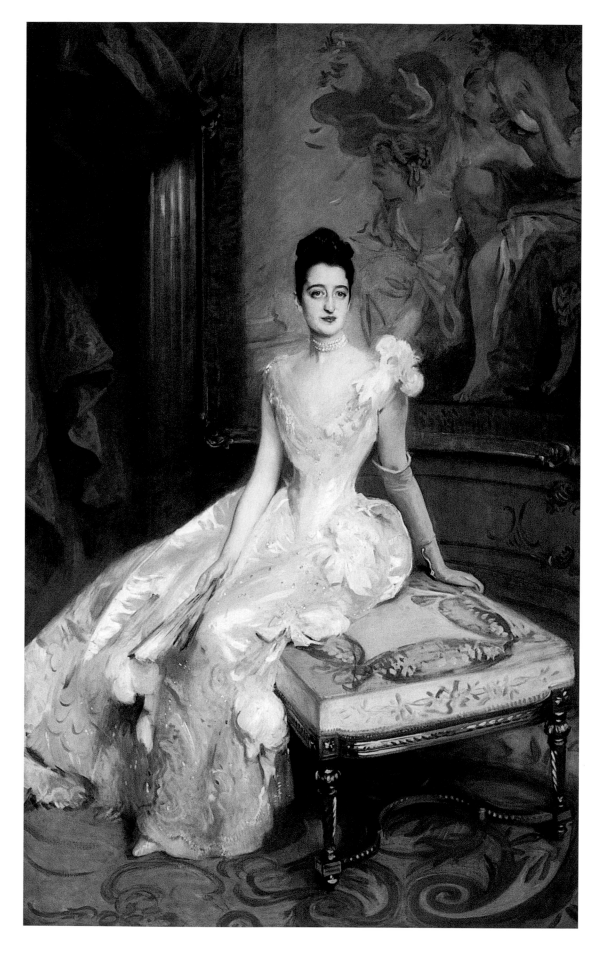

John Singer Sargent (1856–1925)

Mrs. Hamilton McKown Twombly, 1890

Oil on canvas, 90⅛ × 56½ in. (228.9 × 143.5 cm)

Columbia University, New York

Cosmopolitanism and Nationalism

William McGregor Paxton (1869–1941)

The New Necklace, 1910

Oil on canvas, 36⅛ × 28¾ in. (91.8 × 73 cm)

Museum of Fine Arts, Boston, Zoe Oliver

Sherman Collection, 1922.22.644

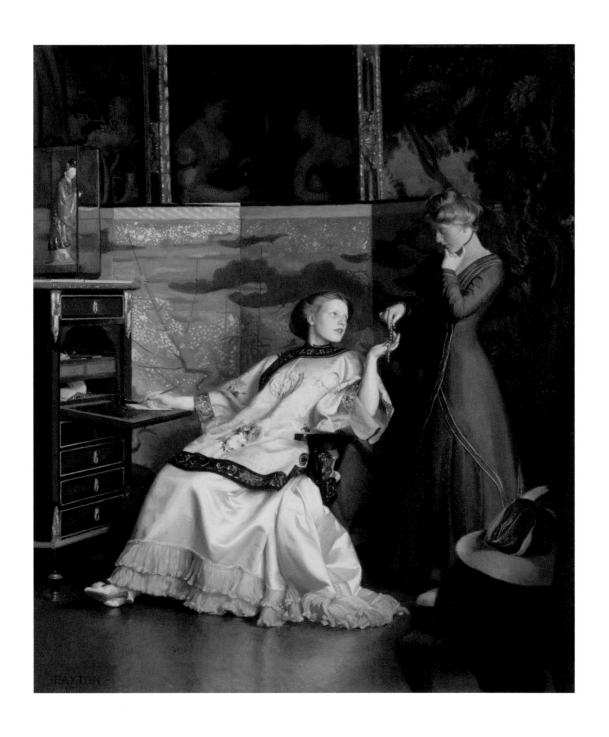

Frederick Frieseke (1874–1939)

Mrs. Frieseke at the Kitchen Window, 1912

Oil on canvas, 25¾ × 31¼ in. (65.4 × 80.6 cm)

Terra Foundation for American Art, Chicago

Daniel J. Terra Collection, 1987.12

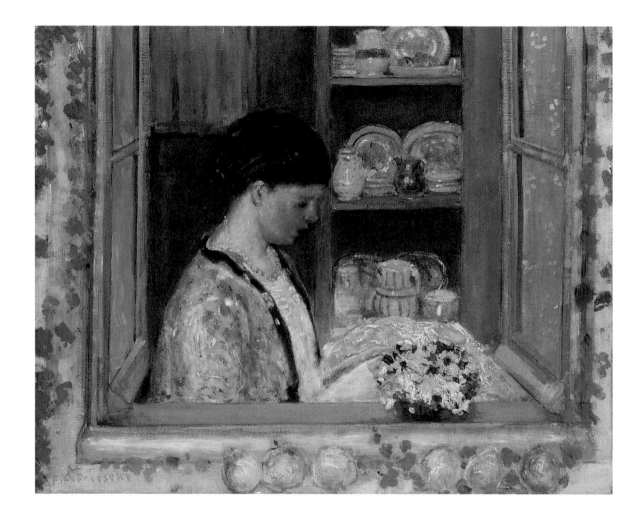

Cosmopolitanism and Nationalism

Mary Cassatt (1844–1926)

Jenny and Her Sleepy Child, 1891–92

Oil on canvas, 29 × 23¼ in. (73.7 × 60.3 cm)

Terra Foundation for American Art, Chicago

Daniel J. Terra Collection, 1988.24

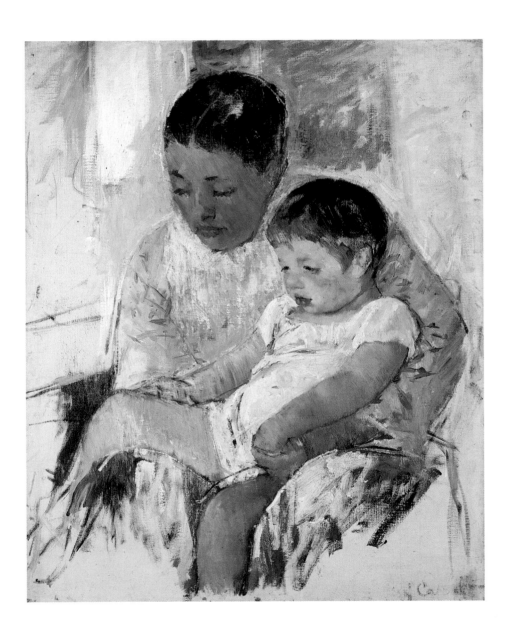

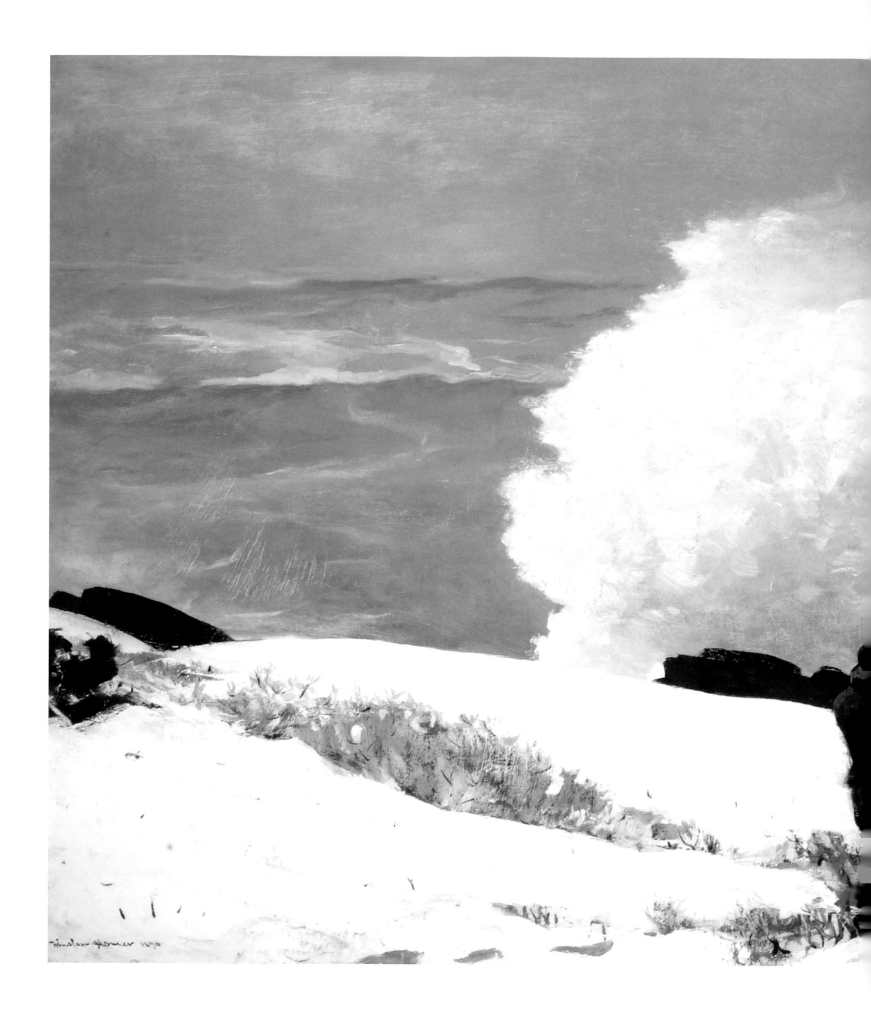

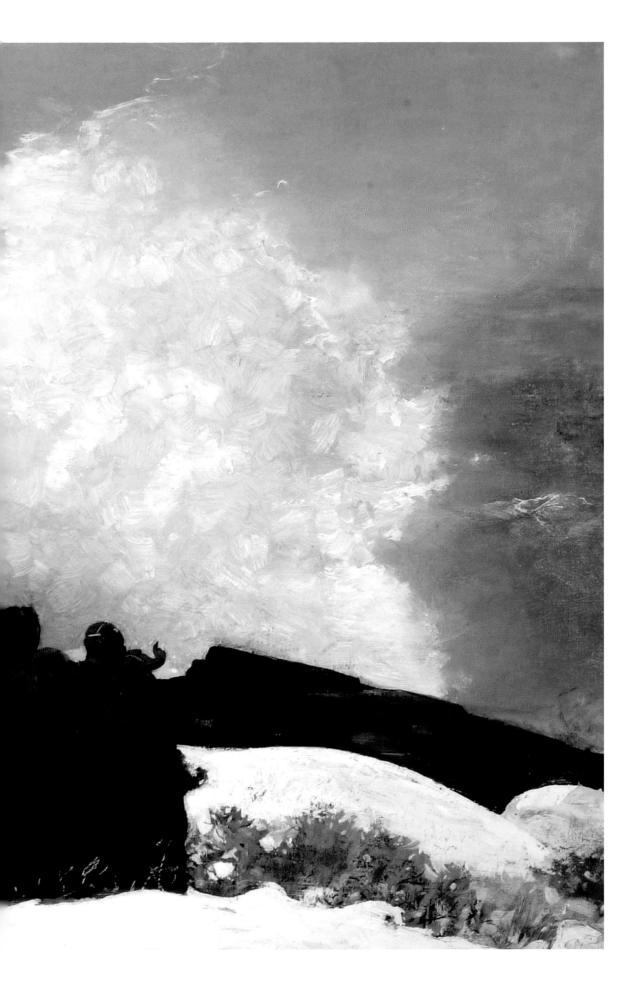

Winslow Homer (1836–1910)

Watching the Breakers: A High Sea, 1896

Oil on canvas, 38 × 41 in. (96.5 × 104.1 cm)

The Arkell Museum at Canajoharie,

New York

Thomas Eakins (1844–1916)

The Biglin Brothers Racing, 1872

Oil on canvas, 24⅛ × 36 in. (61.3 × 91.4 cm)

National Gallery of Art, Washington, D.C.

Gift of Mr. and Mrs. Cornelius Vanderbilt

Whitney, 1953.71

George Luks (1866–1933)

Knitting for the Soldiers: High Bridge Park

c. 1918

Oil on canvas, 30¼ × 36⅛ in. (76.8 × 91.8 cm)

Terra Foundation for American Art, Chicago

Daniel J. Terra Collection, 1999.87

Maurice Prendergast (1858–1924)

Fruit and Flowers, c. 1915

Oil on canvas, 19 × 22 in. (48.3 × 55.9 cm)

Montclair Art Museum, New Jersey

Museum purchase, Lang Acquisition Fund,
1954.20

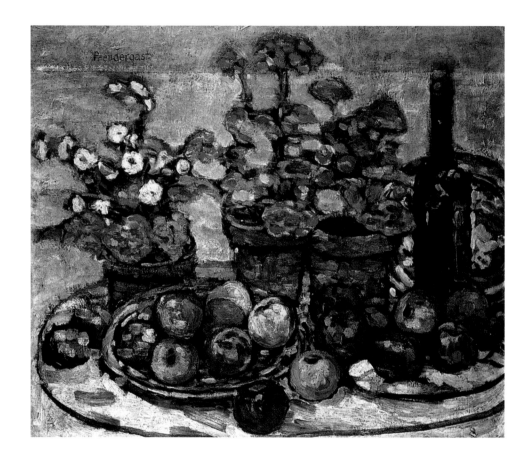

Maurice Prendergast (1858–1924)

Beach Scene, *c.* 1910–13

Oil on canvas, 30 × 34 in. (76.2 × 86.4 cm)

Williams College Museum of Art,

Williamstown, Massachusetts

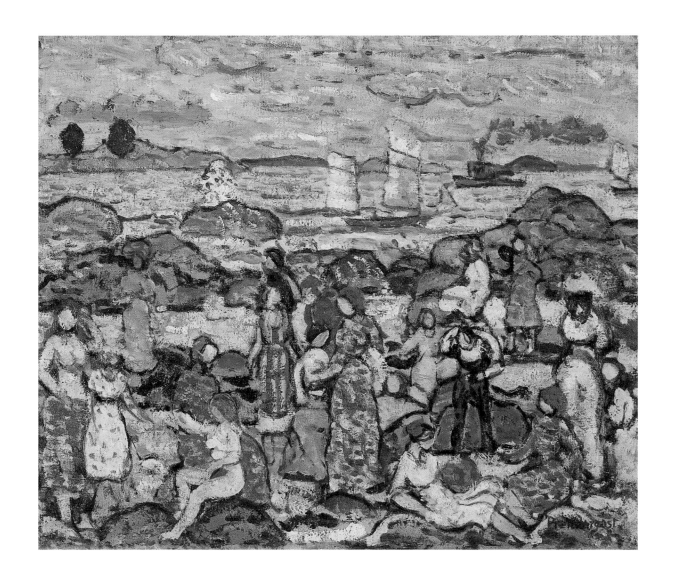

Ernest Blumenschein (1874–1960)

The Plasterer, 1922

Oil on canvas, 42 × 30 in. (106.7 × 76.2 cm)

Eiteljorg Museum of American Indians

and Western Art, Indianapolis

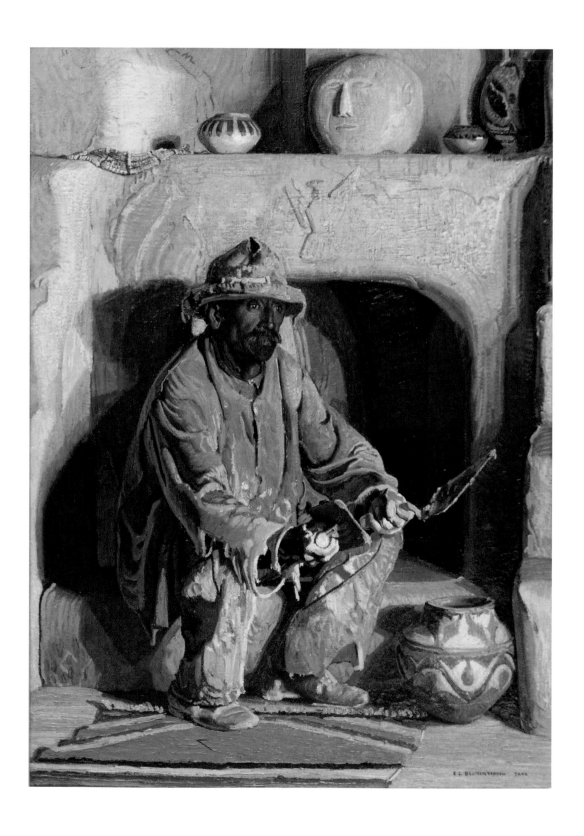

Cosmopolitanism and Nationalism

Robert Henri (1865–1929)

Gregorita, n.d.

Oil on canvas, 32 × 26 in. (81.3 × 66 cm)

Gilcrease Museum, Tulsa

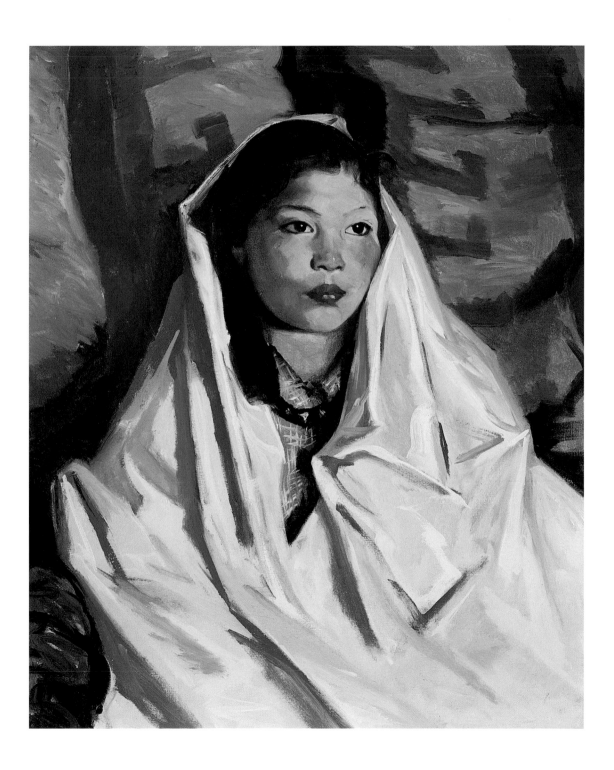

George Bellows (1882–1925)

Elinor, Jean and Anna, 1920

Oil on canvas, 59 × 66 in. (149.9 × 167.6 cm)

Albright-Knox Art Gallery, Buffalo,

New York, Charles Clifton Fund, 1923:32

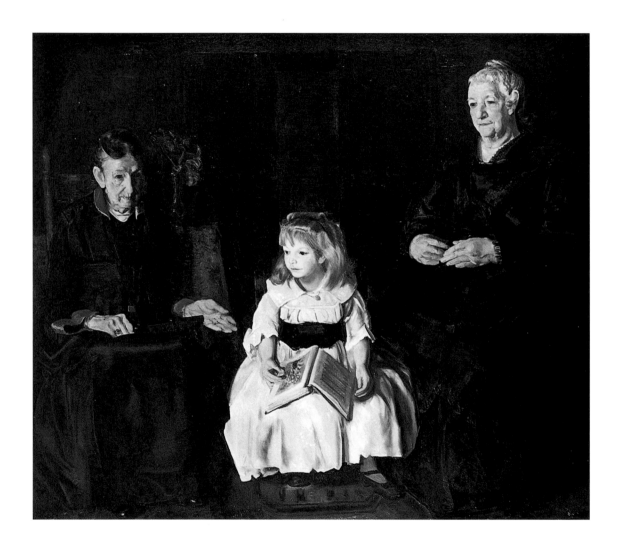

Robert Henri (1865–1929)

Chinese Lady, 1914

Oil on canvas, 40½ × 22½ in.

(102.9 × 57.2 cm)

Milwaukee Art Museum, Gift of Mr. and

Mrs. Donald B. Albert, M1965.61

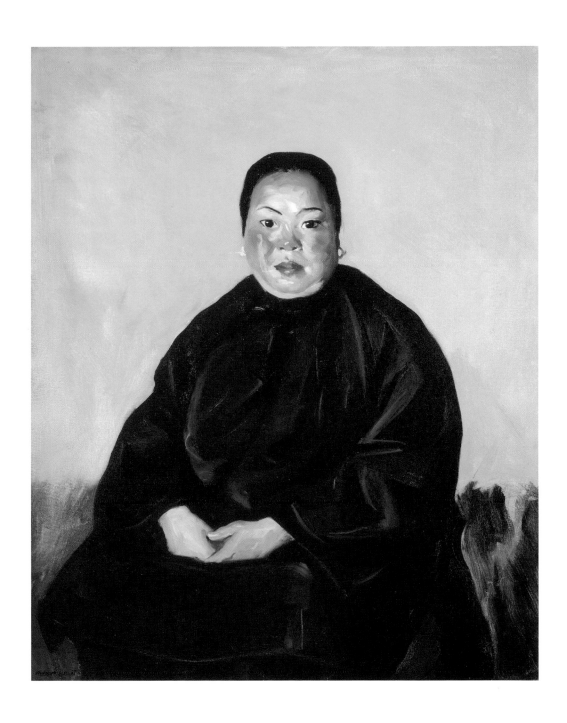

George Bellows (1882–1925)

Men of the Docks, 1912

Oil on canvas, 45¼ × 63½ in. (114.8 × 161.3 cm)

Maier Museum of Art, Randolph-Macon

Woman's College, Lynchburg, Virginia

First purchase of the Randolph Macon

Art Association, 1920, M.1920.1

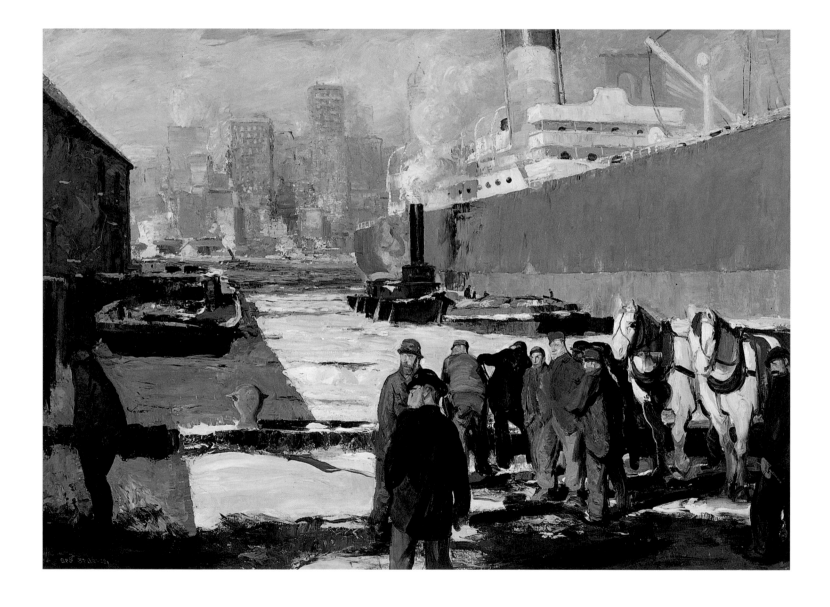

Cosmopolitanism and Nationalism

John Sloan (1871–1951)

Election Night, 1907

Oil on canvas, 26⅜ × 32¼ in. (67 × 81.9 cm)

Memorial Art Gallery of the University of

Rochester, New York, Marion Stratton

Gould Fund, 41.33

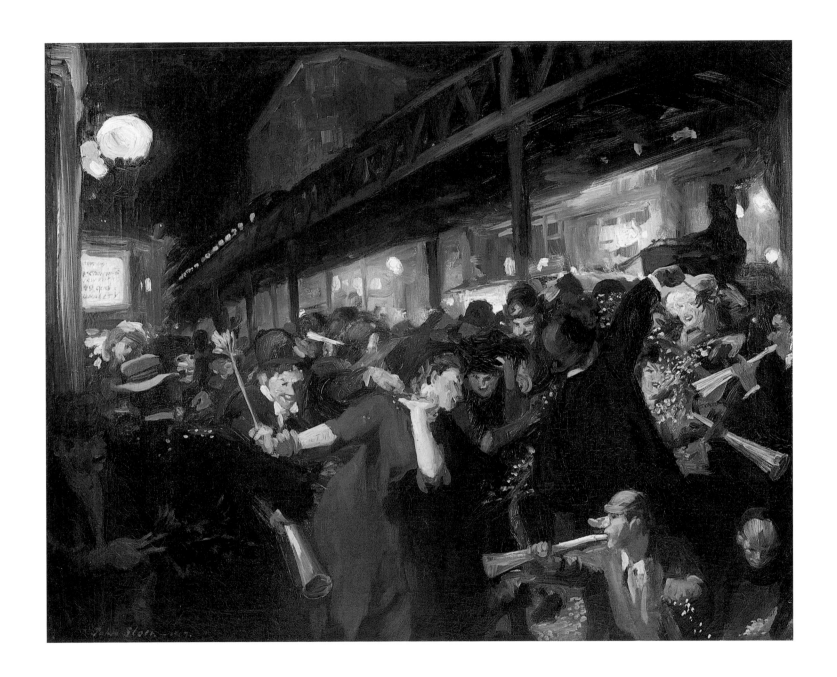

Frank W. Benson (1862–1951)

Lady Trying on a Hat (The Black Hat), 1904

Oil on canvas, 40¹⁄₄ × 32¹⁄₈ in. (102.2 × 81.6 cm)

Rhode Island School of Design Museum,

Providence, Gift of Walter Callender,

Henry D. Sharpe, Howard L. Clark, William

Gammell and Isaac C. Bates, 06.002

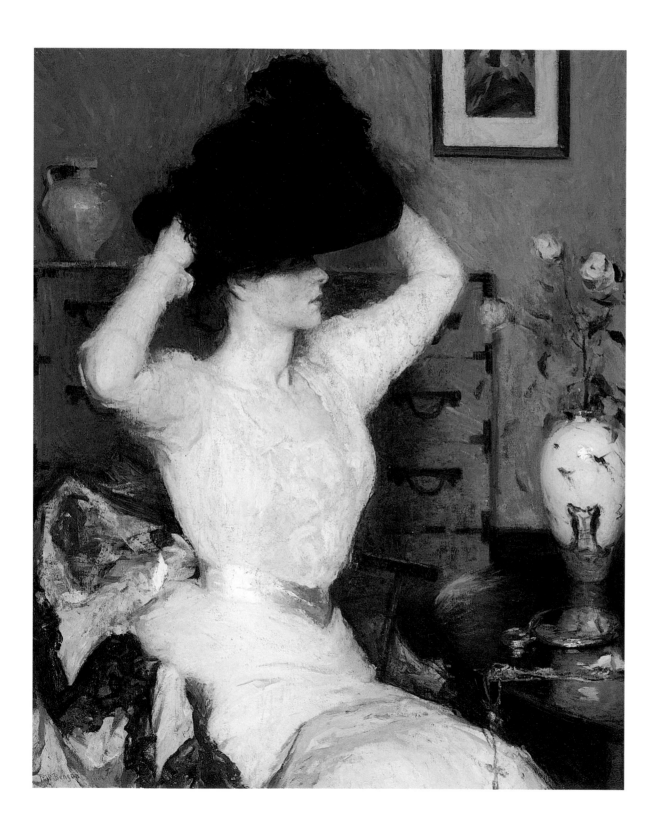

Cosmopolitanism and Nationalism

John Sloan (1871–1951)

Hairdresser's Window, 1907

Oil on canvas, 31⅞ × 26 in. (80.6 × 66 cm)

Wadsworth Atheneum Museum of Art,

Hartford, Connecticut, The Ella Gallup Sumner

and Mary Catlin Sumner Collection Fund

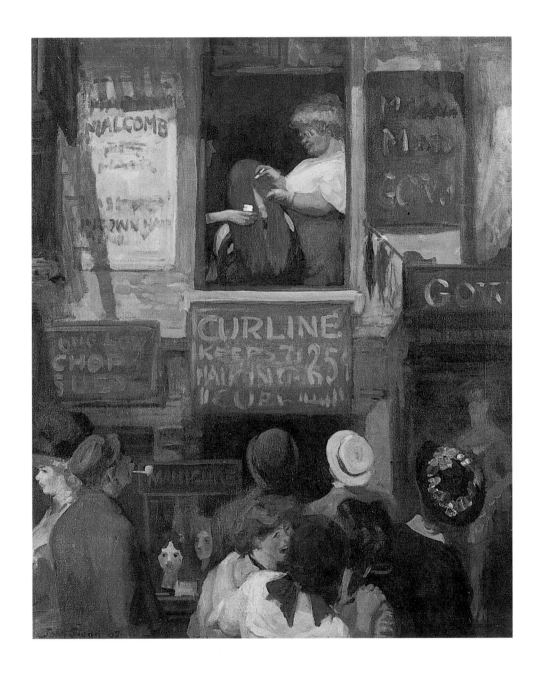

William Glackens (1870–1938)

The Shoppers, 1907–08

Oil on canvas, 60 × 60 in. (152.4 × 152.4 cm)

Chrysler Museum of Art, Norfolk, Virginia

Gift of Walter P. Chrysler, Jr.

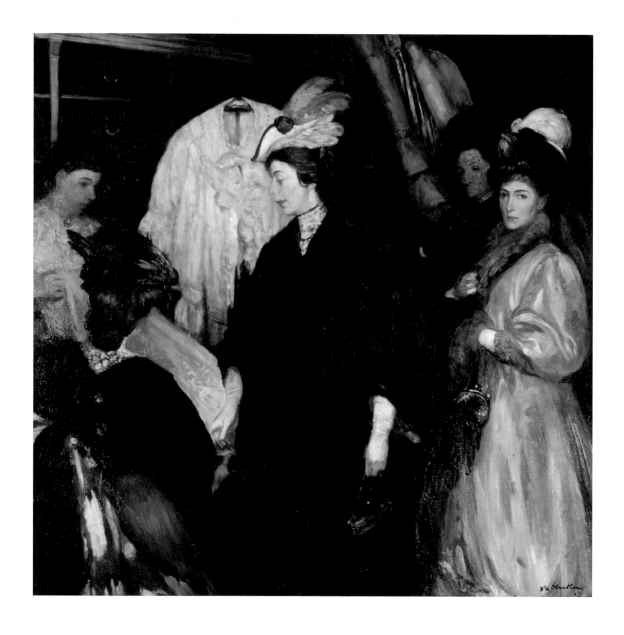

Cosmopolitanism and Nationalism

Everett Shinn (1876–1953)

The Vaudeville Act, 1902–03

Oil on canvas, 17¹/₂ × 19¹/₂ in. (44.5 × 49.5 cm)

Penn State University, University Park,

Pennsylvania, Collection of the Palmer

Museum of Art

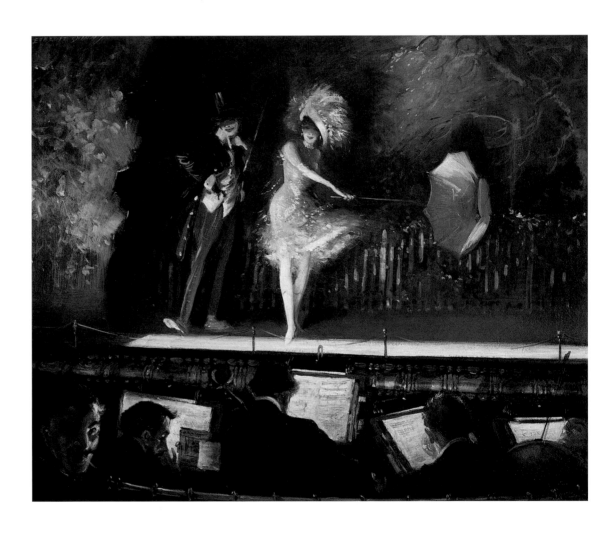

(1915–45)

Modernism and Regionalism

The Politics of American Modernism

Justin Wolff

According to Clement Greenberg (1909–1994), one of the most influential critics of Modern art during the 1940s and 1950s, good paintings emphasized their own surfaces, were concerned primarily with formal questions, and were produced most satisfactorily by the Abstract Expressionists. In "Abstract Art" (1944), Greenberg summarized one of his principal arguments: "Let painting confine itself to the disposition pure and simple of color and line," he urged, "and not intrigue us with things we can experience more authentically elsewhere."[1] His point was that art, painting in particular, was destined to address only itself and not those "things"—be they political, social, or religious—that we encounter through other means. Though Greenberg's thesis that Modern art attempted systematically to distance itself from politics is compelling, and though he was correct to emphasize the formal concerns of Modern painters, today his arguments seem impossibly quaint and idealistic, for the story of American Modernism is a political one. Put simply, the formal innovations of such painters as Stuart Davis (1894–1964) and Thomas Hart Benton (1889–1975) were intended and received as engagements with, for instance, Communist and liberal ideologies. In fact, one way to isolate the beginnings of Modernism in America is to identify the moment when artists began to turn away from the escapism of preceding generations and to see their art as intertwined with contemporary social and political life. Modern art in America was a piece of modernity in America.

EARLY ABSTRACTION:
THE ARMORY SHOW AND THE FORUM EXHIBITION

One event that historians commonly associate with the beginnings of American Modernism was the Armory Show. Officially known as the International Exhibition of Modern Art, the show opened on February 17, 1913, at an armory in Manhattan belonging to the New York National Guard. The exhibition, which lasted just one month and then traveled to Boston and Chicago, included over one thousand paintings, sculptures, and decorative works, of which a majority were by American and the rest by European artists. The exhibition, organized by the Association of American Painters and Sculptors, had as its original purpose the showcasing of American artists, but under the guidance of the Association's president Arthur B. Davies (1862–1928), who was sympathetic to European avant-garde art, the exhibition took on an international flavor and became a forum for comparing and contrasting artists from Germany and France with those from the United States.

Much of the public's reaction to the Armory Show was reserved for the now-iconic *Nude Descending a Staircase, No. 2* by Marcel Duchamp (1887–1968; fig. 76). The painting, which represents a single figure at several points in space and time, confounded and angered critics. Theodore Roosevelt, US president from 1901 to 1909, reviewed the exhibition in the guise of a "layman" and equated Duchamp's painting with the "really good Navajo rug" that hung on his bathroom wall; another critic memorably described the painting as an "explosion in a shingle factory."[2] Other European artists represented in the Armory Show were Constantin Brancusi, Paul Gauguin, Paul Cézanne, and Henri Matisse, whose paintings struck one visitor as "the most hideous monstrosities ever perpetrated in the name of long-suffering art."[3]

Despite the astonishment of these critics, the American works in the exhibition illustrated that artists in the United States had already come to terms with European stylistic innovations. Such painters as Maurice Prendergast (1858–1924) and Marsden Hartley (1877–1943), for example, exhibited works that demonstrated their sympathy with Post-Impressionist painting in France. The Armory Show, however, was a

crucial moment in the development of American Modernism not only because it offered urban audiences their first encounter with the forms and influence of the European avant garde, but also because it drew connections between cultural and political independence. Most of the printed material accompanying the exhibition, such as posters and postcards, included an illustration of a pine tree that closely resembled the symbol adorning many New England flags during the Revolutionary War. The American organizers of the Armory Show were intent on developing an analogy between the country's war for independence and its new art, thus reinforcing longstanding beliefs that cultural innovation was emblematic of political change.[4]

This nationalist message was not lost on Alfred Stieglitz (1864–1946), a photographer and perhaps the most important patron of and spokesperson for Modern art in America from 1915 to 1935. Before and immediately after the Armory Show, Stieglitz operated a gallery, known as the 291 Gallery (named after its address on Fifth Avenue in New York), that promoted the art of such Parisian Modernists as Brancusi, Matisse, and Picasso as well as American painters and sculptors—John Marin (1870–1953), Alfred Maurer (1868–1932), and Arthur Dove (1880–1946) among them—influenced by European trends. Though 291 remained in operation until 1917, following the Armory Show Stieglitz began to champion American artists almost exclusively. Stieglitz's own photographs from the first decades of the twentieth century celebrated New York's technology and romanticized the city's urban constructions; one of his subjects was the Flatiron (fig. 77), a uniquely shaped building that he once described as "moving toward me like the bow of a monster ocean steamer—a picture of new America still in the making."[5]

It was in 1916, however, that Stieglitz put his newfound nationalism into action. That year Stieglitz and four other men from the New York art world helped the critic Willard Huntington Wright (1888–1939) organize the Forum Exhibition of Modern American Painters at the Anderson Galleries. Wright was the brother of Stanton Macdonald-Wright (1890–1973), who with Morgan Russell (1886–1953) founded a new style of painting, called Synchromism, in Paris in 1913. Macdonald-

Wright returned to New York in 1915, bringing with him his strange new canvases, and Synchromism was understood as one of the first abstract styles developed by American artists. As the two men envisioned it, Synchromism was a manner of painting based on the notion that color and sound are analogous and that colors can be arranged—or orchestrated—in scales, thus evoking new sensations. Macdonald-Wright's *Oriental: Synchromy in Blue-Green* is typical of his early work in that it represents volume and dynamism using distinct "notes" of color. Willard Huntington Wright was close to his brother and lived with him in New York on and off during these years; as a result, he was friendly with many early American Modernists and he conceived of the Forum Exhibition as a way to showcase their talent.

The exhibition's catalogue explained that it meant "to turn public attention for the moment from European art and concentrate it on the excellent work being done in America."[6] That "excellent work" included 193 canvases by seventeen artists, including Macdonald-Wright, Hartley, Marin, Dove, and Thomas Hart Benton, all of whom at least knew Stieglitz and desired his blessing. Though these artists worked in various styles, they all used at least some abstract elements, and the Forum Exhibition, though not a success financially speaking, consecrated this first wave of American abstract painting. One of Hartley's contributions to the exhibition was *Movements* (fig. 78), a large oil painting that resembles his *Painting No. 50* (p. 211), which was exhibited at 291 in the same year as the Forum Exhibition. Though there are important differences between the two paintings—*Painting No. 50* is more delicate and symmetrical than *Movements*—both works arrange fundamental geometric shapes into flat patterns. In addition, both paintings formulate experience of the material world as personal, imaginative, and pictorial. In his brief statement for the exhibition, Hartley remarked, "It will be seen that my personal wishes lie in the strictly pictural [*sic*] notion, having observed much to this idea in the kinetic and the kaleidoscopic principles. Objects are incidents: an apple does not for long remain an apple if one has the concept."[7] In other words, objects, according to Hartley, limit our experience of nature—it is the conception of an object that is fresh and poignant.

Fig. 77 **Alfred Stieglitz (1864–1946)**
The Flatiron Building, Plate I from *Camera Work* (New York), no. 4, October 1903
Gravure on vellum, 12⅞ × 6⅝ in. (32.7 × 16.8 cm)
The Museum of Modern Art, New York
Purchase 403.1976

Fig. 78 **Marsden Hartley (1877–1943)**
Movements, 1915
Oil on canvas, 47⅛ × 47¼ in. (119.7 × 120 cm)
The Art Institute of Chicago
Alfred Stieglitz Collection, 1949.544

Fig. 79 Charles Henry Demuth (1883–1935)

The Figure 5 in Gold, 1928

Oil on cardboard, 35¼ × 30 in. (90.2 × 76.2 cm)

The Metropolitan Museum of Art, New York

Alfred Stieglitz Collection, 1949 (49.59.1)

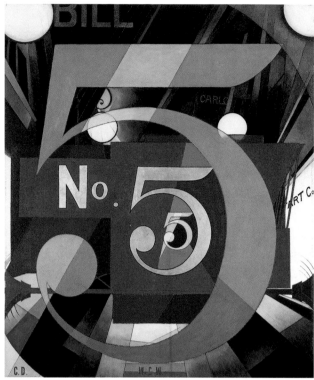

Fig. *80 (below)* Lewis Hine (1874–1940)

Powerhouse Mechanic working on

Steam Pipe, 1920

Gelatin-silver print

National Archives and Records

Administration, Records of the Work

Projects Administration (69-RH-4L-2)

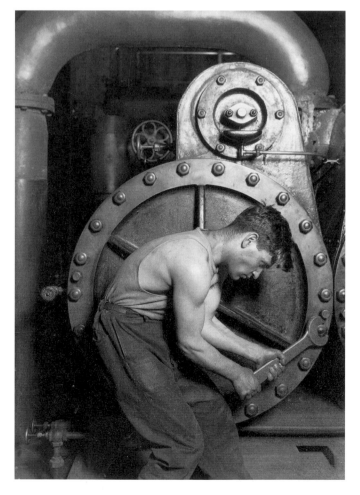

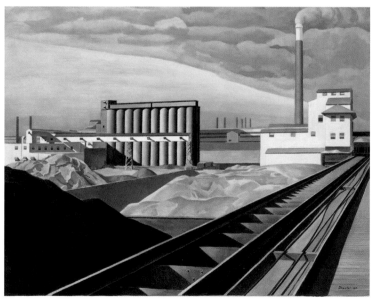

Fig. *81 (above)* Charles Sheeler (1883–1965)

Classic Landscape, 1931

Oil on canvas, 25 × 32¼ in. (63.5 × 81.9 cm)

National Gallery of Art, Washington, D.C.

Collection of Barney A. Ebsworth, 2000.39.2

Similarly, Dove believed that impressions gathered from nature were more provocative than material actuality. One of his paintings in the Forum Exhibition, *Nature Symbolized, No. 2*, illustrates his desire "to give in form and color the reaction that plastic objects and sensations of light from within and without have reflected from my inner consciousness." Despite his earnest ambitions, however, the painting is also an apt emblem for Dove's beliefs that sensation "should be a delightful adventure" and that one ought to "enjoy life out loud."[8]

Willard Huntington Wright was acutely conscious of the theories of the painters in the exhibition, and in his essay for the catalogue, titled "What is Modern Painting?," he ranked abstraction above the representation of recognizable objects. Benton, who in the 1920s would abandon abstraction for a modern realism, also contributed to the catalogue, remarking, "In conclusion I wish to say that I make no distinctions as to the value of subject matter. I believe the representation of objective forms and the presentation of abstract ideas of form to be of equal artistic value."[9]

As noteworthy as the avant-garde nature of the paintings on display was the degree to which the organizers of the exhibition struck the chord of American exceptionalism. Many of the participants in the exhibition felt that the Armory Show had reinforced the popular notion that Modern American art insincerely copied European innovations, and Wright's foreword to the catalogue illustrated his belief that the Forum Exhibition was an opportunity to remedy this view. In his catalogue article, John Weichsel complained about the stodgy conventionalism of American art patrons ("As a rule, art-patronage adds weight to long-established standards"), and Stieglitz, in his essay, expressed a hope that the Forum Exhibition would once and for all show the American people that "no public can help the artist unless it has become conscious that it is only through the artist that it is helped to develop itself."[10]

In recent years, American historians and art historians have started to identify the beginnings of the rhetoric of American exceptionalism not in the years around World War II but in the years before and after the Forum Exhibition.[11] Nor was this nationalist rhetoric limited to painters; poets and essayists of the period also employed a nationalist rhetoric. Carl Sandburg (1878–1967), for instance, in his book of poems *Chicago* (1916), celebrated the average American citizen living in cities. In his poem "Masses", Sandburg writes, "Great men, pageants of war and labor, soldiers and workers,/mothers lifting their children—these all I/touched, and felt the solemn thrill of them."[12] And in 1915, the literary historian Van Wyck Brooks (1886–1963), a nationalist member of the Stieglitz circle, spoke of the need to identify in America a usable past and to adopt an artistic expression that sought high ideas in the nation's everyday life.[13]

The point here is that the Forum Exhibition ought to be understood as far more than a first step in the direction of Greenberg's art-for-art's-sake; the exhibition was born in the context of a political idea, one that was nationalist and that sought to wrest away American art from bourgeois interests and capitalist promoters of European culture. In this sense early American abstraction can be conceived of as emblematic of a new order, one in which the artist did not merely record society but shaped it as well.

DYNAMIC AMERICA: NEW FORMS FOR A NEW ORDER

During the years before and after World War I, American artists turned to the city, New York especially, and machines and industry for their subjects. These were appropriate symbols for the new art because urbanism and industry were growing in America faster than anywhere else, and artists and average citizens alike believed this to be emblematic of the nation's youth, vitality, and modernity. In addition, because most of these artists lived in New York, it made sense for them to examine their home city as the location of a new society that was distinct from typical bourgeois America. Finally, after World War I—a horrific conflagration that annihilated whole regions of Europe—artists, writers, and philosophers from all over the globe identified in America's cities and industry a "new world order based on rationality and science."[14] The artist Louis Lozowick (1892–1973), who was born in Russia, commented on this trend in a 1927 essay titled "The Americanization of Art": "The intriguing novelty, the crude virility, the stupendous magnitude of the new American environment furnishes such material in extravagant abundance."[15]

The appearance of Duchamp in New York in 1915 also influenced this turn to a machine aesthetic. Just before his arrival, Duchamp had stopped painting and turned his attention to "readymades," found industrial objects that he exhibited as sculptures. The most famous of these Dada sculptures was *Fountain,* a urinal that he turned upside-down and exhibited in New York, where Stieglitz photographed it using a Hartley painting as the backdrop. Though Duchamp's readymades were intended as layered critiques of "high art," one effect they had was to liberate those American artists who were already suspicious of conventional attitudes among audiences and gallery-owners regarding appropriate subject matter.

Joseph Stella (1877–1946) was one such artist. An Italian by birth, Stella was influenced by Futurism, an art movement that took hold in his native country in 1909. The Futurists admired the speed, movement, and power of machinery, all of which were visible in New York City. Stella was especially struck by these modern elements during a nighttime visit to Coney Island in 1913. Coney Island's park, with its colorful crowds, bright lights, and noisy, mechanical amusements, is the subject of his *Battle of Lights, Coney Island* (fig. 16), a painting that transforms the site's cacophony into prismatic colors and a hallucinatory swirl of fractured shapes. In keeping with the philosophies of the Futurists, Stella identified in American technology a spiritual dimension—a truly New World. He painted the Brooklyn Bridge (p. 213), an icon of American ingenuity completed in 1883, and a decade later he remembered that "many nights I stood on the bridge . . . [feeling] deeply moved, as if on the threshold of a new religion or in the presence of a new DIVINITY."[16]

The painter Charles Demuth (1883–1935) also studied the forms and attitudes of the city. Though he was yet another artist who benefited from an association with Stieglitz, he was not a pure New Yorker. Demuth divided his time between Manhattan and Lancaster, Pennsylvania, the small city where he was born and which he painted in *Welcome to Our City* (p. 215). The painting, which illustrates the nineteenth-century courthouse he could see from his home, transforms his view into an abstracted cityscape where buildings from different eras flatten out and overlap. This aspect of his work—the conversion of architectural spaces into meticulous designs—came to be called "Precisionism" and, until the mid-1920s, artists who worked in this style, including Georgia O'Keeffe, were sometimes referred to as "Immaculates."

The most famous example of Precisionism is Demuth's *The Figure 5 in Gold* (fig. 79), a painting influenced by the poem "The Great Figure" written in 1921 by Demuth's college friend William Carlos Williams (1883–1963). Years later, in his autobiography, Williams remembered the incident that inspired his poem. It was a hot day in July and the poet dropped in on his friend Marsden Hartley "for a talk, a little drink maybe and to see what he was doing." Williams continues: "As I approached . . . I heard a great clatter of bells and the roar of a fire engine passing the end of the street down Ninth Avenue. I turned just in time to see a golden figure 5 on a red background flash by. The impression was so sudden and forceful that I took a piece of paper out of my pocket and wrote a short poem about it."[17]

> The Great Figure
> Among the rain
> and lights
> I saw the figure 5
> in gold
> on a red
> fire truck
> moving
> tense
> unheeded
> to gong clangs
> siren howls
> and wheels rumbling
> through the dark city[18]

Demuth's painting depicts the figure 5 "moving . . . unheeded" directly at the viewer and shows the two headlights of the speeding fire truck. The

painting also manages to describe the noise of "gong clangs/siren howls/and wheels rumbling," sensations embodied in the precise lines that radiate out from the center of the canvas. Ten years after Williams wrote his poem, and just three years after Demuth made his painting, the journalist Frederick Lewis Allen reflected on the opulence of the 1920s and described with uncanny accuracy the attitude of many artists of the period: "One of the striking characteristics of the era of Coolidge Prosperity," he wrote, "was the unparalleled rapidity and unanimity with which millions of men and women turned their attention, their talk, and their emotional interest upon a series of tremendous trifles— a heavyweight boxing-match, a murder trial, a new automobile, a transatlantic flight."[19]

The machines and industry of the 1920s struck some American artists as reincarnations of classical forms. The photographer Lewis Hine (1874–1940), for example, spent much of the decade taking pictures of the men who built New York's skyscrapers and worked in the bowels of the city's industrial buildings. His 1925 photograph *Powerhouse Mechanic* (fig. 80) has become an icon of this era. The photograph's impact derives from its blunt comparison of manual labor with mechanical power: Hine depicts man and machine as at war—as forces that struggle against one another—yet at the same time the photograph, because of its symmetry and allusion to classical forms and proportions, shows man and machine as complementary and equally awesome forces. The kind of social commentary embedded in the photograph was not uncommon during the first decades of the twentieth century, but sympathy for the working class would be expressed more fully by American artists in the 1930s, during the Depression.

Charles Sheeler (1883–1965) was another artist who identified a classical iconography in the American industrial landscape. Sheeler was first seduced by industrial spaces in 1927, when he was hired by an advertising agency to photograph a new Ford Motor Company complex on the Rouge River near Detroit, Michigan, and in the years that followed he painted and photographed factories almost exclusively. Like Demuth, Sheeler was a Precisionist painter, though his subjects are more literal and his depiction of space more three-dimensional.

Classic Landscape (fig. 81) demonstrates the severity of Sheeler's aesthetic: the painting is composed of repeated parallel and perpendicular lines, the lighting is harsh, and the scene is utterly devoid of human presence. What was in fact a noisy and busy factory becomes in this painting a silent temple. Not surprisingly, after spending so much time studying industrial buildings, Sheeler came to see them as shrines to a new order and as modern equivalents to medieval cathedrals—"our substitute for religious expression," he said.[20]

In this instance, William Carlos Williams was influenced by a painting: six years after Sheeler produced *Classic Landscape,* Williams published a poem titled "Classic Scene" (1937) which describes a power plant in a voice as sparse and precise as Sheeler's style. What matters more than these little influences, however, is how American artists and writers had jointly anointed industry a "high" subject in their paintings, poems, and essays.

Perhaps the supreme expression of this paradox—this introduction of low subjects into high art—was Benton's mural *America Today.* Benton was a controversial but principal player in the story of American Modernism. From 1915 to 1945, he crossed paths with every major artist and artistic movement: he knew Macdonald-Wright in Paris; he met and corresponded with Stieglitz in New York; early in his career, he painted Synchromist canvases and contributed abstracted figure compositions to the Forum Exhibition; later, he rejected abstraction and painted massive narrative murals for important clients; he was a teacher and mentor to Jackson Pollock, perhaps the most famous American artist; and he wrote controversial essays and reviews for every major arts publication in New York. Though he later feuded with some major figures of the period (including Stieglitz and the painter Stuart Davis), during the late 1920s and early 1930s Benton believed—as most Modernists did—that contemporary experience rather than distant history or mythology was the only appropriate subject for serious artists. From the beginning of his career, however, he admired the great Renaissance painters, especially Michelangelo, and his unique contribution to American Modernism was to depict contemporary social and political life in a historical medium—mural painting.

Fig. 82 Thomas Hart Benton (1889–1975)
City Activities with Dance Hall
from *America Today*, 1930
Distemper and egg tempera on gessoed
linen with oil glaze, 92 × 134⅛ in.
(233.7 × 341.6 cm)
Collection of AXA Financial, Inc.,
through its subsidiary The Equitable Life
Assurance Society of the US

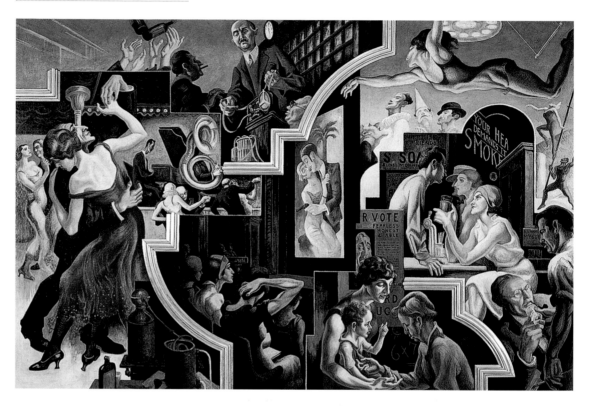

Fig. 83 Aaron Douglas (1899–1979)
Aspects of Negro Life: From Slavery
Through Reconstruction, 1934
Oil on canvas, 60 × 139 in. (152.4 × 353.1 cm)
New York Public Library, Collection of
The Schomburg Center for Research in
Black Culture

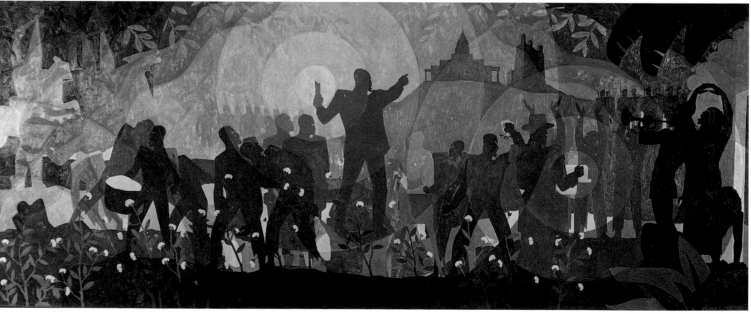

His first big mural commission was for the New School for Social Research, a university established in Manhattan in 1919 and conceived of as a liberal alternative to traditional schools and as a progressive institution intent on promoting Modernism and scientific reasoning in the service of social justice. When the school made plans for a new building, its board wanted distinctly Modern painters to decorate its walls: the work, the school's director demanded, should be "of such importance that no history written a hundred years from now could fail to devote a chapter to it."[21] The new building, designed by Joseph Urban (1872–1933), opened to the public in 1931 and included murals by Benton and the Mexican painter José Clemente Orozco (1883–1949).

America Today, as Benton's mural series is called, does not seem to meet the commission's demands; it is not clear at first glance how this mural makes "history." The panels are lavish—crowded with colors, figures, and overlapping narratives—and so resist easy interpretation and categorization. As mentioned earlier, however, part of the mural's success is the way it takes a seemingly mundane subject, everyday America, and makes it grand: dancing, theater-going, even drinking, take on importance just by virtue of the fact that they are plastered, in massive scale, on the walls of a Modern building. But Benton's great triumph in the mural is how he integrates varied people and activities from daily life into a single work. Within each particular vignette and within the mural as a whole, he depicts manual labor and mechanized power as simultaneous means of production; in such panels as *City Activities,* he illustrates the connections between individual effort, seen in the foreground, and the construction of society, represented by the skyscrapers in the distance. Benton shows his "today," 1920s America, as a bustling and entertaining dynamo, a nation running on the energy of farmers, laborers, lovers, and dancers. Only a mural, a medium requiring much industry and bravado, could do justice to this new spirit.

The director of the New School, it turned out, was pleased: Benton, he wrote, "has observed the sense of triumph on the face of the man who handles a great machine, taps a blast furnace, sees a building rising out of the blueprint in his hands."[22] But Benton's best trick in *America Today* was to include himself in the mix; he is there in the lower right-hand corner of the panel *City Activities with Dance Hall* (fig. 82), holding a paintbrush and toasting none other than Alvin Johnson, the New School's director. The new artist in America, according to Benton, intervenes in modernity.

BLACK EXPERIENCES: THE HARLEM RENAISSANCE

Cultural change during the 1920s was not limited to the area of lower Manhattan. In the upper portion of the city, in the mostly black neighborhood of Harlem, philosophers, writers, and artists discovered new voices and forms in which to express and transform their unique American experiences. Certainly the African-American community in Harlem was influenced by "white" Modernism, but the Harlem Renaissance was more a consequence of artistic heritages that blacks from the American South and the Caribbean carried with them to the city. Even before the 1920s, black music, notably jazz and the blues, had become very popular, resulting in the opening of numerous successful nightclubs. But in the decades that followed, many blacks—facing gross oppression in the South, including lynching—migrated to northern cities and sought in places like Harlem to modernize their culture and establish a new racial consciousness.

One of the leaders of this new movement was Alain Locke (1886–1954), a professor of philosophy, who in 1924 was asked to edit a special volume of the journal *Survey Graphic* dedicated to the so-called "New Negro." Locke began his first essay for the volume by lamenting how little white New Yorkers actually knew about Harlem, but he assured his readers that the neighborhood had the potential to revolutionize race relations throughout America:

> First, we shall look at Harlem . . . as the waymark of a momentous folk movement; then as the center of a gripping struggle for an industrial and urban foothold. But more significant than either of these, we shall also view it as the stage of the pageant of contemporary Negro life. In the drama of its new and progressive aspects, we may be witnessing the resurgence of a race.[23]

Perhaps the most articulate literary voice of this "resurgence" belonged to Langston Hughes (1902–1967), a poet and essayist who celebrated ordinary black experience and vigorously promoted black pride. In one essay, Hughes stressed the importance of ignoring how whites received African-American culture. "The present vogue in things Negro," he argued, "although it may do as much harm as good for the budding artist, has at least done this: it has brought him forcibly to the attention of his own people among whom for so long, unless the other race had noticed him beforehand, he was a prophet with little honor." Hughes also mentioned the special importance of jazz to the black psyche: "[J]azz to me is one of the inherent expressions of Negro life in America; the eternal tom-tom beating in the Negro soul—the tom-tom of revolt against weariness in a white world, a world of subway trains, and work, work, work; the tom-tom of joy and laughter, and pain swallowed in a smile."[24]

One way for black painters of the Harlem Renaissance to retain their heritage was to combine African forms with the new forms of Modernism. According to Locke, Harlem painters were less interested in being modern than in re-establishing abstraction, design, and decoration as the visual idioms of their race; nevertheless, their preference for such idioms coincided with a taste among the white artists in the Stieglitz circle for similarly "primitive" shapes and symbols. Though he painted the social life of African Americans in Chicago, Archibald Motley (1891–1981) was one painter associated with the Harlem Renaissance. His *Saturday Night* (p. 222) demonstrates how he blended visual representations of pulsing jazz sounds with an urban aesthetic: the figures in the painting have given themselves over to the music performed by the band and are represented more as embodiments of music than as characters in a specific narrative. In keeping with trends in urban Modernism, Motley's figures become symbolic extensions of the city and resist subjection to convention. But more important, perhaps, is that Motley depicted his black subjects as free and vital rather than burdened by a history of brutal subjugation.

However, other painters of the Harlem Renaissance, such as Aaron Douglas (1899–1979), chose to produce images that spoke to historical black experiences. Douglas's *Aspects of Negro Life: From Slavery through Reconstruction* (fig. 83) is one panel from a four-panel series that represents specific moments from African-American history. This painting tells how black Americans rose from slavery, depicted in the background, to develop a vibrant culture centered around music and performance. Douglas borrowed from ancient Egyptian murals a style characterized by flatness, hard edges, and repeated forms, though he modernizes this style by representing contemporary black culture with forms that mimic the sounds of drumbeats and jazz trumpet. White painters, such as Stuart Davis, were influenced by both the music and the painting of the Harlem Renaissance, but an equally important legacy of the movement is that it demonstrated how the formalism of American Modernism could liberalize society even as it called attention to the nation's fundamental inequalities.

AMERICAN SCENES:
THE DEPRESSION, REALISM, AND REGIONALISM

The exuberance of the Jazz Age expired along with the stock market on October 29, 1929. The crash devastated the nation: one-quarter of the labor force was unemployed; farmers saw prices for their crops drop by half; per capita income shrank by almost the same amount; and many families lost their savings and homes. The economic catastrophe was exacerbated in 1931, when severe drought struck the midwestern and southern plains for close to a decade, turning them into a dust bowl. The writer John Steinbeck (1902–1968) described the hardships facing the country's farmers in his Pulitzer Prize-winning novel *The Grapes of Wrath* (1939), which tells the story of the Joads, a family driven from their land in Oklahoma. Woody Guthrie, America's most famous folk singer, saw the film version of Steinbeck's book in 1940; shortly after, he wrote a column about the film for the *People's Weekly World,* the newspaper of the Communist Party USA. The story, Guthrie remarked, "shows the damn bankers' men that broke us and the dust that choked us, and comes right out in plain old English and says what to do about it. It says you got to get together and have some meetins, and stick together, and raise old billy hell till you get your job, and get your farm

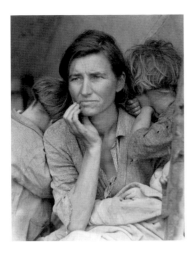

Fig. 84 **Dorothea Lange (1895–1965)**

***Migrant Mother*, 1936**

Gelatin-silver print

Library of Congress, Washington, D.C.

Prints & Photographs Division

FSA/OWI Collection, LC-DIG-fsa-8b29516

back, and your house and your chickens and your groceries and your clothes, and your money back."[25]

As Guthrie's comments demonstrate, American artists became much more political during the 1930s. To be sure, avant-garde artists had been associated with the left long before the Depression. In 1915, for instance, John Weichsel, an art critic and engineer, and one of the organizers of the Forum Exhibition, founded the People's Art Guild, an institution designed to bring together modern aesthetic theory with progressive socialist politics. In 1926, a new magazine emerged that had ties to the Communist Party: *New Masses* published writing by such leftists as John Dos Passos, Eugene O'Neill, and Carl Sandburg, and printed satirical cartoons by such artists as Boardman Robinson and Stuart Davis. And in November 1929, just after the market crash, some intellectuals associated with the magazine established the John Reed Club in New York. Though it was not an official Communist club, membership was open to any "writer, artist and worker in any of the cultural fields, subscribing to . . . the ultimate triumph of the working class."[26]

Indeed, even if their art was not explicitly concerned with social justice, most Modern painters of the 1920s practised progressive politics. Even Benton's *America Today* included a small testament to leftist ideology. Since the effects of the Depression were spreading just as Benton finished the project, he installed *Outreaching Hands*, a long, narrow panel, over the door leading into the boardroom where the mural was situated. The panel depicts the bony hands of faceless men begging for bread and coffee. Contrasted with these empty hands is the fist of a top-hatted gentleman, which clutches a bundle of cash. As Benton saw it, such greedy capitalists were to blame for the nation's collapse. Though Benton ultimately rejected Communism, he once described himself as "pro-labor, anti-big capitalist, and psychologically ready for large-scale social change."[27]

The Depression, based as it was on the invisible workings of Wall Street speculators, invigorated the rhetoric of the American left and bred a generation of socialist humanists. Many artists found work producing images that documented the effects of economic ruin and the Dust Bowl for one of the many organizations instituted as part of President

Franklin Roosevelt's New Deal. The Farm Security Administration, for instance, paid photographers to travel the back roads of America and record the plight of the country's hard-hit agricultural laborers: *Migrant Mother* (fig. 84) of 1936 by Dorothea Lange (1895–1965), which represents a displaced pea-picker as a noble victim, a "Madonna of the Fields," is perhaps the most iconic image from the Depression. Ben Shahn (1898–1969), who came to the United States in 1906 from Lithuania and was a committed leftist, was both a photographer and a painter for the Farm Security Administration. His *Farmers* (fig. 85) captures the resigned expressions of three men who know their work will receive little reward.

Another painter of this generation was Raphael Soyer (1899–1987), a Russian immigrant who was involved with the original John Reed Club in New York. Soyer painted many images that described the physical and psychological ruin wrought by the Depression, and his unflinching but sympathetic style of the 1930s is epitomized by *In the City Park* (fig. 86), which shows several destitute figures on a park bench waiting for better days. Soyer actually befriended such men, recalling in one essay, "I met one of these homeless men outside my studio, 'fishing' for a coin with a piece of chewing gum attached to a string under a subway grating. There was an air of loneliness about him which moved me. . . . We became friends."[28] Raphael's brother, Isaac Soyer, painted in a similar manner and his *Employment Agency* represents the inexorable wait for a payday during the height of the Depression.

As these works demonstrate, Realism was the preferred style for politically-minded artists of the 1930s. Only profound scrutiny of society, the thinking went, could puncture the veils of corruption and ideology to reveal reality. Of course, realism served an ideology as well, be it reformist or revolutionary in nature, and many paintings from the period borrowed from Soviet art a bold, propagandistic style. Joe Jones (1909–1963), a radical from the Midwest, was one artist who directly promoted political action in some of his paintings. For instance, Jones's *We Demand* depicts a determined protester holding in his big fist a placard demanding that the US Congress pass a Communist-sponsored

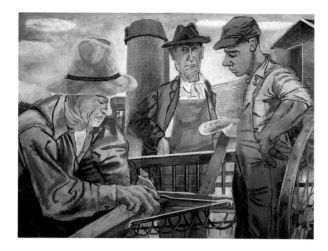

Fig. 85 **Ben Shahn (1898–1969)**

Farmers, 1937

Gouache on composition board

31 × 42 in. (78.7 × 106.7 cm)

University of Kentucky Art Museum,

Lexington, Allocation from the US

Government (Farm Security Administration)

1943.2.139

bill for unemployment insurance. Even more powerful is Jones's *White Justice (American Justice)* (p. 223), which testifies to the horror of racial violence in America. In the painting, a black woman, who we are led to believe has been driven from her home—burning in the background—and then raped by the Ku Klux Klan members behind her, is about to be lynched. Jones, political activist that he was, leaves nothing to the imagination.

But realism had a subtler side during the 1930s. Edward Hopper (1882–1967) was a less political and more conservative painter than most of his peers, though his paintings captured the sad and alienated spirit of the age with equal forcefulness. Hopper, who was born to a middle-class family in a small town on the Hudson River in New York, studied with Robert Henri (1865–1929) before traveling to Paris for a few years during the first decade of the twentieth century. Many American painters went to Paris and fell under the sway of Modernism, but Hopper claimed that he was barely moved by the new art in Europe: "Whom did I meet? Nobody. I'd heard of Gertrude Stein, I don't remember having heard of Picasso at all. I used to go to the cafés at night and sit and watch. I went to the theatre a little. Paris had no great or immediate impact on me."[29]

Hopper's paintings are not totally unique—they share with Sheeler's work, for instance, a precise linearity and awkward stillness— but they are intensely personal and psychological: his work from the 1920s and 1930s tends to depict solitary figures battling *ennui* and loneliness, conditions commonly attributed to the dark side of modernity. The rapid growth of America's cities, though inspiring to some American painters, did meet with some resistance in the cultural sphere. For example, in a 1925 essay titled "The Terrible Super-City," the editors of *Commonweal*, an independent Catholic magazine, expressed doubt as to the benefits of America's growing cities. "It is impossible to conceive of these teeming millions in their physical multiplication, and in their spiritual loneliness, without repulsion," they wrote. "It needs but little thought to show that in these regimented crowds, all the essential qualities and enjoyment of citizenship and civilization must be lost."[30]

In *Room in New York*, a typical painting from this period, Hopper depicts a man and a woman, presumably a couple, during a moment that is both casually intimate—the man reads a newspaper while the woman idly tinkles the keys of a piano—and devastatingly morose: there seems to be an insurmountable emotional gulf between the figures. This latter quality derives in part from an overall listlessness—there is nothing in the painting that signifies even a modicum of synergy between the man and the woman—and probably in part from Hopper's own tormented marriage. But it also arises, the *Commonweal* editors might have argued, from the erosion of "the spiritual bond," which in the city is "attenuated to the danger point" (fig. 87).[31] Hopper sought escape from this attenuation on frequent trips to Cape Cod on the Massachusetts coast. His New England paintings, however, share with his city scenes a foreboding quality: many of them, such as *Corn Hill (Truro, Cape Cod)* (p. 228), do not include any figures at all and are emphatically devoid of social vitality.

The paintings of one contemporary of Hopper's, Reginald Marsh (1898–1954), make an interesting contrast to his work. Marsh was from a wealthy family and studied art at Yale University, after which he made a living drawing satirical sketches for New York magazines and newspapers. Like Hopper, Marsh made paintings of life in New York City; unlike Hopper, however, Marsh described the city as bustling and full of distractions—cheap entertainments, such as movies and plays, and commercial enticements, such as tattoo parlors and burlesques. Marsh's *Pip and Flip* (p. 224) captures the audacious atmosphere of a Coney Island carnival, which seems worlds away from Hopper's sad apartments. The title of the painting refers to the poster seen in the background advertising a sideshow for *Pip & Flip*, "twins from Peru," and indeed the whole scene seems to be a staged performance: voluptuous women hug one another and whip up the sexual desires of the crowd.

One effect of the social upheaval of the 1930s on American painters was that it compelled them to employ Modernism's new forms—bold colors, cubistic shapes, compressed space—in the construction of no-nonsense proclamations. Whether these proclamations were aimed at

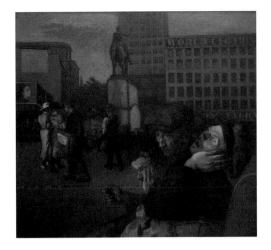

political and social injustice, the alienating aspects of city life, or the promiscuity that accompanies urbanism was up to the individual artists, but one thing remained constant: it was society, not aesthetic concerns alone, that shaped the art.

It would be easy to assume that New York City was the exclusive home of Modern art in America. Certainly, from the Forum Exhibition until the early 1930s, the vast majority of Modernists worked in or around Manhattan. The reasons for this are fairly obvious: New York had the galleries, the museums, and the schools that supported artists. But one consequence of the Farm Security Administration and other similar organizations, such as the Federal Writers Project, was that American artists and writers visited and researched long-neglected rural areas in the American South and Midwest. Moreover, even some of the most metropolitan of intellectuals laid a philosophical foundation for questioning the supremacy of the city in American society and culture. Lewis Mumford (1895–1990), a major cultural critic of the period who wrote about technology, architecture, and literature, argued throughout the 1930s that modern urban society had great, even utopian, potential, but that unchecked industrialism would be ruinous. And John Dewey (1859–1952), an enormously influential philosopher and advocate of progressive education, redefined the concept of "experience" by exposing the pretensions of élitism: "all interests, however humble," he said, help to make "public opinion."[32] In *Art as Experience* (1934), Dewey's main contribution to aesthetic theory, he argued for a more democratic conception of experience: "Even a crude experience, if authentically an experience, is more fit to give a clue to the intrinsic nature of aesthetic experience than is an object . . . set apart from any other mode of experience."[33] In other words, Dewey recognized no inherent distinction between the refined and the unsophisticated, the urban museum and the dusty backroom.

Such arguments about ordinary, everyday experience influenced many artists, especially those who were not from New York and had grown tired of the city's dominance of the art scene. These painters turned to their own home states for subject matter and inspiration, just as many writers had done before them, and came to be known as

Regionalists. One difference between the Regionalists—Benton, Grant Wood (1891–1942), and John Steuart Curry (1897–1946) most prominent among them—and those artists who customarily worked outside New York City—Demuth in Pennsylvania or Marin in Maine—was that the latter painters usually exhibited in the city at Stieglitz's various galleries. In addition, the Regionalists, Benton especially, were vocal about their distaste for the New York art scene.

Benton, always provocative and controversial, had become an outspoken opponent of abstraction and New York museums, and he left New York and moved back to Missouri in 1935. In interviews and essays published in New York newspapers just before his departure, Benton claimed that New York had lost its soul: the city, he said, was "feeble and querulous and touchy" and was marked by "snobbishness" and "superiorities."[34] By contrast, the Midwest, Benton argued, was home to honest, hard-working citizens who represented best the "real" America: "I had in mind," he wrote, ". . . to show that America had been made by the 'operations of people' who as civilization and technology advanced became increasingly separated from the benefits thereof."[35]

In such paintings as *The Ballad of the Jealous Lover of Lone Green Valley,* Benton depicted the small dramas of rural Americans in a grand, heroic style—the figures may be anonymous but they are substantial and are caught up in the vortex of their environment. The painting also testifies to Benton's love of American traditions, especially folk music, an art form he encountered on his numerous journeys into the Ozark Mountains and the South. As the figures in the foreground play the song of the painting's title, the drama comes to life behind them. As was Benton's custom, he includes in the painting many details that speak to life in the hinterland: a ramshackle hut and outhouse, a rickety wooden fence, and a cow observing the whole scene. In Benton's hands, this regional ballad becomes an archetypal American story—the best Regionalist paintings may have treated particular people and places, but they were always national in their reach.

Like Benton, Wood was born in the Midwest, and, like Benton, he had traveled to Europe to study painting but tired of the international art scene and returned home. "I realized that all the good ideas I'd ever had

came to me while I was milking a cow," Wood put it. "So I went back to Iowa."[36] He presented himself as a simple and humble man sympathetic to small-town values, and his painting *Stone City, Iowa* (p. 226) exemplifies his meticulous style. The painting also reveals something about Wood's attitudes regarding industrialization, for Stone City had once been a bustling town, home to many limestone quarries, but that era passed and the city reverted to its sleepy past. Wood depicts the city as a verdant farm town distinguished by pastures and rolling hills, thus implying that progress in the Midwest is measured differently than in places like New York (fig. 89). As a group, then, the Regionalists attempted to describe America as a nation of plain folk and distinct geographical areas, not as a nation beholden to metropolitan values. Equally important, however, was that Wood and Benton redefined what it meant to be an artist in modern America: they demonstrated that artists could be independent, both ideologically and geographically, of New York.

THE TRIUMPH OF ABSTRACTION

Benton and Wood may have been sympathetic to laborers and wary of concentrated power and élitism, but it was easy for critics to accuse them of being backward and conservative. Their realism, opponents said, was distinct from the Social Realism of artists on the left, such as the Soyers, and their politics were too soft. As World War II approached, the political rhetoric of anti-Fascists and Soviet sympathizers became increasingly convoluted, and Benton and Wood found themselves branded as naïve nationalists. Perhaps Benton's most biting critic was Stuart Davis, an artist and editor long associated with the American left. In 1935, Davis went so far as to argue that Benton "should have no trouble in selling his wares to any Fascist or semi-Fascist type of government."[37] Three years later, Meyer Schapiro, a New York critic, charged Benton with providing a "pitiful and inept" alternative to "realism guided by radical values."[38] Benton fought back: he accused abstract artists of being out of touch with common experience and wrote a cruel review of a book about Stieglitz, saying that "the contagion of intellectual idiocy" at the 291 Gallery "rose to unbelievable heights."[39]

This debate was just as much about artistic style as it was about political ideology, however. Though Realism was the dominant style of the 1930s, and though *Time* magazine ran a story on the Regionalists that featured Benton on the cover, a coterie of painters associated with Stieglitz continued to work in abstract styles. Not surprisingly, Davis was one of the most adamant defenders of abstraction; it was, he believed, the most appropriate form for the avant garde. "In the materialism of abstract art," Davis wrote, "...is implicit a negation of many ideals dear to the bourgeois heart"[40]

Davis's *New York Mural* illustrates some of the differences between himself and Benton. The painting, like Benton's *America Today* mural, shows the city as a bright and dynamic place dominated by skyscrapers. Unlike Benton, however, Davis represents his scene in an ultramodern way: his painting is a flat collage of cubistic and even surreal forms.[41] Davis was also strongly influenced by music, but his taste was for jazz rather than folk music and his *Swing Landscape* exemplifies how he translated the free-form sounds of jazz into a pictorial arrangement.

One artist who managed to blend the representational and the abstract was Georgia O'Keeffe (1887–1986), who was married to Alfred Stieglitz. One of the very few women artists who achieved fame working in a Modern style, O'Keeffe imbued her paintings with a feminine aura that continues to capture the popular imagination. She began painting flowers in 1924, and her *Red Amaryllis* (fig. 88) and *Red Poppy VI* (p. 218) demonstrate her ability to paint recognizable forms in a highly suggestive manner that evokes female sexuality and the mysteries of the organic world. But O'Keeffe also had a regional sensibility, and in 1929 she began spending summers in Taos, New Mexico, in the southwest region of the United States, where she was influenced by the strange landscape and the forms of Native American art, such as the Navajo rugs that Roosevelt alluded to in his review of the Armory Show. In the decades that followed, O'Keeffe painted the Southwest, producing images, such as *Cow's Skull: Red, White, and Blue* (p. 231), that speak to the special spirit of the place but that are also redolent with nationalist symbolism.

But it was Jackson Pollock (1912–1956) who came to embody the triumph of abstraction. Pollock had been Benton's student and close

Fig. 87 (below) **Edward Hopper (1882–1967)**

Chop Suey, 1929

Oil on canvas, 32⅛ × 38⅛ in. (81.6 × 96.8 cm)

Collection of Barney A. Ebsworth

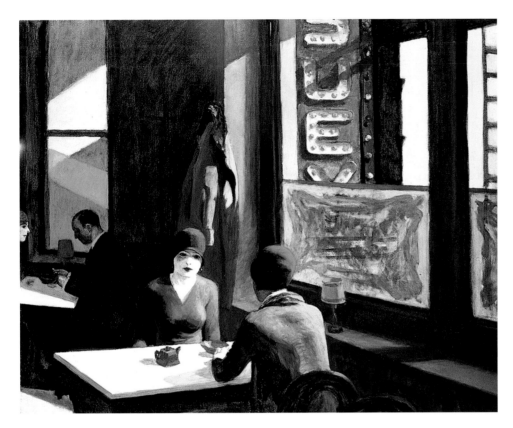

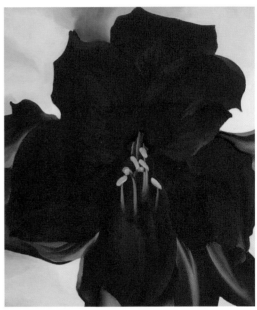

Fig. 88 (above right) **Georgia O'Keeffe (1887–1986)**

Red Amaryllis, 1937

Oil on canvas, 12 × 10⅛ in. (30.5 × 25.7 cm)

Terra Foundation for American Art, Chicago

Gift of Mrs. Henrietta Roig, C1984.1

Fig. 89 **Grant Wood (1891–1942)**

Sheaves of Corn, 1931

Oil on wood panes, 15½ × 23½ in.
(39.4 × 59.7 cm)

Midwest Museum of American Art,

Elkhart, Indiana

friend in New York during the early 1930s—in fact, the young harmonica player depicted in Benton's *The Ballad of the Jealous Lover* is a portrait of Pollock. There is no doubt that Benton had a large influence on Pollock—his earliest paintings bear the unmistakable imprint of his teacher's bold style—but Pollock ultimately rejected his mentor and opted to work in a totally abstract style, thus spelling the end of 1930s realism. Pollock's *The Moon-Woman* (p. 233) illustrates the degree of his break from Benton, for its stylized perspective and looping lines owe more to Picasso and Joan Miró than any naturalist painter. Moreover, the subject of the painting is obscure: this so-called "moon-woman"

comes from the artist's own psychic imagination rather than ordinary experience. Pollock and his fellow Abstract Expressionists, Willem de Kooning (1904–1997) and Mark Rothko (1903–1970), were truly a new generation of artists who in the years after World War II seemed to have little outward interest in political rhetoric; as Clement Greenberg put it, "[O]nce the avant-garde had succeeded in 'detaching' itself from society, it proceeded to turn around and repudiate revolutionary as well as bourgeois politics."[42] Maybe it was not as simple as that, but certainly the debates between Benton and Davis were quickly forgotten. The time had come for another new order.

Max Weber (1881–1961)

Rush Hour, New York, 1915

Oil on canvas, 36¼ × 30¼ in. (92.1 × 76.8 cm)

National Gallery of Art, Washington, D.C.

Gift of the Avalon Foundation, 1970.6.1

MODERNISM and REGIONALISM

Notes

1. Clement Greenberg, "Abstract Art," *The Nation,* no. 158 (April 15, 1944), p. 451.

2. Theodore Roosevelt, "A Layman's Views of an Art Exhibition," *Outlook,* no. 103 (March 29, 1913), p. 719; and Julian Street, in *Everybody's Magazine,* quoted in Richard Guy Wilson, Dianne H. Pilgrim, and Dickran Tashjian, *The Machine Age in America: 1918–1941* (New York: The Brooklyn Museum and Harry N. Abrams, 1986), p. 211.

3. Harriet Monroe, quoted in Milton Brown, *The Story of the Armory Show* (New York: The Joseph H. Hirshhorn Foundation, 1988), p. 172.

4. See Shelley Staples, *The Virtual Armory Show,* May 2001, http://xroads.virginia.edu/ ~MUSEUM/Armory/armoryshow.html.

5. Alfred Stieglitz, quoted in Dorothy Norman, *Alfred Stieglitz: An American Seer* (New York: Random House, 1973), p. 45.

6. Mitchell Kennerley, *The Forum Exhibition of Modern American Painters,* March 13th to March 25th, 1916 (New York: Anderson Galleries, 1916), p. 5.

7. Marsden Hartley, explanatory note, in Kennerley.

8. Arthur G. Dove, *ibid.*

9. Thomas Hart Benton, *ibid.* See also William C. Agee, "Willard Huntington Wright and the Synchromists: Notes on the Forum Exhibition," *Archives of American Art Journal* 24, no. 2 (1984), p. 12.

10. John Weichsel, foreword, in Kennerley, p. 36, and Stieglitz, foreword, in *ibid.,* p. 35.

11. See for example Wanda Corn, *The Great American Thing: Modern Art and National Identity, 1915–1935* (Berkeley, Calif.: University of California Press, 1999), pp. xiv–xv.

12. Carl Sandburg, *Chicago Poems* (Urbana, Ill.: University of Illinois Press, 1992), p. 6.

13. Van Wyck Brooks, *America's Coming of Age* (New York: Huebsch, 1915).

14. Barbara Haskell, *The American Century: Art & Culture 1900–1950* (New York: Whitney Museum of American Art, in association with W.W. Norton & Company, 1999), p. 145.

15. Louis Lozowick, "The Americanization of Art," in Patricia Hills, ed., *Modern Art in the U.S.A.: Issues and Controversies of the 20th Century* (Upper Saddle River, NJ: Prentice Hall, 2001), p. 49.

16. Joseph Stella, "The Brooklyn Bridge (A Page of My Life)," *Transition,* nos. 16–17 (June 1929), pp. 86–88. See also Haskell, p. 118.

17. William Carlos Williams, *Autobiography* (New York: New Directions, 1967), p. 172.

18. Williams, "The Great Figure," in *Collected Poems of William Carlos Williams: Volume I 1909–1939* (New York: New Directions, 1986), p. 174.

19. Frederick Lewis Allen, *Only Yesterday: An Informal History of the 1920s* (1931; reprint, New York: HarperCollins, 2000), p. 161.

20. Charles Sheeler, quoted in Karen Tsujimoto, *Images of America: Precisionist Painting and Modern Photography,* exhib. cat. (San Francisco: San Francisco Museum of Modern Art, 1982), p. 85.

21. Alvin Johnson, *Notes on the New School Murals* (New York: New School for Social Research, n.d.), p. 3.

22. *ibid.,* p. 7.

23. Alain Locke, "Harlem," *Survey Graphic,* no. 6 (March 1925), p. 630.

24. Langston Hughes, "The Negro Artist and the Racial Mountain," *The Nation,* 112 (June 23, 1926), pp. 692–94.

25. Woody Guthrie, *Woody Sez* (New York: Grosset & Dunlap, 1975), p. 133.

26. *New Masses,* quoted in Andrew Hemingway, *Artists on the Left: American Artists and the Communist Movement, 1926–1956* (New Haven, Conn.: Yale University Press, 2002), p. 20.

27. Thomas Hart Benton, "American Regionalism: A Personal History of the Movement," 1951, reprinted in Benton, *An American in Art: A Professional and Technical Biography* (Lawrence, Kan.: The University Press of Kansas, 1969), p. 168.

28. Raphael Soyer, "An Artist's Experiences in the 1930s," in Hills, p. 92.

29. Edward Hopper, quoted in Brian O'Doherty, "Portrait: Edward Hopper," *Art in America,* no. 52 (December 1964), p. 73.

30. *Commonweal,* 2 (May 13, 1925), p. 1, reprinted in Steven Conn and Max Page, eds., *Building the Nation: Americans Write about Their Architecture, Their Cities, and Their Landscape* (Philadelphia: University of Pennsylvania Press, 2003), p. 227.

31. *ibid.*

32. John Dewey, quoted in Thomas Bender, *New York Intellect: A History of Intellectual Life in New York City, from 1750 to the Beginnings of Our Own Time* (Baltimore: Johns Hopkins University Press, 1987), p. 313.

33. John Dewey, *Art as Experience* (1934; reprint, New York: Perigee, 1980), p. 9.

34. Thomas Hart Benton, in "Mr. Benton Will Leave Us Flat," *New York Sun* (April 12, 1935).

35. Benton, "American Regionalism," p. 149.

36. Grant Wood, "Wood, Hard-Bitten," *Art Digest,* no. 10 (February 1, 1936), p. 18.

37. Stuart Davis, "Rejoinder," *Art Digest,* no. 9 (April 1, 1935), p. 13.

38. Meyer Schapiro, "Populist Realism," *Partisan Review,* no. 4 (January 1938), p. 55.

39. Benton, "America and/or Alfred Stieglitz," *Common Sense,* no. 4 (January 1935), pp. 22–24.

40. Stuart Davis, "A Medium of 2 Dimensions," *Art Front,* no. 1 (May 1935), p. 6.

41. For more on the relationship between Davis and Benton, see Erika Doss, *Benton, Pollock, and the Politics of Modernism: From Regionalism to Abstract Expressionism* (Chicago: University of Chicago Press, 1991), pp. 116–24.

42. Greenberg, "Avant-Garde and Kitsch," *Partisan Review,* 6 (Fall 1939), reprinted in Greenberg, *Art and Culture: Critical Essays* (Boston: Beacon Press, 1989), p. 5.

Joseph Stella (1877–1946)

Brooklyn Bridge, 1919–20

Oil on canvas, 84¾ × 76⅝ in. (215.3 × 194.6 cm)

Yale University Art Gallery, New Haven,

Connecticut, Gift of Collection Société Anonyme

Stuart Davis (1894–1964)

Matches, 1927

Oil on canvas, 28 × 20 in. (71.1 × 50.8 cm)

Chrysler Museum of Art, Norfolk, Virginia

Bequest of Walter P. Chrysler, Jr., 89.48

Modernism and Regionalism

Charles Demuth (1883–1935)

Welcome to Our City, 1921

Oil on canvas, 25⅛ × 20⅛ in. (63.8 × 51.1 cm)

Terra Foundation for American Art, Chicago

Daniel J. Terra Collection, 1993.3

Ralston Crawford (1906–1978)

Buffalo Grain Elevators, 1937

Oil on canvas, 40¹/₄ × 50¹/₄ in. (102.2 × 127.6 cm)

Smithsonian American Art Museum,

Washington, D.C.

Modernism and Regionalism

Charles Sheeler (1883–1965)
Steam Turbine, 1939
Oil on canvas, 22 × 18 in. (55.9 × 45.7 cm)
Butler Institute of American Art,
Youngstown, Ohio, Museum Purchase, 1950

Georgia O'Keeffe (1887–1986)

Red Poppy VI, 1928

Oil on canvas, 35¼ × 29¾ in. (90.2 × 75.6 cm)

Private collection

Arthur Dove (1880–1946)

Alfie's Delight, 1929

Oil on canvas, 22¾ × 31 in. (57.8 × 78.7 cm)

Herbert F. Johnson Museum, Cornell

University, Ithaca, New York, Dr. and Mrs.

Milton Lurie Kramer, Class of 1936, Collection;

Bequest of Helen Kroll Kramer, 77.62.2

(*left*) Thomas Hart Benton (1889–1975)

The Axes (American Historical Epic,

Second Chapter), 1924–27

Oil on canvas, 59¼ × 41¼ in.

(150.5 × 104.8 cm)

Private collection

(*right*) Thomas Hart Benton (1889–1975)

Planters (American Historical Epic,

Second Chapter), 1924–27

Oil on canvas, 66⅛ × 72⅜ in.

(168.6 × 183.8 cm)

Private collection

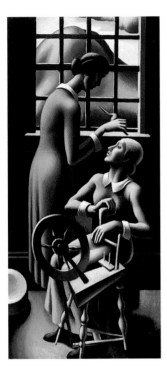

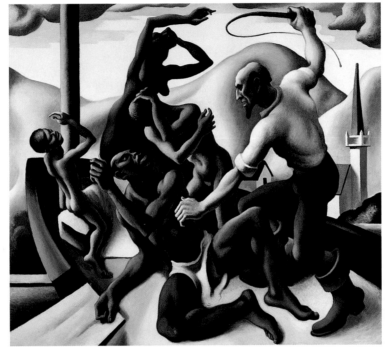

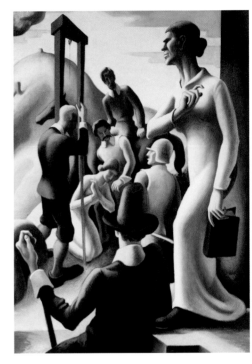

(left) Thomas Hart Benton (1889–1975)

Industry (American Historical Epic,

Second Chapter), 1924–27

Oil on canvas, 66⅛ × 30 in. (168 × 76.2 cm)

Terra Foundation for American Art, Chicago

Daniel J. Terra Art Acquisition Endowment

Fund, 2003.3

(right) Thomas Hart Benton (1889–1975)

Religion (American Historical Epic,

Second Chapter), 1924–27

Oil on canvas, 59¼ × 41¼ in.

(150.5 × 104.8 cm)

Private collection

(center) Thomas Hart Benton (1889–1975)

Slaves (American Historical Epic,

Second Chapter), 1924–27

Oil on canvas, 66½ × 72⅜ in.

(168.9 × 183.8 cm)

Terra Foundation for American Art, Chicago

Daniel J. Terra Art Acquisition Endowment

Fund, 2003.4

Archibald J. Motley, Jr. (1891–1981)

Saturday Night, 1935

Oil on canvas, 34 × 48 in. (86.4 × 121.9 cm)

Howard University, Gallery of Art,

Washington, D.C.

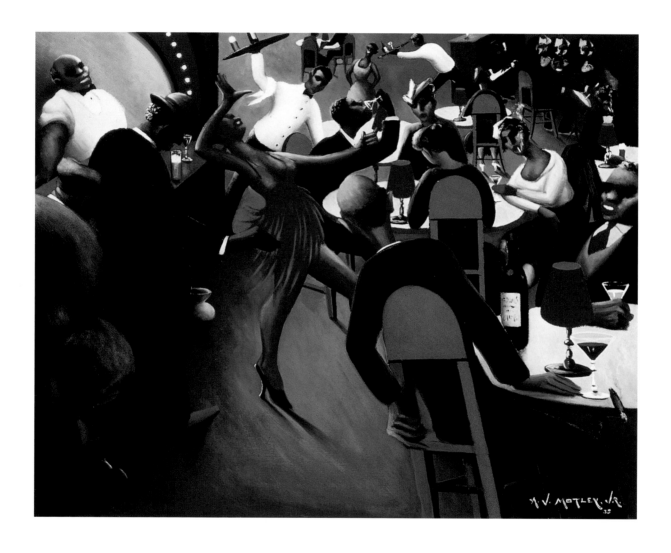

Joe Jones (1909–1963)

White Justice (American Justice), 1933

Oil on canvas, 30 × 36 in. (76.2 × 91.4 cm)

Columbus Museum of Art, Ohio

Museum purchase, Derby Fund, from the

Philip J. and Suzanne Schiller Collection

of American Social Commentary Art

1930–70, 2005.012.032

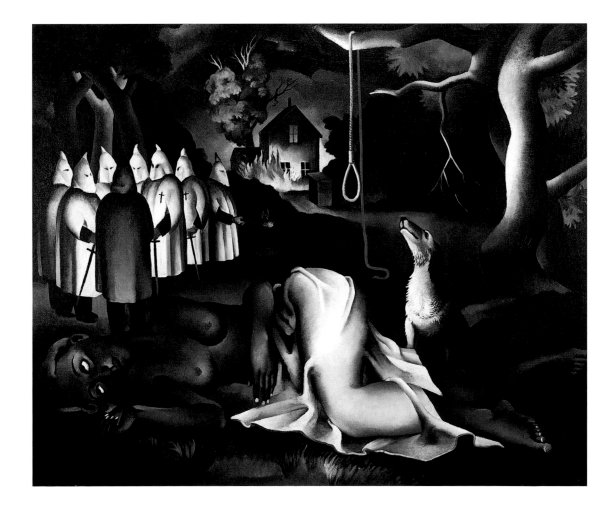

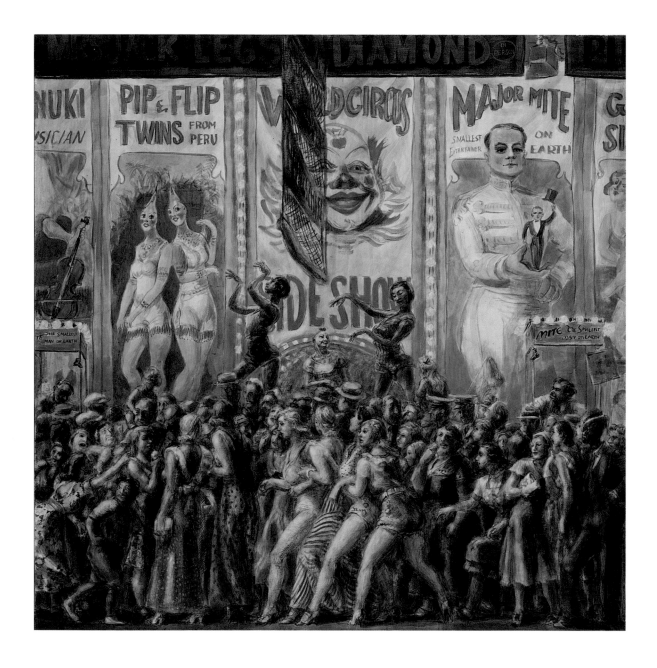

Modernism and Regionalism

Walt Kuhn (1877–1949)

Clown with Drum, 1942

Oil on canvas, 60⅞ × 41⅜ in.

(154.6 × 105.1 cm)

Terra Foundation for American Art, Chicago

Daniel J. Terra Collection, 1992.172

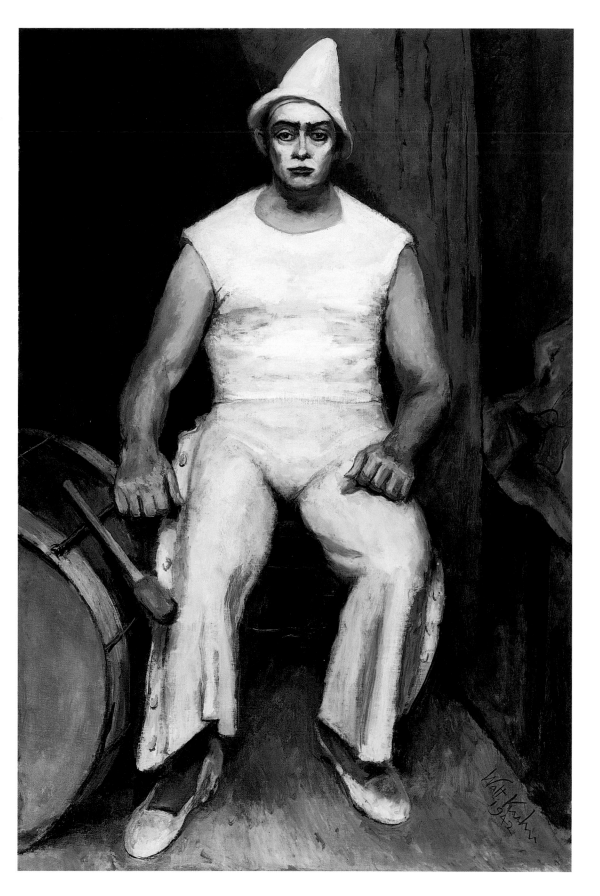

Grant Wood (1891–1942)

Stone City, Iowa, 1930

Oil on wood panel, 30¼ × 40 in.

(76.8 × 101.6 cm)

Joslyn Museum of Art, Omaha, Nebraska

Gift of the Art Institute of Omaha, 1930–35

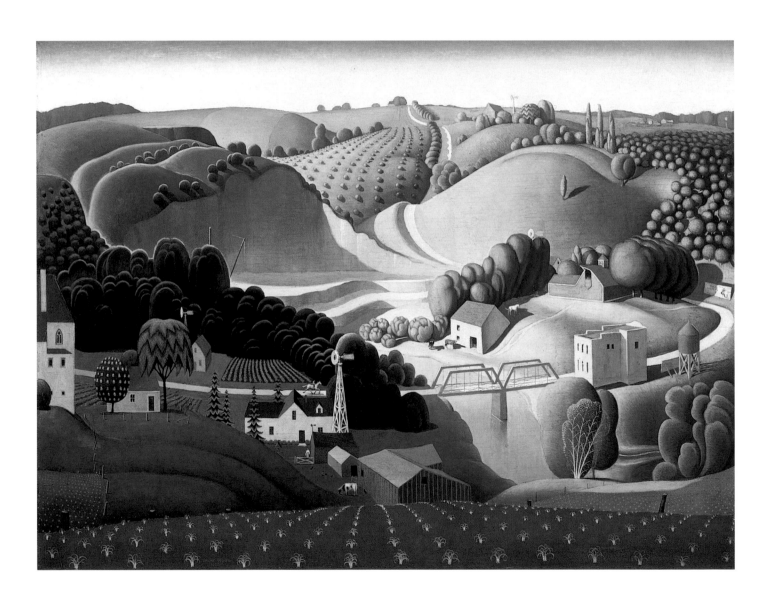

Modernism and Regionalism

Edward Hopper (1882–1967)

Dawn in Pennsylvania, 1942

Oil on canvas, 24⅜ × 44¼ in. (61.9 × 112.4 cm)

Terra Foundation for American Art, Chicago

Daniel J. Terra Collection, 1999.77

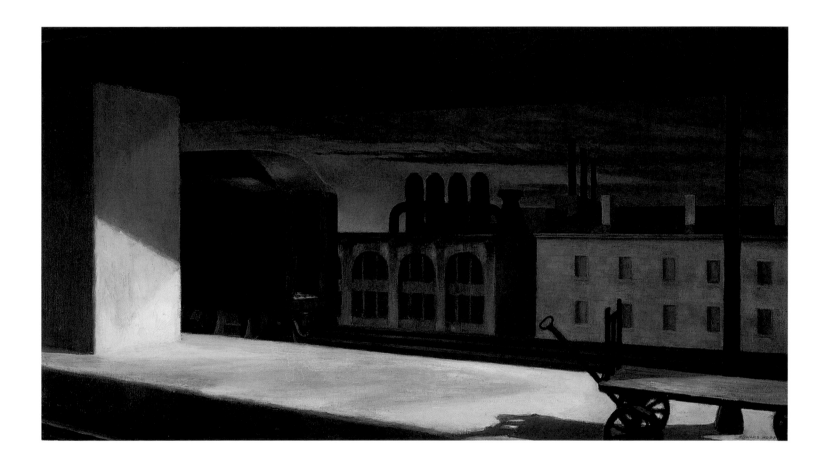

Edward Hopper (1882–1967)

Corn Hill (Truro, Cape Cod), 1930

Oil on canvas, 29 × 43 in. (73.7 × 109.2 cm)

Marion Koogler McNay Art Museum,

San Antonio, Texas, Mary and Sylvan Lang

Collection, 1975.27

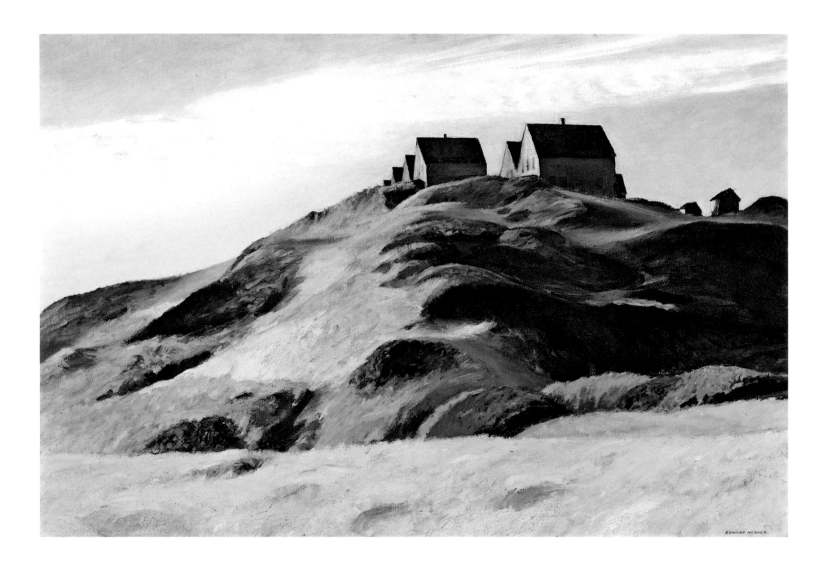

Modernism and Regionalism

Andrew Wyeth (b. 1917)

Winter, 1946

Tempera on board, 31⅛ × 48 in.

(79.7 × 121.9 cm)

North Carolina Museum of Art, Raleigh

Purchased with funds from the State

of North Carolina, 72.11

Norman Rockwell (1894–1978)

Rosie the Riveter, 1943

Cover for *The Saturday Evening Post*,
May 29, 1943

Oil on canvas, 52 × 40 in. (132.1 × 101.6 cm)

Ranger Endowments Management,
Dallas, Texas

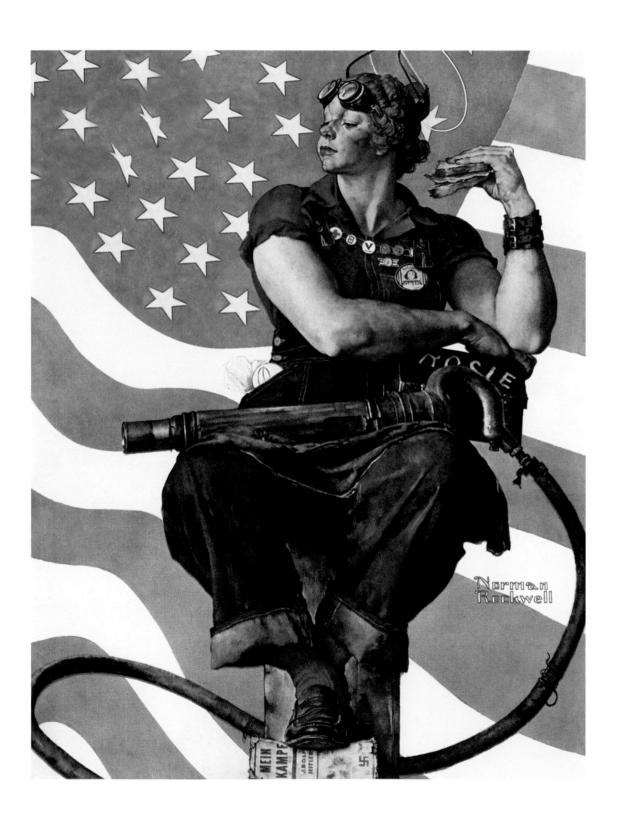

Modernism and Regionalism

Georgia O'Keeffe (1887–1986)

Cow's Skull: Red, White, and Blue, 1931

Oil on canvas, 39⅞ × 35⅞ in. (101.3 × 91.1 cm)

The Metropolitan Museum of Art,

New York, Alfred Stieglitz Collection, 1952,

(52.203)

Arshile Gorky (1904–1948)

Golden Brown Painting, 1943–44

Oil on canvas, 44⅞ × 55½ in. (114 × 141 cm)

Washington University, St. Louis, Mildred

Lane Kemper Art Museum, University

Purchase, Bixby Fund, 1953, WU 3841

Modernism and Regionalism

Jackson Pollock (1912–1956)

The Moon-Woman, 1942

Oil on canvas, 69 × 43 in. (175.3 × 109.2 cm)

Solomon R. Guggenheim Foundation,

Peggy Guggenheim Collection, Venice, Italy

1976, 76.2553.141

A Brief History of Painting in Chinese America to 1945

Anthony W. Lee

Although Chinese migrants had been traveling to North America in search of work since at least the 1630s, they began to arrive in large numbers only in the late 1840s with the discovery of gold in California.[1] They immediately established a network of settlements throughout the west coast region, some in the foothills of the Sierra Nevada, others in the farming regions in the fertile Central Valley, and still others in small fishing villages (rather like those they had left behind in the Pearl River Delta) along the rocky shoreline between the San Francisco and Monterey bays. They built stores and temples, formed family associations and mutual aid societies, and created a rich and layered social world that sustained the many men who had come so far from their ancestral homes. The settlements tended to be insular and self-contained, densely populated and heavily male, and usually maintained something of a migrant flavor. Most of the Chinese men did not settle permanently in one town or another but constantly moved between them in search of a decent wage, transforming the rooming houses and back rooms of the small Chinese stores into a rotating set of bunks. Yet it was in these small settlements, fluid and continually changing as they were, that something like an artistic scene was first nurtured and sustained.

Unlike the many other goods that quickly filled the Chinese stores, the products of the fine arts, especially paintings, lagged somewhat behind. There were several reasons for this. First, the numbers of Chinese men who made paintings were extraordinarily few; most of them were Guangdong peasants who viewed their efforts in California as part of an overall family strategy to earn enough money to support the ancestral village and farm in their homeland. Secondly, the market that had been previously established for Chinese-made goods among non-Chinese

buyers, dating as far back as the mid-1700s in the eastern ports of the United States, was for a more material culture, as the demand tended to be for porcelain, silk, and lacquer.[2] And thirdly, the early patrons of painting in California, most of whom were self-made men who had struck it rich in the Gold Rush, had a distinct taste for oils in the European style.

This general environment, though restrictive, shaped the kind of pictures that first appeared from among the Chinese community. Unfortunately, no known works survive from this initial period, but an early lithograph, conventionally attributed to Joshua Pierce and dated to 1853, provides a glimpse into the kind of world the earliest paintings inhabited (fig. 91). In the "Chinese Sales Room" of the San Francisco merchants James Tobin and William Duncan, the familiar and much sought-after silk and porcelain fill the room, the stacks of fine cloth neatly folded and overflowing each shelf. Men and women peer intently at the goods on display and, decked out in their smartest clothes, have made the salesroom not only a place to buy Chinese luxury items but also a venue for socializing, to see and be seen. Yet, amid all the cloth finery and social congestion and behind the Chinese sales clerks, we can spy on the upper shelves a series of small sculptures—from the looks of them, figurines of gods and goddesses or perhaps of the Eight Immortals—and on the back walls, small paintings in heavy frames. These paintings were almost certainly made by artists in China.

Pierce's scene had its share of fantasy. Most San Franciscans in this early pioneer period could hardly claim any of the social distinction imagined among the patrons of the Chinese Sales Room; and the store, located on Sacramento Street near the heart of an emerging Chinatown,

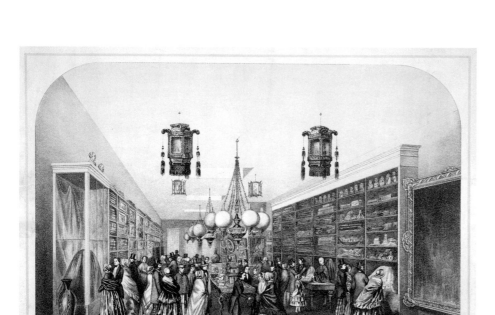

Page 235

Fig. 90 Yun Gee (1906–1963)

The Flute Player (Self-Portrait), 1928

Oil on canvas, 23 × 19 in. (58.4 × 48.3 cm)

Private collection

Fig. 91 Joshua H. Pierce (active 1850s)

Interior of Tobin and Duncan's Chinese Sales Room, 1853

Lithograph

California Historical Society, San Francisco

TN-5120

Fig. 92 (below left) Unknown photographer

[Interior with Chinese man playing musical instrument], 1905

Photograph

Courtesy of The Bancroft Library, University of California, Berkeley

Fig. 93 (below right) Lai Yong (1840–c. 1900)

Ping H., c. 1873

Photograph

Private collection

Fig. 94 (left) Lai Yong (1840–c. 1900)

[Portrait of Adolph Sutro], 1870

Oil on canvas mounted on wood

24 × 20 in. (61 × 50.8 cm)

California Historical Society, San Francisco, Fine Arts Collection, TN-6170

and razed and rebuilt so many times that its several retailers were driven out of business, had none of the character of permanence or social destination that is suggested in the print. Yet, despite its wishful thinking, it does match what little we know of the earliest appearance of Chinese paintings in the United States. They were freely mixed with other luxury items, accorded a secondary rank in the market, and, importantly, aimed not at the many Chinese who began populating California but at the non-Chinese buyer.

In this environment the earliest known Chinese painter living in California, a man named Lai Yong, tried to make his mark.[3] Born in 1840 in Guangdong (he died c. 1900), he had traveled to San Francisco in the early 1860s with much the same intentions as most of his fellow Chinese. But in 1867, instead of pursuing work in the factories or fields, he opened a portrait studio on Dupont Street, the main thoroughfare in Chinatown and only a short distance from the site of the original Chinese Sales Room. He must have had some training in China; there were no art schools of any note in the city, and of the few studios known to exist, none took on Chinese apprentices. In addition to his efforts with the brush and canvas, Lai Yong was a photographer and kept a separate photography studio on Washington Street, about a block away from his painting studio. The very few surviving works by him, both paintings and photographs, suggest a practical reason for this division. His paintings are entirely devoted to non-Chinese sitters, as in the case of his portrait of the great San Franciscan patrician Adolph Sutro (fig. 94). It is an accomplished work and, in its stolid image of the man, suggests something of Lai Yong's skills and his attractiveness to an *arriviste* class. In contrast, his small photographs are almost entirely of Chinese, as in a *carte-de-visite* of a sitter named Ping H. (fig. 93). It, too, is an accomplished work, in the sense that it follows the conventions of seated portraiture so typical of this early period of photography. In Lai Yong's understanding of the social world around him, portraiture had two kinds of patron, who wanted (and could afford) different kinds of objects. Among other purposes, the Chinese men wanted pictures of themselves to send home, to provide evidence of their well-being to parents, wives, and siblings, and, if the men were unmarried, to find a wife. Most

Chinese in this early period had no use for expensive paintings of themselves and could not support a painter who relied on them for his livelihood. On the other hand, non-Chinese merchants, politicians, and their wives, suddenly flush with money, wanted painted portraits of themselves for the family parlor or the newly popular men's social clubs, and were willing to pay for them. The newspapers were amused by this arrangement in social climbing. "[O]ur only Mongolian artist," the *San Francisco Chronicle* observed, "is painting 'heep plicture Melican man,' and charging 'Melican man's' price for the same."[4] Yet, being so few in number, the non-Chinese sitters, too, could not support a painter who relied exclusively on them. For an aspiring painter, some hybrid practice was necessary.

Lai Yong's efforts exemplify this first phase in the history of painting in Chinese America. Among the few Chinese artists, painting was primarily devoted to non-Chinese portraiture—not portraits of Chinese, and certainly not the western landscapes or genre scenes that preoccupied and brought fame to so many non-Chinese artists. Furthermore, in cultivating their sitters, they were keenly aware of the strong social differences between the two kinds of patron, Chinese and non-Chinese, who did not comfortably mix in the studio. In a pioneer town, where men and women from different parts of the world came together, it was as if the efforts at self-fashioning of one constituency could not easily admit or accommodate the similar efforts being waged by the other.

The social tensions between Chinese and non-Chinese implicit in Lai Yong's two-pronged practice surfaced on the streets with greater directness and, occasionally, violence during the 1870s. Where once the Chinese, although previously subject to many kinds of prejudice, could try to make homes for themselves in the United States, during the 1870s they faced an increasingly hostile non-Chinese workforce. The large factories, which pitted immigrants and migrants of all sorts against each other, brought about the rise of nativist labor unions, which began to agitate for laws to exclude the Chinese from the country. In 1882, a combination of US politicians needing votes and white union labor needing jobs brought about the passage of an Exclusion Act, in which

Chinese workers were barred from further entry to the country. The Act was and remains one of the harshest in the United States's long history of immigration. And it greatly affected the nature of picture-making during what may be called the second phase of painting in Chinese America.

In that phase, stretching from roughly the Exclusion Act to the late 1920s and the eve of the Great Depression, Chinese painters increasingly turned inward, into the community, for their patronage and subject matter. There had always been an ethic of self-reliance among the family associations and mutual aid societies, but with the harshness of the Exclusion Act and its social and economic fallout, aspiring painters were thrown back on an even more limited audience and reliable support. This cut at least two ways. On the one hand, a more stringently conservative artistic taste took root among merchants and family heads and the painters who provided for them. Where once Chinatown's temples, theaters, and benevolent associations had obtained their sculptures and paintings from China, after 1882 they began more and more to receive the work of local artists and artisans. In keeping with their own precarious status, perhaps even in compensation for it, they patronized traditional subjects, among them nearly every rendition of the many gods and goddesses (the Tang guardian Ch'in-Shu-Po seems to have been a favorite), and so asked painters to adhere more closely to the stock imagery of the Qing visual cultures from which these merchants came.

On the other hand, the pall of the Exclusion Era gave opportunities for painters to experiment, especially those living in the first decades of the twentieth century and loosely connected to the rise of revolutionary social and political movements in both China and Chinatown. Two self-portraits epitomize the range of possibilities. The first, a photograph of an unnamed Chinese artist taken in the early 1920s, pictures a musician-painter surrounded by his work (fig. 92). The paintings are a mix of calligraphy (we can barely catch the edge of work on the upper left), figure studies, and landscapes, and together represent a breadth rarely seen prior to this in the work of Chinese painters in America. They are astonishingly varied in style as well, ranging from the spare ink drawing to the Japanese-inspired linear prints, to landscapes done in the

Arts and Crafts manner, the latter reminiscent of the work of Arthur Mathews (1860–1945), a much revered San Francisco painter at the turn of the century. The eclecticism was facilitated by a certain freedom enjoyed by Chinese painters, who, because they had no firm footing in an art market or in the fledgling art academies, could, as a matter of interest and survival, range widely in a variety of modes. The potential disjunction of the different styles and subjects did not produce a compartmentalized and rigidly bounded practice, as it had in the case of Lai Yong. Rather, the musician-painter strums a tune for the benefit of the camera and, in turn, represents himself as a composite of the many forms of expression, a harmonious blending of East and West, conventional and experimental.

A remarkable self-portrait, an oil painting called *The Flute Player* (fig. 90) by Yun Gee, is an even more self-conscious expression of eclecticism and daring. Gee was born in 1906 in Kaiping County, Guangdong (he died in 1963), and arrived illegally in San Francisco in 1921.[5] He settled in Chinatown and almost immediately began to study the Parisian style of easel painting at the California School of Fine Arts. We see the school's effects in *The Flute Player*, where the facets and edges, the upright planes, the choppy strokes, and simple studio still lifes so typical of Salon Cubism are everywhere in evidence. Gee called his paintings "revolutionary" and intended that to describe the style but also to carry a social and political charge, in keeping with his founding in 1926 of a Revolutionary Artists' Club. That club, comprising young Chinese men living in San Francisco, attempted to link radical artistic form with a new nationalist sensibility and expressiveness among the Chinese. Importantly, Gee also helped to found the Modern Gallery, an avant-garde collective whose goal was to introduce the latest Modernist painting in Europe and America to the Bay Area. In all these ambitions, Gee was not rejecting his Chinese past but attempting to incorporate it in a pan-Modernist world. In the self-portrait, he plays a Chinese flute, offering a song to himself and, like the musician-painter in fig. 92, harmonizing the potentially disparate elements—the porcelain teapot, the brushes and fans, the hard Parisian style—and claiming them as constituent of himself.

In 1924, Congress renewed the 1882 Exclusion Act and even added to its stringency by closing any loopholes that had existed in the previous

Fig. 95 **Dong Kingman (1911–2000)**

Chinese Laundry, 1944

Watercolor on paper, 19 × 27 in.

(48.3 × 68.6 cm)

Courtesy Dong Kingman Estate

act, doing away with the small allowances once made for merchants, educators, students, and their wives. The act put a stranglehold on an already thinning Chinese population in America. For those Chinese who continued to live there, the means of obtaining a living wage were limited, but in one of the most long-lasting decisions to affect the Chinese in America, Chinese business leaders, attempting to survive such harsh times, began to transform their communities—the Chinatowns—into a destination for the tourist. Countless restaurants, curio shops, and temple-inspired architectural renovations sprouted and created an alluring, intensely Chinese atmosphere that has remained more or less intact to this day. Ironically, cultivating and marketing "Chinese-ness" became one of the most successful means for these Chinese to gain a foothold in American society and the economy. Out of this important development came perhaps the most famous painter of Chinese America, Dong Kingman.[6]

Kingman (1911–2000) was born in Oakland, California. He moved to Hong Kong at age five and received his earliest artistic training there in painting and calligraphy at the Lingnan School. He returned to the United States in 1929, worked in a restaurant and as a dishwasher and houseboy (typical occupations for Chinese men during the Exclusion Era), and soon began creating a significant body of watercolor paintings. In 1936 he had his first solo exhibition in San Francisco, where he attracted critical and popular acclaim, the first of many notices that eventually led to two Guggenheim Fellowships in the early 1940s. Kingman's forte was pictures of the streets and buildings of the expanding urban scene. Much of the appeal of his work can be attributed to his deft handling of watercolor, what quickly became known as the "California Style," marked by little or no preliminary pencil sketching, the application of broad, brushy strokes, and the use of the unpainted white paper as a key compositional shape.[7] Others in California, trying to find a style to match the bright and constantly shifting light of the Pacific Coast, had been experimenting in this loose, sketchy mode since at least the mid-1920s, but in Kingman's hands, with his background in calligraphy and Lingnan painting, the style reached a suggestive synthesis. The work

"arises from the Chinese culture that permeates his soul," a later commentator observed, and displays an "Oriental love of the natural world and its creatures [and a] visual communion with the manifold, transient yet eternal forms of life."[8] An additional appealing facet of his work was that he often painted the very neighborhoods, as in *Chinese Laundry* (fig. 95), that were undergoing transformation for the tourist. In a sense, in both style and subject matter, Kingman was providing a visual analogy for the efforts of Chinese everywhere in the United States who were cultivating aspects of their "Chinese-ness" for a non-Chinese audience. He soon achieved national fame, the first painter in Chinese America to gain such widespread acclaim, and went on to become a leading watercolorist in the 1950s and 1960s.[9] When diplomatic relations between the People's Republic of China and the United States began to normalize in the 1970s, Kingman was again seen as a key figure, becoming in 1981 the first American painter to secure a major exhibition in Beijing, Hangzhou, and Guangzhou. By that point, his "Chinese-ness" and "American-ness" traveled in both directions across the Pacific.

Kingman's success portended a slow but sure shift in the fortunes of painting in Chinese America and an expansion from its historical base on the West Coast to new opportunities on the East. After World War II and the lifting of the old exclusion laws, the Chinese communities in America began to revive, nurtured by renewed immigration and slowly increasing access for their children to a variety of schools and jobs. Painting began to flourish as never before, as American-born men and women, finally given widespread training in American academies, began to explore a whole range of styles and subjects, participating in every significant art movement in the United States from the early 1950s. These men and women have not always received the kind of acclaim that many of their non-Chinese contemporaries have enjoyed. But it is becoming increasingly apparent to today's scholars that no adequate history of art in America can ignore them, and that their many efforts with the brush are an integral part of the larger story of American painting.[10] A larger Asian-American history of art, of which this essay is a very small part, is only just beginning to be told.

Notes

1. On the earliest known Chinese in North America, see Homer H. Dubs and Robert S. Smith, "Chinese in Mexico City in 1635," *Far Eastern Quarterly*, vol. 1 (1942), pp. 387–89. Good general histories of the Chinese in America can be found in Ronald Takaki, *Strangers From a Different Shore: A History of Asian Americans* (New York: Little, Brown, and Company, 1989); and Roger Daniels, *Asian America: Chinese and Japanese in the United States Since 1850* (Seattle: University of Washington Press, 1988).

2. John Kuo Wei Tchen, *New York Before Chinatown: Orientalism and the Shaping of American Culture, 1776–1882* (Baltimore: Johns Hopkins University Press, 1999), pp. 3–24.

3. Details about this obscure artist and his contemporaries are fleeting, but see Peter Palmquist, "Asian American Photographers on the Pacific Frontier, 1850–1930," in *With New Eyes: Toward an Asian American Art History in the West* (San Francisco: San Francisco State University Art Department Gallery, 1995); and Anthony W. Lee, *Picturing Chinatown: Art and Orientalism in San Francisco* (Berkeley, Calif.: University of California Press, 2001), pp. 9–58.

4. "The Easel," *San Francisco Chronicle* (February 2, 1877), p. 1.

5. On Gee, see Lee, *Yun Gee: Poetry, Writings, Art, Memories* (Seattle: University of Washington Press, 2003).

6. On Kingman's career, see Irene Poon, *Leading the Way: Asian American Artists of the Older Generation* (Wenham, Mass.: Gordon College, 2001), p. 25.

7. On the California Style, see Gordon McClellan, *The California Style: California Watercolor Artists, 1925–1955* (Beverly Hills, Calif.: Hillcrest Press, 1985).

8. "Dong Kingman's Watercolours," *Arts of Asia*, vol. 3, no. 2 (March–April 1973), pp. 45–53.

9. For an example of the tenor of Kingman's recognition, see Alan Gruskin, *The Watercolors of Dong Kingman and How the Artist Works* (New York: Studio Publications, 1958); and Gruskin, *Dong Kingman* (San Antonio: Witte Memorial Museum, 1968).

10. There are increasingly good examples of scholarship on Asian-American art and its relation to the familiar movements in Modernism. See, especially, Jeffrey Wechsler, ed., *Asian Traditions, Modern Expressions: Asian American Artists and Abstraction, 1945–1970* (New York: Harry N. Abrams, 1997).

(1945–80)

Prosperity and Disillusionment

The Innovative Moment: Postwar American Art

Robert Rosenblum

In 1945, with the apocalyptic conclusion of World War II at Hiroshima, the history of our planet seemed to be divided into two parts. There was an old world that, in both Japan and Europe, had become a cemetery of destroyed lives, cities, and civilizations. But within this desolation, there would have to be a new, as yet unimaginable world being born from these ruins. The United States, which had witnessed these disasters from a safe distance, could suddenly offer promise as a place of renewal, as if an almost extinct world could be resurrected on a different continent. And such migrations were, in fact, literally true. After all, many pioneers of Modern art and music—among them Piet Mondrian (1872–1944) and Max Ernst (1891–1976), Arnold Schoenberg (1874–1951) and Igor Stravinsky (1882–1971)—had fled Europe and ended their lives on American shores.

This traumatic watershed of history provides a background for the astonishing innovations of American art that emerged in the years after 1945. With New York as a center, one painter after another created works of such daring unfamiliarity that, at the time, most viewers, whether sympathetic or hostile, thought they were seeing art resembling nothing that had ever been made before. Each member of this group of artists, whose work began to be lumped together as "Abstract Expressionism"— a term originally applied to Vasily Kandinsky (1866–1944) and one that implied the depiction of strong emotions and impulses in the language of abstraction—seems to have pushed the vocabulary of painting to what looked like rock-bottom simplicity. For Jackson Pollock (1912–1956), there seemed to be nothing but the chaos of interweaving filaments of dripped paint. For Mark Rothko (1903–1970), there were only hovering clouds of atmospheric color. For Barnett Newman (1905–1970), the whole world was an endless field of color pierced by a quivering vertical line. For Clyfford Still (1904–1980), the universe was equally unformed,

like an imaginary map of a prehistoric continent. For Franz Kline (1910–1962), everything was raw force, lightning bolts of ragged black electrifying a turbulent white ground.

Confronted with such elemental images, it was easy to think that art was being reborn in the United States, as if these painters were offering their own contributions to the genesis of a new world, distilling to primordial purity such mysteries as boundless light, space, color, and energy or such polar extremes as infinite restlessness and numbing stillness. By the 1950s, it appeared that the vital traditions of Modern art had crossed the Atlantic during the war years and that, in the future, the important events of art history would happen in New York, not in Paris. And to this was added, with a sense of nationalist triumph, the fact that this revolution was specifically American. The critic Clement Greenberg (1909–1994), an early champion of the movement, referred to it as "American-style painting," and when, in 1958–59, the Museum of Modern Art sent a group show of this work to eight European museums, the title proclaimed it as "The New American Painting."

Today, a half-century later, what once looked like nothing ever seen before has begun to face backward as well as forward. The work of what were once young rebels has not only become venerable, essential to museum collections and to the history of art, but has also begun to reveal its roots in many earlier European as well as American traditions. The early pioneers of twentieth-century art began to provide ancestral support. The pools of floating hues in the work of Pierre Bonnard (1867–1947) and Henri Matisse (1869–1954) could offer clues to Rothko's even more disembodied chromatic clouds. Mondrian's vocabulary offered a precedent to Kline's restriction to an abstract black armature on a white ground; Pollock's efforts to work by unleashed impulse connect with many Surrealist ventures into automatism, and

his exploration of an overwhelming expansiveness in which substance becomes shadow could be likened to the most audacious achievements of late Claude Monet (1840–1926). And the nineteenth century, especially in the territory of Romantic landscape, could offer prophecies. For example, the attraction of J.M.W. Turner (1775–1851) to nature's extremes of boundless turbulence (a storm at sea) and awesome serenity (a sunset on the horizon) can conjure up the dualities found in pairing Pollock and Rothko. As for Willem de Kooning (1904–1997), the "Abstract Expressionist" who, because of his ongoing obsession with the almost palpable depiction of human, especially female, flesh, had always differed from his American colleagues, deeper European lineages were even clearer. He was born in Rotterdam, in whose art academy he learned his craft, and both his passion for transforming pigment into female flesh and his energetic, bravura brushwork clearly hark back to the Netherlandish painters of the seventeenth century, who, from his childhood on, provided both general inspiration and specific sources for his work. Throughout his ongoing series of female deities and monsters, generically titled "Women," we sense the ghosts of these old masters: Peter Paul Rubens's adoration of the voluptuous female nude; Frans Hals's crackling brushwork that could capture the spirit of a witch; Rembrandt's more meditative visions of half-clothed bathers, exposing their bodies to the elements (fig. 96).

But what also began to emerge was that this new art, which at first seemed almost willfully to uproot itself from European traditions, as if a completely new era were to be proclaimed, had strong connections with indigenous American painting, a point that becomes clearer when the work is seen, as it is here, in the context of the nineteenth-century abundance of images that mirror the unique marvels of the New World. Europe, of course, had its Alps and its waterfalls, but not only were these deeply ingrained parts of Western history, they were, in terms of sheer size, modest by comparison with such sublime spectacles as the Rocky Mountains (pp. 132–33) or Niagara Falls (pp. 120–21), magical sites painted again and again by American artists as reminders of their nation's origins as a primeval landscape. Even in the late 1950s, many European spectators noted that the awesomely large dimensions of many of these paintings—especially those of Newman (pp. 258–59) and Still (p. 260)—reflected an objective fact, namely, the way in which the continent of North America, unlike that of Europe, was often close to that of a vast prehistoric landscape of staggering size, in which seemingly infinite distances revealed no signs of human intervention. It was almost possible here to obliterate history. Such artists as Thomas Cole (1801–1848), Frederic Edwin Church (1826–1900), Albert Bierstadt (1830–1902; fig. 97), and Thomas Moran (1837–1926; fig. 98) often thrilled their audiences by painting these gigantic peaks and chasms in super-sized canvases that would produce the stunning illusion of actual confrontations with this magnificence. These were the kind of spectacular sites that would eventually become enshrined as National Parks and that from the 1970s on would often inspire the construction of "earthworks" by artists—Michael Heizer (born 1944; fig. 99), Walter de Maria (born 1935; fig. 100), Robert Smithson (1938–1973), James Turrell (born 1943)—willing to travel to and work in territories that feel light years away from the contemporary world.

In front of a Pollock or a Still, a Rothko or a Newman, we may often have a comparable feeling of having been transported to some domain far outside the chronicles of civilization, as if the Book of Genesis were being re-enacted. It is worth mentioning, too, that one of the aspects of nineteenth-century American landscape painting most often commented on is its fascination with capturing an almost mystically pervasive light that seems capable of transforming all matter into an intense and silent glow. Often referred to as "Luminism," and apparent in works by such artists as Martin Johnson Heade (1819–1904; p. 117), Sanford Gifford (1823–1880; fig. 57), and John Kensett (1816–1872), these immersions in the spiritual light of landscapes often untouched by human presences now have a prophetic character, especially in the context of Rothko's fields of colored light, pulverizing any substance that falls within its radiance. We are left with something close to altarpieces, in which light is the primal force.

But it is not only these nineteenth-century views of the terrifying immensity and power of the American continent that evoke an ancestry for the Abstract Expressionists. Many of the early generation of

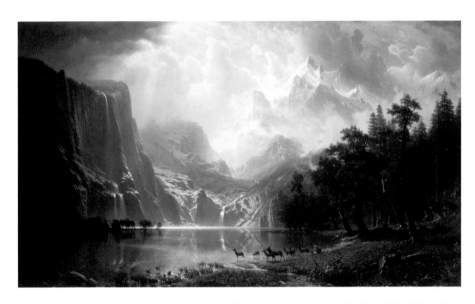

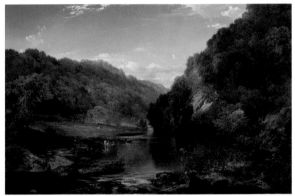

Fig. 101 **Helen Frankenthaler (b. 1928)**

Canal, 1963

Acrylic on canvas, 81 × 57½ in.

(205.7 × 146 cm)

Solomon R. Guggenheim Museum,

New York, Purchased with the aid of funds

from the National Endowment for the

Arts, Washington, D.C., a Federal Agency;

matching funds contributed by Evelyn

Sharp, 1976, 76.2225

American Modernists, emerging during World War I and flourishing in the 1920s and 1930s, explored a similar kind of mysticism in landscape. Georgia O'Keeffe (1887–1986) and Arthur Dove (1880–1946; p. 219), in particular, often worshiped at the shrine of unpolluted nature, immersing themselves in the spectacle of uninterrupted horizons, boundless skies, and celestial orbs, as if they were members of a pagan religion. And the vocabularies they invented to grasp these natural wonders often moved in the direction of an immaterial, fluid language of pulsating shapes, disembodied color, and immeasurable spaces, visual ideas expanded not only in the work of the Abstract Expressionists but in that of later generations of such artists as Helen Frankenthaler (born 1928; fig. 101) and Morris Louis (1912–1962), who continued to explore a floating world of luminous hues completely untethered to the laws of gravity.

Confronted with any anthology of paintings by Abstract Expressionists, it would be hard to find specific clues revealing the fact that most of them were made in a particular place (New York) and at a particular time (c. 1945–60). Their imagery willfully excludes any reference to the space-time coordinates of contemporary life, producing the effect of an imaginary voyage to a prehistoric world that takes us back to biological and geological origins. It is ironic, of course, that this look of the primordial quickly became associated throughout the world with a specifically American, even nationalistic style. The very titles of Newman's paintings—*Adam, Uriel, Covenant, Tundra*—suggest that the artist could never have polluted his mythic terrain by reference to the world in which he actually lived, Manhattan. So it came as even more of a shock when, beginning in the 1950s, a whole new generation of artists lost patience with the remoteness of this abstract universe from the everyday facts of urban life in America. Traditionally, the purities of abstract art were seen as a kind of antidote to the coarseness and pollution of what actually lay outside the studio door; but with welling force, rebellious young artists opened wide the doors to the ivory tower, embracing rather than rejecting the commonplaces of American experience, whether found in the daily newspaper, the sidewalks, the movies, the supermarket, or the gas station.

Looking backward, it was a phenomenon already familiar to American painting in the early twentieth century. While many artists preferred to paint visions of nature that provided complete escapes from contemporary life—whether in the rugged vision of the remote coast of Maine, where few humans would dare trespass, of Winslow Homer (1836–1910), or in the more hazy vistas of equally unpopulated landscapes by Thomas Dewing (1851–1938) or John Twachtman (1853–1902; p. 176), inspired by the fogs and blurs of Impressionist and Symbolist styles—others would enthusiastically welcome the coarse energies of city life. There were artists of the so-called "Ashcan" school who would immerse themselves in gritty, proletarian realities—John Sloan (1871–1951) could join the street crowds on election night; George Bellows (1882–1925) could seize up-close the brutal excitement of a heavyweight boxing match; Everett Shinn (1876–1953) could capture the populist fun of music-hall entertainment. And as soon as the European language of Cubism and Futurism was absorbed, with its shattering velocities and colliding, fractured planes, urban life could become even more frenzied and explosive, with such artists as Max Weber (1881–1961) and Joseph Stella (1877–1946) using these new vocabularies to grasp everything from the whirling spectacles of electric light at Coney Island to such city commonplaces as a Chinese restaurant or a construction site.

History repeats itself, and beginning in the 1950s, while audiences both at home and abroad were learning to absorb the universal, timeless language of Abstract Expressionism, seemingly born in a world that witnessed the creation of light or of Adam and Eve, one American artist after another became intoxicated by the experience of living in the completely artificial environment of postwar America. The major pioneer into this visual territory, which people of refined sensibilities assumed to belong to a vulgar, populist world of visual pollution and chaos, was Robert Rauschenberg (born 1925), who, with a nonstop sense of fresh discovery, explored the detritus of urban streets, from Coca-Cola bottles and traffic signs to license plates and broken furniture, jumbling together in both two- and three-dimensional monuments the invigorating mess that lay just outside the studio door (fig. 103). Moreover, the boundaries between high and low, so essential to

Fig. 102 **Max Weber (1881–1961)**

***Construction*, 1915**

Oil on canvas, 22⅞ × 27⅞ in. (58.1 × 70.8 cm)

Terra Foundation for American Art, Chicago

Daniel J. Terra Collection, 1987.31

maintaining abstract art's purity, were shockingly effaced, so that cheap reproductions of masterpieces by Botticelli or Rubens got equal time with news photos of Gloria Vanderbilt or Dwight Eisenhower.

Despite his passion for another kind of mess, that of oil pigment, slathered and dripping as it had been in the work of De Kooning, Rauschenberg was also fascinated by mechanical means of image reproduction, especially screenprint techniques, which, as in *Barge* of 1962–63, a panoramic vista more than thirty feet wide, merges the machine-made language of black-and-white photography with the traditional craft of handpainted oil on canvas (pp. 266–67). Here, with a scope of almost God's-eye expansiveness, Rauschenberg creates a new kind of American *"perpetuum mobile,"* moving between heaven and earth, with overhead views of labyrinthine traffic intersections, glimpses of athletes in mechanized motion, adventures in space travel.

Everywhere, it seemed, American artists would loudly proclaim their national identity, as if they no longer wanted to be assimilated into an international community of Modernism, but insisted on asserting the coarsest visual facts of the contemporary world that surrounded them. At times, this was done in more devious and complex ways, as in the case of the maps and flags of the United States by Jasper Johns (born 1930), in which the most obvious public symbols of nationalism could be seen as familiar patterns subjected by the artist to exquisite visual variations that might even include, like diary entries, personal memories (p. 265). But more often, the specifically American imagery of what by the 1960s was commonly known as "Pop art" was as startlingly clear as the harsh, impersonal look of paintings that seemed to be made by machines, a look that quickly made obsolete those old-fashioned artists who wanted to explore their unique private emotions and sensibilities. By 1962, this assault on hallowed traditions of élite art took on the character of a revolution within the galleries of New York, with the main players—Andy Warhol (1928–1987), Roy Lichtenstein (1923–1997), James Rosenquist (born 1933), Claes Oldenburg (born 1929)—clearly defined; but it was equally clear that this was a nationwide rebellion, embracing, for example, such California artists as Ed Ruscha (born 1937) and Wayne Thiebaud (born 1920).

Any anthology of this work reveals an insistent infatuation with material that was specifically American. Lichtenstein was immediately drawn to low-grade comic strips and the cheapest commercial advertising (pp. 270, 271; fig. 21). Warhol spread his range farther, often into emotionally disturbing territory, embracing not only the supermarket icons of American fast food, from soup cans to Coca-Cola bottles, but a vast chronicle of American public history that could move from movie-star celebrities and the assassination of President Kennedy to the most brutal commonplaces of the American way of death, whether in race riots, automobile crashes, or the electric chair (pp. 268, 269). Rosenquist would often combine in one field huge, close-up fragments that swept across American experience, capturing simultaneously everything from an image of JFK or the engine of a Ford automobile to a blow-up of the happy-ending lovers' clinch from a drive-in movie (fig. 104). And on the West Coast, Ruscha was thrilled to make paintings that venerated, rather than sneered at, such roadside icons as local gas stations and the giant HOLLYWOOD sign marking the Los Angeles horizon (fig. 105).

In most cases, these artists, in depicting such American commonplaces, explored new techniques that seemed appropriate to an industrial world of mechanized image-making. For Warhol, in particular, the silkscreen image became an essential ingredient that created an impersonal, journalistic truth as the foundation for the artist's personal variations (a screenprinted soup can could then be reinvented with fantastic colors of the artist's choice) (p. 273). Rosenquist, trained as a professional billboard artist, would go on to explore in his oil paintings the slick, brushless surfaces familiar in the giant roadside ads seen from a moving automobile. Lichtenstein, in turn, was mesmerized by the atomic language of Benday dots, black outlines, and the three primary colors as the elementary vocabulary of low-budget commercial imagery, focusing on this virtually abstract vocabulary as the source of new kinds of decorative luxury and order.

The overall direction was clear, to move from the handmade to the machine-made, from the personal to the industrial, a direction that soon began to embrace the ironic possibility of artists attempting to replicate

Rosenblum

Fig. 103 **Robert Rauschenberg (b. 1925)**

Canyon, 1959

Oil, pencil, paper, fabric, metal, cardboard box, printed paper, and reproductions, photograph, wood, paint tube, and mirror on canvas with oil on bald eagle, string, and pillow

81¼ × 70 × 24 in. (207.6 × 177.8 × 61 cm)

Courtesy Sonnabend Collection, New York

Fig. 104 **James Rosenquist (b. 1933)**

President Elect, 1960–61

Oil on isorel, 89¼ × 144⅞ in. (228 × 366 cm)

Musée national d'art moderne, Paris

Centre Georges Pompidou

by hand the illusion of a photograph's immaculate, impersonal surfaces. This goal is most often referred to as Photo-Realism, a style that flourished in the 1970s and is represented in the work of Robert Bechtle (born 1932), Richard Estes (born 1932), Charles Bell (1935–1995), Tom Blackwell (born 1938), and Chuck Close (born 1940). In retrospect, this mode of using the photographic image as the source of painting can be thought of as a later variation of Pop art. For one thing, most of the artists who embraced this style chose aggressively American subjects—the family automobile (fig. 106), a parked motorcycle, a candy machine, the local movie house or diner. Even in the case of Close's billboard-sized portraits, whether of himself or his friends, we seem to be confronted with a mugshot anthology of ordinary American faces in which even art-world celebrities, stripped of their professional attributes and seen only from the neck up, are given equal, democratic time with lesser-known members of the artist's circle (p. 283).

Here again, history repeats itself when Photo-Realism is seen within a broader view of American art. There are, in fact, many precedents for this seamless fusion of photography and painting, most particularly in the work of Charles Sheeler (1883–1965; fig. 81; p. 217), who would often erase the boundaries between these two media, one handmade, the other machine-made. And it should be added that the concept of Photo-Realism could be expanded into the third dimension, as apparent in the show-stopping sculptures of Duane Hanson (1925–1996), which offer a palpable replication of literal truth, in this case the material facts of the most ordinary, working-class Americans—janitors, cleaning women, shoppers—recreated in minuscule detail, from the polish on their fingernails to the wrinkles on their uniforms. Hanson's eerie images of human clones had, in fact, more the character of science fiction than of old-fashioned waxworks, a point that may have helped to make him a major source of inspiration for younger American artists fascinated by the phenomenon of body doubles, including Charles Ray (born 1953) and Jeff Koons (born 1955).

Looked at one way, the 1960s and 70s might be seen as an unexpected triumph of American nationalist imagery, in which movie stars, junk food, automobiles, cartoon characters, politics, highways, and

ordinary people invaded the unpolluted territories inhabited since the early twentieth century by artists who clung to a faith in abstract art, an international language that could cross every border. But, in fact, these venerable traditions of purity, in which painting and sculpture would be stripped of any discernible reference to a visible, material world, continued to flourish side by side with this enthusiastic embrace of the American scene. The more irregular, organic vocabulary of Abstract Expressionism was often countered by an ongoing faith in the legacy of geometry, so that by the 1960s, such painters as Ellsworth Kelly (born 1923; p. 281), Kenneth Noland (born 1924), Frank Stella (born 1936; p. 280), and Brice Marden (born 1938; p. 289) had already forged personal styles in which pure hues and ruler-and-compass shapes declared a visual realm so pristine that the germs of reality would instantly perish in their climes.

The 1960s, in fact, resurrected what was a traditional aesthetic battle in the history of Modern art, namely, the opposition between abstraction and realism. The battle was particularly heated in the case of the emergence in the early 1960s of what was called Minimalism at exactly the same time as the appearance of Pop art, especially since artists representing these opposing camps might often be shown at the same gallery, as, for instance, were Stella and Lichtenstein at Leo Castelli's. Minimalism was a particularly powerful force in three dimensions, spawning a new generation of sculptors—Carl Andre (born 1935; p. 286), Donald Judd (1928–1994; p. 287), Dan Flavin (1933–1996; pp. 284–85), Robert Morris (born 1931)—who worshiped at only the purest of historical shrines, especially at such ancestral icons as *Black Square* by Kazimir Malevich (1878–1935) or Utopian dreams of towering monuments based on the purest of geometric modules by Vladimir Tatlin (1885–1953). The look of these Minimalist sculptures was severe, puritanical, with rudimentary units—a square, a cube, a cylinder—repeated in regularized rhythms that were rigorously predetermined. At the time, they seemed to stand firmly against everything Pop art was for, replacing the harsh assault of commonplace reality with blueprints of geometric order, and the hostility between the two groups often turned into heated polemics, a Campbell's soup can and a perfect cube at war with each other.

But history has a way of changing things, and today, from the vantage point of the early twenty-first century, Pop art and Minimalism often seem to be complementary. It is clear, for instance, that one of Warhol's most favored structural forms, the grid, was also the geometric basis for many works by Judd and Andre, as if the machine-belt patterns of supermarket display or printing presses had been reduced to their unpolluted essence. And just as Pop art espoused new, more mechanized techniques of image-making, from Benday dots to silkscreen, so, too, did Minimalist sculpture bury the old-fashioned world of bronze and marble in favor of new industrial materials ranging from Plexiglas and galvanized iron to Styrofoam and enamel finishes. Perhaps the most complete fusion of these presumably contradictory worlds is found in Flavin's fluorescent sculptures (fig. 107). Each tubular unit is an industrial product of cylindrical perfection, a pure module from which more complex, but equally pure, structures can be made. But when these artificial lights are turned on, they not only emanate an abstract luminosity that transcends earthly space-time coordinates, but also evoke the ever more pervasive visual environment of the indoor fluorescent lighting that has become commonplace in American homes, office buildings, and shopping centers. The abstract and the real may be two sides of the same coin.

Fig. 105 **Ed Ruscha (b. 1937)**

The Back of Hollywood, 1977

Oil on canvas, 22 × 80 in. (55.9 × 203.2 cm)

Musée d'art contemporain de Lyon, France

Fig. 106 **Robert Bechtle (b. 1932)**

'71 Buick, 1972

Oil on canvas, 47⅛ × 68 in. (121.6 × 172.7 cm)

Solomon R. Guggenheim Museum,
New York, Purchased with funds
contributed by Mr. and Mrs. Barrie M.
Damson, 1979, 79.2664

Fig. 107 **Dan Flavin (1933–1996)**

untitled (to Jan and Ron Greenberg), 1972–73

Yellow and green fluorescent light

8-ft fixtures, 97 × 84 × 10 in.

(246.4 × 213.4 × 25.4 cm) in a corridor

97 × 84 in. (246.4 × 213.4 cm)

Solomon R. Guggenheim Museum,
New York, Panza Collection, 1991, 91.3708

PROSPERITY and DISILLUSIONMENT

Jackson Pollock (1912–1956)

Eyes in the Heat, 1946

Oil and enamel on canvas

54 × 43 in. (137.2 × 109.2 cm)

Solomon R. Guggenheim Foundation,

Peggy Guggenheim Collection, Venice, Italy

1976, 76.2553.149

Mark Rothko (1903–1970)
Untitled (Violet, Black, Orange, Yellow
on White and Red), 1949
Oil on canvas, 81¹⁄₂ × 66 in. (207 × 167.6 cm)
Solomon R. Guggenheim Museum,
New York, Gift of Elaine and Werner
Dannheisser and the Dannheisser
Foundation, 1978, 78.2461

Barnett Newman (1905–1970)

Uriel, 1955

Oil on canvas, 96 × 216 in.

(243.8 × 548.6 cm)

Onnasch Collection, Berlin

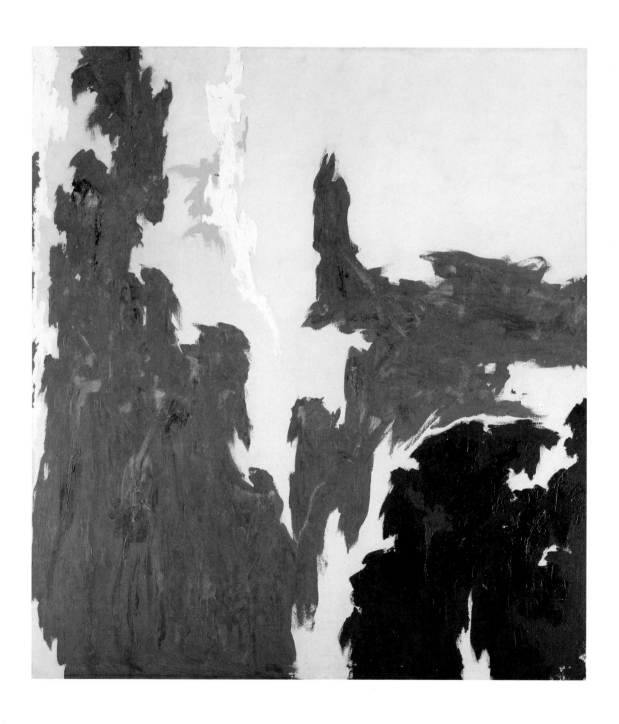

Prosperity and Disillusionment

Franz Kline (1910–1962)

Monitor, 1956

Oil on canvas, 78¾ × 115¼ in. (200 × 292.7 cm)

Museum of Contemporary Art, Los Angeles

The Panza Collection, 85.18

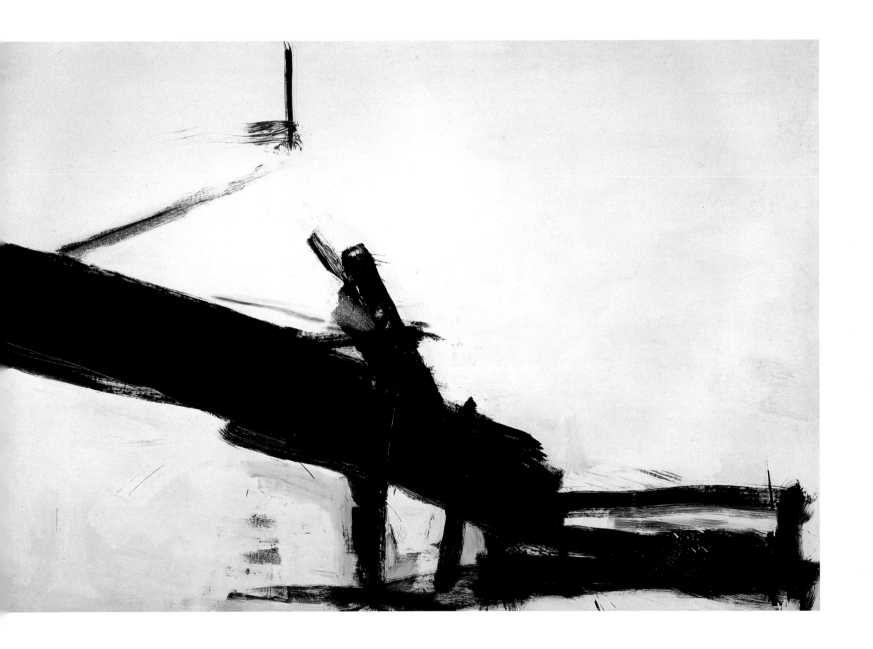

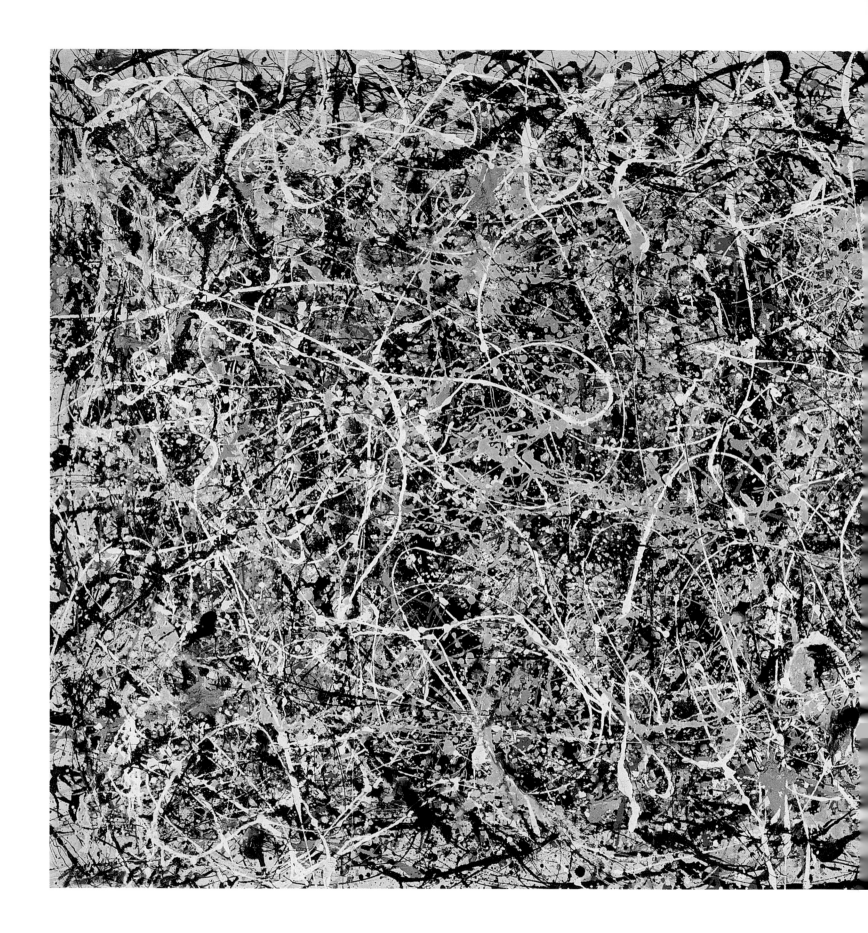

Prosperity and Disillusionment

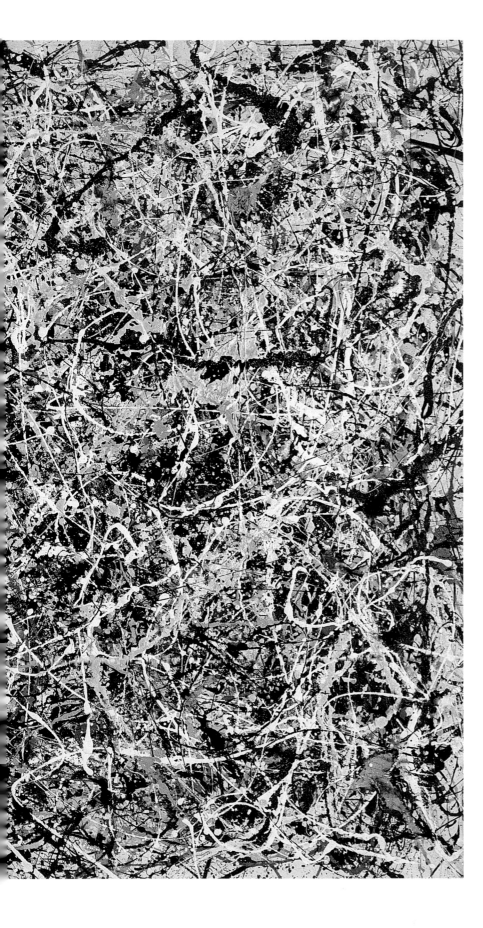

Jackson Pollock (1912–1956)

No. 1, 1949, 1949

Enamel and metallic paint on canvas

63 × 102 in. (160 × 259.1 cm)

Museum of Contemporary Art,

Los Angeles, The Rita and Taft Schreiber

Collection, Given in loving memory of her

husband, Taft Schreiber, by Rita Schreiber

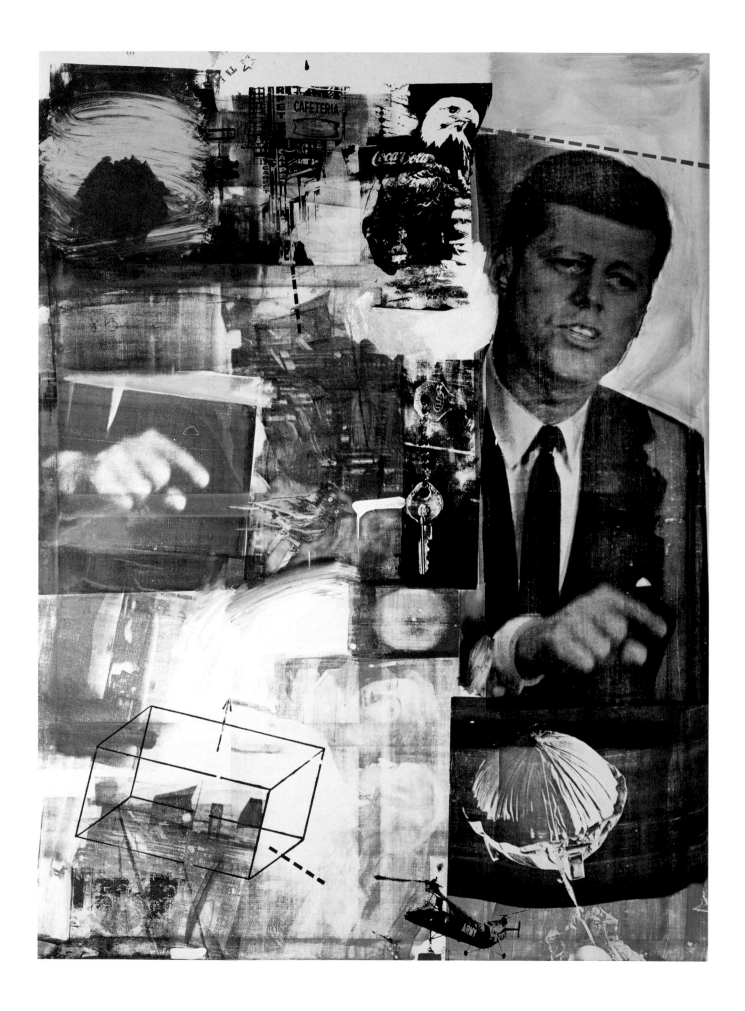

Prosperity and Disillusionment

Robert Rauschenberg (b. 1925)

Buffalo II, 1964

Oil and silkscreened ink on canvas

96 × 72 in. (243.8 × 182.9 cm)

The Robert B. Mayer Family Collection,

Chicago

Jasper Johns (b. 1930)

Flag, 1967

Encaustic and collage on three canvas

panels, 33½ × 56¼ in. (85.1 × 142.9 cm)

The Eli and Edythe L. Broad Collection,

Los Angeles

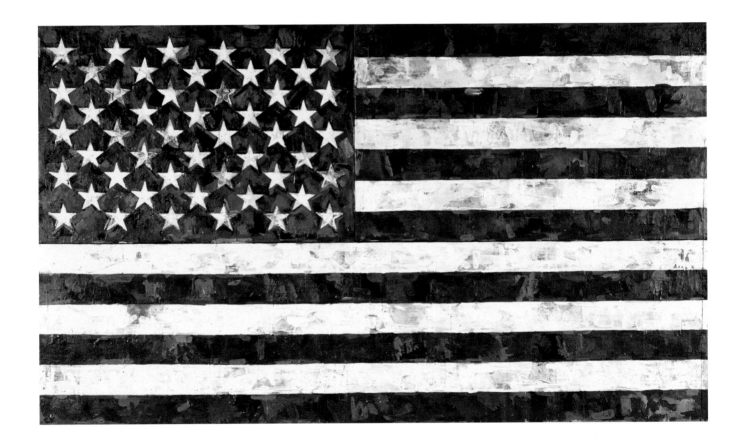

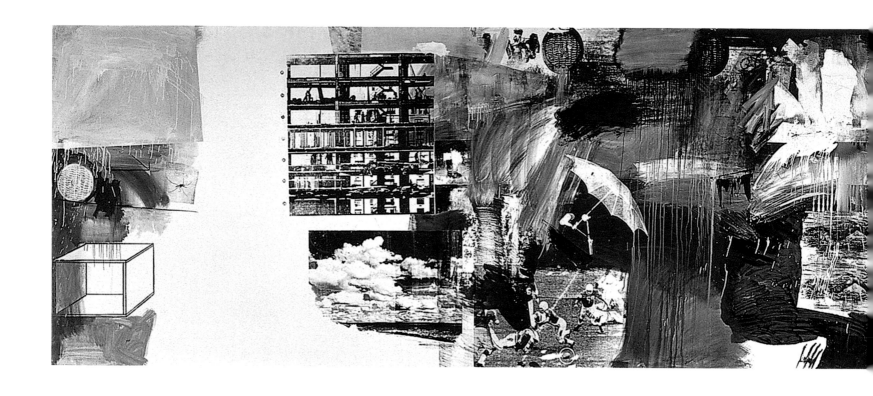

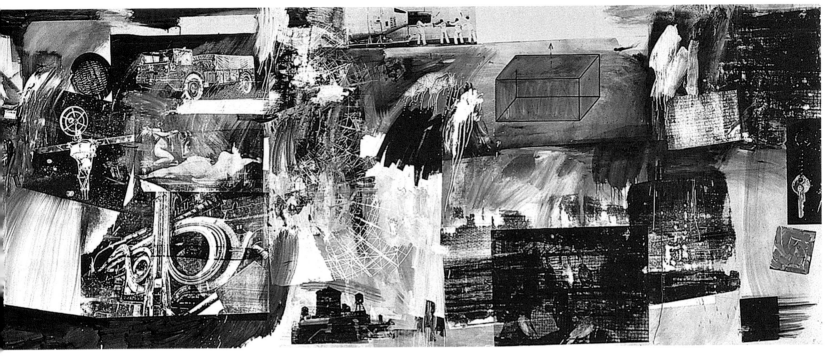

Robert Rauschenberg (b. 1925)

Barge, 1962–63

Oil and silkscreened ink on canvas

80⅛ × 386 in. (203.8 × 980.4 cm)

Guggenheim Bilbao Museoa, Spain, and
Solomon R. Guggenheim Museum, New York,
with additional funds contributed by Thomas
H. Lee and Ann Tenenbaum; the International
Director's Council and Executive Committee
Members; Ulla Dreyfus-Best; Norma and
Joseph Saul Philanthropic Fund; Elizabeth Rea;
Eli Broad; Dakis Joannou; Peter Norton; Peter
Lawson-Johnston; Michael Wettach; Peter
Littmann; Tiqui Atencio; Bruce and Janet Karatz;
and Giulia Ghiradi Pagliai, 1997, 97.4566;
GBM 1997.10

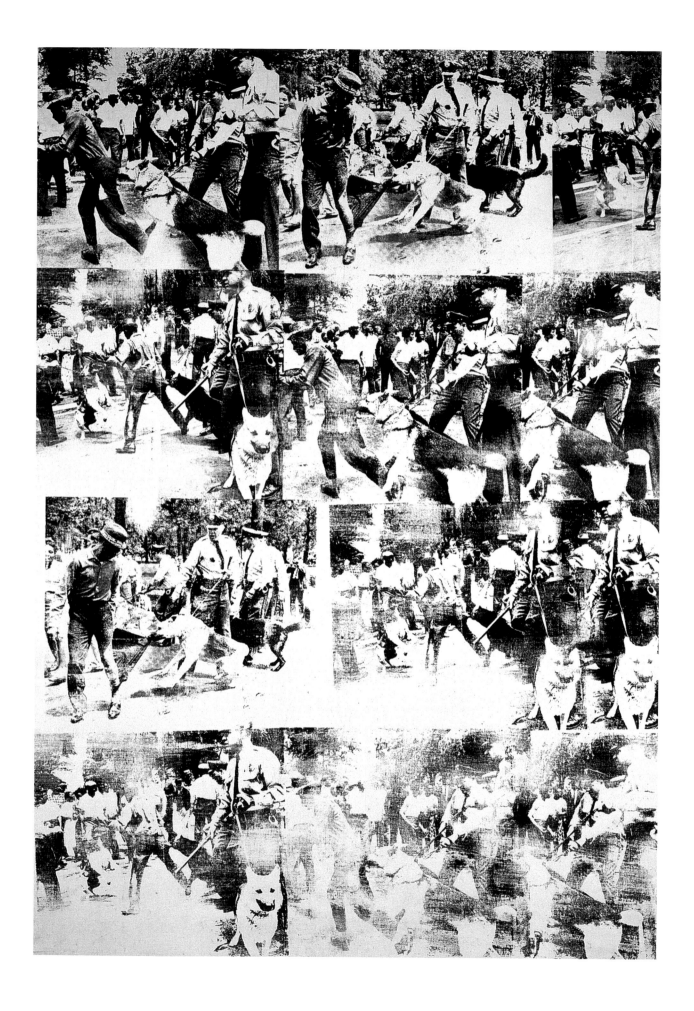

Andy Warhol (1928–1987)
Race Riot, 1963
Silkscreened ink and graphite on canvas
57 × 76 in. (144.8 × 193 cm)
Daros Collection, Zurich, Switzerland

Andy Warhol (1928–1987)
Double Elvis (Ferus Type), 1963
Silkscreened ink and silver paint on linen
84¼ × 53 in. (214 × 134.6 cm)
Andy Warhol Museum, Pittsburgh
Founding Collection, Contribution from
the Andy Warhol Foundation for the
Visual Arts, Inc.

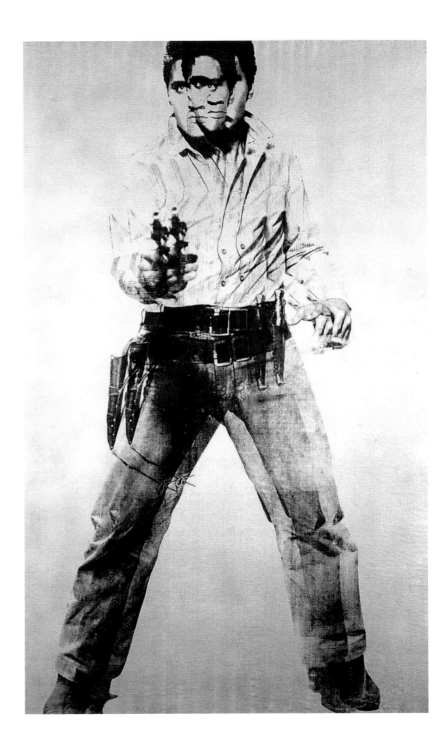

Roy Lichtenstein (1923–1997)

Eddie Diptych, 1962

Oil on canvas, two panels

overall: 44 × 52 in. (111.8 × 132.1 cm)

Courtesy Sonnabend Collection, New York

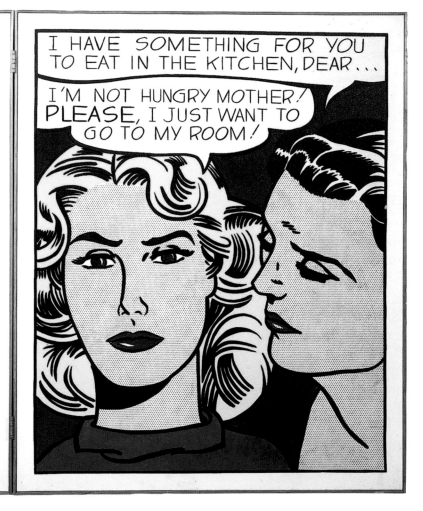

Roy Lichtenstein (1923–1997)
Grrrrrrrrrr!!, 1965
Oil and Magna on canvas
68 × 56⅛ in. (172.7 × 142.6 cm)
Solomon R. Guggenheim Museum,
New York, Gift of the Artist, 1997, 97.4565

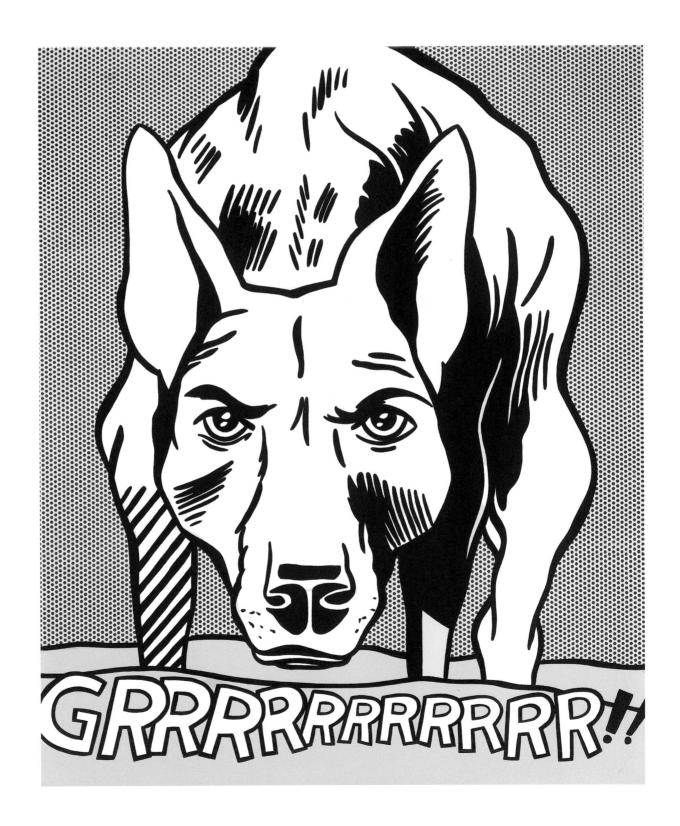

Tom Wesselmann (1931–2004)

Still Life # 34, 1963

Acrylic and collage on panel

47½ in. (120.7 cm) diameter

Mugrabi Collection

Andy Warhol (1928–1987)

Four Colored Campbell's Soup Cans, 1965

Acrylic and silkscreened ink on canvas

Four panels, each: 36¼ × 24 in. (92.1 × 61 cm)

Courtesy Sonnabend Collection, New York

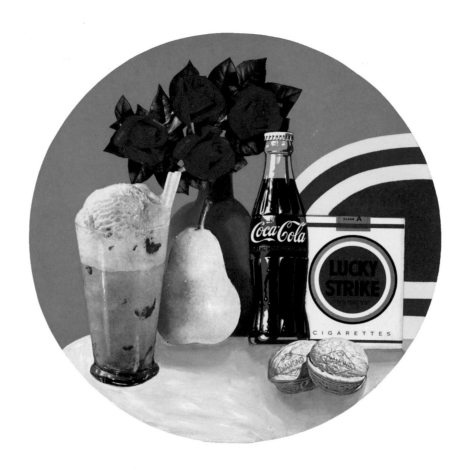

Prosperity and Disillusionment

Ed Ruscha (b. 1937)

Standard Station, Amarillo, Texas, 1963

Oil on canvas

65 × 120⅝ in. (165.1 × 306.4 cm)

Dartmouth College, Hanover, New
Hampshire, Hood Museum of Art, Gift of
James J. Meeker, Class of 1958, in Memory
of Lee English

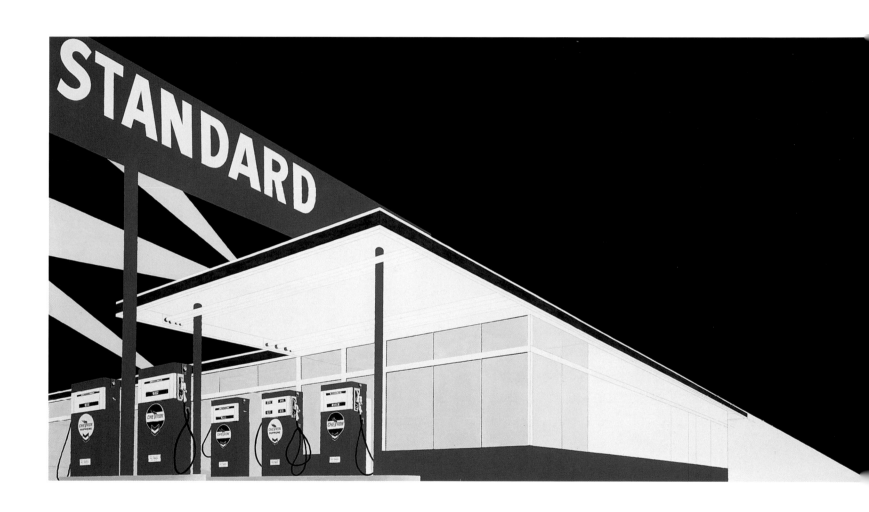

Prosperity and Disillusionment

James Rosenquist (b. 1933)
The Swimmer in the Econo-mist
(Painting 3), 1997–98
Oil on canvas, 137¾ × 240⅛ in. (350 × 610 cm)
Solomon R. Guggenheim Museum,
New York, Commissioned by Deutsche
Bank AG in consultation with the
Solomon R. Guggenheim Foundation for
the Deutsche Guggenheim, Berlin, 2005.77

Prosperity and Disillusionment

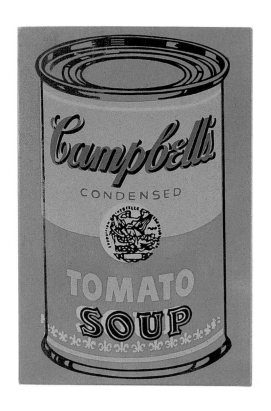
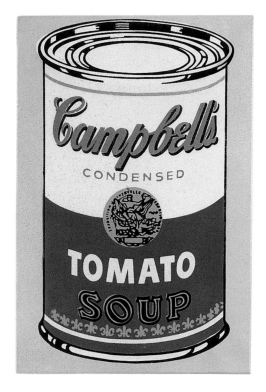
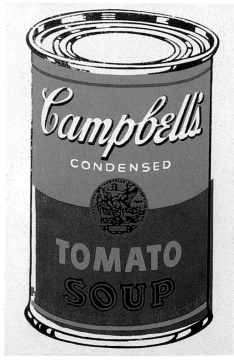
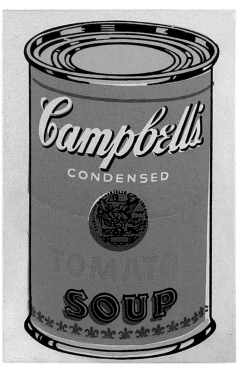

John Chamberlain (b. 1927)

Dolores James, 1962

Welded and painted steel

72½ × 101½ × 46¼ in. (184.2 × 257.8 × 117.5 cm)

Solomon R. Guggenheim Museum,

New York, 1970, 70.1925

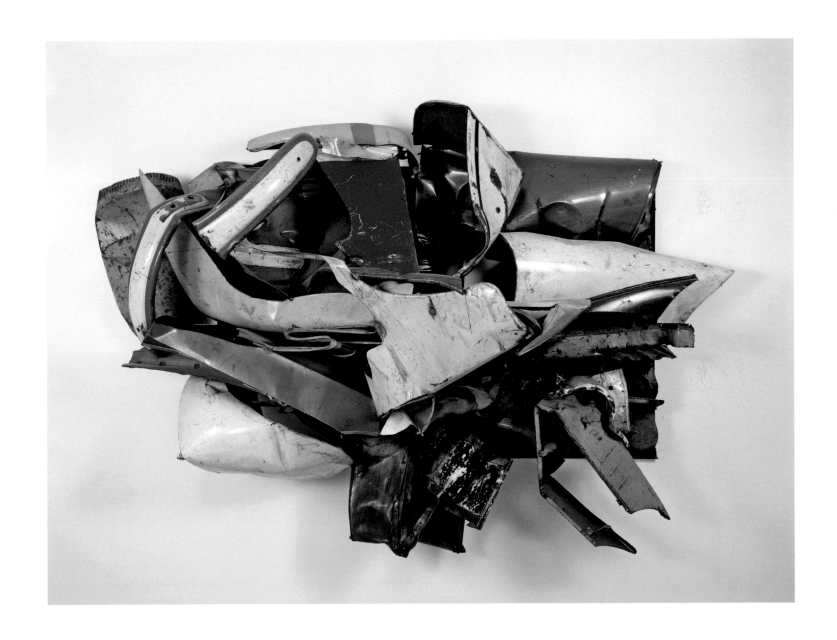

Edward Kienholz (1927–1994)

The Portable War Memorial, 1968

Plaster casts, tombstone, blackboard, flag, poster, restaurant furniture, photographs, working Coca-Cola machine, stuffed dog, wood, metal, and fiberglass

114 × 384 × 96 in. (289.6 × 975.4 × 243.8 cm)

Museum Ludwig, Cologne, Germany

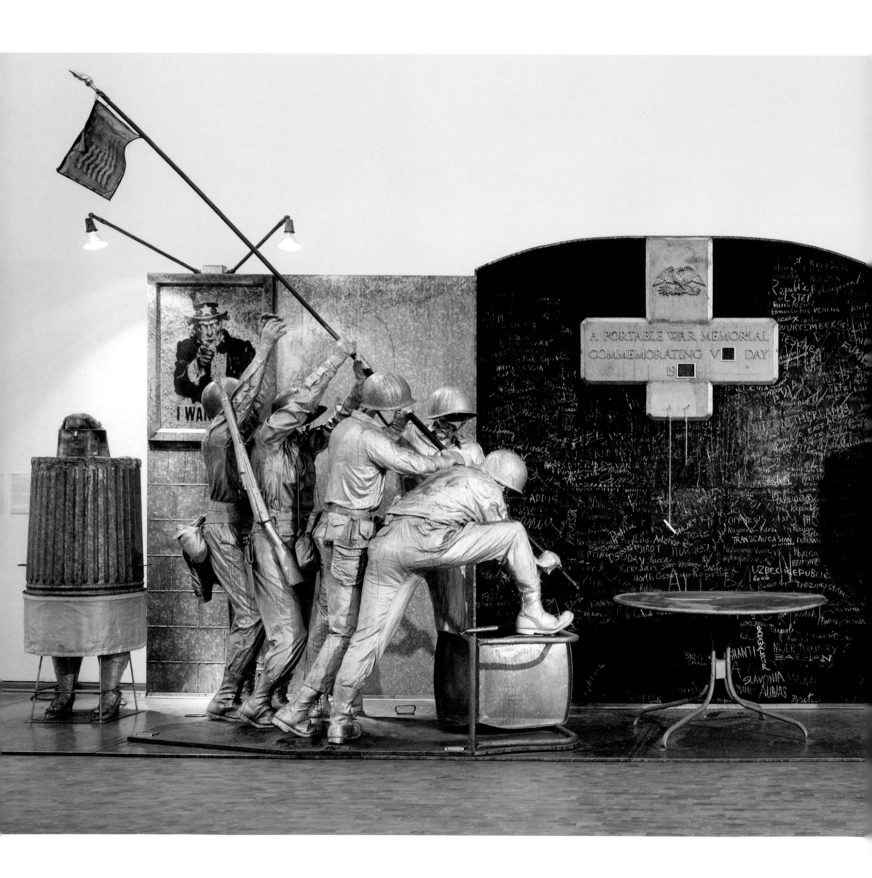

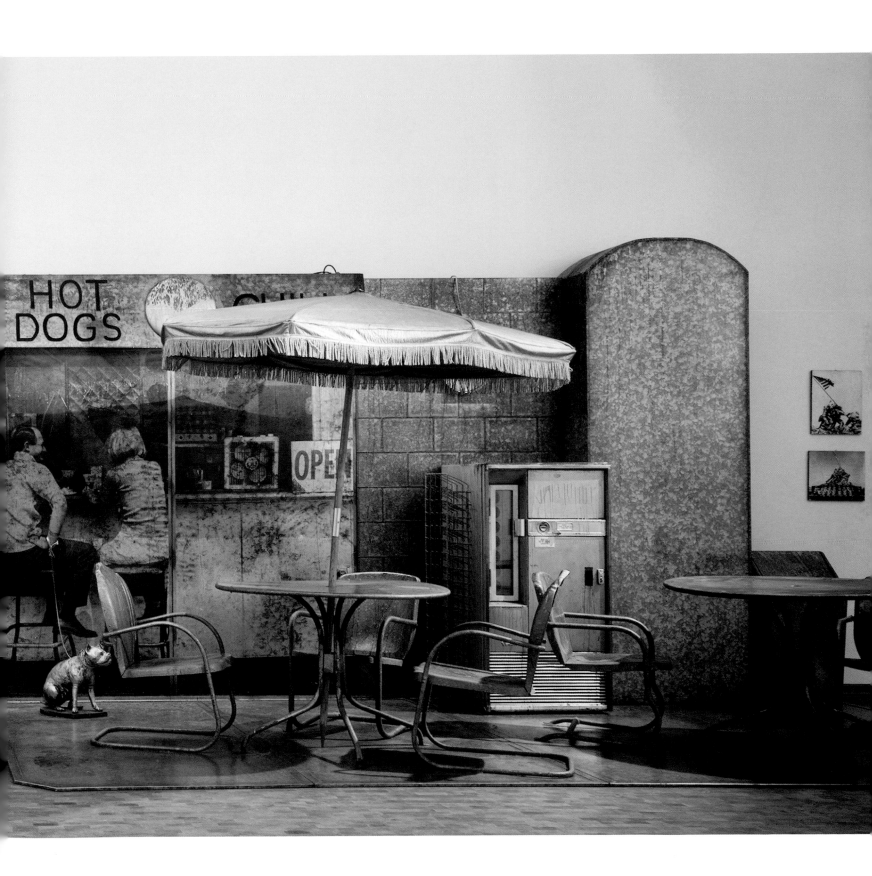

Frank Stella (b. 1936)

Harran II, 1967

Polymer and fluorescent polymer paint

on canvas, 120 × 240 in. (304.8 × 609.6 cm)

Solomon R. Guggenheim Museum,

New York, Gift of Mr. Irving Blum, 1982

82.2976

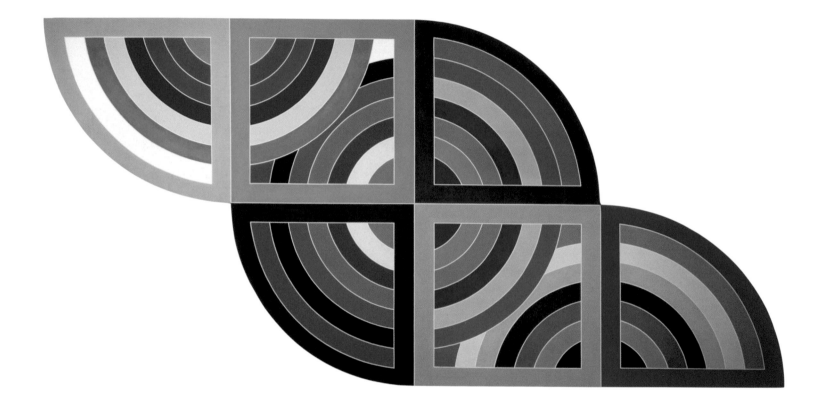

Ellsworth Kelly (b. 1923)

Dark Blue Curve, 1995

Oil on canvas, 46 × 190 in. (116.8 × 482.6 cm)

Solomon R. Guggenheim Museum,

New York, 1996, 96.4512

George Segal (1924–2000)

Cinema, 1963

Plaster, illuminated Plexiglas, and metal

118 × 96 × 39 in. (299.7 × 243.8 × 99.1 cm)

Albright-Knox Art Gallery, Buffalo, New

York, Gift of Seymour H. Knox, Jr., K1964:3

Chuck Close (b. 1940)

Stanley, 1980–81

Oil on canvas, 108 × 84 in. (274.3 × 213.4 cm)

Solomon R. Guggenheim Museum, New

York, Purchased with funds contributed by

Mr. and Mrs. Barrie M. Damson, 1981, 81.2839

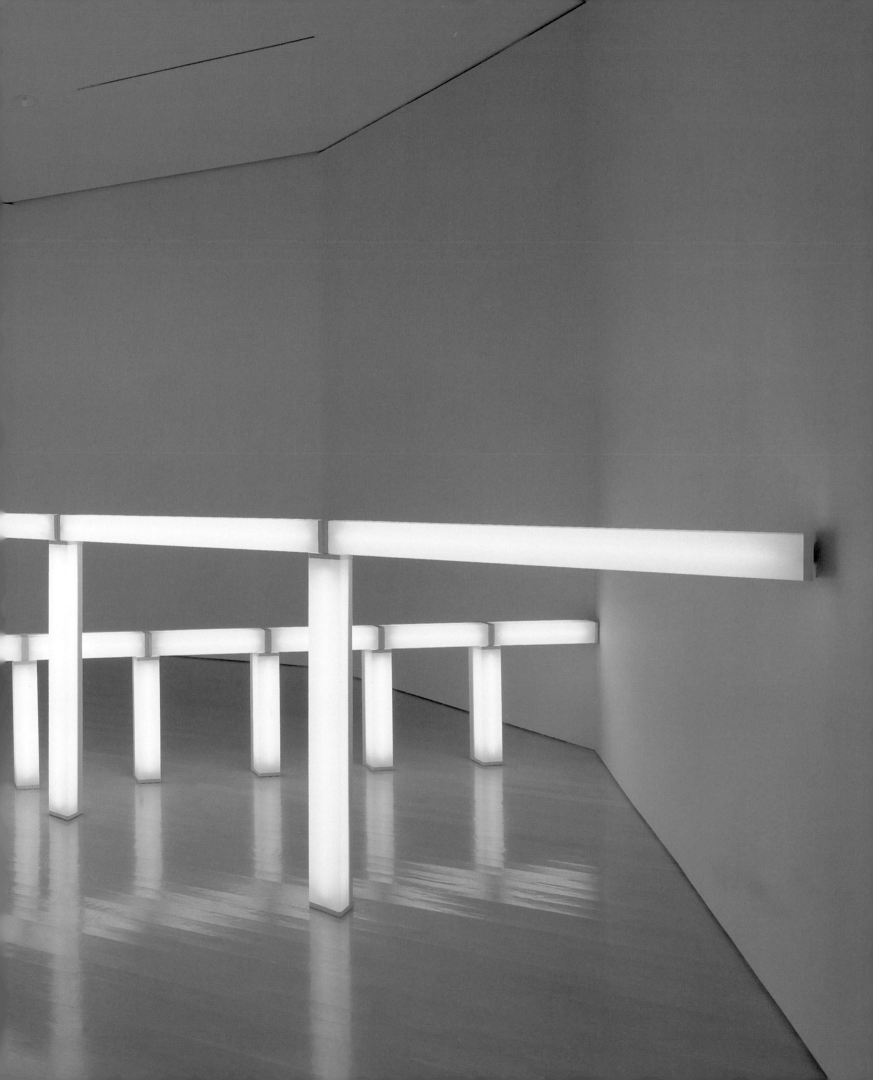

Pages 284–85

Dan Flavin (1933–1996)

*green crossing green (to Piet Mondrian
who lacked green)*, 1966

Green fluorescent light, 2- and 4-ft.
fixtures

first section: 48 × 240 in. (121.9 × 610 cm)

second section: 24 × 263¾ in. (61 × 669.9 cm)

Solomon R. Guggenheim Museum,
New York, Panza Collection, 1991, 91.3705

Carl Andre (b. 1935)

10 × 10 Altstadt Copper Square, 1967

Copper, 100 units, overall: ¼ × 197 × 197 in.
(0.6 × 500.4 × 500.4 cm)

Solomon R. Guggenheim Museum,
New York, Panza Collection, 1991, 91.3673

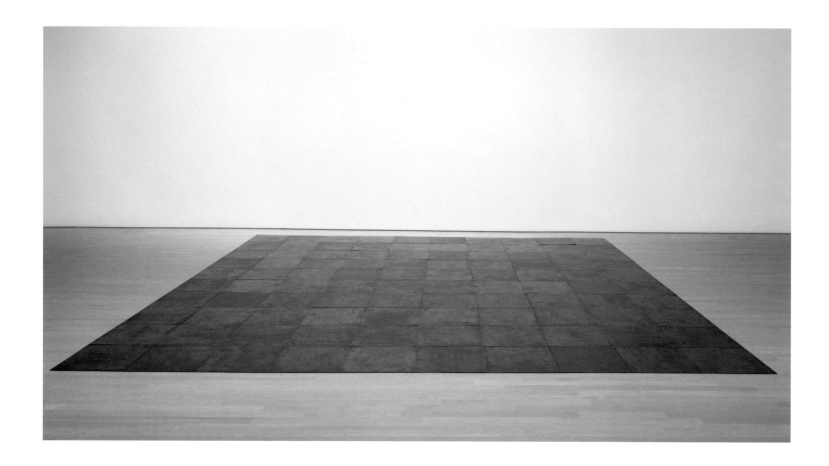

Prosperity and Disillusionment

Donald Judd (1928–1994)

Untitled, 1969

Copper, ten units, each: 9 × 40 × 31 in.

(22.9 × 101.6 × 78.7 cm), with 22.8-cm

(9-in.) intervals

Solomon R. Guggenheim Museum,

New York, Panza Collection, 1991, 91.3713

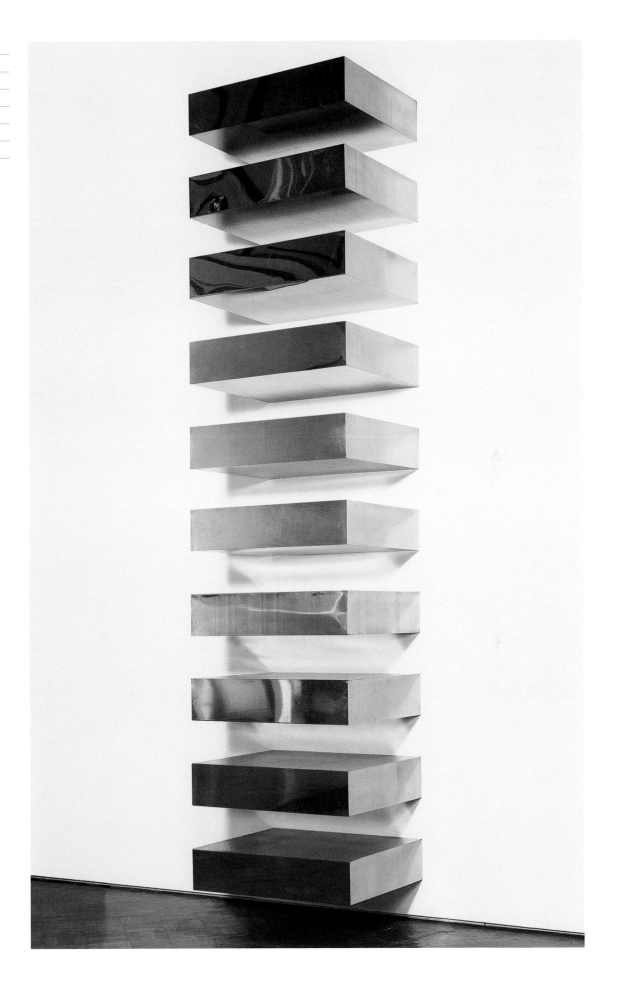

Richard Serra (b. 1939)

Right Angle Prop, 1969

Lead antimony

72 × 72 × 34 in. (182.9 × 182.9 × 86.4 cm)

Solomon R. Guggenheim Museum,

New York, Purchased with funds

contributed by the Theodoron Foundation,

1969, 69.1906

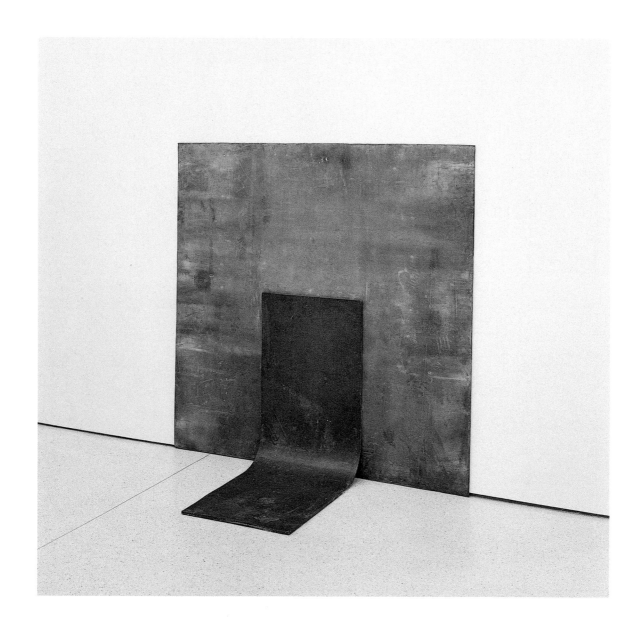

Prosperity and Disillusionment

Brice Marden (b. 1938)

Untitled, 1973

Oil and wax on canvas, two panels,

overall: 72 × 72⅛ in. (182.9 × 183.2 cm)

Solomon R. Guggenheim Museum,

New York, Panza Collection, 1991, 91.3789

Bruce Naumann (b. 1941)

None Sing Neon Sign, 1970

Ruby-red and cool white neon, edition 6/6

13 × 24¼ × 1½in. (33 × 61.6 × 3.8 cm)

Solomon R Guggenheim Museum,

New York, Panza Collection, 1991, 91.3825

Joseph Kosuth (b. 1945)

Titled (Art as Idea as Idea) [Water], 1966

Photostat mounted on board

48 × 48 in. (121.9 × 121.9 cm)

Solomon R. Guggenheim Museum,

New York, Gift of Leo Castelli, New York,

1973, 73.2066

wa·ter (wâ′tẻr), *n.* [AS. *wæter* = D. *water* = G. *wasser*, akin to Icel. *vatn*, Goth. *watō*, water, also to Gr. ὕδωρ, Skt. *udan*, water, L. *unda*, a wave, water; all from the same root as E. *wet*: cf. *hydra, otter¹, undine*, and *wash*.] The liquid which in a more or less impure state constitutes rain, oceans, lakes, rivers, etc., and which in a pure state is a transparent, inodorous, tasteless liquid, a compound of hydrogen and oxygen, H_2O, freezing at 32° F. or 0° C., and boiling at 212° F. or 100° C.; a special form or variety of this liquid, as rain, or (often in *pl.*) as the liquid ('mineral water') obtained from a mineral spring (as, "the *waters* of Aix-la-Chapelle".

TO SEE A

Nationalism and Globalism: Issues in American Art, 1980s to the Present[1]

Susan Cross

The cowboy has long been a symbol of American identity; an icon of strength, independence, and pioneering spirit. A loner at heart, with the grit of an outlaw, and a self-imposed duty to maintain order and justice on the lawless frontier, he can be seen as a manifestation of the character of the United States itself, past and present. Yet while the economy and lifestyle that sustained the mythic hero have all but disappeared, the ideal of the maverick on his horse remains a powerful figure in the contemporary imagination. The enduring and unmatched allure of the cowboy legend is evident in the countless incarnations of the romantic figure found in pop culture (as well as contemporary art), from the overwhelming success of the television show *Dallas* to the clothing empire that Ralph Lauren built on denim, turquoise, and silver belt buckles. Perhaps even more telling of the image's poignancy are the familiar photographs of presidents Ronald Reagan and George W. Bush playing the part of the Western hero in a Stetson hat (fig. 109). Each politician (one a former Hollywood actor, the other a graduate of Andover and Yale) adopted this image of swaggering potency to reach the White House, convincing the country that a real man, a real American, would be watching out for our interests.

SOCIETY OF THE SPECTACLE

At the time of Reagan's election in 1980, the United States was reeling from the oil crisis and suffering the highest unemployment and inflation rates since the Depression. Iran was holding fifty-two Americans hostage, and the country was ready for a new "sheriff." The ruggedly handsome "rancher" from California seemed right for the rôle. The hostages were released shortly after Reagan took office,[2] and, with the implementation of "Reaganomics," which consisted of major tax cuts and monumental defense spending, the country enjoyed an unprecedented level of

prosperity between 1983 and 1987. But some would say that the explosion of new wealth (fueled by deficit spending) and a ravenous consumer culture was, like Reagan's cowboy image, all based on illusion. Iconic photographs of the Marlboro Man by artist Richard Prince (born 1949), which were made during the same period, examine both the seduction and the emptiness of this powerful symbol, and the "society of spectacle," as Guy Debord (1931–1994) described it, that would come to define the Postmodern era (fig. 108). Equating smoking with masculinity, the serial cowboy ads Prince appropriated were selling a macho image—an identity—as much as cigarettes. Exposing the rôle of the mass media in shaping who we are and how we live, Prince is one of many artists of his generation whose photo-based works reflected the interrogation of representation—as well as modernism—inspired by such theorists as Roland Barthes (1915–1980), Jean Baudrillard (born 1929), Jacques Derrida (1930–2004), and Michel Foucault (1926–1984).

The authority of this endless stream of images to construct identity, and reinforce patriarchic power structures, became of particular interest to a generation of female artists who have deconstructed the coded pictures that form the idea of woman in our society. *Film Stills* by Cindy Sherman (born 1954), for example, are emblematic of the period and its critique of representation (p. 310). Mimicking the all-too-familiar female stereotypes seen in print and on screen, the photographs feature the artist costumed and posed as the "naïve waif," the "budding starlet," and the "temptress," among many other personae. They are often mistaken for stills taken from actual films, but on closer examination the artifice of Sherman's works and her rôle as producer and subject are exposed. Copies without originals, the fabrications are reminiscent of the "simulacra" that have supplanted the real in our media-saturated society. The works of Barbara Kruger (born 1945), which co-opt the

(1980–present) Multiculturalism and Globalization

Lawrence Weiner (b. 1942)

Cat. #278, TO SEE AND BE SEEN, 1972

Language + the materials referred to

Dimensions variable

Solomon R. Guggenheim Museum,

New York, Panza Collection Gift, 1992

92.4193

ND BE SEEN

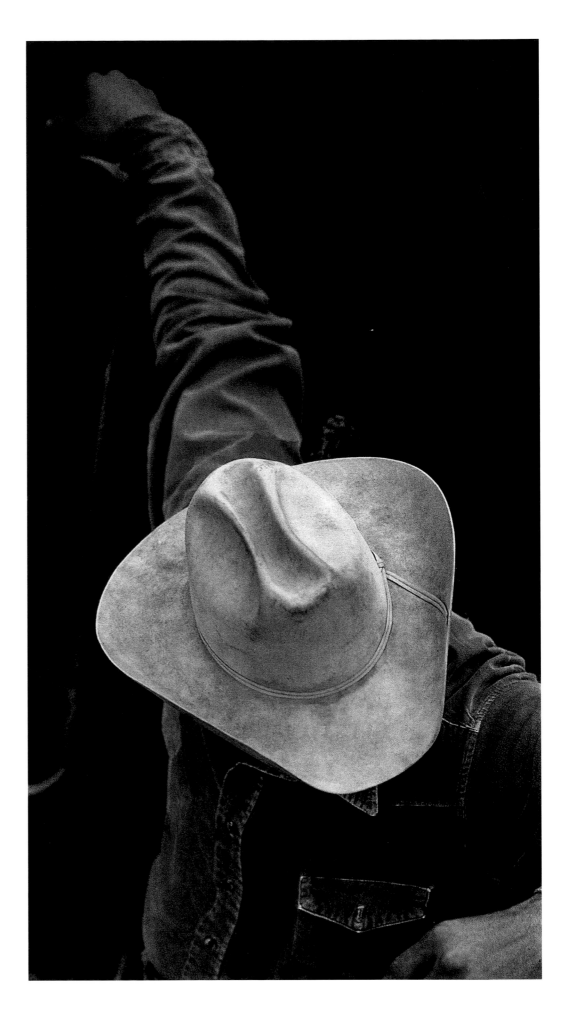

Fig. 109 *"My Heroes have Always Been Cowboys"*, bumper sticker

visual language of advertising, meld similarly trite images of women with language that subverts the standard messages framing women as "other" or "less than," or existing as objects of desire. Reminiscent of posters and billboards, Kruger's works use pithy slogans, yet the artist speaks alternately to both male and female audiences, complicating the typically male subject (p. 309). Artist Jenny Holzer (born 1950) also examined the rôle of language in the formation of gender rôles and systems of belief. In her *Truisms* series, Holzer created mock clichés that mimicked the meta-narratives or myths Roland Barthes revealed as a tool to legitimize prevailing power relations. Her weighty yet humorous platitudes, such as "Money Creates Taste" (fig. 110) and "Sex Differences Are Here to Stay," draw attention to language as an invisible means of control. Disseminating her "anonymous" texts via street posters, brass building plaques, and LED signs in Times Square and even on airport baggage carousels, the artist emphasized the network of meanings informing both the social and the personal within the public sphere.

While the critical examination of both the image and the sign gave rise to the predominance of photographic and textual work in the 1980s and the subsequent decades, several painters, most notably David Salle (born 1952) and Eric Fischl (born 1948), were exploring similar ideas on canvas (pp. 312, 313). Salle's works, which often merged unrelated pictures from both pop cultural and art-historical sources taken out of context, reflected the Postmodern concept of pastiche. Rejecting the modernist notion of progress, these disparate images articulate both the fragmented experience of a media-saturated landscape and the era's democratic embrace of high and low, old and new. A fascination with the surface—the result of a proliferation of images unanchored by history—prompted Fischl to play with outside appearances and to dig for another truth behind the flawless images presented in the mass media. Rendering film-still-like tableaux, he fashioned his own perspective on contemporary culture, influenced by his suburban upbringing. Reminiscent of snapshots, his unguarded family scenes hint at adolescent fantasies, infidelities, and even incest, and expose the psychosexual drama coursing underneath the veneer of picture-perfect suburbia.

At the same time, in reaction against the coolness of conceptualism and appropriation, a tendency toward exuberant expressionism and an updated interpretation of traditional figuration flourished in the work of such painters as Francesco Clemente (born 1952) and Sandro Chia (born 1946) (both Europeans working in the United States) and Julian Schnabel (born 1951; p. 314). Schnabel's mosaic-like plate paintings, as well as his large-scale canvases, which married Classical imagery with the artist's gestural brushstrokes and hermetic text, reinstated the rôle of "genius artist" dismantled by the likes of Sherman, Prince, and Sherrie Levine (born 1947), who rejected the modernist cult of authorship and originality. An increased demand for painting developed, however, as the bull market of the 1980s created wealthy patrons and unprecedented prices. Schnabel has come to epitomize the "art star" of the decade, whose celebrity status rivaled that of his famous collectors and movie stars alike.

While Schnabel was making references to the traditions of Europe, other expressionists found their inspiration in the street. Keith Haring (1958–1990) and Jean-Michel Basquiat (1960–1988) translated the energy of graffiti into an aesthetic vocabulary that broke down barriers and engaged a mass audience (pp. 315, 316–317). Moving comfortably between the subway and city sidewalks, and galleries and museums, both artists were inspired by youth culture and the energy of hip-hop. Haring's graphic, cartoon-like figures and radiating haloes of paint seemed to defy age, sex, race, and class, while Basquiat's raw, primal forms and graffiti-inspired markings spoke a universal language. Both artists were embraced by the marketplace: in his short life, which ended at the age of twenty-seven, Basquiat was a superstar and a part of Andy Warhol's circle, while Haring created Pop Shop, a commercial venture that allowed the general public access to his art in the form of T-shirts and affordable objects bearing his signature images.

The materialism of American culture captivated a range of artists, among them Jeff Koons (born 1955), who recast the forms of consumer merchandise advertising as an aesthetic language. Examining the psychology of marketing strategies in his *Luxury and Degradation* series, Koons drew attention to the socio-economic identities associated with

different types of products. Yet Koons also embraced the fetishistic qualities valued by an object-driven culture, even at the most quotidian level. Vacuums, as well as *tchotchkes* (souvenir figurines), figurines, balloon animals, and blow-up dolls, transformed into seductive sculptures like his oversized, mirrored *Rabbit* (1986), have been reframed by Koons as cousins to the Baroque masterpieces of Bernini (fig. 112). Like Prince, whose subjects have included biker chicks, low-brow jokes, monster trucks, and muscle cars, Koons has engaged the working-class tastes of America usually overlooked by the cultural élite.

ART AND ACTIVISM

While the 1980s were characterized by prosperity and a propensity for excess, the decade was also marked by devastation. The AIDS epidemic caused a staggering number of deaths, and the disease as well as the apathy of the public and the administration hit the worlds of art, fashion, and dance particularly hard. A culture of activism sprang up in the wake of the crisis. Such collectives as Group Material and Gran Fury, as well as individuals ranging from Donald Moffett (born 1955) to Haring (fig. 111), merged art with political action and fought for gay rights and an awareness of AIDS both in cultural institutions and on the street. While many artists adopted the overt language of political protest or used timelines and educational formats, Felix Gonzalez-Torres (1957–1996) mined the powerful aesthetic language of Minimalism to articulate the fragility and beauty of life, love, and death in an array of poetic works that also invited public participation. His paper stacks and candy spills allowed visitors to take home bits of his art, a means of democratizing his practice and spreading his message outside of the museum walls (p. 319). Using billboards, Gonzalez-Torres more emphatically brought his commentary on homosexuality, AIDS, and remembrance to the masses (fig. 25). *"Untitled"* of 1989, for example, a work painted on a billboard in Sheridan Square, New York, listed a series of significant events that affected the homosexual community, in the neighborhood where the famous Stonewall riots had taken place twenty years earlier. Listed out of chronological order, the incidents and individuals seem to exist outside of an official history, yet they recall a personal mode of remembering. Using this very public platform, the artist gave a voice of authority to the usually disenfranchised and made visible a history usually left untold.[3]

As the authority of the white heterosexual male came under fire, Postmodernism also introduced an openness to multiculturalism. While the legacies of colonialism were revisited by European artists, in the United States an interest in the experience of Native Americans and African Americans came to the fore. Over the past several decades many of the strongest voices in American art have been those of African Americans. As we begin to recognize and revise our limited version of history, one shaped by the dominant ideologies under scrutiny since the postwar era, artists are addressing with greater confidence the ugly past of racism in the United States as well as the silencing of black voices. Since the 1970s, David Hammons (born 1943) has been creating works in the streets and in museums that focus on black culture. With poetry and humor he has transformed empty wine bottles, bags stained with fried chicken grease, and human hair into works of beauty that simultaneously expose the stereotypes informing racism while paying homage to a particular black experience. His 1986 sculpture *Higher Goals* (fig. 115), basketball hoops made from old car windshields and telephone poles adorned with beer-bottle caps arranged in Islam- and Africa-inspired motifs, urged black youth to see past the lure of basketball as the only route to success for black men sanctioned by the white mainstream.[4]

Despite the strides in views on race evidenced in the politically-correct 1980s, the rise of hip-hop culture, and the visibility of successful black cultural leaders like Oprah Winfrey, the next decade began with the videotaped beating of a black man named Rodney King by a group of white policemen in 1992. The subsequent riots that rocked Los Angeles, and the polarizing trial of O.J. Simpson, made clear the rift that the United States faced and still faces. Many artists turned their attention to slavery to understand its lingering effects. The landmark exhibition *Mining the Museum* (1992) by Fred Wilson (born 1954), in which he re-presented many of the objects related to African-American history gathering dust in the collection of the Maryland Historical Society, unearthed the stories that had been left buried. Glenn Ligon's text-based paintings, drawn from the writings of James Baldwin (1924–1987), Ralph

Fig. 110 **Jenny Holzer (b. 1950)**
***Messages to the Public*, 1982**
Spectacolor electronic sign, Times Square,
New York. Text: *Truisms* (1977–79)
Courtesy Jenny Holzer Studio

Ellison (1913–1994), and others, are often made with stencils, oilstick, and coal dust. A potentially combustible by-product of mining, the material seems an apt metaphor for the rage of African Americans as described by Baldwin. Layering repeated phrases into an illegible mass, Ligon (born 1960) manifests the invisibility of black narratives.

Kara Walker's works, which depict outrageous racial stereotypes and atrocious acts of sex and violence, boldly acknowledge a past most would like to forget. Using the form of the silhouette, a nineteenth-century portrait tradition that recalls the era of the ante-bellum South and America's slave past, Walker (born 1969) creates fantastic tableaux that render these "types"—the overtly sexualized slave mistress, the pickaninny—both larger than life and simultaneously flat (p. 330–31). Recalling shadows, these images remind us of a history that will always follow us while illustrating that these two-dimensional images, lacking in detail, do not represent the real. By confronting what are still real monsters, however, while simultaneously emphasizing the fictional construction of race, Walker begins to conquer the stereotypes she co-opts.

THE AMERICAN DREAM

In many ways the 1990s seemed to herald a new era. Recovering from the market crash in 1987, the US economy was again booming. Bill Clinton embodied the American Dream of the small-town Southern boy becoming president. His plans for universal health care indicated a concern for the welfare of the working poor and middle class, while his interest in civil rights promised an era of multicultural understanding. The Cold War was over, the Berlin Wall fell, apartheid came to an end in South Africa, and democracy was making headway throughout the world. Globalization was introducing freer trade between nations, and the internet and e-mail made the world smaller and more accessible. Yet while the American Dream seemed to be spreading across the globe, many artists in the United States were questioning the authenticity of such a notion here at home. Cady Noland's images and installations feature an array of Americana, including the flag, cowboy images, saddles, and remnants of the country's car culture, yet the allusions to excess and waste (powerfully manifested by her walls of Budweiser beer

cans in such works as *This piece doesn't have a title yet* of 1989, (fig. 114) articulate the dissolution of the dream felt by so many. Referencing the Vietnam War, Patty Hearst's capture and conversion to terrorism, and the Charles Manson murders, Noland (born 1956) brings up many of the recent chapters in American history that are difficult to face (p. 318).[5]

Likewise, such artists as Mike Kelley (born 1954), Paul McCarthy (born 1945), and Robert Gober (born 1954) have all questioned the family values, religious beliefs, and picture of the happy home life that lie at the foundation of this dream. Paul McCarthy's tableau *Cultural Gothic* of 1992–93 (p. 324), for example, re-imagines, as curator Ralph Rugoff has pointed out, what might go on behind the barn in the corn-fed American country life immortalized in *American Gothic* of 1930 by Grant Wood (1892–1942). In McCarthy's version a father introduces his young son to bestiality, a shocking way of referring to the more acceptable, yet still questionable mores, such as sexism and racism, that are passed from generation to generation.[6] McCarthy's use of ketchup and chocolate to mimic the blood and feces that sully Santa, Pinocchio, Disney characters and other icons of American childhood in his work, illustrates an embrace of the repressed, and the abject and a rejection of socialization and the prevailing order. Kelly, who has often collaborated with McCarthy, also alludes to social taboos in his works. His manipulations of dirty, stuffed animals and knit afghans are often interpreted as allusions to sublimated memories and desires as well as the specter of sexual abuse or more mundane traumas of childhood. His use of materials associated with craft and of inexpensive, raw, or handwrought elements—and the proliferation of chaotic, even messy installations by these and other artists in the 1990s—seem to be a reaction against the slick materialism of the 1980s as well as the restrained aesthetic of Minimalism, a symbol of the dominant cultural power.

This assault on social norms and expectations can be seen in other interpretations of the destabilization of the family, as in *Family Romance* of 1992 by Charles Ray (born 1953). A group of mannequins depicting what would be a typical nuclear family save for the exaggerated size of the children and the graphic nudity, the work demands a new perspective of the American family, hinting at the developmental sexual fantasies of

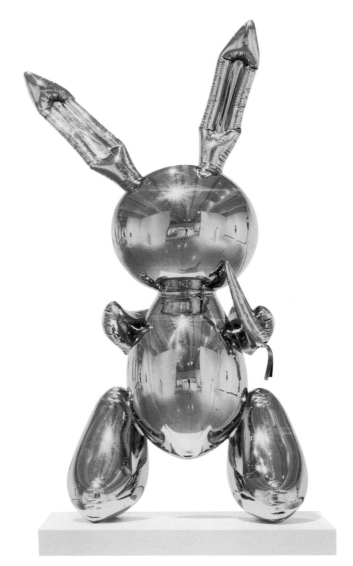

children and the dark jealousies that drive them. Robert Gober's carefully crafted replicas of sinks add a surreal element to the most mundane of domestic subjects, rendering their normalcy suspect. Referencing cleanliness as well as loss (water flowing out of the drain), Gober's iconic sinks speak to the AIDS crisis as well as the discrimination against and misinformation about homosexuality and its "dirtiness." The works were inspired by the artist's memories of the basement of his childhood house, a pleasant memory of his father's masculine realm as well as a frightening artifact from a site that traditionally manifests fantasies of domestic terror—monsters, murderers, and the like—perhaps transformations of more real threats to domestic bliss. Together these artists shook the bedrock of a collective, mythic American identity and replaced the romantic vision of a country united in the pursuit of God, family, and a two-car garage with a more complex reality affected by alternative desires.

THE RISE OF TECHNOLOGY

Though many artists in the 1990s were working with more humble materials, the advent of new technologies has prompted an explosion of art in new media. Video has become more sophisticated and at the same time more accessible, while digital technologies have allowed artists to alter existing images and create new images from scratch. Photographs are routinely digitally enhanced to such an extent that viewers often take it for granted that the image they see has been manipulated; debunking the documentary character of the photograph has preoccupied artists for much of the century. The ubiquity of the computer has inspired a wave of art on and about the internet, while in more recent years digital animation and video-game technology have been adopted by artists as the latest forms of pop-culture imagery. In the 1990s the video art of the 1970s and 1980s was transformed with the development of technologies that freed the video from monitors. Video moved to the walls and became part of the trend toward installation art that characterized the last decade. Gary Hill (born 1951) and Bill Viola (born 1951) were pioneers in the creation of dramatic environments that envelop the viewer, submerging them in almost cinematic experience. Viola, perhaps the best-known

artist working in the medium, has merged the grand tradition of painting with the spatial and temporal capabilities of video. Infusing his works with a spiritual element, the artist grapples with timeless themes of birth, death, suffering, and beauty, and the installations can seem like living, breathing paintings.

Other artists have exploited video to create a new concept of narrative and time altogether. Using multiple screens, artists can better mimic the influx of visual stimuli on everyday life while allowing for several viewpoints at once and a non-linear progression of events. Doug Aitken's video installations create environments that reflect the fragmented contemporary global landscape. Multiple screens depict changing locations while framing a psychological space as much as a geographical one. Many of Aitken's subjects, such as that of *Electric Earth* (p. 323), include desolate sites. Hinting at a transitory, nomadic lifestyle and the importance of daily experiences or insignificant moments in a world driven and connected by technology, Aitken (born 1968) conveys a sense of personal alienation in a society that is, after all, still disconnected, in most senses.

The omnipresence of video and the simultaneous interest in the cinematic has led artists like Matthew Barney (born 1967) to film. Perhaps no other artist has so defined and divided the artistic landscape in America in the late 1990s. His five-part series of *CREMASTER* films, titled after the muscle that moves the testicles, weaves a layered, cryptic narrative that merges history and fantasy in a sprawling psychosexual drama. Influenced in part by the artist's own background (he was a football player, originally from Boise, Idaho), the operatic story revisits many icons of American history past and present. Football, Busby Berkeley musicals, cowboys, rodeo, and the Utah Salt Flats figure in Barney's work, as do the Chrysler building, the Mormon Temple, and the Freemasons—a fraternal order that included many of the founding fathers: George Washington, Thomas Jefferson, and Benjamin Franklin— (fig. 115). Writer Norman Mailer (born 1923) and sculptor Richard Serra (born 1939), each the incarnation of American bravado, also make appearances. Barney's translation of biological processes into sculptural and narrative forms broadened the already expansive definitions of art-making in recent years. Yet his work also articulates current cultural

Fig. 115 *(below)* **Matthew Barney (b. 1967)**

CREMASTER 2: The Book of Mormon, 1999

C-print in acrylic frame (shown unframed)

Edition of 6 and 1 AP

54 × 43 × 1 in. (137.2 × 109.2 × 2.5 cm)

Courtesy the artist and Gladstone Gallery,

New York, MB126

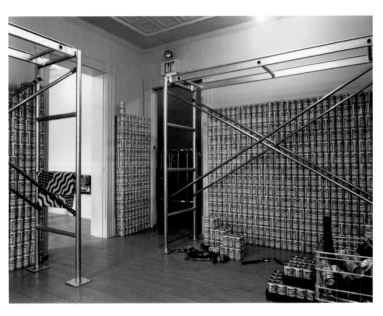

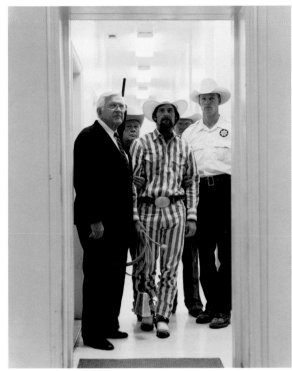

Fig. 114 *(above)* **Cady Noland (b. 1956)**

This piece doesn't have a title yet, 1989

Beer cans, scaffolding, cloth and vinyl flags,

and hand tools

The Mattress Factory, Pittsburgh

Courtesy the artist and The Mattress

Factory

Fig. 116 *(right)* **Kelley Walker (b. 1969)**

Black Star Press; Black Star, Star Press Star

2004

Diptych, scanned image and silkscreened

white, milk and dark chocolate on digital

print, canvas

Each: 36 × 28 in. (91.4 × 71.1 cm)

Overall: 36 × 56 in. (91.4 × 142.2 cm)

Courtesy Paula Cooper Gallery, New York

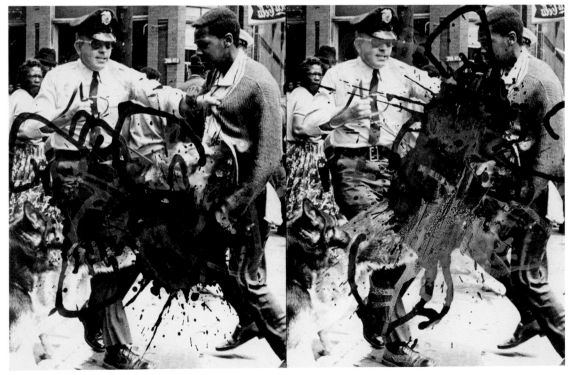

Fig. 117 **Nate Lowman (b. 1979)**

***Paper Airplane*, 2004**

Alkyd on canvas, 60 × 60 in. (152.4 × 152.4 cm)

Courtesy of Maccarone Inc. and the artist

trends, which prompted artists to examine the unparalleled influence of film on the cultural psyche as well as the proliferation of diverse readings of history. The rejection of one master narrative and the acknowledgment of multiple viewpoints, as well as interest in the rôle of the subconscious in the formation of subjectivity, which had revolutionized artistic production and identity theory in the 1970s and 1980s, has continued to inform the art of younger artists, including the work of Barney. The artist's early gender-bending performances and his use of the metaphor of the undifferentiated zygote (the fertilized egg before becoming male or female) are indebted to the gender theory of the previous decades that explored the Lacanian concept of the split subject.

THE PERPETUAL RETURN OF PAINTING

The ascendancy of installation art and its interactive qualities has pushed painting to the periphery over the years. Aligned with conservative thinking and an interest in beauty and formal issues, conventions that were rejected by a Postmodern generation (as well as Conceptual artists before them and the Russian Constructivists before that), painting has been declared dead as often as it has been resurrected. The past ten years have witnessed a renewed interest in figure painting, a trend exemplified by the popularity of such artists as John Currin (born 1962) and Lisa Yuskavage (born 1962; pp. 326, 327). Borrowing from a long tradition of master painters, ranging from Lucas Cranach the Elder (1472–1553) to Botticelli (1444/45–1510) to Caravaggio (1571–1610), Edgar Degas (1834–1917), and even Norman Rockwell (1894–1978), both artists re-examine the female form in a contemporary context. In their canvases, the traditional nude is distorted and exaggerated, almost to cartoon-like ends. Likened to sex kittens and kewpie dolls, the women in these lush paintings walk a fine line between acknowledging the burden of the male gaze and succumbing to it. Yet while the subjects of these works may be said boldly to take ownership of their sexuality, they also remain vehicles for the pure act of painting, simultaneously paying homage to and critiquing a long tradition.[7]

The works of Elizabeth Peyton (born 1965; p. 328), which likewise helped to feed the return to painting, have also been contextualized

within an esteemed historical tradition of portraiture, exemplified in her case by the likes of Frans Hals (*c.* 1580–1666), who has been invoked in descriptions of the artist's works.[8] Yet, while Currin and Yuskavage take on the familiar female form, Peyton's works are often filled with boys and men. Influenced by Andy Warhol (1928–1987) as well as David Hockney (born 1937) and his portraits of intimates and cultural figures, the artist creates sensitive renderings of friends, celebrities, and historical personalities alike. Evidence of our fascination with celebrity and the artist's own status as fan,[9] Peyton's works impart to their subjects a familiarity and a humanity that are lost in the usual frenzy of star-watching. The paintings of Tim Gardner (born 1973), based on polaroids of his brothers and other young men in sports jerseys hanging out on couches, sitting in hot tubs, or drinking beer, offer an unusual firsthand look into a private, masculine world. In contrast to an established art-historical convention that focused on the female form, these studies of a macho realm, particularly in an age that is usually suspicious of the white male, are strikingly atypical. Captured in paint, these portraits of youthful, masculine identity are elevated to another level. Perhaps what has made the work of these painters of particular interest to an art world usually hungry for more media-based art is the urge to slow down the act of looking, the need for a break from the fast stream of images already available, and the opportunity to exert even more control over them.

POST-9/11

The control of images has taken on particular significance in America in the last few years, which have witnessed the implementation of Homeland Security and heightened surveillance strategies as well as the suppression of images that are a threat to the American status quo. Images of bodies jumping from the World Trade Center as well as the flag-draped coffins shipped home from Iraq are seen everywhere but in the United States. Despite such erasures, in the wake of the terrorist attacks on September 11, 2001, the American public has gained a new awareness of American identity as well as the country's place on the international stage. The United States is again the image reflected by the current president—the lone cowboy bravely righting wrongs as he waves

Fig. 118 Jules de Balincourt (b. 1972)

US World Studies III, 2005

Oil, acrylic, and enamel on panel

59 × 72 in. (149.9 × 182.9 cm)

Courtesy of The Saatchi Gallery, London

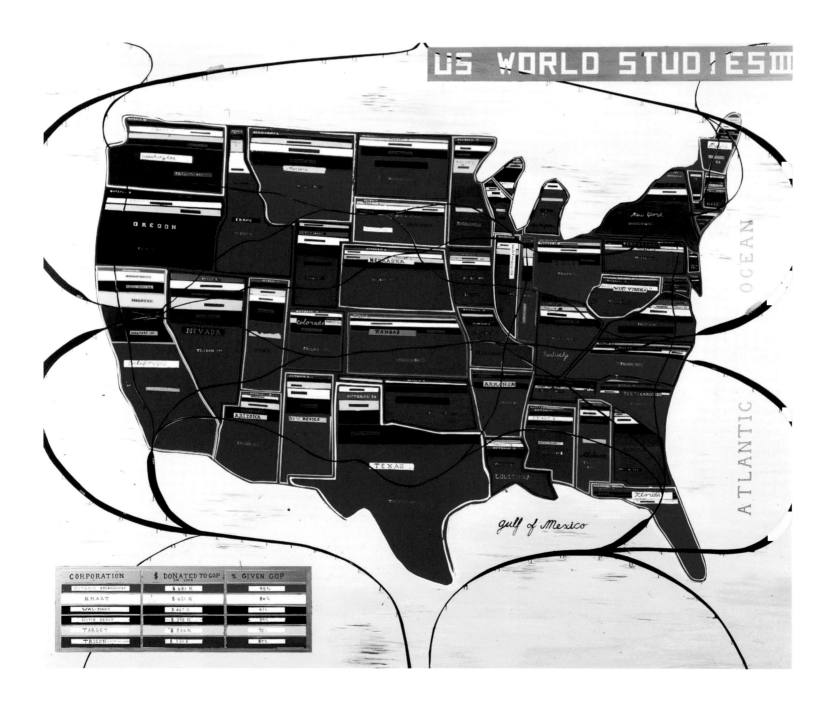

the flag. Young artists and audiences alike have become more engaged with art that addresses the political situation at home and abroad. The irreverent work *Drawing Decisions* of 2005 by Christian Holstad (born 1972), from his series of "Eraserhead Drawings," transforms images of military officials into ghoulish, cartoon-like apparitions by rubbing out part of the newsprint. Reminiscent of Paul Pfeiffer's digitally manipulated videos, which expunge the protagonists from media spectacles such as NBA games and boxing matches, the small but powerful drawing illustrates the impulse to control images that are, in fact, a means of control themselves.

The war in Iraq, the threat of terrorism, the effects of globalism, not to mention the looming specter of environmental catastrophe, have ushered in an age of anxiety. Likewise, the Enron scandal and other examples of corporate greed have called into question the ethics of American capitalism. *Paper Airplane* (2004) by Nate Lowman (born 1979; fig. 117), an image of a twenty-dollar bill folded to create a scene of buildings on fire, directly references the events at the World Trade Center but seems to embed the narrative (and its causes) firmly in the domain of the US economy. An abundance of apocalyptic imagery reflects both a sense of despair and a kind of warning. Paul Chan (born in 1973 in Hong Kong, raised in Nebraska) is both an artist and a political activist who has spent time in Iraq. His digital animations, such as *My birds ... trash ... the future,* of 2004, are both seductive and shocking, depicting a stark post-apocalyptic landscape littered with Humvees, bodies hanging from trees, and swirling clouds of papers reminiscent of the office documents that covered Ground Zero.

While many artists continue to appropriate images directly from the mass media, others have translated newsworthy topics into paint. The pointedly naïve styles of painters Dana Shutz (born 1976) and Jules de Balincourt (born 1972; a French-born artist raised in the United States) add a certain baseness to their subjects, which have included Bush Administration cabinet members and more faceless figures of authority. Shutz's colorful, raw, thickly painted images of "self-eaters," and canvases populated by grotesque faces and dismembered bodies, conjure a nightmarish world, a sign of the angst echoed in such exhibition titles

as "Panic". Her subjects include disco balls and rock stars, indicating her interest in the "media hype that distracts us from what is really going on."[10] De Balincourt's works reflect a similar landscape of turmoil, informed by the recent vision of America as a scene of battle between red and blue states (fig. 118). Creating his own versions of the geography of the United States, De Balincourt maps the flow of funds from corporate sources like K-mart and the owner of Kentucky Fried Chicken to the Bush campaign. His painting *Blind Faith and Tunnel Vision* of 2005 depicts a scene of urban devastation that could as easily be war-torn Iraq as some future vision of New York in the aftermath of an impending catastrophe, as likely to be wrought from within as from without. The work's title and the rays of colored light that fill the sky above warn against seeing the current state of the world with rose-colored glasses.[11]

In a work from 2001, Kelley Walker (born 1969) poked fun at the high level of hysteria that informs our age with the addition of a digital, toxic orange river to a found poster image of a collapsed highway in *We Joked That Under the Paving Slabs There Was Gold*. Yet in the intervening time, perhaps the urgency of our situation has become real. A certain levity has been observed in the post-9/11 climate as well, however. Tom Sachs's study of globalism—both its positive and negative effects—took riotous form in *Nutsy's* (2002), an interactive installation with race cars and bong-hit stations in which the artist compares the American McDonald's franchise to the failed utopian vision of Le Corbusier's French housing project Unité d'Habitation. Like many artists of the current generation, Sachs (born 1966) condenses consumer imagery with that of culture, politics, and even gaming in an effort to understand intersecting economies and agendas (p. 321).[12]

Appropriation is as central to art production now as it was in the late 1970s and 1980s, yet the artists of the current generation seem slightly more at ease with the lack of borders between mass communication and high art, information and entertainment. Images of Britney Spears are given as much attention as those of the prisoners of Abu Ghraib, their predominance in the visual landscape and their place in one economic and ideological system recognized—a notion already made clear by such artists as Andy Warhol. Kelley Walker's Photoshop manipulations of

reproductions of the Birmingham race riots and Lowman's screenprinted images of bullet holes on shaped aluminum are both indebted to Warhol's methods and his use of images of violence repeated to render them impotent. Adding a layer of expressionistic splatterings of chocolate to his images, Walker complicates their status as copy while linking them with the realm of desire and consumption (fig. 116). Walker's work further radicalizes the question of originality and authorship of the image: not only does he use found images, he also produces CDs of his works, which can be further manipulated by others.[13] His collaborations with artist Wade Guyton (born 1972) reflect a general trend toward, or resurgence of, collaboration and collectives. Sharing the burden of producing meaning, Walker and his peers are a sign of what has been called a broader, international "emphasis on discursivity and sociability," which may define the current state of artistic practice and a desire for a more inclusive, democratic approach.[14]

Looking back at the past twenty-five years of art in America, one can see a fantastic array of difference and nuance, yet it is also apparent that the mass media and the enormous effect of film, television, magazines, and, now, the internet on contemporary culture continue to engage, enrage, and inspire artists, not just in America, but on a global level. In fact, it is impossible to speak of the art of the last decade in specifically nationalistic terms. The effects of globalism are evident in an art world that is increasingly more inclusive and international. As is evident in the last several biennials at the Whitney Museum of American Art, which have included many non-American artists who work in the United States and are influential figures in the cultural landscape, the definition of "American" is becoming ever more complicated.

1. See also Lisa Phillips, "Restoration and reaction: 1976–1990" and "Approaching the Millennium," *The American Century: Art and Culture 1950–2000* (New York and London: Whitney Museum of American Art in association with W.W. Norton, 1999); and Hal Foster, Yves-Alan Bois, Benjamin Buchloh, and Rosalind Krauss, "1980–1989" and "1990–2003," *Art since 1900* (London: Thames & Hudson, 2004).

2. The release has been associated with Reagan and his image of strength, though it was President Jimmy Carter's negotiations that paved the way for this outcome.

3. Nancy Spector, *Felix Gonzalez-Torres* (New York: Guggenheim Museum, 1995), pp. 16–24.

4. Steve Cannon, Kellie Jones, and Tom Finkelpearl, *David Hammons: Rousing the Rubble* (New York: The Institute for Contemporary Art, P.S. 1 Museum; Cambridge, Mass.: MIT Press, 1991), p. 29.

5. Lane Relyea, "Hi-yo Silver: Cady Noland's America," *Artforum International*, vol. 31, no. 5 (January 1993), pp. 50–54.

6. Ralph Rugoff, "Mr. McCarthy's Neighborhood," Ralph Rugoff, Kristine Stiles, and Giacinto Di Pietrantonio, *Paul McCarthy* (London: Phaidon Press, 1996), pp. 65–66.

7. Marcia B. Hall, " Lisa Yuskavage's Painterly Paradoxes," Claudia Gould, ed., *Lisa Yuskavage*, exhib. cat. (Philadelphia: Institute of Contemporary Art, 2001), pp. 23–24.

8. Rochelle Steiner, *Currents 71: Elizabeth Peyton* (St. Louis: St. Louis Art Museum, 1997).

9. Jerry Saltz, "Getting Real: Elizabeth Peyton's Saint James," *Village Voice*, April 14–20, 1999, p. 167.

10. Katrin Wittnever, "Welcome to Neverland," *Parkett*, no. 75 (2005), p. 36.

11. Brian Boucher, "Jules de Blaincourt at Zach Feuer (LFL)," *Art in America*, vol. 93, no. 5 (May 2005), p. 165.

12. See John Hanhardt and Maria-Christina Villaseñor, eds., *Tom Sachs: Nutsy's* (New York: Guggenheim Museum, 2002).

13. Emily Speers Mears, "Kelley Walker," Chrissie Iles and Philippe Vergne, *Whitney Biennial 2006: Day for Night* (New York: Whitney Museum of American Art, 2006), p. 356.

14. Hal Foster, *et al.*, p. 667.

MULTICULTURALISM and GLOBALIZATION

Barbara Kruger (b. 1945)
Untitled (Questions), 1991
Photographic silkscreen on vinyl
66 × 93 in. (167.6 × 236.2 cm)
Marieluise Hessel Collection,
on permanent loan to the Center for
Curatorial Studies, Bard College,
Annandale-on-Hudson, New York

LOOK FOR THE MOMENT WHEN PRIDE BECOMES CONTEMPT WHO IS FREE TO CHOOSE? WHO IS BEYOND THE LAW? WHO IS HEALED? WHO IS HOUSED? WHO SPEAKS? WHO IS SILENCED? WHO SALUTES LONGEST? WHO PRAYS LOUDEST? WHO DIES FIRST? WHO LAUGHS LAST?

Richard Prince (b. 1949)

Untitled (Cowboy), 1995

Ektacolor photograph

48 × 72 in. (121.9 × 182.9 cm)

Modern Art Museum of Fort Worth, Texas,

Museum Purchase made possible by a

grant from the Burnett Foundation

David Salle (b. 1952)

Comedy, 1995

Oil and acrylic on canvas, two panels

Overall: 96¼ × 144⅛ in. (244.5 × 366.1 cm)

Solomon R. Guggenheim Museum,

New York, Purchased with funds

contributed by the International Director's

Council, Mr. and Mrs. Edward G. Shufro,

the Eli Broad Family Foundation, and

Rachel Lehmann, 1996, 96.4505

Multiculturalism and Globalization

Eric Fischl (b. 1948)

Squirt (for Ian Giloth), 1982

Oil on canvas, 68 × 96 in. (172.7 × 243.8 cm)

Courtesy Thomas Ammann Fine Art, A.G.,

Zurich, Switzerland

Julian Schnabel (b. 1951)

Self Portrait in Andy's Shadow, 1987

Oil, plates, and Bondo on two wood panels

103 × 72 × 10 in. (261.6 × 182.9 × 25.4 cm)

The Eli and Edythe L. Broad Collection,

Los Angeles

Multiculturalism and Globalization

Keith Haring (1958–1990)

Untitled, 1982

Vinyl ink on vinyl

144 × 144 in. (365.8 × 365.8 cm)

François Pinault Collection

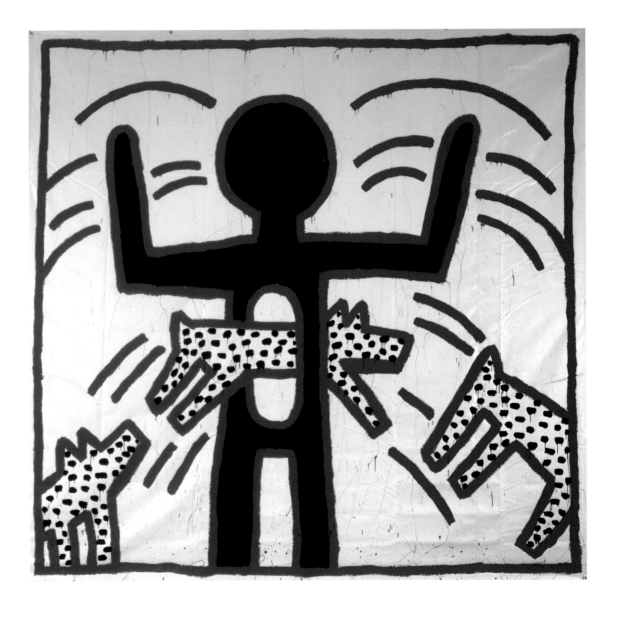

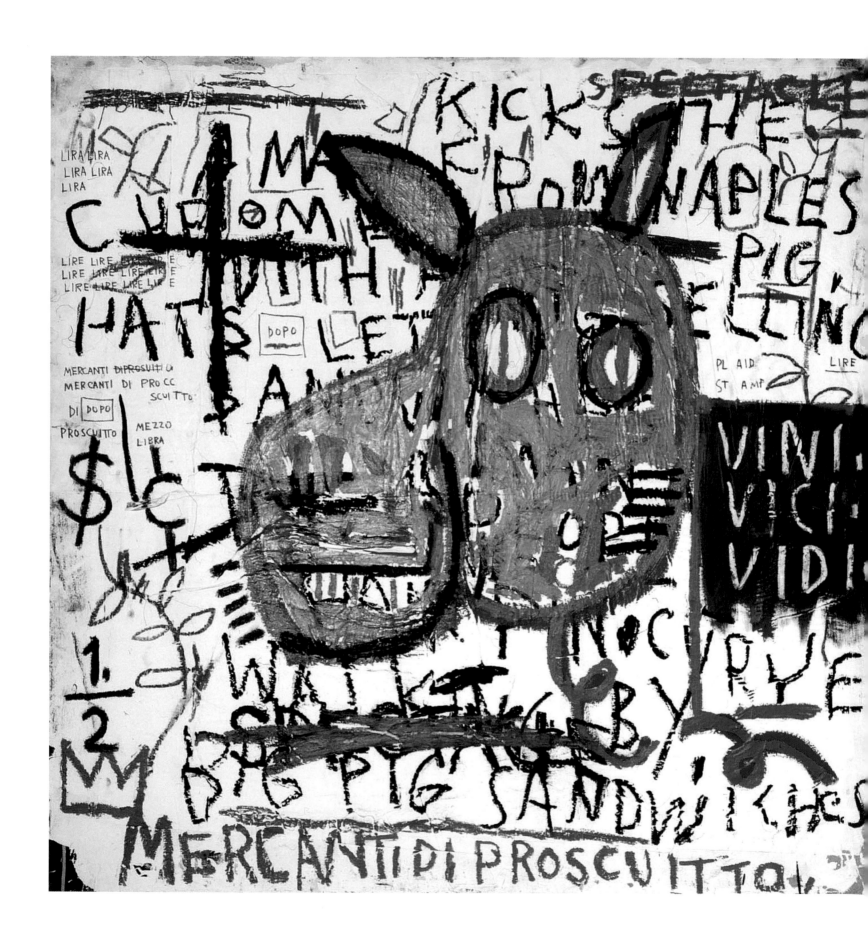

Multiculturalism and Globalization

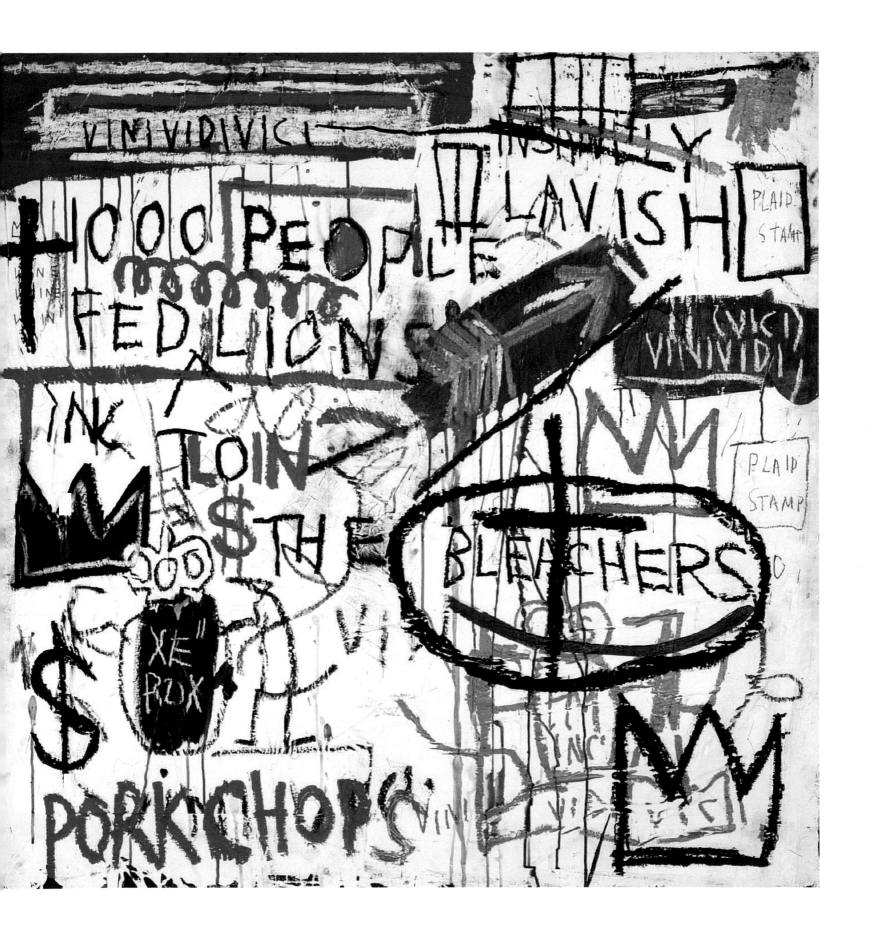

317

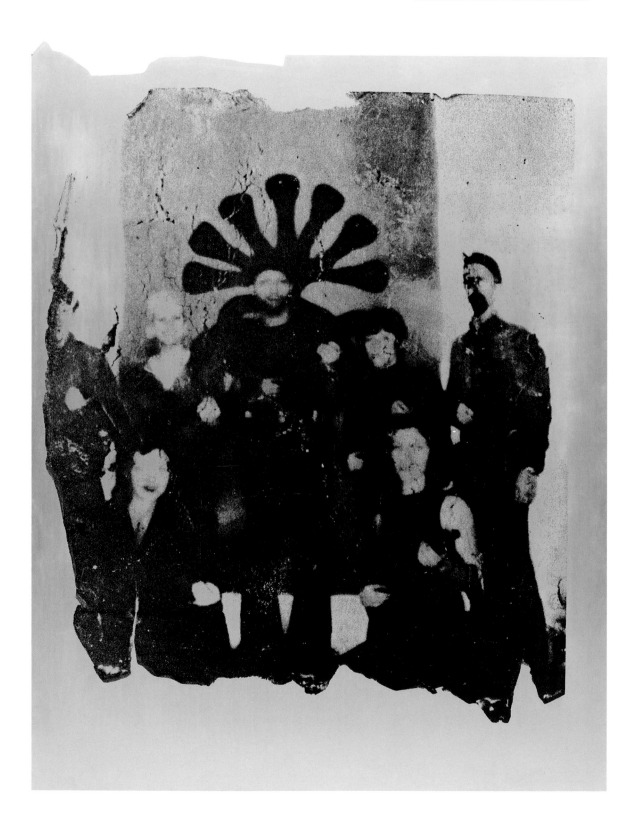

Felix Gonzalez-Torres (1957–1996)

"Untitled" (Public Opinion), 1991

Black rod licorice candy, individually
wrapped in cellophane; endless supply
Ideal weight: 700 lbs (318 kg)
Solomon R. Guggenheim Museum,
New York, Purchased with funds
contributed by the National Endowment
for the Arts Museum Purchase Program,
1991, 91.3969

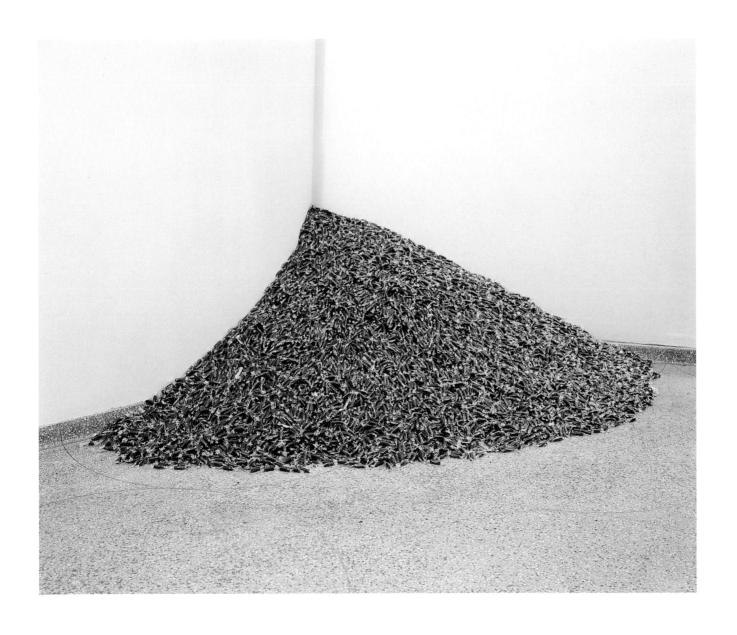

Jeff Koons (b. 1955)

Three Ball 50/50 Tank, 1985

Glass, steel, distilled water, and three basketballs

60½ × 48¾ × 13¼ in. (154 × 129 × 34 cm)

The Broad Art Foundation, Santa Monica, California

Tom Sachs (b. 1966)

Nutsy's 1/1 McDonald's v. 2, 2003

Plywood, steel, synthetic polymer, refrigerator, freezer, grill, friolator, blower, fluorescent lights, pin-spot light, acrylic boxes, foamcore, thermal adhesive, casters, solenoids, 13 empty Jack Daniel's whiskey bottles for rendering fat, 3 electric pumps, linoleum tile, heat lamp, 12-gauge shotgun cartridges, photocopier, plastic paper, duct tape, Sharpie, pine wood, vinyl tubing, and Icerette ice maker

96 × 74 × 72 in. (243.8 × 188 × 182.9 cm)

Private collection

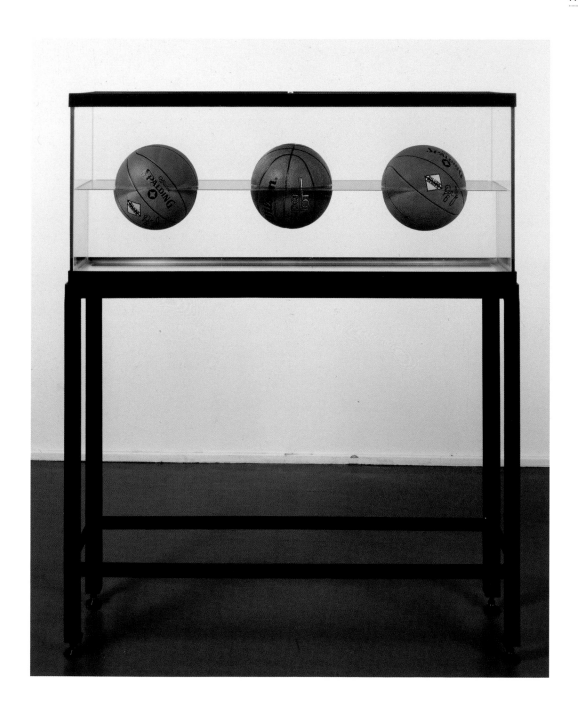

Multiculturalism and Globalization

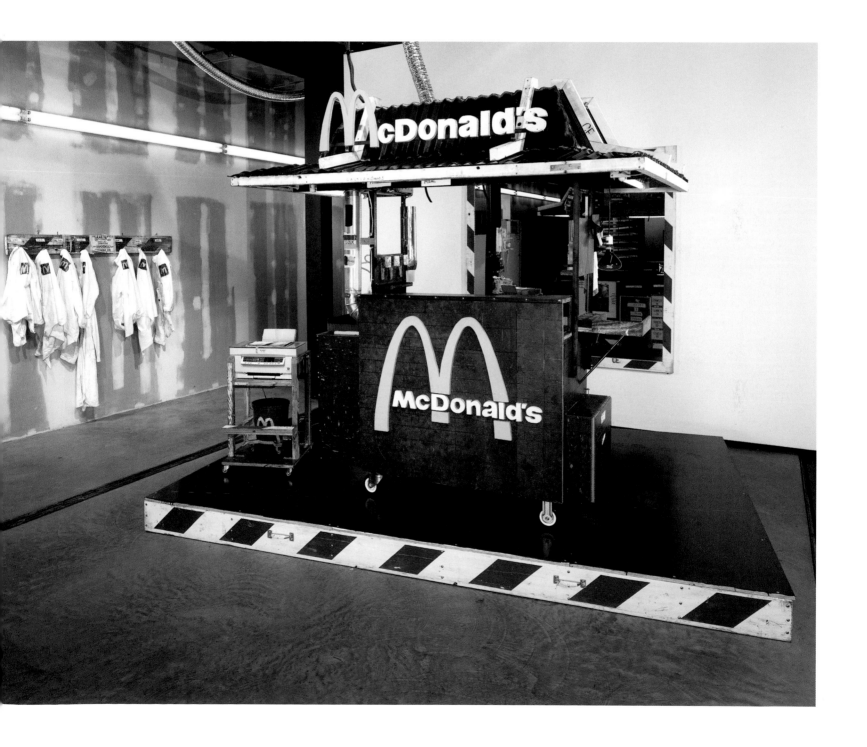

Matthew Barney (b. 1967)

CREMASTER 3: Five Points of Fellowship

2002

C-print in acrylic frame (shown unframed)

Edition 1/6, 2 AP, 54 × 44 in. (137 × 112 cm)

Courtesy Gladstone Gallery, New York,

MB213

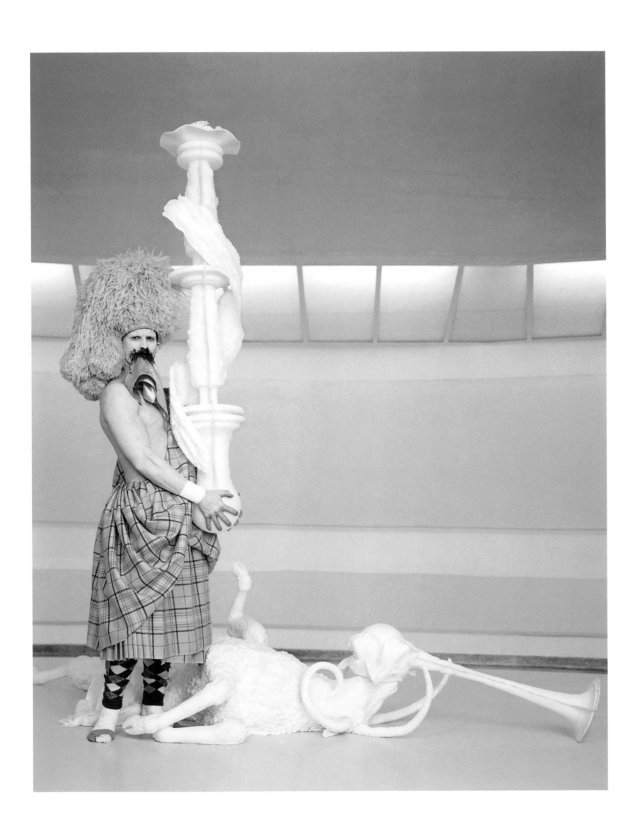

Multiculturalism and Globalization

Doug Aitken (b. 1968)

Electric Earth, 1999

8 laser disc installation, edition 3/4

Dimensions variable

Museum of Contemporary Art, Los Angeles

Partial and promised gift of David Teiger

in honor of Jeremy Strick, 2000.13

Paul McCarthy (b. 1945)
Cultural Gothic, 1992–93
Metal, wood, pneumatic cylinder,
compressor, programmed controller;
burlap with foam, acrylic and dirt;
fiberglass, clothing, wigs, and stuffed goat
96 × 94 × 94 in. (241 × 235 × 235 cm)
Rubell Family Collection, Miami

Multiculturalism and Globalization

Charles Ray (b. 1953)

Unpainted Sculpture, 1997

Fiberglass and paint

60 × 78 × 171 in. (152.4 × 198.1 × 434.3 cm)

Walker Art Center, Minneapolis, Gift of

Bruce and Martha Atwater, Ann and Barrie

Birks, Dolly Fiterman, Erwin and Miriam

Kelen, Larry Perlman and Linda Peterson

Perlman, Harriet and Edson Spencer, with

additional funds from the T.B. Walker

Acquisition Fund, 1998, 1998.74.1-.85

John Currin (b. 1962)

Thanksgiving, 2003

Oil on canvas, 68⅛ × 52⅛ in. (172.9 × 132.3 cm)

Tate Gallery, London, Lent by the

American Fund for the Tate Gallery,

Courtesy Marc Jacobs 2004

Multiculturalism and Globalization

Lisa Yuskavage (b. 1962)

Blonde, Brunette, Redhead, 1995

Oil on linen, three panels

Overall: 36 × 108 in. (91.4 × 274.3 cm)

Collection of Yvonne Force Villareal,

New York

Elizabeth Peyton (b. 1965)

Democrats Are More Beautiful

(after Jonathan), 2001

Oil on board, 10 × 8 in. (25.4 × 20.3 cm)

Collection of Stafford Broumand,

Courtesy Gavin Brown's Enterprise

and the artist

Kehinde Wiley (b. 1977)

Charles I and Henrietta Maria, 2006

Oil on canvas, 84 × 96 in. (213.4 × 243.8 cm)

Sender Collection, Courtesy Rhona

Hoffman Gallery, Chicago

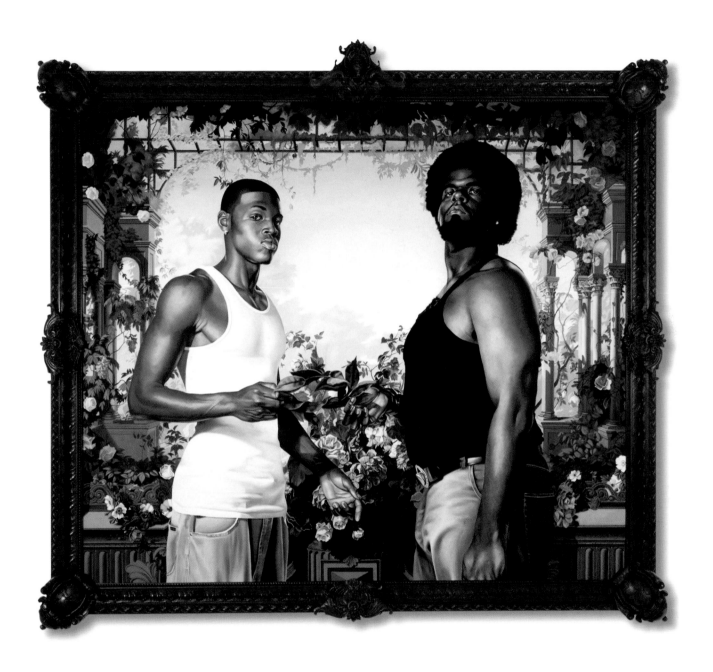

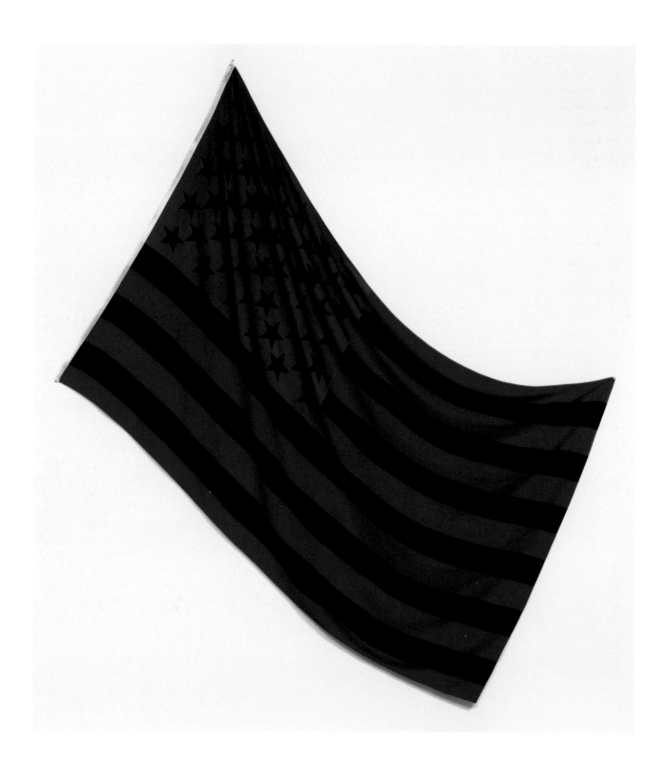

Multiculturalism and Globalization

Pages 330–31 **Kara Walker (b. 1969)**

Insurrection! [Our Tools Were Rudimentary,
Yet We Pressed On], 2000

Cut paper silhouettes and light projections

Dimensions variable

Solomon R. Guggenheim Museum, New
York, Purchased with funds contributed by
the International Director's Council and
Executive Committee Members: Ann Amers,
Edythe Broad, Elaine Terner Cooper, Dimitris
Daskalopoulos, Harry David, Gail May
Engelberg, Ronnie Heyman, Dakis Joannou,
Cindy Johnson, Barbara Lane, Linda
Macklowe, Peter Norton, Willem Peppier,
Tonino Perna, Denise Rich, Simonetta
Seragnoli, David Teiger, and Elliot K. Wolk,
2000, 2000.68

Opposite

David Hammons (b. 1943)

African-American Flag, 1990

Dyed cotton, 56 × 88 in. (142.2 × 223.5 cm)

Collection of Lois Plehn

Jonathan Horowitz (b. 1966)

The Official Portrait of George W. Bush
Available Free From the White House Hung
Upside Down, 2001

Framed color print, 14¹⁄₂ × 13 in. (37 × 33 cm)

The Wonderful Fund, London

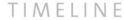

TIMELINE

Compiled by Helen Hsu

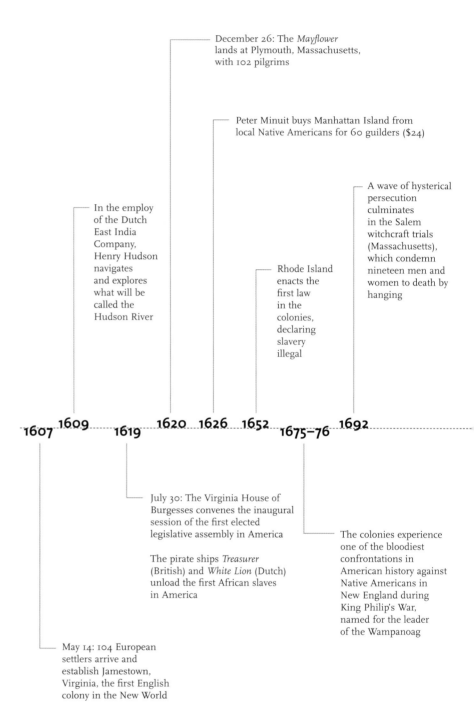

December 26: The *Mayflower* lands at Plymouth, Massachusetts, with 102 pilgrims

Peter Minuit buys Manhattan Island from local Native Americans for 60 guilders ($24)

In the employ of the Dutch East India Company, Henry Hudson navigates and explores what will be called the Hudson River

Rhode Island enacts the first law in the colonies, declaring slavery illegal

A wave of hysterical persecution culminates in the Salem witchcraft trials (Massachusetts), which condemn nineteen men and women to death by hanging

1607 1609 1619 1620 1626 1652 1675–76 1692

July 30: The Virginia House of Burgesses convenes the inaugural session of the first elected legislative assembly in America

The pirate ships *Treasurer* (British) and *White Lion* (Dutch) unload the first African slaves in America

The colonies experience one of the bloodiest confrontations in American history against Native Americans in New England during King Philip's War, named for the leader of the Wampanoag

May 14: 104 European settlers arrive and establish Jamestown, Virginia, the first English colony in the New World

The events included in this timeline constitute an interpretive history of the United States. For additional information or viewpoints see the books listed in the Select Bibliography; in numerous cases these sources were referred to for the compilation of the timeline.

The colonies experience the religious evangelism of the Great Awakening, roused by the fire-and-brimstone sermons of Jonathan Edwards, George Whitefield, and Gilbert Tennant (through c. 1745)

January: Thomas Paine's *Common Sense* fuels revolutionary sentiment demanding independence from Great Britain

April 30: George Washington takes the oath of office as the first President of the United States (1789–97) after being unanimously elected to office by the Electoral College, the only candidate to receive this kind of support in the nation's history

March 5: British soldiers kill five colonists in the Boston Massacre, fomenting aspirations for independence

July 4: Congress adopts the Declaration of Independence, establishing the United States of America, with fifty-six signatories including future presidents John Adams (1797–1801) and Thomas Jefferson (1801–09), and statesman Benjamin Franklin

The Fugitive Slave Act becomes law, facilitating the capture of escaped slaves and inflicting severe penalties on those who might help them

April 18–19: Paul Revere alerts Lexington Minutemen to the British Army's arrival during his Midnight Ride, and the American Revolution begins

State conventions ratify US Constitution (completed September 17, 1787), replacing the Articles of Confederation; Delaware ratifies first (December 7, 1787), New Hampshire's ratification provides the nine states required to put the Constitution in effect (June 21, 1788), and Rhode Island is the last of the thirteen colonies to complete the process (May 29, 1790)

The nation's capital moves from Philadelphia to Washington, D.C., designed by French architect Pierre L'Enfant and modeled on Paris and Versailles

1704 **1730** **1765** **1770** **1773** **1775** **1776** **1783** **1787** **1787–90** **1789** **1791** **1793** **1794** **1800** **1803**

The Northwest Ordinance paves the way for settlement and eventual annexation of territory north of the Ohio River and east of the Mississippi River

March 14: Eli Whitney patents the cotton gin, spurring economic development in the agrarian South

December 16: The Sons of Liberty, organized by Samuel Adams, dump imported tea into Boston Harbor as a protest against British taxes, in the Boston Tea Party

December 15: The US adopts the Bill of Rights, the first ten Amendments to the Constitution ensuring fundamental rights for all its citizens

British Parliament enacts the Stamp Act taxing imports to America, inciting boycotts and riots (repealed in 1766)

The British recognize American independence with the Treaty of Paris, formally ending the Revolutionary War

April 30: The Louisiana Purchase, under Thomas Jefferson's administration, doubles American territory with 800,000 square miles of land, from the Mississippi River to the Rocky Mountains, acquired from the French

April 24: John Campbell edits and prints the inaugural issue of the Boston *News-Letter*, America's first newspaper

Lewis and Clark lead the Corps of Discovery exploring the Louisiana Purchase and unmapped territories as far as the Pacific Ocean

President Andrew Jackson (1829–37) signs the Indian Removal Act, pushing all Native Americans from the land east of the Mississippi to Oklahoma

The Missouri Compromise establishes the distinction between free and slave states north and south of the Mason-Dixon line, comprising the southern border of Pennsylvania and extending westward along the Ohio River, assigning the status for future states carved out of land from the Louisiana Purchase

Pennsylvania Hall (Philadelphia), also called Freedom Hall, built by a coalition of abolitionists, including women and African Americans, and workers, opens on May 14 and is burned to the ground by angry mobs three days later

Four thousand Cherokee die in the forced move west on the Trail of Tears as a result of the Indian Removal Act, overseen by General Winfield Scott, succeeding General John Wool who resigned his command in protest against the action

General Andrew Jackson leads the US Army against the Seminole Native Americans in Florida in the First Seminole War, caused by rising unease about the fugitive slave population integrated there

The Cherokee tribe in Georgia adopt a constitution and declare a sovereign Cherokee Nation

Alexis de Tocqueville's *Democracy in America* is published

Nearly one thousand pioneers complete the westward migration on the 2170-mile Oregon Trail, ending in the Willamette Valley

EXPANSION and FRAGMENTATION

1803–06 1812–15 1817–18 1819 1820 1823 1827 1828 1830 1831 1835 1838 1841 1843 1844 1845

British forces burn the Capitol and the White House (September 13–14, 1814) during the War of 1812, initiated by an American attempt to expand into present-day Canada, discontent over British and French embargoes related to the Napoleonic Wars, and suspicions of British aid to Native American adversaries on the Western frontier

The Monroe Doctrine declares intolerance for European intervention in the Americas and the promise of American neutrality in European affairs, establishing an isolationist US foreign policy

A network of safe havens guiding escaped slaves to freedom in the north and Canada that began operating after the Fugitive Slave Act (1793) is dubbed the Underground Railroad (through 1865)

US Supreme Court rules in favor of West African captives who mutinied aboard the slave ship *Amistad* in July 1839

May 4: Samuel Morse sends the first telegraphic message from Washington, D.C., to Baltimore

Noah Webster's *An American Dictionary of the English Language* is published, containing 70,000 entries

January 1: William Lloyd Garrison begins to publish the abolitionist newspaper *The Liberator*

August 21–22: Nat Turner leads a slave revolt in Southampton County, Virginia (hanged and flayed on November 11)

Narrative of the Life of Frederick Douglass, an American Slave, Written by Himself is published

Spain cedes Florida to the US in the Adams-Onís treaty

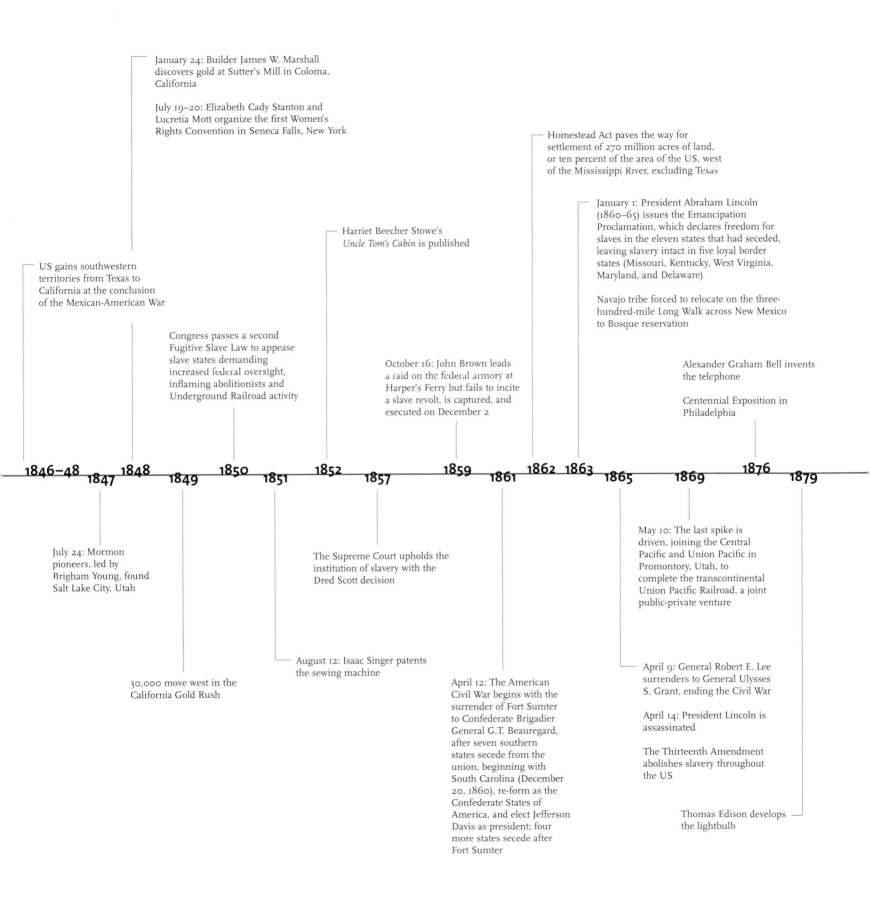

January 24: Builder James W. Marshall discovers gold at Sutter's Mill in Coloma, California

July 19–20: Elizabeth Cady Stanton and Lucretia Mott organize the first Women's Rights Convention in Seneca Falls, New York

Homestead Act paves the way for settlement of 270 million acres of land, or ten percent of the area of the US, west of the Mississippi River, excluding Texas

January 1: President Abraham Lincoln (1860–65) issues the Emancipation Proclamation, which declares freedom for slaves in the eleven states that had seceded, leaving slavery intact in five loyal border states (Missouri, Kentucky, West Virginia, Maryland, and Delaware)

Harriet Beecher Stowe's *Uncle Tom's Cabin* is published

US gains southwestern territories from Texas to California at the conclusion of the Mexican-American War

Navajo tribe forced to relocate on the three-hundred-mile Long Walk across New Mexico to Bosque reservation

Congress passes a second Fugitive Slave Law to appease slave states demanding increased federal oversight, inflaming abolitionists and Underground Railroad activity

October 16: John Brown leads a raid on the federal armory at Harper's Ferry but fails to incite a slave revolt, is captured, and executed on December 2

Alexander Graham Bell invents the telephone

Centennial Exposition in Philadelphia

1846–48 1848 1850 1852 1859 1862 1863 1876
1847 1849 1851 1857 1861 1865 1869 1879

July 24: Mormon pioneers, led by Brigham Young, found Salt Lake City, Utah

The Supreme Court upholds the institution of slavery with the Dred Scott decision

May 10: The last spike is driven, joining the Central Pacific and Union Pacific in Promontory, Utah, to complete the transcontinental Union Pacific Railroad, a joint public-private venture

August 12: Isaac Singer patents the sewing machine

30,000 move west in the California Gold Rush

April 12: The American Civil War begins with the surrender of Fort Sumter to Confederate Brigadier General G.T. Beauregard, after seven southern states secede from the union, beginning with South Carolina (December 20, 1860), re-form as the Confederate States of America, and elect Jefferson Davis as president; four more states secede after Fort Sumter

April 9: General Robert E. Lee surrenders to General Ulysses S. Grant, ending the Civil War

April 14: President Lincoln is assassinated

The Thirteenth Amendment abolishes slavery throughout the US

Thomas Edison develops the lightbulb

COSMOPOLITANISM and NATIONALISM

Congress passes the Chinese Exclusion Act, prohibiting Chinese laborers from immigrating after the arrival of over 100,000 Chinese since the 1849 Gold Rush, many working in mines and on the railroads

John D. Rockefeller organizes the Standard Oil Trust

The Spanish–American War results in an independent Cuba and Puerto Rico, Guam, and the Philippines passing into American sovereignty

February 17: The Armory Show opens in New York, shocking and invigorating the contemporary art world with an enormous gathering of current works by European artists on view to the American public for the first time

May 28: John Muir helps to establish the Sierra Club, an organization dedicated to the conservation and preservation of nature, and is elected its first president

Henry Ford implements the moving assembly line in his automobile factory in Detroit

Coca-Cola soft drink goes on sale

Samuel Gompers organizes the American Federation of Labor

May 4: A national strike for an eight-hour workday leads to the Haymarket Riot in Chicago

September 4: Apache chief Geronimo surrenders at Skeleton Canyon, Arizona, ending the last major US–Native American war

July 6: A strike at the Carnegie Steel Company in Homestead, Pennsylvania, erupts in violence as Pinkerton security agents clash with workers

April 18: The San Francisco earthquake sparks fires that raze the city, leaving more than half the population homeless

The National Association for the Advancement of Colored People (NAACP) is founded

September 4: George Eastman patents a camera using roll film and registers the trademark Kodak

Emma Goldman's *Anarchism and Other Essays* is published

1881 1882 1884 1886 1887 1888 1890 1892 1896 1898 1903 1906 1908 1909 1910 1911 1913 1914

Mark Twain's *The Adventures of Huckleberry Finn* is published

Jacob A. Riis's illustrated *How the Other Half Lives: Studies Among the Tenements of New York* is published

Congress passes the Sherman Antitrust Act to regulate and discourage monopolies

December 29: Lakota defeated in the Wounded Knee Massacre, South Dakota

W.E.B. du Bois's *The Souls of Black Folk* is published

December 17: The Wright brothers achieve the first airplane flight in Kitty Hawk, North Carolina

The first movie studio, Nestor Studios, opens in Hollywood

March 25: A fire breaks out in the Triangle Shirtwaist Factory, New York, killing 146 workers, mostly women, creating one of the worst industrial accidents to date

Clara Barton founds the American Red Cross to provide disaster relief and wartime assistance

The US Supreme Court's Plessy v. Ferguson sets the precedent for "separate but equal"-style segregation

Henry Ford's Model-T becomes the first widely affordable automobile

President Theodore Roosevelt founds the Federal Bureau of Investigation

The Dawes (General Allotment) Act converts communal Native American lands into individual allotments, ultimately diminishing overall territory, in an attempt to assimilate Native Americans into the white mainstream

Panama Canal is completed (begun 1904), expediting passage and trade between America's coasts and worldwide seafaring

MODERNISM and REGIONALISM

The influenza pandemic hits the US, killing over 650,000 in less than a year

September 11: Nicola Sacco and Bartolomeo Vanzetti, known anarchists, are falsely indicted for a murder-robbery in South Braintree, Massachusetts

Labor leader and activist Eugene V. Debs runs for president as the Socialist Party of America candidate, for the fifth time, while imprisoned for an antiwar speech he gave on June 16, 1918, in Canton, Ohio

The Meriam Report exposes fraud and corruption associated with the Dawes Act (1887), leading to its belated repeal in 1934, and failures in Native American policies in general

May 20–21: Charles Lindbergh pilots the *Spirit of St. Louis* from Long Island, New York, to Paris in the first solo transatlantic flight

August 23: Sacco and Vanzetti are electrocuted nearly seven years after their initial indictment and a series of failed appeals

Eighteenth Amendment is repealed and alcohol is freely imbibed

Franklin Delano Roosevelt is elected president (1933–45) and launches reforms addressing the Depression in his New Deal

Let Us Now Praise Famous Men with text by James Agee and photographs by Walker Evans is published, describing the plight of white sharecroppers devastated by the Depression

December 7: Japan bombs Pearl Harbor, drawing the US into World War II (which began in 1939)

The Works Progress Administration and Federal Arts Project are established to aid writers and artists during the Depression with funding for public projects, often documenting and reflecting on the harrowing experiences of the time

President Roosevelt establishes Social Security, providing retirement benefits and unemployment insurance for working Americans

1917 1918–19 1919 1920 1924 1924–27 1927 1928 1929 1933 1934 1935 1937–38 1941 1942

Eighteenth Amendment prohibits the making, selling, and transport of alcohol

Nineteenth Amendment enables women to vote

Race riots explode in cities across the US during the Red Summer, ignited by unemployment, inflation, and racism aggravated by postwar social and economic malaise

US enters World War I (which began in 1914)

J. Edgar Hoover serves as the director of the FBI, a tenure lasting until his death, during which he wields expansive, heavy-handed authority and dubious tactics including blackmail

October 28–29: The stock market crash commences the Great Depression

Two thousand eight hundred American volunteers form the Abraham Lincoln Brigade to defend the Republic in the Spanish Civil War against General Francisco Franco's Nationalists, who are supported by Fascist Italy and Nazi Germany

February 10: Workmen destroy Diego Rivera's *Man at the Crossroads* (1933–34) mural in Rockefeller Center, New York, because of newspaper attacks against its anticapitalist imagery and a prominent portrait of Vladimir Lenin

May 23: Bonnie Parker and Clyde Champion Barrow are ambushed and killed by FBI officers after capturing the public's imagination during their sensational crime spree, which began in February 1932

Congress passes the National Origins or Immigration Act restricting East Asian and Asian Indian immigration and limiting Southern and Eastern European immigration

The Teapot Dome scandal, in which Warren Harding's Secretary of the Interior Albert B. Fall had received bribes for leasing the Teapot Dome oil fields, Wyoming, reveals governmental corruption

President Roosevelt's Executive Order 9066 leads to the relocation of 110,000 Japanese people, including Japanese-American citizens, to ten remote detention camps

First nuclear reactor built, Chicago Pile Number One (CP-1) on the University of Chicago campus

Korean War: US deploys nearly 500,000 troops to defend South Korea from communist North Korea's attempt to reunite the two countries forcibly

The first commercially produced birth-control pills become available

February 13–15: US Air Force participates in the British-led firebombing of Dresden

August 6, 9: US drops atomic bombs on Hiroshima and Nagasaki, ending World War II

January 26: *The Family of Man* opens at the Museum of Modern Art, New York, an exhibition of photography from around the world, designed by Edward Steichen

December 1: African-American seamstress and housekeeper Rosa Parks refuses to vacate her seat on a bus in Montgomery, Alabama, commencing the nearly thirteen-month-long Montgomery bus boycott

President Harry Truman (1945–53) founds the Central Intelligence Agency (CIA)

April 15: Jackie Robinson's major league debut with the Brooklyn Dodgers breaks the color line in baseball. He wins the first Rookie-of-the-Year award

October: The threat of nuclear war nearly becomes reality during the Cuban Missile Crisis, before the Soviets agree to withdraw missile installations on the island nation

June 19: Julius and Ethel Rosenberg are executed for selling atomic bomb secrets to the Communists

1945 **1946** **1947** **1948** **1950–53** **1952** **1953** **1954** **1955** **1957** **1960** **1961** **1962** **1963**

February 15: Developed at the Moore School of Electrical Engineering, University of Pennsylvania, during World War II, the ENIAC, the first electronic digital computer, is dedicated

Color television becomes available in the US

The Supreme Court rules against racial segregation in Brown v. Board of Education, Topeka, Kansas

A US–backed invasion by Cuban exiles at the Bay of Pigs fails to overthrow Fidel Castro's government

President Truman establishes the National Security Agency (NSA) to gather intelligence for the nascent Cold War

June 23: The first residents begin moving into Levittown, New York, a sprawling model postwar suburb

President Dwight Eisenhower sends troops to protect nine black students in the desegregation of Little Rock Central High School, Arkansas

Betty Friedan's *The Feminine Mystique* is published

August 28: Dr. Martin Luther King, Jr. leads 250,000 people in the March on Washington for Jobs and Freedom

November 22: President John F. Kennedy is assassinated in Dallas

July 26: President Truman signs Executive Order 9981, commanding the racial integration of the US armed forces

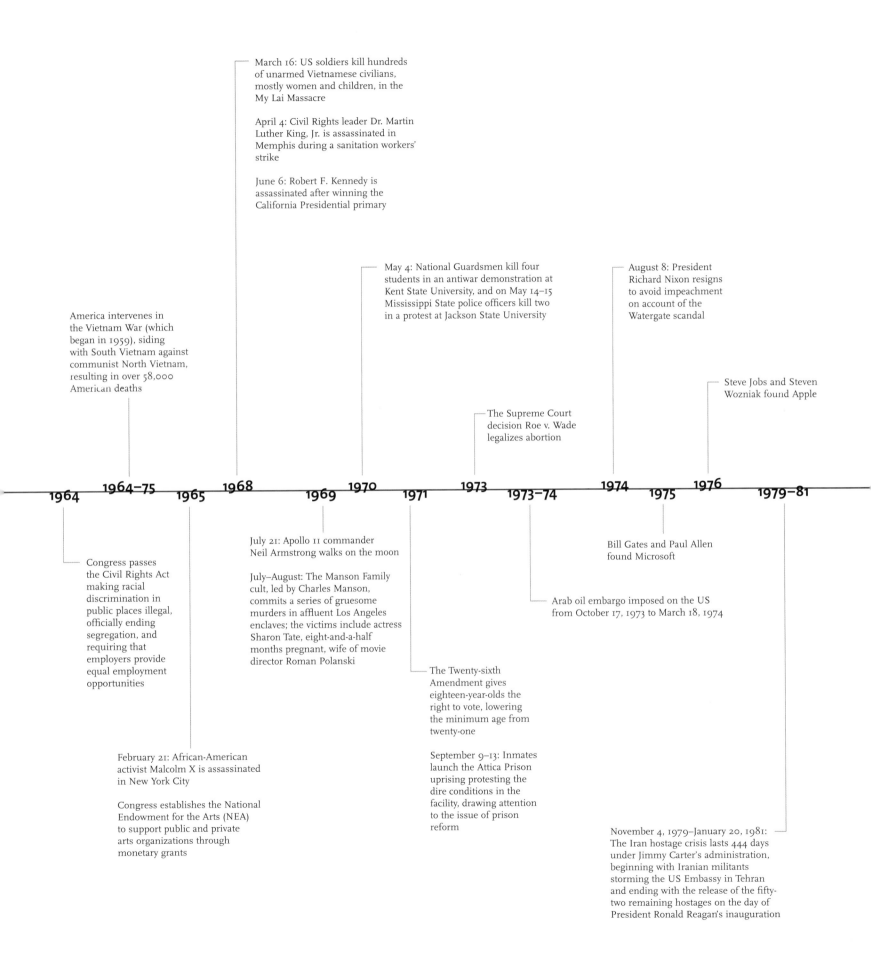

March 16: US soldiers kill hundreds of unarmed Vietnamese civilians, mostly women and children, in the My Lai Massacre

April 4: Civil Rights leader Dr. Martin Luther King, Jr. is assassinated in Memphis during a sanitation workers' strike

June 6: Robert F. Kennedy is assassinated after winning the California Presidential primary

May 4: National Guardsmen kill four students in an antiwar demonstration at Kent State University, and on May 14–15 Mississippi State police officers kill two in a protest at Jackson State University

August 8: President Richard Nixon resigns to avoid impeachment on account of the Watergate scandal

America intervenes in the Vietnam War (which began in 1959), siding with South Vietnam against communist North Vietnam, resulting in over 58,000 American deaths

Steve Jobs and Steven Wozniak found Apple

The Supreme Court decision Roe v. Wade legalizes abortion

1964 **1964–75** **1965** **1968** **1969** **1970** **1971** **1973** **1973–74** **1974** **1975** **1976** **1979–81**

July 21: Apollo 11 commander Neil Armstrong walks on the moon

July–August: The Manson Family cult, led by Charles Manson, commits a series of gruesome murders in affluent Los Angeles enclaves; the victims include actress Sharon Tate, eight-and-a-half months pregnant, wife of movie director Roman Polanski

Bill Gates and Paul Allen found Microsoft

Congress passes the Civil Rights Act making racial discrimination in public places illegal, officially ending segregation, and requiring that employers provide equal employment opportunities

Arab oil embargo imposed on the US from October 17, 1973 to March 18, 1974

The Twenty-sixth Amendment gives eighteen-year-olds the right to vote, lowering the minimum age from twenty-one

February 21: African-American activist Malcolm X is assassinated in New York City

Congress establishes the National Endowment for the Arts (NEA) to support public and private arts organizations through monetary grants

September 9–13: Inmates launch the Attica Prison uprising protesting the dire conditions in the facility, drawing attention to the issue of prison reform

November 4, 1979–January 20, 1981: The Iran hostage crisis lasts 444 days under Jimmy Carter's administration, beginning with Iranian militants storming the US Embassy in Tehran and ending with the release of the fifty-two remaining hostages on the day of President Ronald Reagan's inauguration

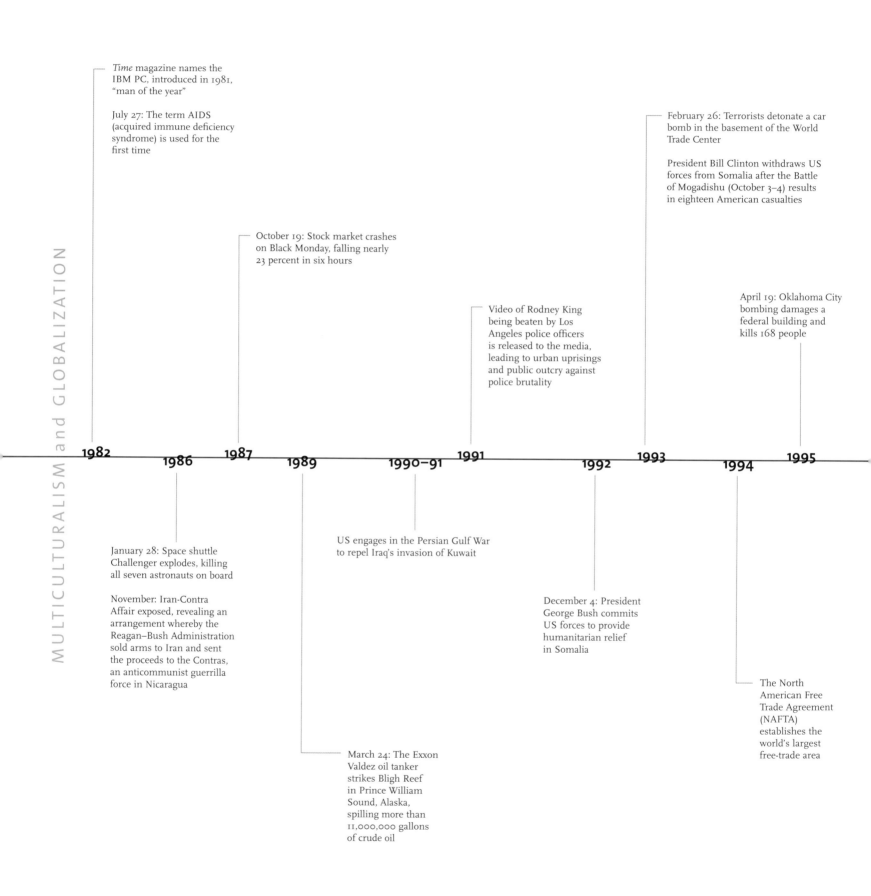

MULTICULTURALISM and GLOBALIZATION

Time magazine names the
IBM PC, introduced in 1981,
"man of the year"

July 27: The term AIDS
(acquired immune deficiency
syndrome) is used for the
first time

October 19: Stock market crashes
on Black Monday, falling nearly
23 percent in six hours

February 26: Terrorists detonate a car
bomb in the basement of the World
Trade Center

President Bill Clinton withdraws US
forces from Somalia after the Battle
of Mogadishu (October 3–4) results
in eighteen American casualties

Video of Rodney King
being beaten by Los
Angeles police officers
is released to the media,
leading to urban uprisings
and public outcry against
police brutality

April 19: Oklahoma City
bombing damages a
federal building and
kills 168 people

1982 **1986** **1987** **1989** **1990–91** **1991** **1992** **1993** **1994** **1995**

January 28: Space shuttle
Challenger explodes, killing
all seven astronauts on board

November: Iran-Contra
Affair exposed, revealing an
arrangement whereby the
Reagan–Bush Administration
sold arms to Iran and sent
the proceeds to the Contras,
an anticommunist guerrilla
force in Nicaragua

US engages in the Persian Gulf War
to repel Iraq's invasion of Kuwait

December 4: President
George Bush commits
US forces to provide
humanitarian relief
in Somalia

The North
American Free
Trade Agreement
(NAFTA)
establishes the
world's largest
free-trade area

March 24: The Exxon
Valdez oil tanker
strikes Bligh Reef
in Prince William
Sound, Alaska,
spilling more than
11,000,000 gallons
of crude oil

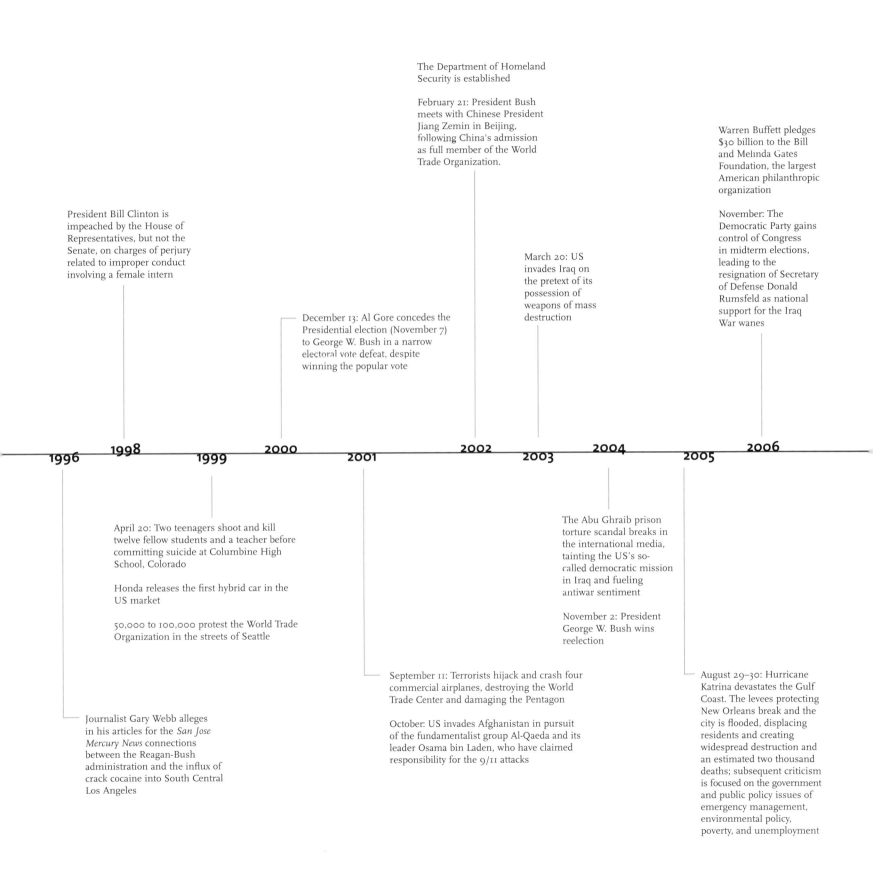

The Department of Homeland Security is established

February 21: President Bush meets with Chinese President Jiang Zemin in Beijing, following China's admission as full member of the World Trade Organization.

Warren Buffett pledges $30 billion to the Bill and Melinda Gates Foundation, the largest American philanthropic organization

President Bill Clinton is impeached by the House of Representatives, but not the Senate, on charges of perjury related to improper conduct involving a female intern

March 20: US invades Iraq on the pretext of its possession of weapons of mass destruction

November: The Democratic Party gains control of Congress in midterm elections, leading to the resignation of Secretary of Defense Donald Rumsfeld as national support for the Iraq War wanes

December 13: Al Gore concedes the Presidential election (November 7) to George W. Bush in a narrow electoral vote defeat, despite winning the popular vote

1996 **1998** **1999** **2000** **2001** **2002** **2003** **2004** **2005** **2006**

April 20: Two teenagers shoot and kill twelve fellow students and a teacher before committing suicide at Columbine High School, Colorado

Honda releases the first hybrid car in the US market

50,000 to 100,000 protest the World Trade Organization in the streets of Seattle

The Abu Ghraib prison torture scandal breaks in the international media, tainting the US's so-called democratic mission in Iraq and fueling antiwar sentiment

November 2: President George W. Bush wins reelection

September 11: Terrorists hijack and crash four commercial airplanes, destroying the World Trade Center and damaging the Pentagon

October: US invades Afghanistan in pursuit of the fundamentalist group Al-Qaeda and its leader Osama bin Laden, who have claimed responsibility for the 9/11 attacks

Journalist Gary Webb alleges in his articles for the *San Jose Mercury News* connections between the Reagan-Bush administration and the influx of crack cocaine into South Central Los Angeles

August 29–30: Hurricane Katrina devastates the Gulf Coast. The levees protecting New Orleans break and the city is flooded, displacing residents and creating widespread destruction and an estimated two thousand deaths; subsequent criticism is focused on the government and public policy issues of emergency management, environmental policy, poverty, and unemployment

Select Bibliography

Survey Books and General Works:

Matthew Baigell, *A Concise History of American Painting and Sculpture,* rev. edn, New York, HarperCollins/Icon Editions, 1996

_____, *Dictionary of American Art,* rev. edn, New York, HarperCollins/Icon Editions, 1996

David Bjelajac, *American Art: A Cultural History,* 2nd edn, Upper Saddle River, NJ, Pearson Prentice Hall, 2005

Elspeth H. Brown, Catherine Gudis, and Marina Moskowitz (eds.), *Cultures of Commerce: Representation and American Business Culture, 1877–1960,* New York, Palgrave Macmillan, 2006

Patricia M. Burnham and Lucretia Hoover Giese (eds.), *Redefining American History Painting,* Cambridge, Cambridge University Press, 1995

Sarah Burns, *Painting the Dark Side: Art and the Gothic Imagination in Nineteenth-Century America*, Berkeley, Calif., University of California Press, 2004

Mary Ann Calo (ed.), *Critical Issues in American Art,* Boulder, Col., Westview Press, 1998

John Carlin and Jonathan Fineberg, *Imagining America: Icons of Twentieth-Century American Art,* New Haven, Conn., Yale University Press, 2005

Whitney Chadwick, *Women, Art, and Society,* London, Thames & Hudson, 1990, 1996

Annie Cohen-Solal, Painting American: *The Rise of American Artists, Paris 1867–New York 1948,* New York, Alfred A. Knopf 2001

Wayne Craven, *American Art, History and Culture,* Madison, Wis., Brown and Benchmark, 1994

Thomas Crow, *Modern Art in the Common Culture,* New Haven, Conn., Yale University Press, 1996

Marianne Doezema and Elizabeth Milroy (eds.), *Reading American Art,* New Haven, Conn., Yale University Press, 1998

Erika Doss, *Twentieth-Century American Art,* Oxford, UK, Oxford University Press, 2002

Philip S. Foner and Reinhard Schultz (eds.), *The Other America: Art and the Labour Movement in the United States,* London, Journeyman Press, 1985

Thomas W. Gaehtgens and Heinz Ickstadt (eds.), *American Icons: Transatlantic Perspectives on Eighteenth- and Nineteenth-Century American Art*, Los Angeles, Getty Center for the History of Art and the Humanities; distributed by University of Chicago Press, 1992

William H. Gerdts, *Art Across America: Two Centuries of Regional Painting in America, 1710–1920,* New York, Abbeville Press, 1990

Barbara Groseclose, *Nineteenth-Century American Art,* Oxford, UK, Oxford University Press, 2000

Catherine Gudis, *Buyways: Billboards, Automobiles, and the American Landscape,* New York, Routledge, 2004

Barbara Haskell, T*he American Century, Art, and Culture, 1900–1950,* exhib. cat., New York, Whitney Museum of American Art in association with W.W. Norton, 1999

Patricia Hills, *Modern Art in the USA: Issues and Controversies of the Twentieth Century,* Upper Saddle River, NJ, Prentice Hall, 2001

Guiyou Huang, *Whitmanism, Imagism, and Modernism in China and America,* Selingsgrove, Pa., Susquehanna University Press, and Cranbury, NJ, Associated University Presses, 1997

Robert Hughes, *American Visions: The Epic History of Art in America,* New York, Alfred A. Knopf, 1997

Elizabeth Kennedy and Katherine M. Bourguignon, *An American Point of View: The Daniel J. Terra Collection,* Chicago, Terra Museum of American Art, and Giverny, France, Musée d'Art Américain, 2002

Rosalind Krauss, Yve-Alain Bois, and Hal Foster (eds.), *Art Since 1900: Modernism, Antimodernism, Postmodernism,* London, Thames & Hudson, 2005

Michael Leja, *Looking Askance: Skepticism and American Art from Eakins to Duchamp,* Berkeley, Calif., University of California Press, 2004

Amy Ling (ed.), *Yellow Light: The Flowering of Asian American Arts,* Philadelphia, Temple University Press, 1999

Jean Lipman and Tom Armstrong (eds.), *American Folk Painting of Three Centuries,* New York, Hudson Hills Press, 1980

John W. McCoubrey (ed.), *American Art, 1700–1960: Sources and Documents,* Englewood Cliffs, NJ, Prentice Hall, 1965

Guy C. McElroy, *Facing History: The Black Image in American Art, 1710–1940,* exhib. cat., San Francisco, Bedford Arts, and Washington, D.C., Corcoran Gallery of Art, 1990

David C. Miller (ed.), *American Iconology: New Approaches to Nineteenth-Century Art and Literature,* New Haven, Conn., Yale University Press, 1993

Linda Nochlin, *The Politics of Vision: Essays on Nineteenth-Century Art and Society,* New York, HarperCollins, 1991

Ellwood C. Parry III, *The Image of the Indian and the Black Man in American Art, 1590–1900,* New York, Braziller, 1974

Lisa Phillips, *The American Century: Art & Culture, 1950–2000,* exhib. cat., New York, Whitney Museum of American Art in association with W.W. Norton, 1999

Frances K. Pohl, *Framing America: A Social History of American Art,* New York, Thames & Hudson, 2002

Brendan Prendeville, *Realism in Twentieth-Century Painting,* London, Thames & Hudson, 2000

Jules David Prown and Barbara Rose, *American Painting: From the Colonial Period to the Present,* rev. edn, New York, Rizzoli, 1977

Harold Spencer (ed.), *American Art: Readings from the Colonial Era to the Present,* New York, Charles Scribner's Sons, 1980

Leo Steinberg, *Other Criteria. Confrontations with Twentieth-Century Art,* New York, Oxford University Press, 1975

Joshua C. Taylor, *America as Art,* New York, Harper and Row/Icon Editions, 1976

John Wilmerding, *American Views: Essays on American Art,* Princeton, NJ, Princeton University Press, 1991

Bryan Jay Wolf, *Romantic Re-Vision: Culture and Consciousness in Nineteenth-Century American Painting and Literature*, Chicago, University of Chicago Press, 1982

Colonization and Rebellion (1700–1830)

James Axtell, *The European and the Indian: Essays in the Ethnohistory of Colonial North America*, New York, Oxford University Press, 1982

Peter Benes (ed.), *Painting and Portrait Making in the American Northeast*, Boston, Boston University, 1995

Russell Bourne, *Gods of War, Gods of Peace: How the Meeting of Native and Colonial Religions Shaped Early America*, New York, Harcourt, 2002

Jon Butler, *Becoming America: The Revolution Before 1776*, Cambridge, Mass., Harvard University Press, 2000

Cary Carson, Ronald Hoffman and Peter J. Albert, *Of Consuming Interests: The Style of Life in the Eighteenth Century*, Charlottesville, Va., University Press of Virginia for the United States Capitol Historical Society, 1994

Wayne Craven, *Colonial American Portraiture: The Economic, Religious, Social, Cultural, Philosophical, Scientific, and Aesthetic Foundations*, Cambridge, UK, Cambridge University Press, 1986

Neil Harris, *The Artist in American Society: The Formative Years, 1790–1860*, New York, Braziller, 1966

Patricia Johnston (ed.), *Seeing High and Low: Representing Social Conflict in American Art*, Berkeley, Calif., University of California Press, 2006

Michael Kammen, *Empire and Interest: The American Colonies and the Politics of Mercantilism*, Philadelphia, Lippincott, 1970

Margaretta Lovell, *Art in a Season of Revolution: Painters, Artisans & Patrons in Early America*, Philadelphia, University of Pennsylvania Press, 2005

Amy Meyers (ed.), *The Culture of Nature: Art and Science in Philadelphia, 1740–1840*, New Haven, Conn., Yale University Press, 2006

Ellen G. Miles et al., *American Paintings of the Eighteenth Century*, exhib. cat., Washington, D.C., National Gallery of Art, 1995

Richard H. Saunders and Ellen G. Miles, *American Colonial Portraits, 1700–1776*, Washington, D.C., Smithsonian Institution Press for the National Portrait Gallery, 1987

Simon Schama, *Rough Crossings: Britain, the Slaves and the American Revolution*, New York, Ecco, 2006

Robert Blair St. George (ed.), *Possible Pasts: Becoming Colonial in Early America*, Ithaca, NY, Cornell University Press, 2000

Laurel Ulrich, *The Age of the Homespun: Objects and Stories in the Creation of an American Myth*, New York, Alfred A. Knopf, 2001

Expansion and Fragmentation (1830–80)

Robert Charles Bishop and Jacqueline M. Atkins, *Folk Art in American Life*, New York, Viking Studio Books/Penguin Books, 1995

Albert Boime, *The Magisterial Gaze: Manifest Destiny and American Landscape Painting, ca. 1830–1865*, Washington, D.C., Smithsonian Institution Press, 1991

Elizabeth Johns, *American Genre Painting: The Politics of Everyday Life*, New Haven, Conn., Yale University Press, 1991

David Lubin, *Picturing a Nation: Art and Social Change in Nineteenth-Century America*, New Haven, Conn., Yale University Press, 1994

Angela Miller, *The Empire of the Eye: Landscape Representations and American Cultural Politics, 1825–1875*, Ithaca, NY, Cornell University Press, 1993

Barbara Novak, *Nature and Culture: American Landscape Painting*, rev. edn, Oxford, UK, Oxford University Press, 1995

Judith O'Toole and Arnold Skolnick, *Different Views in Hudson River School Painting*, New York, Columbia University Press, 2006

Jules Prown et al., *Discovered Lands, Invented Pasts: Transforming Visions of the American Frontier*, New Haven, Conn., Yale University Press, 1992

Richard Slotkin, *The Fatal Environment: The Myth of the Frontier in the Age of Industrialization, 1800–1890*, New York, Athenaeum, 1985

William H. Truettner (ed.), *The West as America: Reinterpreting Images of the Frontier*, Washington, D.C., Smithsonian Institution Press, 1991

John Wilmerding (ed.), *American Light: The Luminist Movement, 1850–1875*, exhib. cat., Washington, D.C., National Gallery of Art, 1980

Andrew Wilton and Tim Barringer, *American Sublime: Landscape Painting in the United States, 1820–1880*, Princeton, NJ, Princeton University Press, 2002

Cosmopolitanism and Nationalism (1880–1915)

Kathleen Adler, Erica E. Hirshler, and H. Barbara Weinberg, *Americans in Paris: 1860–1900*, exhib. cat., London, National Gallery, 2006

Jay Bochner, *An American Lens: Scenes from Alfred Stieglitz's New York Secession*, Cambridge, Mass., MIT Press, 2005

Milton Wolf Brown, *The Story of the Armory Show*, 2nd edn, New York, Abbeville Press, 1988

Paul Buhle and Edmund B. Sullivan, *Images of American Radicalism*, Hanover, Mass., Christopher Publishing House, 1998

Sarah Burns, *Inventing the Modern Artist: Art and Culture in Gilded Age America*, New Haven, Conn., Yale University Press, 1996

Holly Edwards, *Noble Dreams, Wicked Pleasures: Orientalism in America, 1870–1930*, Princeton, NJ, Princeton University Press, 2000

Nancy Mowll Mathews with Charles Musser, *Moving Pictures: American Art and Early Film, 1880–1910*, Manchester, Vt., Hudson Hills Press, 2005

Emily Neff and George T.M. Shackelford, *American Painters in the Age of Impressionism*, exhib. cat., Houston, Tex., Museum of Fine Arts, 1994

Kathleen Pyne, *Art and the Higher Life: Painting and Evolutionary Thought in Late Nineteenth-Century America,* Austin, Tex., University of Texas Press, 1996

Bailey Van Hook, *Angles of Art: Women and Art in American Society, 1876–1914,* University Park, Pa., Pennsylvania State University Press, 1996

Catherine Hoover Voorsanger and John K. Howat (eds.), *Art and the Empire City: New York, 1825–1861,* exhib. cat., New York, Metropolitan Museum of Art, 2000

H. Barbara Weinberg, Doreen Bolger, and David Park Curry, *American Impressionism and Realism: The Painting of Modern Life, 1885–1915,* exhib. cat., New York, Metropolitan Museum of Art; distributed by Harry N. Abrams, 1994

James Abbott McNeill Whistler, *The Gentle Art of Making Enemies,* ed. Sheridan Ford, New York, F. Stokes & Brother, 1890

Rebecca Zurier, Robert W. Snyder, and Virginia Mecklenburg, *Metropolitan Lives: The Ashcan Artists and Their New York,* Washington, D.C., National Museum of American Art in association with W.W. Norton, 1995

Rebecca Zurier, *Picturing the City: Urban Vision and the Ashcan School,* Berkeley, Calif., University of California Press, 2006

Modernism and Regionalism (1915–45)

Allan Antliff, *Anarchist Modernism: Art, Politics, and the First Avant-Garde,* Chicago, University of Chicago Press, 2001

Alfred H. Barr, Jr., *Defining Modern Art: Selected Writings of Alfred H. Barr, Jr.,* ed. Irving Sandler and Amy Newman, New York, Abrams, 1986

Bruce I. Bustard, *A New Deal for the Arts,* Washington, D.C., National Archives and Records Administration in association with the University of Washington Press, 1997

Holger Cahill and Alfred H. Barr, Jr. (eds.), *Art in America in Modern Times,* New York, Reynal & Hitchcock, 1934

Belisario R. Contreras, *Tradition and Innovation in New Deal Art,* Lewisburg, Pa., Bucknell University Press, 1983

Wanda Corn, *The Great American Thing: Modern Art and National Identity, 1915–1935,* Berkeley, Calif., University of California Press, 1999

Abraham A. Davidson, *Early American Modernist Painting, 1910–1935,* New York, Da Capo Press, 1981

Bram Dijkstra, *American Expressionism: Art and Social Change, 1920–1950,* New York, Harry N. Abrams in association with the Columbus Museum of Art, 2003

Sarah Greenough et al., *Modern Art and America: Alfred Stieglitz and His New York Galleries,* exhib. cat., Washington, D.C., National Gallery of Art, and Boston, Bulfinch Press, 2000

Gail Levin, *Synchromism and American Color Abstraction, 1910–1925,* New York, Braziller, 1978

Sophie Lévy (ed.), *A Transatlantic Avant-garde: American Artists in Paris, 1918–1939,* exhib. cat., Berkeley, Calif., University of California Press, 2003

Susan Platt, *Modernism in the 1920s: Interpretations of Modern Art in New York From Expressionism to Constructivism,* Ann Arbor, Mich., UMI Research Press, 1985

_____, *Art and Politics in the 1930s: Modernism, Marxism, Americanism, A History of Cultural Activism During the Depression Years,* New York, Midmarch Press, 1999

Richard Powell and David A. Bailey, *Rhapsodies in Black: Art of the Harlem Renaissance,* exhib. cat., London, Hayward Gallery, Institute of International Visual Arts, and Berkeley, Calif., University of California Press, 1997

Dickran Tashjian, *A Boatload of Madmen: Surrealism and the American Avant-garde, 1920–1950,* New York, Thames & Hudson, 1995

Steven Watson, *Strange Bedfellows: The First American Avant-garde,* New York, Abbeville Press, 1993

Nicolas Fox Weber, *Patron Saints: Five Rebels Who Opened America to a New Art, 1928–1943,* New York, Alfred A. Knopf, 1992

Prosperity and Disillusionment (1945–80)

David Anfam, *Abstract Expressionism,* London, Thames & Hudson, 1990

Dore Ashton, *The New York School: A Cultural Reckoning,* New York, Viking Press, 1973

Gregory Battcock (ed.), *Minimal Art: A Critical Anthology,* New York, E.P. Dutton, 1968

_____, *The New Art: A Critical Anthology,* New York, E.P. Dutton, 1973

Herschel B. Chipp (ed.), *Theories of Modern Art: A Sourcebook by Artists and Critics,* Berkeley, Calif., University of California Press, 1968

Diana Crane, *The Transformation of the Avant-Garde: The New York Art World, 1940–1985,* Chicago, University of Chicago Press, 1987

Thomas Crow, *The Rise of Sixties American and European Art in the Era of Dissent,* New York, Harry N. Abrams, 1996

Jonathan Fineberg, *Art Since 1940: Strategies of Being,* rev. edn, New York, Harry N. Abrams, 2000

Henry Geldzahler (ed.), *New York Painting and Sculpture: 1940–1970,* New York, E.P. Dutton, 1969

Ann Eden Gibson, *Abstract Expressionism: Other Politics,* New Haven, Conn., Yale University Press, 1997

Clement Greenberg, *The Collected Essays and Criticism,* ed. John O'Brian, Chicago, University of Chicago Press, 1986

Serge Guilbaut, *How New York Stole the Idea of Modern Art, Abstract Expressionism, Freedom, and the Cold War,* trans. Arthur Goldhammer, Chicago, University of Chicago Press, 1983

David Hopkins, *After Modern Art: 1945–2000,* Oxford, UK, Oxford University Press, 2000

Ellen H. Johnson, *American Artists on Art from 1940 to 1980,* New York, Harper & Row, 1982

Amelia Jones (ed.), *A Companion to Contemporary Art Since 1945,* Malden, Mass., Blackwell Publishing, 2006

Caroline A. Jones, *Machine in the Studio: Constructing the Postwar American Artist,* Chicago, University of Chicago Press, 1996

Donald Judd, *Donald Judd: Complete Writings 1959–1975: Gallery Reviews, Book Reviews, Articles, Letters to the Editor, Reports, Statements, Complaints,* Halifax, Nova Scotia, Press of the Nova Scotia College of Art and Design, 2005

Max Kozloff, *Renderings: Critical Essays on a Century of Modern Art,* London, Studio Vista Limited, 1970

Rosalind Krauss, *The Originality of the Avant-Garde and Other Modernist Myths*, Cambridge, Mass., MIT Press, 1985

Pamela M. Lee, *Chronophobia: On Time in the Art of the 1960s*, Cambridge, Mass., MIT Press, 2004

Michael Leja, *Reframing Abstract Expressionism: Subjectivity and Painting in the 1940s*, New Haven, Conn., Yale University Press, 1993

Steven Henry Madoff (ed.), *Pop Art: A Critical History*, Berkeley, Calif., University of California Press, 1998

Christin J. Mamiya, *Pop Art and Consumer Culture: American Super Market*, Austin, Tex., University of Texas Press, 1992

James Meyer, *Minimalism: Art and Polemics in the Sixties*, New Haven, Conn., Yale University Press, 2001

Roszika Parker and Griselda Pollock (eds.), *Framing Feminism: Art and the Woman's Movement 1970–1985*, London, Pandora, 1987

Francis Pohl, *In the Eye of the Storm: An Art of Conscience, 1930–1970*, San Francisco, Pomegranate Artbooks, 1995

Sidra Stich, *Made in the U.S.A.: An Americanization in Modern Art, the 50s and 60s*, Berkeley, Calif., University of California Press, 1987

Brandon Taylor, *Avant-Garde and After: Rethinking Art Now*, New York, Harry N. Abrams, 1995

Cécile Whiting, *A Taste for Pop: Pop Art, Gender and Consumer Culture*, Cambridge, UK, Cambridge University Press, 1997

Multiculturalism and Globalization (1980–present)

Maurice Berger, *Modern Art and Society: An Anthology of Social and Multicultural Readings*, New York, HarperCollins, 1994

Hans Bertens, *The Idea of Postmodern: A History*, London, Routledge, 1995

Richard Bolton (ed.), *Culture Wars: Documents from the Recent Controversies in the Arts*, New York, New Press; distributed by W.W. Norton, 1992

Whitney Chadwick, *Women, Art, and Society*, 3rd edn, New York, Thames & Hudson, 2002

Douglas Crimp (ed.), *AIDS: Cultural Analysis, Cultural Activism*, Cambridge, Mass., MIT Press, 1987

Nicolas De Oliveira, Nicola Oxley, and Michael Petry, *Installation Art in the New Millennium: The Empire of the Senses*, New York, Thames & Hudson, 2003

Erika Doss, *Spirit Poles and Flying Pigs: Public Art and Cultural Democracy in American Communities*, Washington, D.C., Smithsonian Institution Press, 1995

Hal Foster (ed.), *The Anti-Aesthetic: Essays on Postmodern Culture*, Port Townsend, Wash., Bay Press, 1983

Catherine Gudis (ed.), *A Forest of Signs: Art in the Crisis of Representation*, Cambridge, Mass., MIT Press, 1989

Glenn Harper (ed.), *Interventions and Provocations: Conversations on Art, Culture, and Resistance*, Albany, NY, State University of New York Press, 1998

Caroline A. Jones (ed.), *Sensorium: Embodied Experience, Technology, and Contemporary Art*, Cambridge, Mass., MIT Press, 2006

Zoya Kocur and Simon Leung (eds.), *Theory in Contemporary Art Since 1985*, Malden, Mass., Blackwell Publishing, 2005

Rosalind Krauss (ed.), *October: The Second Decade, 1986–1996*, Cambridge, Mass., MIT Press, 1997

Lucy Lippard, *Mixed Blessings: New Art in a Multicultural America*, New York, Pantheon Books, 1990

Margo Machida *et al., Asia/America: Identities in Contemporary Asian American Art*, New York, The New Press, 1994

Thomas McEvilley, *Art & Otherness: Crisis in Cultural Identity*, Kingston, NY, Documentext/McPherson, 1992

_____, *The Exile's Return: Toward a Redefinition of Painting for the Postmodern Era*, Cambridge, UK, Cambridge University Press, 1993

Craig Owens, *Beyond Recognition: Representation, Power, and Culture*, ed. Scott Bryson, Berkeley, Calif., University of California Press, 1992

Robert Pincus-Witten, *Entries (Maximalism): Art at the Turn of the Decade*, New York, Out of London Press, 1983

Lawrence Rinder, *The American Effect: Global Perspectives on the United States*, exhib. cat., New York, Whitney Museum of American Art, 2003

Jean Robertson and Craig McDaniel, *Themes of Contemporary Art: Visual Art After 1980*, New York, Oxford University Press, 2005

Jerry Saltz (ed.), *Beyond Boundaries: New York's New Art*, New York, A. van der Marck Editions, 1986

Kristine Stiles and Peter Selz (eds.), *Theories and Documents of Contemporary Art: A Sourcebook of Artists' Writings*, Berkeley, Calif., University of California Press, 1996

Calvin Tomkins, *Post- to Neo-: The Art World of the 1980s*, New York, Penguin Books, 1988

Bill Viola, *Reasons for Knocking at an Empty House: Writings, 1973–1994*, ed. Robert Violette, Cambridge, Mass., MIT Press, and London, Anthony d'Offay Gallery, 1995

Brian Wallis, *Art After Modernism: Rethinking Representation*, New York, The New Museum of Contemporary Art in association with David R. Godine, Publishers, 1984

_____, *Blasted Allegories: An Anthology of Writings by Contemporary Artists*, Cambridge, Mass., MIT Press, 1987

Linda Weintraub, *Art on the Edge and Over: Searching for Art's Meaning in Contemporary Society, 1970s–1990s*, Litchfield, Conn., Art Insights, 1996

Index

Photography Credits

Fig. 2: © American Antiquarian Society. Figs. 3, 68: Image © 2006 Board of Trustees, National Gallery of Art, Washington, D.C. Fig. 4: National Portrait Gallery, Smithsonian Institution/Art Resource, New York. Fig. 5: © 1990 The Detroit Institute of Arts. Fig. 8: Courtesy of the Architect of the Capitol. Fig. 14: © The Cleveland Museum of Art. Figs. 15, 23, 77: Digital Image © The Museum of Modern Art/Licensed by SCALA/Art Resource, New York. Fig. 17: Photo: R. Lemke. Fig. 22: Photo: Joshua Nefsky, Courtesy of Michael Rosenfeld Gallery, New York. Fig. 24: Courtesy of Ronald Feldman Fine Arts, New York. Fig. 25: Photo: Peter Muscato, Courtesy of The Andrea Rosen Gallery, New York, and The Museum of Modern Art, New York. Fig. 29: © 1985 The Metropolitan Museum of Art. Figs. 30, 45, 97: Smithsonian American Art Museum, Washington, D.C./Art Resource, New York. Fig. 35: © 1985 The Detroit Institute of Arts. Figs. 38 and 40: © 1998 The Metropolitan Museum of Art. Fig. 43: © 2004 Historic Deerfield, Photo: Penny Leveritt. Fig. 48: Photo: Erich Lessing/Art Resource, New York. Fig. 49: © 1999 The Metropolitan Museum of Art. Fig. 53: © 1995 The Metropolitan Museum of Art. Fig. 59: Photo: S. Watson. Fig. 62: Courtesy of The United States National Park Service. Fig. 66: Photo: Graydon Wood. Fig. 72: Photo: Michael Agee. Fig. 78: © The Art Institute of Chicago. Fig. 79: © 1986 The Metropolitan Museum of Art. Fig. 82: © 1988 Dorothy Zeidman, © AXA Financial, Inc. Fig. 83: Photo: Dawoud Bey. Fig. 95: Courtesy of the Estate of Dong Kingman. Fig. 96: Photo: Lee Stalsworth. Fig. 100: © Dia Art Foundation, Photo: John Cliett. Fig. 104: CNAC/MNAM/ Dist. Réunion des Musées Nationaux/Art Resource, New York. Fig. 105: © Blaise Adilon. Fig. 107: © The Solomon R. Guggenheim Foundation, New York. Fig. 108: Courtesy of The Gladstone Gallery, New York. Fig. 110: Photo: Lisa Kahane, Courtesy of The Jenny Holzer Studio. Fig. 111: Courtesy of the Estate of Keith Haring. Fig. 112: Photo: Douglas M. Parker Studio, Los Angeles. Fig. 113: Courtesy of The Jack Tilton Gallery, New York. Fig. 114: Photo: Michael Olijnyk, Courtesy of the artist and The Mattress Factory. Fig. 115: Photo: Michael James O'Brien. Fig. 117: Courtesy of Maccarone Inc. p. 62: The Newark Museum/Art Resource, New York. pp. 72, 114: Photo: Richard Walker. p. 72: © New York State Historical Association, Cooperstown, NY. p. 114: © Fenimore Art Museum, Cooperstown, NY. p. 174: Photo: Holly Agueri. p. 185: Photo: James Via. p. 187: Photo: Joseph Szaszfai. p. 216: Smithsonian American Art Museum, Washington, D.C./Art Resource, New York. p. 218: Courtesy of The Gerald Peters Gallery, New York. pp. 220, 221 (Religion): Photo: Kathryn Carr. p. 230: © 1943 SEPS: Licensed by Curtis Publishing, Indianapolis. All rights reserved. www.curtispublishing.com. p. 231: © 1994 The Metropolitan Museum of Art. pp. 258–59: Courtesy of The Barnett Newman Foundation. pp. 262–63: Photo: Susan Einstein Photography, Los Angeles. p. 264: © 1989 Christopher Gallagher. p. 268: Photo: Jochen Littkemann, Berlin. p. 269: Photo: Richard Stoner. p. 270: Photo: Eric Pollitzer. p. 311: Courtesy of The Gladstone Gallery, New York. p. 315: Courtesy of the Estate of Keith Haring. p. 326: Photo: Tate Gallery, London/Art Resource, New York. p. 327: Courtesy of The David Zwirner Gallery, New York. p. 329: Photo: Michael Tropea. p. 332: Digital image © The Museum of Modern Art/Licensed by SCALA/Art Resource, New York